D0312834

IMPRESSIONIST QUARTET

ALSO BY JEFFREY MEYERS

BIOGRAPHY

A Fever at the Core: The Idealist
in Politics

Married to Genius

Katherine Mansfield

The Enemy: A Biography of
Wyndham Lewis

Hemingway

Manic Power: Robert Lowell
and His Circle

D. H. Lawrence

Joseph Conrad

Edgar Allan Poe: His Life and Legacy

Scott Fitzgerald

Edmund Wilson

Robert Frost

Bogart: A Life in Hollywood

Gary Cooper: American Hero

Privileged Moments: Encounters
with Writers

Wintry Conscience: A Biography
of George Orwell

Inherited Risk: Errol and Sean Flynn
in Hollywood and Vietnam

Somerset Maugham: A Life

CRITICISM

Fiction and the Colonial Experience

The Wounded Spirit: T. E. Lawrence's
Seven Pillars of Wisdom

A Reader's Guide to George Orwell

Painting and the Novel

Homosexuality and Literature

D. H. Lawrence and the
Experience of Italy

Disease and the Novel

The Spirit of Biography

Hemingway: Life into Art

BIBLIOGRAPHY

T. E. Lawrence: A Bibliography

Catalogue of the Library of the Late
Siegfried Sassoon

George Orwell: An Annotated
Bibliography of Criticism

EDITED COLLECTIONS

George Orwell: The Critical Heritage

Hemingway: The Critical Heritage

Robert Lowell: Interviews and
Memoirs

The Sir Arthur Conan Doyle Reader

The W. Somerset Maugham Reader

EDITED ORIGINAL ESSAYS

Wyndham Lewis: A Revaluation

Wyndham Lewis by Roy Campbell

D. H. Lawrence and Tradition

The Legacy of D. H. Lawrence

The Craft of Literary Biography

The Biographer's Art

T. E. Lawrence: Soldier, Writer,
Legend

Graham Greene: A Revaluation

IMPRESSIONIST QUARTET

The Intimate Genius of

MANET *and* MORISOT, DEGAS *and* CASSATT

JEFFREY MEYERS

HARCOURT, INC.

Orlando Austin New York San Diego Toronto London

Requests for permission to make copies of any part of
the work should be mailed to the following address:
Permissions Department, Harcourt, Inc.,
6277 Sea Harbor Drive, Orlando, Florida 32887-6777.

www.HarcourtBooks.com

Library of Congress Cataloging-in-Publication Data
Meyers, Jeffrey.
Impressionist quartet: the intimate genius of Manet
and Morisot, Degas and Cassatt/Jeffrey Meyers.
p. cm.
Includes bibliographical references and index.
ISBN 0-15-101076-5
1. Impressionist artists—France—Biography.
2. Impressionism (Art)—France. 3. Painting, French—
19th century. I. Title.
ND547.5.I4M49 2005
759.4—dc22 2004021329

Text set in Garamond MT
Designed by Liz Demeter

Printed in the United States of America

First edition
K J I H G F E D C B A

Contents

Acknowledgments

❧ I AM PLEASED to acknowledge the help I received while writing this book. I am grateful to Alex Colville and Marvin Eisenberg for stimulating conversations about painting; Dr. Ellen Alkon for information about Manet's illness; Elena Balashova and Jim Spohrer for library research; George Mauner and Seymour Howard, Martin Battestin and Claude Rawson for insights about art and literature.

I had useful material from the Bibliothèque Publique d'Information, Centre Pompidou (bpiinfo@bpi.fr); Smith College Libraries (Karen Kukil and Burd Schlessinger); and Swiss Institute for Art Research, Zurich (Dina Epelbaum).

As always, my wife, Valerie Meyers, helped with the research, read and improved each chapter, and compiled the index.

❧ IN THE LAST third of the nineteenth century in Paris, the Manet-Degas circle of painters, the greatest concentration of artistic genius since the Italian Renaissance, created a new way of looking at the world. Like all innovators, they had to struggle to achieve acceptance. Rejected by the official Salons and derided by the critics, they were the first artists to court publicity and risk scandal and ridicule to further their cause. Called "impressionists" by a scornful critic, they took the name as a badge of honor. They abandoned stale religious and classical subjects, broke the stranglehold of the academic tradition and transformed the finished surfaces and sharp edges of earlier masters, Jacques-Louis David and Jean-Auguste-Dominique Ingres, into new forms of brilliance and color. They recorded the fleeting effects of light in the landscape and celebrated the ordinary lives of sensuous men and women. The Impressionists' portrayal of everyday life and the natural landscape not only taught viewers to see the world through their eyes, but also sparked a revolution that propelled art in the direction of Cézanne, Picasso and abstraction.

Though Edouard Manet did not participate in the Impressionists' exhibitions, they considered him their leader. He painted with Edgar Degas at Boulogne in the summer of 1869, and with Claude Monet and Pierre-Auguste Renoir at Argenteuil in the summer of 1874. Monet and Alfred Sisley, who became members of "*la bande à Manet*," learned a great deal from his vigorous brushstrokes, his habit of painting directly on white canvas, his striking palette and unified compositions. The young

men gathered for intense discussions about new ways of painting light and color, exhibitions and dealers, politics and art-politics, in the Café Guerbois near Manet's studio. Monet, eight years younger than Manet, recalled how these talks "sharpened one's wits, encouraged frank and impartial inquiry, and provided enthusiasm that kept us going for weeks and weeks until our ideas took final shape. One always came away feeling more involved, more determined, and thinking more clearly and distinctly."

Manet and Degas were the most cultivated, talented and intellectually interesting Impressionist painters. Manet and Berthe Morisot, like Degas and Mary Cassatt, had close emotional and artistic bonds. The men both encouraged and dominated their gifted disciples and sometimes even "corrected and improved" their paintings; the women were informal pupils of the occasionally harsh masters they loved and admired. Like members of the London Bloomsbury group half a century later, they were friends and rivals who gained strength and confidence from their social and professional connections. They drank, dined and traveled together, frequented the same family soirées and salons; they painted and exhibited together, inspired and influenced each other's work; they shared models, patrons, dealers, and vital information on how to conduct the business of art. They posed for each other and collected each other's art. Today their paintings are frequently reproduced and instantly recognized, and pictures that once sold for a few francs now fetch millions of dollars. But their lives—unlike those of Gauguin, Van Gogh and Lautrec—are not well known.

Though revolutionary, the Impressionist Quartet saw themselves as part of the artistic tradition. Manet visited Eugène Delacroix, Degas visited Ingres, and both had their early work praised by the older masters. Both Manet and Degas went to Spain and admired Diego Velázquez. Manet, Morisot and Degas lived at the center of French culture and had strong ties with the leading writers of the time: Charles Baudelaire, who advocated

the painting of modern life; Stéphane Mallarmé, an intimate friend of both Manet and Morisot; Emile Zola, the champion of Manet; the Goncourt brothers, Joris-Karl Huysmans, Paul Valéry and André Gide, as well as George Moore and other distinguished visitors from England: Dante Gabriel Rossetti, Algernon Swinburne, Oscar Wilde and Frank Harris.

In contrast to the self-destructive painters and poets of the next generation, Van Gogh and Rimbaud, Manet's circle came from an upper-class background and led stable lives devoted to art. They dressed fashionably but conservatively, rejecting bohemian capes, broad felt hats, long hair and loose cravats. Manet's and Morisot's fathers were successful lawyers; Degas' and Cassatt's were prosperous bankers. Unlike Camille Pissarro, Monet and Renoir, who came from poor families in the provinces or colonies, Manet, Morisot and Degas all grew up in Paris. Cassatt, born near Pittsburgh, spent most of her adult life in France. Manet and Degas were eldest sons; Morisot and Cassatt were youngest daughters. Manet and Degas were male counterparts of these two rich, sheltered and talented younger women. The Manet and Morisot, Degas and Cassatt relationships lasted a lifetime.

These painters lived through a period of political upheaval and stressful social change. Manet and Degas both served in the National Guard during the Prussian siege of Paris in 1870. Manet and Morisot (who remained in Paris during the war) had nervous breakdowns after the starvation and slaughter during the Commune of 1871. Cassatt suffered a breakdown after the death of her brother in 1911, and Degas remained neurasthenic throughout his life. Manet (two years older than Degas) and Morisot (three years older than Cassatt) died in their early fifties; Degas and Cassatt in their early eighties. All four had considerable courage. Manet endured decades of public vilification; Degas and Cassatt struggled with increasing blindness, which finally extinguished their careers. Morisot and Cassatt fought social

disapproval and became successful professional artists in a world dominated by men.

This Impressionist Quartet, the art critic Robert Herbert observed, was "equally devoted to contemporary life, rendered in naturalistic terms, without idealization, without need for 'noble' subjects, without literary sources."[1] Yet they were not always objective observers. Manet and Degas, two powerful personalities, had emotional connections to Morisot and Cassatt as enduring as their artistic and intellectual influence. The portraits Manet painted of Morisot and those Degas did of Manet and Cassatt reveal their powerful ties to their subjects. These four artists have vanished into their paintings. This book illuminates their intimate relationship.

A WORD on method: I frequently use comparisons with literature to illuminate the painters' characters and art, and analyze the crucial incidents of their lives more thoroughly and extract more meaning than previous biographers. Unlike most art critics, I'm not interested in the historical sources of the paintings, in the obtuse and often abusive criticism written by the artists' contemporaries, or in applying fashionable theory to their lives or careers. I take a fresh look at the art, with careful attention to detail, and describe exactly what I see. I explain, within the context of the artist's life and time, what's happening in the paintings and what they mean. In this way, I offer new interpretations of a dozen great pictures: Manet's *Portrait of M. and Mme. Auguste Manet, Luncheon on the Grass, The Battle of the Kearsarge and the Alabama, The Luncheon, Chez le Père Lathuille, The Escape of Rochefort,* and *A Bar at the Folies-Bergère;* Degas' *The Misfortunes of the City of Orléans, Interior: The Rape, The Pedicure* and *Mary Cassatt at the Louvre: The Etruscan Gallery;* and Cassatt's *The Caress.* I have used English translations of French, Italian and German sources when available; otherwise, the translations are mine.

IMPRESSIONIST QUARTET

EDOUARD MANET

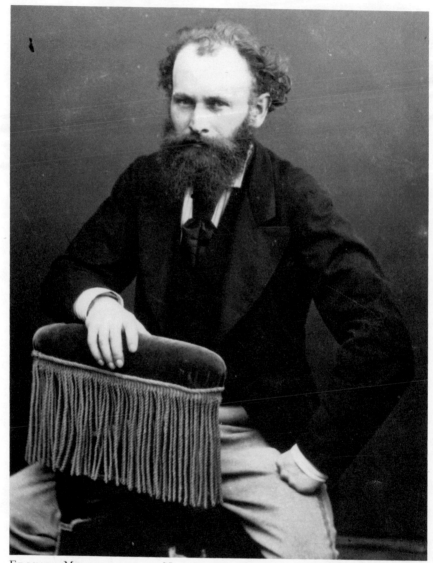

EDOUARD MANET, PHOTO BY NADAR, 1865. *Réunion des Musées Nationaux/ Art Resource, New York*

INDEFINABLE FINESSE

1832–1858

I

❧ EDOUARD MANET, the notorious creator of sexually daring paintings, was beloved by his friends and despised by the critics and the public. In the 1860s, when he began his career, he was handsome, charming and always fashionably dressed in his carefully tailored jacket, light-colored trousers and tall, wide-brimmed hat. Burning to succeed, and sure that he knew the direction painting should go, he worked with models in his studio, met friends in the Louvre and in private galleries, talked art and politics in the Paris salons and cafés. The crusading novelist Emile Zola, an early defender of his art, noted his "keen, intelligent eyes, [his] restless mouth turning ironic now and again; the whole of his expressive, irregular face has an indefinable finesse and vigor about it." Armand Silvestre, a contemporary critic, described Manet's appealing character and caustic wit. He was "a kind of dandy. Blond, with a sparse, narrow beard which was forked at the end, he had in the extraordinary vivacity of his gaze, in the mocking expression on his lips—his mouth was narrow-lipped, his teeth irregular and uneven—a very strong dose of the Parisian street urchin. Although very generous, and very good-hearted, he was deliberately ironic in conversation, and often cruel. He had a marvelous command of the annihilating and devastating phrase."

Antonin Proust, his faithful friend since childhood, emphasized Manet's courtly manners. He was of "medium height and

muscular build. He had a lithe charm which was enhanced by the elegant swagger of his walk. No matter how much he exaggerated his gait or affected the drawl of the Parisian urchin, he was never in the least vulgar. One was conscious of his breeding." Manet, easily astonished and easily amused, had a character as dazzling as his appearance. Despite his sharp tongue, nervous outbursts and fits of depression, he impressed distinguished friends like Baudelaire and Mallarmé. He told Zola that "he adored society and discovered secret pleasures in the perfumes and brilliant delights of evening parties."[1] Théodore Duret, who met Manet in Madrid in 1865 and became his friend, summed him up as essentially "a man of the world, refined, courteous, polished... fond of frequenting salons, where he was remarked and admired for his verve and his flashing wit."

The art dealer René Gimpel suggested his physical charm, remembering how the very smoothness of "his beard, well kept, brushed, curled, soft and caressing, [was] almost uniquely suitable for love." The journalist Paul Alexis defined the sensitivity and responsiveness that made so many women fall in love with him. Manet was "one of the five or six men of present-day Parisian society who still know how to talk to a woman. The rest of us...are too bitter, too distracted, too deep in our obsessions: our forced gallantries make us resemble bears dancing the polka."

One story synthesizes Manet's delightful personality and delicate wit. When a collector bought his *Bunch of Asparagus* and was so pleased with the painting that he paid an additional 200 francs, Manet painted another still life, of a single asparagus spear, and sent it along with a note that read: "There was one missing from your bunch."[2] Manet's social graces and artistic genius attracted many followers. He would need all his courage and self-confidence, all the loyalty and support of family and friends, to face years of official rejection, critical hostility and public neglect.

As a child Edouard showed little sign of the academic talent so prized in France. Intended by his father to be a lawyer, he studied first at the Institut Poiloup and then—from the age of twelve to sixteen—at the Collège Rollin. "'This child is feeble,' the headmaster noted on Edouard's report card, 'but he shows zeal, and we hope he will do well.'" Here he met his future biographer, Antonin Proust, who later described Manet's boredom and misery in that oppressively grim atmosphere. The Collège, at one time a girls' reform school, had become a typically austere school for boys:

> [There was] an ill-lit, prison like room, stinking of smoky lamps in the evening, furnished in the most primitive manner with narrow, rough benches, screwed so close to desks that they crushed your chest. We were packed in there like sardines. There was nothing on the walls, not even a map....
>
> The only lesson which interested him at college, apart from gymnastics and the drawing lessons which he took from time to time, was history.

A few years later his reports had marginally improved, from "feeble" to "distracted," "slightly frivolous" and "not very studious." Relying on his own memories, Proust declared that "Edouard was as happy at home as he was unhappy at the Collège Rollin,"[3] but this was not true.

Manet "came from one of those austerely high-minded and pious families," the art critic John Richardson observed, "which traditionally provided the French state with the most eminent of its public servants." They were also, as Baudelaire wrote (with some exaggeration) of his own parents, "idiots or maniacs, in grand apartments, all of them victims of terrible passions." Manet's ancestors had made money, bought land, and established solid positions in the learned professions and in upperclass society. His father Auguste (born in 1797) was a supervisor of personnel in the Ministry of Justice, where he gathered files

on prospective judges, and rose rapidly through the administrative ranks to become a judge in the civil court. He sat on the bench with two other judges to hear "cases that included contested wills, paternity suits, legal separations, negligence charges, and copyright violations." On his mother's side Manet had some connections with Napoleonic royalty. His maternal grandfather, Joseph Fournier, a successful merchant in Sweden, had helped Napoleon's marshal Jean Bernadotte to become crown prince and then King Charles XIV of Sweden. Bernadotte became godfather to Manet's mother, Eugénie Désirée, who was born in Gothenburg in 1811 and married Auguste Manet in 1831.

Auguste's salary and his wife's dowry, his investments and inherited property in Gennevilliers (on the Seine, north of Paris) provided a substantial income and a comfortable home. One critic called Auguste "a man of duty, sternly honest, unflaggingly virtuous. He was enormously self-righteous,"[4] and had solidly bourgeois ambitions for his three sons. Edouard, the oldest, was born in Paris on January 23, 1832, followed by his brothers Eugène in 1833 and Gustave in 1835. The teenage Manet was unhappy at school and at home, where his father's disappointment in his son caused considerable friction. Fortunately, Edouard's uncle and neighbor, the artillery captain Edmond Fournier, encouraged his nephew's talent for drawing, took him to the Louvre on Sundays and gave him his first informal lessons in the history of art.

III

CONVINCED, AT LAST, that his son had no aptitude for the law, and casting about for an alternative, Auguste Manet proposed that he become a naval officer. Eager to escape the tensions of home life, Edouard agreed. His career began badly in July 1848, when at the age of sixteen he failed the entrance exams to the Ecole Navale; but in October the naval regulations were changed to permit potential cadets to retake the naval

exams after making an equatorial voyage. He was offered the opportunity to be one of forty-eight paying guests on a cargo ship bound for Rio de Janeiro, with four instructors to prepare the cadets for exams. He would have no shipboard duties, and leapt at the chance to travel the high seas while his classmates remained grounded in school. On December 9 Auguste accompanied his son to the Channel port of Le Havre. The boy was naively impressed by the splendid ship and wrote his mother that "we're going to be really comfortable; we won't have just the bare necessities, there will even be a certain amount of luxury." One of his shipmates, the young Adolphe Pontillon, eventually became a naval officer and married Berthe Morisot's sister.

The ship, which took two months to cross the Atlantic, carried manufactured goods to Brazil and coffee back to France. Edouard soon became disillusioned with this floating version of the Collège Rollin, and wrote frankly and freely about the miseries of life at sea. On December 15 he noted the severe discipline on the ship, especially for the humblest members of the crew: "Our *maître d'hôtel,* who is a Negro...and is responsible for training [the apprentices], gives them a terrific licking if they don't behave; for our part, we don't take advantage of our right to hit them, we're keeping that in reserve for special occasions." Two days later, when the young sailors had become the victims, he emphasized the arduous work, the bullying and the danger: "it's no fun taking in a reef perched on a yard that is sometimes under water, working day and night in all kinds of weather; the fact is that they all hate their job[s]....The second-in-command, he's a real brute, an old sea-dog who keeps you on your toes and pushes you around like anything."

Five days later the little cadet told his mother about the discomfort, the sickness and the ennui: "The weather was dreadful; it's impossible to form an idea of the sea if you haven't seen it as wild as we did, you can't imagine the mountains of water that surround you and suddenly almost engulf the whole ship, and

the wind that whistles in the rigging and is sometimes so strong that they have to reef in all the sails." *What,* Edouard seems to be asking, *am I doing here?* His complaints were forthright, vivid and funny: "A sailor's life is so boring! Nothing but sea and sky, always the same thing, it's stupid; we can't do a thing, our teachers are sick and the rolling is so bad that you can't stay below deck. Sometimes at dinner we fall on top of each other and the platters full of food with us."

On February 5, 1849, after a lot of rough weather, they finally anchored off Rio de Janeiro. In this warm and peaceful interlude Edouard had some outlet for his talents. To pass the time, the captain asked him to give his shipmates drawing lessons, and Edouard also did amusing caricatures of the officers. When the captain discovered that the red rinds of the Dutch cheeses they were transporting had been discolored by the salt air and seawater, he asked Edouard to repaint them with red lead. By the time he'd finished, the cheeses glistened like tomatoes. The rotten cheese was then sold locally and the result made him feel guilty: "the natives, especially the Negroes, rushed to buy them and devoured them down to the rind, regretting only that there weren't any more. Several days later, the authorities issued an announcement to reassure the population, which had been alarmed by some mild cases of cholera. The announcement attributed them to overindulgence in unripened fruit. Naturally I had my own ideas about this."[5]

When Edouard reached Rio, Brazil was prospering. After a series of bloody revolutions between 1832 and 1845, the country had become relatively peaceful and stable under the enlightened rule of King Pedro II. The largest city in South America, Rio had a population of more than 250,000, equally divided between whites, slaves and free people of mixed race. The main exports were coffee and sugar, and the staples of daily life were rice, beans, manioc flour, sugar, coffee, corn and dried meat. After the crude provisions at sea, the boy had no complaints about the food.

But he found much to dislike in Brazilian society. Rio was the center of what the idealistic, censorious young man called the "revolting spectacle" of slavery. He wrote home earnestly that "all the Negroes in Rio are slaves. The slave trade flourishes here." Making no allowance for the tropical climate, he said the Brazilians were "spineless and seem to have very little energy." He found the white women were carefully chaperoned, and his Parisian manners and handsome uniform failed to impress them. "Their women are generally very good-looking," he wrote, with the air of a connoisseur, "but don't deserve the reputation for looseness they've acquired in France; there's nothing so prudish or stupid as a Brazilian lady." Manet may have had encounters with prostitutes in Rio and contracted the syphilis that later caused his death.

He'd suffered on the ship and his time on shore was just as miserable. He wrote rather dramatically that he'd even considered deserting: "On an excursion to the country with people from the town, I was bitten on the foot by some snake, my foot got terribly swollen, it was agony, but now I'm over it.... In the end I haven't really enjoyed my stay in the roadstead; I've been harassed, a bit roughed up; and have been more than once tempted to jump ship."

Despite his voluble complaints, Edouard had some adventurous, even poetic moments. The hardships of the voyage had matured him and given him self-confidence; the beauty of the tropics sharpened his aesthetic sense. On the voyage out, he'd told his mother: "We've had a fine day, the sea was calm enough for us to do some fencing.... At 4 o'clock they harpooned some *porpoises*.... They swim like lightning and are a very difficult target.... This evening was more phosphorescent than usual, the boat seemed to be plunging through a sea of fire, it was quite beautiful." As an adult, when the painful memories had faded, he reflected that "I learnt a great deal during my voyage to Brazil. I spent night after night watching the play of light and shade in

the wake of the ship. During the day I watched the line of the horizon. That taught me how to plan out a sky."[6] He used this experience when painting great seascapes like *The Battle of the Alabama and the Kearsarge* and *The Escape of Rochefort.*

<div align="center">IV</div>

AFTER HIS RETURN from Rio, Manet once again failed his naval exams. Living at home, older and wiser but still unsuited for a professional career, he finally persuaded his exasperated father, with the help of his uncle Fournier, to allow him to pursue an artistic career. Following the traditional custom, he became the pupil of a successful academic painter who exhibited in the official yearly Salons and sold his work to private and public institutions. In 1850 Manet entered the studio of Thomas Couture, where he stayed for six years. As an essential part of the training, he was granted permission to copy the Old Masters in the Louvre, its collections greatly enhanced by art plundered in Napoleon's campaigns.

Couture had been a pupil of Baron Gros, who had studied with the great neoclassicist Jacques-Louis David. A colorful figure, Gros had been Napoleon's official war painter but, after a number of late failures, had committed suicide in 1835. In 1847 Couture had achieved acclaim and a gold medal at the Salon for his sprawling *Romans of the Decadence,* in which nude women were abundantly displayed, under the guise of moralistic disapproval. Antonin Proust, Manet's fellow student once more, reported that Couture was all too casual about his teaching duties and left his pupils pretty much on their own: "Couture's atelier consisted of twenty-five to thirty students. As in all studios, each student paid a monthly subscription to study from the model, man or woman. Couture came to visit us twice a week; he glanced at our studies with a distracted eye, ordered a 'break,' rolled himself a cigarette, told some stories about his master, Gros, and then took himself off."

It soon became clear that Manet, rebelling from the start

against the lifeless academic tradition, didn't fit into Couture's classes any more than he had at school or at sea. In the teacher's absence Manet challenged the professional models, who assumed what he considered stiff and mannered poses. "'Can't you be more natural?' Manet would exclaim. 'Do you stand like that when you go to buy a bunch of radishes?'" After one particularly heated quarrel with a model, Manet rushed out of the studio and sulked for a month, before obeying his father's orders to return. He complained to Proust: "I can't think why I am here; everything we see here is absurd; the light's false, the shadows are false. When I arrive at the studio I feel as though I'm entering a tomb."[7] Why, then, did he remain with Couture for so long and keep so little of his early work? He was still very young when he entered the atelier. He had to acquire the basic techniques of drawing and painting, to learn how to refine his talent, and the routine of study and practice gave some structure to his rebellious spirit. He also had no choice: after refusing to study law and failing in the navy, he had to stick with art to satisfy his father.

As a teacher Couture also had some redeeming qualities, and was not as reactionary as he seemed. In his *Methods and Conversations in the Studio* (1867), a book describing his lifelong principles of teaching and practice, Couture expressed his belief, later adopted by Manet, that one must paint contemporary life. He stressed the value of modern subjects and insisted that the artist should "*relate to [his] own times*. Why this antipathy for our land, our customs, our modern inventions?" In view of his success with vast scenes of Roman orgies, this might seem an odd assertion. One critic noted that Couture strived to remain in both camps, "to conciliate avant-garde and conservative tendencies.... He nervously sought a style capable of reconciling his longing for traditional forms with his anxiety to be modern." The historian Peter Gay emphasized the parallels between master and pupil and added that Couture "encouraged spontaneity, which meant rapid painting and imaginative composition. Precisely like Manet later, he discountenanced the mixing of colors on the palette; precisely

like Manet, he preferred scraping off the canvas a stroke he disliked to fussing over it with corrections; precisely like Manet, he was skeptical of half tones and taught a variety of techniques to enhance the brilliance of his canvases."[8]

Though Couture himself was attracted to new styles and subjects, he paradoxically treated Manet's early work with scorn. In 1859 Manet was preparing to submit to the Salon his *The Absinthe Drinker,* a shocking treatment of a degenerate alcoholic. Couture—accustomed to noble subjects and anticipating disaster—exclaimed: "An absinthe-drinker! How can you paint anything so abominable? My poor friend, you are the absinthe-drinker, you are the one who has lost his moral sense." The painting was duly rejected. Proust recorded that in these disputes Auguste Manet, though disappointed with his son's choice of career, gave him emotional as well as financial support. When Manet began to exhibit his paintings, his father, "who had been the first to berate his son when he complained of his master Couture, now gave himself over to the bitterest sallies against the painter of the *Romans of the Decadence.*"

Manet's years with Couture gave him practical experience, but his independent study of Delacroix and his travels abroad to copy Old Masters in Italy and Spain had a far more decisive influence. In 1855, on the pretext of asking permission to copy one of Delacroix's paintings in the Musée du Luxembourg, the young Manet visited his studio. A friend warned him, "Beware.…Delacroix is cold." But, Proust recalled, the master was kind to the students who came to his door and the visit was a great success: "Delacroix greeted us in his studio on the rue Notre-Dame-de-Lorette with a perfect grace, asked us about our preferences and told us his. 'You must study Rubens, be inspired by Rubens, copy Rubens.' Rubens was his god.…Manet said to me: 'It's not Delacroix who is cold: his doctrine is glacial. Nevertheless, we'll copy his *Dante's Barque,*' "[9] an illustration, in the romantic style, of a scene from Dante's *Inferno.*

Manet took Delacroix's advice and copied Rubens' *Portrait of*

Helena Fourment and Her Children in the Louvre. Later he painted himself and his future wife as characters in a painting by Rubens, standing in the corner of *Fishing* (1861–63) (a pun on his own name, *manet,* a kind of fishing net). Though too ill to serve on the Salon jury, a few months before his death in 1863 Delacroix saw the exhibition of Manet's paintings at the Galerie Martinet. Despite the hostility and ridicule accorded *The Absinthe Drinker,* he praised the work and maintained that he was sorry that he was unable to defend Manet. On August 1, Manet paid his last respects by attending Delacroix's funeral with Baudelaire.

Unlike Degas, who spent many years in Italy, the young Manet made only brief trips abroad: to Holland in 1852; to Kassel, Dresden, Prague, Vienna and Munich, then to Venice, Florence and Rome in 1853; and, after leaving Couture's studio in 1856, back to Florence the following year. The main purpose of these trips was not to explore different cultures and discover the latest movements in contemporary art, but to copy the Old Masters—Fra Lippo Lippi, Andrea del Sarto, Titian—in the major museums. He knew instinctively that it would be wrong to imitate all the mediocre conventional painters who made a comfortable living by turning out wall-coverings for a complacent, bourgeois society. Manet would shake up the art world and change it forever; but first, as a student, he had to take possession of the greatest European art of the past. Delacroix and Velázquez, not Couture, were his teachers.

Manet lived in a period of great political and social upheaval. He was born two years after Louis-Philippe, the constitutional monarch and "citizen king," who had replaced the Bourbon brothers: the guillotined Louis XVI; Louis XVIII, who had been restored to the French throne after the defeat of Napoleon; and his successor, Charles X. In 1848, the year Manet sailed to Brazil, Louis-Napoleon, Napoleon's opportunist nephew, became president of the Second Republic. In 1851, after a violent coup d'état, he declared himself Emperor Napoleon III.

These dramatic events, in which resisters were shot down, had

a powerful impact on the impressionable, nineteen-year-old Manet, and influenced him both artistically and politically. He learned to loathe Louis-Napoleon, and later based major paintings on contemporary wars and civil conflicts. As soon as Manet and Proust heard the news of the 1851 revolt, they ran into the street to see what was happening. They heard the roll of drums and harsh bugle calls, smelled gunpowder in the air, and saw galloping horsemen and crowds of civilians fleeing for their lives. Proust recalled that they ran into danger and were rescued by chance: "In front of the steps of the Café Tortoni some innocent pedestrians had just been shot. A cavalry charge swept like the wind down the rue Laffitte, cutting down everything before them. The picture-dealer, Beugniet, dragged us to safety into his half-open shop." Lying flat on their stomachs, they watched the bombardment of the district. Later on, they were arrested by a patrol and forced to spend the night in a police station.

The following day they witnessed executions in the streets. The day after that, with Couture's students, they rather cold-bloodedly sketched the corpses of the defeated. This episode, Proust recorded, had a traumatic effect on Manet: "With all our comrades from the atelier, we went to the cemetery in Montmartre where the victims of Louis-Napoléon had been laid out under a covering of straw, with only their heads showing. The visitors...were ordered by the police to file past the dead over rickety planks. This mournful inspection, interrupted from time to time by piercing screams from those who had recognized relatives among the dead, left a terrible impression on us — so terrible that even at the atelier...this visit to the cemetery at Montmartre was never mentioned."[10] Manet, a Left-wing republican, hated the social injustice and violent oppression, the philistine vulgarity and cynical hypocrisy of the Second Empire, which would last until 1870.

FAMILY SECRETS
1859–1864

❧ MANET'S SCENES from contemporary life included many striking portraits, and in 1860 he showed his special gift for conveying psychological insight. His revealing and devastating picture of his parents, *Portrait of M. and Mme. Auguste Manet,* publicly displayed the emotional tensions, inner loneliness and repressed anger within the family. This mood became a keynote of Manet's work: the strange uneasiness and isolation of people, alienated not only from each other but also, in the modern mode, from themselves. In the portrait the seated paterfamilias is heavily bearded and dressed entirely in Spanish black, with his left hand (in a Napoleonic gesture) pushed into his coat. He displays his *Légion d'honneur* ribbon and wears a high, brimless magistrate's hat, like the ones worn by Daumier's judges and by Manet's lawyer cousin, Jules de Jouy, in his portrait of 1879. With clenched fist and stern, angry, even furious expression, Auguste turns away from his wife.

Standing behind him, with thin lips, sharp nose and heavy-lidded eyes, Eugénie wears a white cap, collar and sleeve, and plunges her fingers into the soft, colored wool of a knitting basket. She's enclosed in a stiff black dress trimmed with thick velvet stripes that suggest the bars of a cage and contrast with her glistening wedding ring. She looks down at her husband with a grim, anxious and mournful expression, as if judging the judge. Their faces half in shadow, they seem to be in the midst of a quarrel. She may have reproached him; he's become enraged;

and she's now attempting to mollify him. The picture suggests that Auguste, then paralyzed by syphilis and as hard and rigid as the tortoiseshell box on the table next to them, is desperately trying to maintain his dignity. Unable to speak and hiding the unspeakable, the "unflaggingly virtuous" father suffers for his darkest family secret and sexual sins.

A clear-sighted contemporary critic, noting the unyielding quality of precisely observed truth, wrote that "the Artist's Parents must more than once have cursed the day when a brush was put into the hands of this merciless portraitist." The palpable tension of this early portrait shows that Manet was merciless, not only to his parents, but also to himself, and that he's displaying his own inner life, his own anguish. The philosopher Richard Wollheim, describing "the bleak image of the parents, separated by what they share," noted that "the image of intimacy as a transient moment of intense, shared isolation, must have stamped itself early on in Manet's mind."[1] In Manet's paintings the solitude of his subjects provides the inherent drama.

Manet spent his adolescence and young manhood living at home and in the shadow of the unhappy marriage that ended with his father's death in 1862. A year later, in October 1863, Manet surprised his close friend and confidant, Charles Baudelaire. "Manet has just told me the most unexpected piece of news," he declared. "He's leaving for Holland tonight and will return with *his wife*." The poet, who had a rough time with women himself, was naturally sceptical about the sterling qualities of the bride-to-be: "He does have some excuse, however, for it seems she's beautiful, very kind, and a very great pianist. So many treasures in a single female, isn't that rather monstrous?" Neither Baudelaire nor anyone else knew that the handsome bachelor and boulevardier had had a secret mistress for three years and was about to marry her.

His bride, Suzanne Leenhoff, born in Delft, Holland, in 1829 and three years older than Manet, was the daughter of the or-

ganist of the gothic cathedral in Zaltbommel—and looked exactly like a woman who came from a place called Zaltbommel: large, heavy, bosomy and blunt-featured. Manet slenderized, sculpted and idealized Suzanne in *The Nymph Surprised* (1859–61). He frequently portrayed her fashionably dressed, fishing, reading, at the beach, sitting on a blue couch or in a conservatory and playing the piano. In his *Portrait of Mme. Edouard Manet* (1866–67), Suzanne—with high, chestnut hair, full lips, rosy cheeks and fine skin—looks attractively wistful.

In fact, Manet had met his future wife in his own home. In 1849, at the age of nineteen, Suzanne left her conventional, middle-class family, came to Paris and became the piano teacher of the three Manet sons. Edouard, recently returned from his adventures in Rio, was rather old to begin piano lessons. He had a tin ear and in adult life showed scant interest in music, but Suzanne played a sexual as well as musical role in the highly respectable household. In Paris, in January 1852, she gave birth to an illegitimate child named Léon Koëlla, though no trace of his exotically named father has ever been found. To cover up this embarrassing event, Léon was called Leenhoff and politely passed off as Suzanne's younger brother. He was baptized in 1855, with Manet as his godfather and Suzanne as his godmother. Suzanne had been living in Paris with her two brothers and, after the arrival of the baby, was joined by her grandmother. At the time of their marriage, when the boy was eleven, Manet had been living in his own apartment with Suzanne and Léon for three years.

Giuseppe De Nittis, an Italian painter and friend, described the solid Suzanne as good humored, "kind, simple, and direct, blessed with an unshakable serenity." Duret, who seemed fond of Suzanne, noted that "in her, Manet found a woman of artistic taste, able to understand him and to give him that support and encouragement which helped him better withstand the attacks made upon him." Manet seemed to have a filial as well as matrimonial relationship with his rather phlegmatic wife. As Lady

Ottoline Morrell wrote of Joseph Conrad's wife, Jessie, who also stabilized her neurasthenic and volatile husband: "she seemed a nice and good-looking fat creature, an excellent cook…and was indeed a good and reposeful mattress for this hypersensitive, nerve-wrecked man, who did not ask from his wife high intelligence, only an assuagement of life's vibrations."[2]

Suzanne, a talented pianist, attracted many musicians to their home, including the composer Emmanuel Chabrier. Manet painted two late portraits of the round-faced, bearded composer. Chabrier dedicated his *Impromptu* in C Major for piano (1873) to Suzanne, collected Manet's works and liked to claim that Manet had died in his arms. His biographer, stressing their resemblances, wrote: "Manet and Chabrier, products of a bourgeois milieu, son and grandson of magistrates, are strikingly similar in their behavior and their reactions. They seem interchangeable. They had the same taste for puns, the same frank, bracing, liberating laughter. And also the same sensibility: irritated, bordering on the neurotic, evident in their mobile features, lively talk and expressive gestures."

Though far from monogamous, Manet loved his wife. When separated from Suzanne, who moved to the Pyrenees during the siege of Paris in 1870, Manet wrote to her frequently, expressed his devotion and mentioned how much he missed her. "Your portraits are hanging in every corner of the bedroom," he said, "so I see you first and last thing in the morning and evening." He was also capable, according to a friend who traveled with them to Venice, of teasing "Madame Manet in my presence, usually on the subject of her family, and particularly her father, a typical Dutch bourgeois, sullen, fault-finding, thrifty, and incapable of understanding an artist." De Nittis told a revealing story about Manet, always in search of an attractive model or sexual adventure, "following a slender, pretty, coquettish young woman in the street. Suddenly his wife came up to him and said, laughing, 'There, I've caught you this time.'" To which the quick-witted

Manet retorted, "Well, that's funny. I thought it was you!"[3] Suzanne good-naturedly tolerated Manet's frequent affairs. It was the price she had to pay for her sexual indiscretion and the birth of Léon.

Léon's paternity has remained the crucial mystery of Manet's life. It would seem that, by marrying Suzanne, Manet tacitly acknowledged that Léon was his own son. Yet there is strong evidence to suggest that Auguste Manet was in fact Léon's father. Manet knew his father had syphilis, and had reason to believe he would inherit the disease. Fearful of passing it on to his wife and children, he was reluctant to have a child of his own. The estrangement, fear and barely suppressed rage in his portrait of his parents may have been provoked by the secret surrounding Léon and by Manet's bitter resentment of having to step into the shoes of his hypocritical father—who heard paternity suits and was enormously self-righteous—in more ways than one. Manet may have inherited his father's mistress as well as his fortune, and felt dishonored at home as well as humiliated in the Salons.

Illegitimate children were common among the Impressionist painters. Pissarro, Cézanne, Monet and Renoir all had children out of wedlock and were reluctant to marry their fertile but uneducated mistresses. (The painter Maurice Utrillo and the poet Guillaume Apollinaire were themselves illegitimate.) Monet, for example, lived with his model for many years before marrying her, three years after the birth of their son, in 1870. But all these painters legitimized their children after marriage. Manet did not.

Many friends, including Baudelaire, wondered why Manet married Suzanne. A recent biographer found it hard to believe that Manet would serve as godfather to his father's illegitimate child and then, eleven years after the child's birth, marry his father's mistress. But in a society that placed a premium on keeping up appearances, many kinds of bizarre behavior were tolerated as long as they were discreet. Wives kept quiet, preserving domestic security and their children's loyalty. Husbands and sons

of the haute-bourgeoisie frequented places of entertainment where they could meet semi-respectable women. Servants colluded with their masters to maintain the status quo. Most families would do anything to hide terrible truths. Like Degas, who sacrificially saved the family's honor after his father's bank was ruined, Manet also had dark personal secrets—which included two generations of syphilis.

The Manet scholar Susan Locke noted that there was a good reason why Manet did not legitimize Léon: "in French law of the time, whereas nothing stood in the way of legitimation of children born out of wedlock upon the marriage of their parents, children born to individuals *who were already married to others* at the time of conception could *never* be legitimized under any circumstances." In other words, Manet could have legitimized Léon if Léon were his own son. But he couldn't, and didn't, since Léon's father was a married man.

The French translator Mina Curtiss was the first to suggest, in 1981, that "Manet père was actually Léon's father. Manet's will left everything to his wife with the provision that Léon Leenhoff inherit from her. 'I believe that my brothers will find this provision entirely natural,'" he wrote. Punning, perhaps, on "natural" son, Manet arranged for Léon to inherit the share of the Manet property that Léon had been unable to get from Auguste. To protect the family's honor and Auguste's august reputation, Manet married his father's mistress, adopted his illegitimate child, and disguised Léon as Suzanne's brother and his godson. Manet must surely have resented her previous liaison. After Auguste's death in September 1862, and Edouard's marriage in October 1863, Manet's mother—joining this weird ménage—moved in with Edouard's family. Their Ibsen-like household, predictably enough, generated high tension and personal conflict as the two women fought for emotional control of Manet.

In 1883, a few months after Manet's death, his mother attempted to recover the dowry she'd given Edouard. She told her

nephew, the lawyer Jules de Jouy, that when they'd been sepa-
rated from Edouard during the war of 1870, "Suzanne used to
write her husband a thousand complaints about me, and when
he was able to see for himself what was going on," he realized
her accusations were false. "Her jealousy," his mother added,
"was always there, against me!" Madame Manet justified her ac-
tion by affirming that her son had died childless and there was
no one to inherit the dowry. She bitterly condemned Suzanne's
character, and claimed she was unworthy to receive it: "There
are some things that I will not reconsider, namely the crime she
committed out of affection for that dear boy who is merely a
victim of his unfortunate birth. She wanted more than she was
entitled to have, that is the punishment of her crime, let her
suffer for it."[4] The letter is cryptic, but his mother seems to
be saying that Suzanne's "crime" (which covered up Auguste's
"crime") was to marry—perhaps entrap—Edouard in order to
provide a father for her son. If Manet had no children, as his
mother stated, then Léon could not be his son.

The fear of syphilitic contagion, Manet's hostile portrait of
his parents, his desire to preserve the family's honor, his inability
to legitimize Léon, the stipulation in his will that Léon inherit
from Suzanne, Madame Manet's condemnation of Suzanne's
"crime" and her statement that Manet had no children all
strongly suggest that Auguste was Léon's father.

Manet's numerous paintings of Léon, a convenient and docile
model, provide some additional evidence about his birth and
reveal Manet's gradually evolving attitude toward him. The
handsome Manet had a fine, narrow nose. Léon, like Auguste in
Manet's etchings of 1860, had an unusually broad nose and wide
nostrils. After Auguste's death and his marriage to Suzanne,
Manet showed increasing acceptance of Léon and "outed" him
in his art. In *The Balcony* (1868) Léon appears as he had been: ob-
scure, in the shadowy background, almost hidden and carrying a
pitcher, like a servant. In *The Luncheon* (also 1868) he appears as
he should have been: clear, out in the open and self-assuredly

dominating the foreground, while a servant carries a coffee pot. He wears a yellow straw hat, yellow-striped tie and yellow trousers, the color subtly accentuated by the curled lemon peel on the table. On his right, next to a familiar cat bending over to clean itself, are two ivory-handled swords with gleaming bosses and an armored helmet, which represent the arsenal of the history painter. (Degas had remarked of Ernest Meissonier's *Cuirassiers of 1805* that everything was iron except the breastplates.) On his left are the remains of the luncheon; and the knife on the table, which echoes the swords, links the genres of still life and history. The buxom maidservant standing behind him and the top-hatted bearded man seated at the table may well stand for Suzanne and Edouard, and their belated recognition and acceptance of Auguste's son.

Léon first learned that his legal name was Koëlla at the age of twenty, when in 1872 he was called up for military service. He later told Adolphe Tabarant, an early biographer of Manet, that because of the dark "family secret, about which I never knew the whole truth, [I was] pampered, spoiled by both of them [Edouard and Suzanne] who indulged all my whims. We lived happily, the three of us, above all I myself, with no concern whatever. I therefore had no reason to question my birth." Tabarant concluded that if Edouard had been Léon's father, he surely would have told the boy the truth. In 1868, when Manet painted *The Balcony* and *The Luncheon,* Léon was working as a messenger at Degas' father's bank. As an adult, "he dabbled in several ill-conceived ventures, including the founding of a bank that failed, before succeeding with a store that bred and sold chickens, rabbits and fishing worms."[5]

Madame Manet's inevitable bitterness against his wife made Manet's homelife a torment. Like Thomas Mann's fictional *Buddenbrooks,* the Manet family was in gradual decline. In three generations they went from highly respected judge, to scandalous and universally condemned artist, to humble shopkeeper.

HABITUAL OFFENDER
1859–1864

I

❧ BETWEEN ABOUT 1853 and 1869, when Manet was in his twenties and thirties and making his way as an artist, Paris was being transformed from a medieval to a modern city. Under the ruthlessly progressive rule of Baron Georges Haussmann, the prefect of the Seine during the Second Empire,

> houses were razed, whole streets were suppressed, hills were leveled, roads cut and paved, and row upon row of apartment buildings were erected, imposing patterns of modernity that are still very much in evidence....
>
> There was now an extensive network of long, tree-lined streets—the ubiquitous boulevards; there were four new bridges and ten reconstructed; 27,500 houses were pulled down in the Department of the Seine, and over 102,500 were built or rebuilt; and there were new public squares and parks.

Haussmann's work involved much more than making handsome new streets:

> It was laying out new aqueducts along the Dhuis one hundred miles from Paris; it was doubling the acreage of the city by annexation, fitting new lenses on the gas lamps, having [the architect] Viollet-le-Duc put up a spire of oak and lead on Notre-Dame, declaring open the great collector sewer, providing ways for men to relieve themselves (more or less)

in public, putting an outer circle of railways round the city, building the new Opéra and the new morgue.[1]

The new plan of the city had political as well as social consequences, for the wide avenues made it easier for government troops to fire artillery and suppress disturbances in working-class districts. Though many historic old quarters were destroyed, Paris was made larger, cleaner and more efficient, with a lively and elegant social scene. It became a beloved subject of Impressionist paintings.

When Manet left Couture's studio and began his professional career, the Paris art world was dominated by massive state-sponsored exhibitions. The Salon was a huge annual marketplace, an art competition held in public buildings and attended by everyone of any importance, including the emperor himself. Meant to demonstrate the artistic glory of France, it actually symbolized the Babylonian excesses of the materialistic Second Empire. By the mid-1860s four to five thousand paintings and sculptures were on view, hung in alphabetical order, in four to five rows from floor to ceiling, so tightly packed that their frames touched. On Sundays, when admission was free, 30,000 eager spectators cascaded through the doors, and the total number of visitors reached 300,000. Works by established painters and their favorites were hung in the best places, "on the line" or at eye level, but hundreds of unfortunates had their work dropped to the ground or skied out of sight.

A contemporary art historian explained why the Salons were so popular with the public: "the Parisian habit of taking in the show on the Champs-Elysées had become as much a part of the spring season as the races at Longchamps or the *revues* on the Grand Boulevard." The crowds made "their way through thirty large, hot, dimly-lit rooms: while the ladies passed before portraits of the fashionably dressed, the men headed for the glassed-in sculpture garden where, with a beer in one hand and a cigar in

the other, they could take in the statues of the nude goddesses." Artists desperately struggled to get noticed by the newspaper reporters and reviewers for the weekly journals. They hoped for a vital moment of contact with critics and collectors, and were eager to gain a reputation, sell their work and make some money.

Painters of the French Academy were scornfully called *pompiers* because their pictures were full of Roman soldiers whose helmets made them look like Parisian firemen. The art schools encouraged young painters to copy historical, mythological and allegorical pictures from the past, to imitate the classical models of Greece, Rome and the Italian Renaissance. Artists knew that adopting an academically approved subject and style greatly increased their chances of acceptance by the jury and of a medal, prize or honorable mention. These awards would also help sell their work to the state, which bought many pictures for local and national museums. Rejected works were carried away like corpses from the battlefield. In any case, more than half the works at the Salon were unsalable, and "paintings were exported at reduced prices to England or America or Russia, with the painter receiving twelve francs including the frame."[2]

Manet is now recognized as the greatest painter between Delacroix and Picasso. But in his lifetime he was repeatedly shot down, like a soldier constantly volunteering to go over the top, while attempting to enter the Salons. His friend Duret emphasized the glaring contrast between the prevailing style and Manet's startling innovations: "His contemporaries avoided brilliancy of colour, blended the different tones together, or shrouded the outlines in shadow. Manet, on the other hand, suppressed the shadows, painted everything in a luminous tone, put the boldest, the most incisive colours in immediate juxtaposition."

Over a period of twenty-three years Manet submitted thirty-seven paintings to the Salons and had twenty-six accepted, but most of them were mocked and condemned when exhibited. The conservative Salon juries, extremely reluctant to accept anything

different or new, demanded and got variations on a limited range of subjects, treated in a conventional manner. Manet was impatient with stale academic pictures and believed in his own genius—the rightness of his shocking, revolutionary style and content. But he also wanted to achieve success within the established system, and continued to believe that his talent would eventually be rewarded and his art accepted. "Professing his intention not to offend," Peter Gay observed, Manet paradoxically "persisted in being offensive." He knew he had to educate the eye of the experts and the public, but he could not understand that what he clearly saw was right and true would be so ruthlessly rejected.

His technique itself was a radical departure from the norm. Instead of executing the traditional series of preparatory studies, Manet, like an action painter, "hurled himself on his bare canvas in a rush, as if he had never painted before." One of his models stressed his reliance on intuition, immediacy and natural impulse: "He was not always master of his hand, for he made no use of fixed technique and he had kept a schoolboy's frank naiveté before nature. In beginning a picture he could never have told how it would come out. If genius is made of unconsciousness and of the natural gift of truth, he certainly had genius." Recalling his portrait of Antonin Proust in a letter to his friend, Manet rejoiced in Proust's approval of his rapid method, which led, according to his critics, to an unfinished, slapdash result. He wrote: "I remember, as if it were yesterday, the swift and summary fashion in which I treated the glove in the bare hand. And when at that moment you said to me: 'Please, not a stroke more,' I felt we were in such perfect agreement that I could not refrain from the pleasure of throwing my arms around you."[3]

He'd always believed he had to paint what he saw in his own time, to break out of the traditional mold instead of imitating it, and to resist falling into a rut, even one of his own. "I have only one ambition," he exclaimed, "*not* to stay equal to myself, *not* to

do the same thing day after day. I want to keep on seeing things from new angles. I want to try and make people hear a new note." He was influenced in turn by the Spanish styles and themes of Velázquez and Goya, by Japanese art and the print-making revival, by Impressionism and *plein air* painting. He later told Proust, when adopting the Impressionist aesthetic of light and color: "That's what people don't fully understand yet, that one doesn't paint a landscape, a seascape, a figure; one paints the effect of a time of day on a landscape, a seascape, or a figure."[4]

In 1863, at the beginning of his career, a critic remarked that Manet "has all the qualities needed to be unanimously rejected by every jury on earth." In 1878, toward the end of his all-too-brief career, another critic—alluding to French colonial expansion in Asia and the loss of the eastern provinces in the Franco-Prussian War—wrote: "There is no way of ignoring it, every year there is a Manet problem, just as there is an Orient problem or an Alsace-Lorraine problem."[5] His paintings were consistently attacked for his failures of perspective, his bewildering lack of finish and the way his figures stood out severely against their flat backgrounds.

II

MANET'S FAVORITE model in the 1860s, and the subject of his most striking works, was the charming chameleon, Victorine Meurent. Born in 1844 in a working-class district of Paris, the daughter of an impoverished engraver, she'd modeled for Couture and the Belgian painter Alfred Stevens, who became her lover. She was eighteen when Manet first saw her in a crowd outside the Palais de Justice. Struck by her unusual appearance and self-possessed air, he asked her to pose. According to Manet's friend Adolphe Tabarant, Victorine was an exceptional model. She was "exact, patient, discreet and not given to chattering. Most important, she was [physically uninhibited but] not too vulgar in appearance." She had "fine eyes, animated by a fresh

and smiling mouth. With that, the lithe body of a Parisian, delicate in every detail, remarkable for the flowing line of the hips and the supple grace of the bust." (Many writers, following Tabarant, have claimed that Victorine modeled for *Woman with a Parrot* [1866]. But the eyes of this model are set differently; her face is oval, not round; her nose narrow, not wide; her lips thin, not full; her chin pointed, not rounded; her body lean, not solid. She does not look at all like Victorine.)

Victorine's physical presence and distinct personality inspired Manet to portray her in many unusual and sexually disturbing settings. His technical experiments and willingness to take risks led to some troubling failures, most notably, *Mlle. V[ictorine] in the Costume of an Espada* (a bullfighter who kills with a sword), in 1862. In contrast to Manet's *Bullfight* of 1866, painted after his journey to Spain, or even to the picador's fight (wildly out of perspective) in the background of *Mlle. V.,* the plump female *espada* in male costume, with protruding belly and buttocks, is ludicrously inauthentic. Instead of a bullfighter's *traje de luces,* she wears a long headscarf, tasseled breeches and laced brown slippers. Her *muleta,* the cape that controls the bull and covers the sword, should be blood red (not pink), and held with the hand sideways (not palm down). The drawn sword should always be pointed downward (not pointlessly waved in the air).

The daring composition of *The Dead Toreador* (1864) is far more successful. In a black jacket, breeches and shoes, dramatically set off by a white shirt, tie, scarf, sash and stockings, he lies dead on the sandy ground. His red lips seem to have drunk, Dracula-like, the blood that leaks from his fatal wound. If the painting is turned upside down, the matador, seen from high above, suddenly springs to life and seems to be standing sideways, right hand on chest and left hand clutching the cape, ready to face the charging bull that is about to kill him.

Manet's portraiture ranges from these daring and exotic Spanish figures, imaginary or authentic, to lowlife portraits rem-

iniscent of Goya—like *The Absinthe Drinker* (1858–59), scorned
by Couture and the Salon—to vivid likenesses of friends. The
grubby, stupefied, blurry-featured drinker, wearing an absurdly
high, stiff top hat and swathed in a ragged brown shawl, is a
rather grim complement to the fashionable *Portrait of Theodore
Duret* (1868). His friend Duret is elegant, alert and distinctly de-
lineated, dressed in a soft fedora hat and well-cut suit. Each man
has a foot pointed outward (though the drinker's looks more like
an artificial limb) toward his favorite drink: a shimmering carafe
of wine for Duret and a poisonous glass of greenish absinthe
for the drunkard—extracted from the ominously empty black
bottle on the ground.

Duret left a fascinating account of how Manet, inspired in the
midst of the painting, intuitively and incrementally added new
form and color, interest and meaning, to enhance the portrait:

> One day when I came back, he had me pose as I had been
> and placed a stool near me, which he began to paint with its
> dark red cover. Then he had the idea of taking a soft-bound
> book, which he threw [under] the stool, painting it a light
> green. He also placed on the stool a lacquer tray with a carafe,
> a glass, and a knife. All these objects constitute an additional
> still life, varying in tone, in a corner of the painting. They had
> not been planned and I did not expect them. Finally, he
> added one more object, a lemon balanced on the glass on the
> small tray. I watched him make these successive additions in
> some amazement. When I asked myself why, I realized that I
> was witnessing his instinctive, almost organic way of seeing
> and feeling. Clearly, he did not like the entirely gray and
> monochromatic painting. He missed the colors that satisfied
> his eye and, not having used them from the start, added them
> afterwards, in the form of a still life.

In 1863 the howls of protest from aspiring painters about the
vast number of works rejected by the Salon jury (2,783 out of

5,000 submitted) provoked the emperor himself to authorize an official alternative in an adjacent gallery, the Salon des Refusés. It exhibited only half the rejected canvases and allowed the public to make its own judgments. The critical comments and vicious cartoons in the papers, the open jeering and mockery, amused the crowd and gave it something to talk about. As Flaubert's friend Maxime du Camp remarked, "there is something cruel about this exhibition, people laugh as they do at a farce."[6]

In the Salon des Refusés Manet showed one of his greatest paintings, *Luncheon on the Grass* (1863), a work that synthesized many of his preoccupations and displayed his wit and imagination. With her chin in her hand, Victorine, staring confidently, even brazenly, at the spectator, sits naked on the grass at the center of the painting. Wearing no adornment, her hair coiled in a bun, her breasts exposed, she poses next to two fully dressed men, the one on the right holding a cane and wearing a student's smoking cap, both absorbed in conversation and apparently indifferent to this glowing nude. In the background and some distance from the men, another woman, detached from the group and dressed in a white shift, bathes in a shallow pond. None of the three looks at the others, and the woman is strangely isolated in this naked lunch.

Manet borrowed some elements from a previous painting, a portrait of Suzanne, *The Nymph Surprised* (1859–61). Both pictures have an idyllic forest and pond in the background and a naked woman sitting sideways, her face turned toward the spectator. In the earlier picture Suzanne, seated alone, wearing a ring and pearl necklace, her hair flowing along her back, modestly crosses her arms and legs, and covers her breasts with a sheet. Her eyes look down and her expression seems demure. Victorine sits sideways in *Luncheon on the Grass,* but stares openly at the spectator.

Manet got the idea for this painting while watching ordinary people swimming at Argenteuil, on the Seine, north of Paris. Manet had told Proust that he wanted to redo a famous picture,

Giorgione's *Concert Champêtre* ("Pastoral Concert," c. 1510, now attributed to Titian). In this work, two dressed men and two nude women are playing music in a pastoral setting. Manet said he wanted to "make it translucent, using models like these people we see over there." But the effect of Manet's picture is quite different from the *Concert Champêtre*. His dressed men and undressed woman are like artists and their model chatting in a studio, but they are neither painting nor being painted. In an unreal forest glade, they are neither swimming with the bather, nor rowing the boat that sits idle in the background. And they are not eating their lunch, which consists only of a flask of wine, a single roll and, spilling out of a basket, sensual red cherries and symbolic ripe figs.

Manet's contemporary audience was both mystified and affronted by *Luncheon on the Grass*. In a classical, religious or historical painting, they knew the context from the title and from the dramatic moment the artist had chosen to illustrate. Manet portrayed a modern situation, real people in a natural setting, with a visual analogy to a well-known classical work. But he leaves us puzzled about the context of this casual yet startling situation. What exactly is going on in this painting? How did the men and women get there? What are they looking at? What are they going to do? Did the men modestly lower their eyes when the woman boldly took off her clothes? Or did they watch her undress and carelessly pile the garments beside her during her prelude to this afternoon of a faun?

Despite their apparent detachment from each other, several suggestive details engage the participants and suggest the story of what will happen next: the men plan to disrobe, after some polite talk, and join the women for some *plein air* frolics. The student's right thumb and bather's right arm point to each other, as if he were summoning her to join him, to dispel the potential sexual rivalry and to form two couples. The hand of the man seated in the middle rests next to and perhaps even touches the

woman's smooth white bottom. The woman's bare left sole and the student's left shoe face each other. Her foot is placed seductively between his legs; and if he moved his eyes slightly to the left he could see between her legs. Their provocative posture, as well as the wine and fruit traditionally associated with Bacchus, point not to a pastoral concert, but to a bacchanalian revel. Confronting the respectable spectators with vibrant reality and erotic wit, Manet's vision of a youthful excursion to the protective forest slyly suggests the inevitable sexual climax.

Manet correctly predicted that the critics would "tear him to pieces." One of them maintained that "M. Manet plans to achieve celebrity by outraging the bourgeois....His taste is corrupted by infatuation with the bizarre." Another exclaimed: "A common [low prostitute], stark naked at that, lounges brazenly between two warders....I seek in vain for the meaning of this uncouth riddle." Even the shrewder and generally more sympathetic critic Théophile Thoré observed that the picture "is in questionable taste. The nude woman lacks beauty of form, unhappily...and the gentleman sprawled beside her is as unprepossessing as could well be imagined....I fail to see what can have induced a distinguished and intelligent artist to adopt so absurd a composition." A few critics recognized Manet's talent, but could not approve of his style and subject. To them art was a solemn thing, and involved national pride, epic events, history, religion, nobility, sentiment. They couldn't grasp the humor and wit of the painting.

Emile Zola, Manet's friend and defender, later said that Manet had done exactly what an artist should do: "boldly declare himself a powerful and individual mind, a just and strong nature who can grasp life broadly in his hands and set it whole before us as he sees it."[7] Today's art critics, so familiar with the picture that the original shock has entirely worn off, adopt an art-historical point of view and tend to see the painting merely as a

variation of Titian's *Concert Champêtre*. Manet's contemporaries, bewildered and outraged by *Luncheon on the Grass*, came closer to grasping its bold sexual meaning.

<div align="center">III</div>

IN 1864, the year after he married Suzanne, Manet painted his greatest seascape, *The Battle of the Kearsarge and the Alabama*. Manet refused once again to repeat himself, and his use of the genre represents a complete departure from his portraits and his controversial *Luncheon on the Grass*. The painting, which demands some knowledge of the historical background, is both a seascape and a dramatic record of a contemporary event. It depicts a naval battle in the American Civil War that took place off the coast of France.

The Confederate privateer *Alabama*, "built by British hands, of British oak, armed with British guns, manned by British sailors" and supplied by British coal, was launched in Liverpool in 1862, during the Civil War. Her captain, Raphael Semmes, came from Maryland. In two years she had sunk, burned or captured fifty-eight vessels and destroyed three million dollars' worth of Union merchant ships. France, like Britain, supported the South in the Civil War, and by 1863 had become a center of naval operations for the Confederate fleet. Their ships docked in French ports to repair, rearm and refuel, and sometimes took on French sailors when they left.

In the spring of 1864 the *Alabama* docked at Cherbourg, on the Atlantic coast of France, and was discovered by the Northern navy, which sent the corvette *Kearsarge* to wait for and attack her. Duret stated (and Proust agreed) that Manet, an old sailor, "having been informed beforehand of the coming encounter, went to Cherbourg and watched the action from a pilot-boat." Mary Cassatt, a Northern sympathizer from Pennsylvania, heard the same thing from Manet himself:

"Manet was very much excited over the *Alabama* affair, and actually went to Cherbourg to paint this picture [*Fishing Boat Coming in Before the Wind*, 1864]. He had scarcely finished it when the battle with the *Kearsarge* took place just outside the harbor. Manet witnessed the battle and told me it was one of the most exciting moments of his life. He had never seen a naval contest and it was a great experience for him to see the attack and sinking of the *Alabama*." With a characteristic gesture she continued, "Look at that water! Did you ever see anything so solid? You feel the weight of ocean in it."[8]

Fifteen thousand spectators watched the artillery duel, which took place nine miles out at sea and lasted only sixty-two minutes. A photographer perched on the steeple of a church tower captured the event on film.

An eyewitness wrote that the battle Manet painted was "the first decisive engagement between shipping propelled by steam, and the first test of the merits of modern naval artillery." The ships, with both steam and sails, were equally matched in size, speed, crews and armament. The *Kearsarge* achieved victory with her devastating eleven-inch guns, which fired shells at a range of 700 yards, punctured both sides of the *Alabama* and tore great holes in her deck. Many sailors were blown apart by direct hits or terribly mutilated by flying splinters, and the decks were littered with the bloody debris of the wounded and the dead. The *Alabama*, with rudder and propeller knocked out, quickly sank. The *Kearsarge* was only slightly damaged.

After the *Alabama* sank, about a third of the crew, some of whom couldn't swim and were struggling in the water, was saved. Though the ship had surrendered, the survivors broke their word and managed to escape on the boats of their English allies. Captain Semmes and forty-one others were rescued by the English yacht *Deerhound* and "deposited on the dock at

Southampton, safe and beyond French [and Northern] control. Many survivors were picked up by two small French craft; some of them were taken over to the *Kearsarge,* while others were delivered to the quay at Cherbourg. Twenty-six men from the *Alabama* were either killed in battle or lost by drowning; another twenty-one were listed as wounded." The sinking of the *Alabama,* the historian Philip Nord concluded, "was a setback not just for the slave-holding South but also for [Louis-Napoleon] Bonaparte's pro-South policies."9

In Manet's painting the victorious *Kearsarge,* flying the American flag in the distant background, is partially obscured by the gun smoke and fires on the *Alabama.* The art historian Françoise Cachin wrote that "the French sailboat [on the left and pulling a rowboat, with the captain in a top hat and sailor in a yellow jacket], bounding to the rescue of the [four] men in the water, flies the regulation blue-bordered white flag of pilot boats; as in the descriptions of the action, the three-master [*Alabama*] is about to sink, going down by the stern, all her jibs still set in the attempt to regain the shore; the little steamer at the right is the English rescue ship that will take the Southerners to England." The naval battle is echoed by the conflict between the waves in the sea and the smoke in the sky. Manet's composition was unusual: a vast, greenish blue, choppy sea in the foreground, the fighting American ships in the middle and far distance, the smaller French and British boats balanced in the lower-left and upper-right corners.

Excited by the spectacle of battle and interested in the political ramifications, Manet was also drawn to the natural elements, the weight of the solid sea that Cassatt admired. He visited many museums in Holland, and took his perspective from seventeenth-century Dutch seascapes and pictures of the Anglo-Dutch naval wars by Willem van de Velde, Jacob van Ruisdael, Hendrik Vroom and Jan Porcellis. An art historian

seemed to be precisely describing Manet's picture when she wrote of Jan Porcellis: "He was concerned with the sea itself, the distant view, the effect of the atmosphere on what is seen in the distance, and the changing skies. The ships that sail the seas play a less prominent part."[10]

ELECTRIC BODY
1865–1870

I

❧ THE SALON of 1865 accepted Manet's second nude portrait of Victorine, the startlingly beautiful *Olympia,* a companion piece to *Luncheon on the Grass,* and also painted in 1863. Just as the earlier picture had parodied Titian, so *Olympia* boldly alluded to another masterpiece, Goya's *Naked Maja.* But its story is much less ambiguous. This time Victorine, a courtesan attended by a servant, lies across the width of the canvas, her body more exposed, the colors brighter, the contrast of textures more striking. The painting caused an even greater sensation and scandal than *Luncheon on the Grass* had two years earlier in the Salon des Refusés.

In both paintings, the model stares directly at the viewer, coolly detached yet openly receptive and deliciously ready for sex. In *Luncheon on the Grass* she's out of doors and seated, her body half turned away, seen from the side; in *Olympia* she's indoors, reclining on an amply pillowed bed and a fringed cashmere shawl, adorned with a pink flower in her hair, black ribbon around her neck, gold bracelet on her wrist and heeled slipper on one foot, the bare pink toes of the other foot peeping out enticingly beneath. Everything in the painting leads our eyes to gaze on her nakedness. The gesture of the black maid, who brings her a bouquet wrapped in paper, announces a client's imminent arrival through the parted rear curtains. At the center of the painting, the angle of the screen and its frame form the apex of a *V,* which points to the spread fingers that conceal, yet draw attention to, her crotch. The screen, the curtains on the left and in the

rear, the appearance of the maid, the expectation of a visitor, the black alley cat quivering with electricity, all contribute to the dramatic effect. The maid looks down admiringly at her, but Olympia and the black cat stare directly at the spectator. While Olympia's glance is inviting, the cat, with hostile arched back, seems to be hissing at the client about to intrude in its domain.

The black maid, symbolizing exotic sexuality, recalls the women Manet had seen in Rio de Janeiro and described in a letter to his mother: "The Negresses are generally naked to the waist, some with a scarf tied at the neck and falling over their breasts, they are usually ugly, though I have seen some quite pretty ones....Some wear turbans, others do their frizzy hair in elaborate styles and almost all wear petticoats adorned with monstrous flounces." (Thirteen years later Degas, writing from New Orleans, was also struck by the contrast of black and white skin: "I like nothing better than the negresses of all shades, holding in their arms the little white babies.") Manet imitates the Old Masters in contrasting colors of skin and textures of fabric and fur, yet in a way that seemed shockingly new. The red earrings and bandana of the maid echo the red flowers in her bouquet and on Olympia's beige shawl, just as the whites of the maid's eyes are echoed in the cat's eyes. The cat, whose black fur also contrasts with Olympia's white skin, is a witty and dramatic touch. In French, as in English, synonyms for "cat" suggest the female sexual organ, and the large, erect tail signals sexual promiscuity. A contemporary cartoon turned the cat and maid "into frenzied partners in some erotic sub-plot."

Manet's masterpiece, celebrating female sexuality and involving the viewer in its appeal, continued to provoke revulsion and derision long after his death. As late as 1932 Paul Valéry observed: "*Olympia* is shocking still, arouses a sacred horror.... Monster of profane love...she is a scandal, an idol....The purity of a perfect line embraces the Impure *par excellence,* whose office demands candid, quiet ignorance of shame. Bestial Vestal conse-

crated to the nude absolute, she bears dreams of all the primitive barbarism and animal ritual hidden and preserved in the customs and practices of urban prostitution." *Olympia,* far more than *Luncheon on the Grass,* portrays a forbidden and threatening sexuality. Her bold stare enhances the offer of her body and challenges the virility of the male spectator—the offstage counterpart of the ardent client, coming from the rear, who has sent the *fleurs du mal.* Kenneth Clark explained why this erotically charged portrait of a prostitute provoked uneasiness as well as outrage in contemporary viewers: "for almost the first time since the Renaissance a painting of the nude represented a real woman in probable surroundings....Amateurs were thus suddenly reminded of the circumstances under which actual nudity was familiar to them, and their embarrassment is understandable."[1]

The novelist and always perceptive art critic Huysmans remarked that *Olympia* was Goya's *Naked Maja* "transposed by Baudelaire." The sensual cat, a familiar motif in Manet, recurs in *The Luncheon* and (with an elongated dinosaur neck and seductively beckoning tail) in the provocative lithograph *Cats' Rendezvous* (both 1868). Manet "Baudelairized" all his cats, taking his cue from "Le Chat" in *Les Fleurs du Mal* (The Flowers of Evil), where Baudelaire associates the cat with his enchanting and destructive mulatto mistress:

> When leisurely my fingers stroke your head, your
> elastic back, and my hand thrills from the feel of your
> electric body,
> the image of the woman I love rises before me: her
> gaze, like yours, dear animal, is profound and cold, as
> sharp and penetrating as a sting,
> and from head to foot an elusive atmosphere, a
> threatening perfume, swirls round her dusky limbs.

Baudelaire derived his cats, in turn, from his translation of Edgar Allan Poe's story "The Black Cat," which begins by noting that

sagacious black cats are popularly regarded as witches in dis-
guise. In Poe's story the cat, which has magical powers, repre-
sents the return of the narrator's repressed conscience and his
inevitable self-destruction. Baudelaire strongly identified with
Poe and told Manet: "People accuse me of imitating Edgar Poe!
Do you know why I translate Poe so patiently? Because he re-
sembled me."

Though Manet did not share Baudelaire's identification with
Poe's sense of despair, guilt and doom, he was stimulated by
Baudelaire's verse, just as he was inspired by studying Goya, and
drew on his stock of words and images to create *Olympia*. Baude-
laire's "Les Bijoux" (The Jewels), for example, seems to describe
the bold and dangerous, bewitching and destructive Olympia, so
perfectly embodied by Victorine herself:

> Her eyes fixed as a tiger's in the tamer's trance,
> Absent, unthinking, she varied her poses
> With an audacity and wild innocence
> That gave a strange pang to each metamorphosis.
>
> Her long legs, her hips, shining smooth as oil,
> Her arms and her thighs, undulant as a swan,
> Lured my serene, clairvoyant gaze to travel
> To her belly and breasts, the grapes of my vine.

Theodore Reff, a leading Impressionist scholar, noted how
Olympia "depicts motifs like the Negress, the cat, and the jew-
eled, naked flesh that recur in many of the [*Fleurs du Mal*] poems,
and it is charged with a spirit of artificiality and malevolence that
pervades almost all of them."[2]

II

WHEN MANET met Baudelaire in about 1859, he found a friend
(eleven years older) who had preceded him, and was even bolder,
in challenging public taste. Two years before, *Les Fleurs du Mal*

had been condemned by the censor, and Baudelaire had been convicted and fined "for the arousal of the senses by crude and indecent realism." Nevertheless, he was also convinced of his own genius and naively dreamed, like Manet, of being recognized by the French Academy and achieving the *Légion d'honneur*. Both men, in their youth, had been sent on a voyage to the tropics that had made a deep impression: Manet to Rio, Baudelaire to Mauritius and Réunion, off the east coast of Africa. Baudelaire, recalling the exotic scenery, later wrote: "I see unfold a reach of happy shores / Dazzled by the fires of a monotonous sun."

Manet and Baudelaire, close friends and intellectual companions, spent many long hours talking in his studio and in cafés, at concerts and at the racetrack, even at the funeral of Delacroix, whom they both admired. But almost nothing of their intensely stimulating conversation has survived. Well-educated, attached to yet estranged from his mother, stepson of an army officer whom he despised, Baudelaire was a much more difficult, bohemian and self-destructive man than the elegant and courteous Manet. The photographer Félix Nadar called Baudelaire "a nervous, testy, irritable, and irritating young poet, often utterly unpleasant in private." But Manet always forgave his bizarre behavior. Antonin Proust recalled that "at one time, when the poet wore makeup in an outrageous manner, Manet said: 'he had a layer of it, but there was so much genius under that layer.' "[3]

Baudelaire had also been inspired by Manet. In 1860 he wrote a story based on a tragic incident that occurred when Manet had hired a young boy, Alexandre, to clean brushes, run errands and model for paintings like *Boy with Cherries* (1858–59). He accused Alexandre of stealing sugar and liqueurs, and the boy, consumed with shame, hanged himself in Manet's studio. The guilt-stricken painter had to cut down the corpse, face a police interrogation and break the news to the boy's family. In Baudelaire's "The Rope" (1860), dedicated to Manet, the painter is the unnamed narrator. Fascinated by all the grim details, he says: "the little

monster had used a very thin string, which had cut deeply into the flesh, and I had to pry with narrow scissors between the two rings of swollen flesh, in order to release his neck....When we had to undress him for the burial, the rigidity of the corpse was such that, renouncing hope of bending the limbs, we had to slash and cut his clothes in order to take them off." When he tells the family what happened, the mother asks for the rope "as a horrible and precious relic." In another grotesque twist, the narrator realizes that she plans to sell bits of it to neighbors who believe that it has occult powers and will bring good luck.

Baudelaire, who owned a large collection of Manet's prints, wrote a quatrain that was exhibited with Manet's portrait of the Spanish dancer *Lola de Valence* (1862). That year Manet painted the poet standing, in profile and with a top hat, next to a thick tree trunk among the crowd in *Music in the Tuileries* (1862). He also made five etchings of Baudelaire just after the poet's death in 1867. Two of them show Baudelaire in profile, with a puff of hair billowing beneath his tall banded hat. Three others, based on an 1862 photo of his ravaged features by Nadar, portray him bareheaded and in full face, with a high forehead, flowing hair and loosely tied black cravat.

Manet also paid indirect tribute to the poet in his large portrait, *Baudelaire's Mistress, Reclining* (1862), whose title absorbs the identity of the subject into that of her poet-lover. A friend of the poet described Jeanne Duval as "a mulatto—not very black, or beautiful....She was rather flat-chested, quite tall, and had an awkward gait." The mistress of Nadar, who adored her, she was also an alcoholic, drug addict and prostitute—stupid, greedy and depraved. Jeanne fed on Baudelaire like a bird of prey, and he called her "*simultaneously* the sin and the Hell that punishes it." In a letter to his mother of March 1852, Baudelaire complained bitterly about the radical defects of Jeanne's character: her cruel dominance, inviolable stupidity, boorish disdain, even cruelty to his beloved cat. He also described their sadomasochistic connec-

tion and his humiliating bondage to a woman he both loved
and hated:

> To live with a person who shows no gratitude for your ef-
> forts, who impedes them through clumsiness or permanent
> meanness, who considers you as a mere servant, as her prop-
> erty, someone with whom it is impossible to exchange a word
> about politics or literature, a creature who is unwilling to
> learn a single thing, although you've offered to teach her
> yourself, a creature who *has no admiration for one* and who is not
> even interested in one's studies, would throw one's manu-
> scripts on the fire if that brought in more money than pub-
> lishing them, who drives away one's cat…is all this possible?

Jeanne had become paralyzed by the time Manet painted her
portrait, and some lines from Baudelaire's "Le Monstre" illumi-
nate her physical decay:

> You're certainly not, my dearest darling,
> What Veuillot likes to call a sapling.…
> You're no longer very fresh, my darling,
> My old infanta!

In the portrait Duval wears a gigantic *Gone with the Wind*–style
white, velvet, striped crinoline that flows like a rising tide over
the enormous black sofa. Her complexion is dark, her nose
blunt and mouth thin, and her eyes are lost in deep shadows. She
wears a gold crucifix and holds a black fan, and a white-
stockinged leg and black-slippered foot jut out stiffly from be-
neath her gown. Her right hand (larger than her head) rests on
the fringe of lace curtains that part, exactly above the part of her
black hair, in a form that suggests what lies beneath her dress.
This cruel portrait, which Cachin calls a "devastating record of a
face once passionately loved, now sickly, hardened, and embit-
tered," shares the poet's anguished hostility to the dark lady of
his sonnets.[4]

Manet and Baudelaire were separated during the last years of their friendship, but kept up a correspondence. In the spring of 1864 the poet moved to Brussels in a vain attempt to escape his French creditors and to make some desperately needed money by lecturing and publishing his complete works. Manet acted as his literary agent in Paris. Though the artist was, in a way, his disciple, having followed his advice to paint modern life, Baudelaire wrote almost nothing about Manet's art. In a brief sentence in his minor article and last piece of art criticism, "Painters and Engravers" (1862), he said that Manet "has a definite taste for reality, modern reality—which is a good sign—a rich and lively, sensitive and audacious imagination." Baudelaire's approval was all very well, but the question was: how long could Manet bear the torrent of criticism and ridicule that greeted every masterpiece? He depended on his friends for moral support, and many were concerned that the negative reception of his work would prove too great a strain.

In March 1865, when *Olympia* was severely condemned by the critics, Manet plaintively asked Baudelaire to defend him: "I wish I could have your sound judgment on my pictures because all this uproar is upsetting, and obviously someone must be wrong; [the painter Henri Fantin-Latour] has been an angel, he has been standing up for me." Two months later, Baudelaire responded indirectly in letters to mutual friends, Eléanore Meurice (the wife of a playwright) and Jules Champfleury (a critic), who would convey his harsh message and perhaps soften it a little:

> When you see Manet, tell him this: that torment—whether it be great or small—that mockery, that insults, that injustice are excellent things, and that he should be ungrateful were he not thankful for injustice. I well know he will have some difficulty understanding my theory; painters always want immediate success. But really, Manet has such brilliant and facile ability that it would be unfortunate if he became discouraged.

Baudelaire—an expert in condemnation and suffering—believed that the mockery of fools merely confirmed your talent; that suffering spurred you on to greater effort; that victory, to be meaningful, could only be won after a hard struggle.

Baudelaire was also worried that Manet might lack the will-power to persist in the face of adversity: "Manet has a strong talent, a talent which will resist. But he has a weak character. He seems to me disconsolate and dazed by the shock. I am also struck by the delight of all the idiots who think him ruined." Baudelaire understood his friend's charm, and told Manet's mother that it was "difficult not to love his character just as much as his talents." Stressing Manet's fundamental decency, he also praised his character in a letter to the sympathetic critic Théophile Thoré: "Manet, who is considered a raving madman, is quite simply a very loyal, straightforward man, doing his best to be reasonable but unfortunately marked by Romanticism from birth."[5] By now fatally ill with syphilis, the poet suffered a stroke that left him half-paralyzed and unable to speak, and shortly before his death was brought back to Paris in a wretched condition. Suzanne Manet visited the dying poet and tried to divert him by playing Wagner, his favorite composer, on the piano. Manet observed in his intimate friend the terrifying effects of the disease that would eventually cause his own death. Baudelaire died, at the age of forty-six, on August 31, 1867, and Manet attended his funeral.

Baudelaire was concerned that Manet's character might not be strong enough to withstand the criticism of his work, but he stood up to it quite well. "It is my fate to be vilified," Manet confessed, "and I accept it philosophically." After a friend had fiercely condemned his paintings, then felt obliged to add, "Even so, you have to have what it takes to do work like that," Manet bitterly replied: "One always has what it takes to fail." He shared Baudelaire's view of creative agony, and later told Proust that the attacks on his work had "broken the springs of [his]

life." He explained that the savagery of the critics, "this war with knives, has hurt me very deeply. I've suffered cruelly, but it has been a great stimulus. I wouldn't want any artist to be praised and flattered at the beginning. It would destroy his personality." It must have taken great strength of character—as well as Suzanne's emotional support during these difficult times—to go on painting despite years of public scorn, mockery and humiliation. "You are the happy warrior," Renoir admiringly told Manet, "with hatred for none...and I love you for that cheerfulness in the face of injustice."[6]

III

IN AUGUST 1865, just after the *Olympia* debacle, Manet—enchanted by an enthusiastic letter from his artist friend Zacharie Astruc, who knew Spain well—escaped on a long-planned journey to Burgos, Valladolid, Toledo and Madrid. He was most forcefully affected by the food, the bullfights and the paintings of Velázquez. Théophile Gautier's *Wanderings in Spain* (1845), the authoritative guidebook for French travelers, warned those with delicate palates that "Spain is certainly not peculiarly brilliant in its cookery....The pictures of omelettes full of feathers, of tough cakes, rancid oil, and hard peas that might serve as bullets, are still strictly true." (Fifty years later, Somerset Maugham confirmed that "the food—thin soups, tough steaks, revolting sauces, disgusting innards and rancid oils—was abominable.")

Théodore Duret, just back from a rough trip to Portugal and contrasting Manet's fastidious taste with his own voracious hunger, gave an amusing, Chaplinesque account of how he first met the touchy painter in a typical restaurant in Madrid's Puerta del Sol:

He found the cuisine execrable. Every other minute he ordered some new dish, which immediately afterwards he angrily rejected as inedible. Each time that he sent the waiter

away, I on the contrary called him back, and with ravenous appetite partook of all the dishes indifferently. Meanwhile, I had paid no attention to my neighbour who was so difficult to please. When, however, I again asked the waiter to bring me a dish which he had refused, he suddenly got up, came to near where I was sitting and exclaimed angrily, "Now, sir, you are doing this simply to insult me, to make a fool of me — pretending to relish this disgusting cooking and calling back the waiter every time that I send him away!"

Manet regretfully concluded: "Though this country provides a feast for the eyes, one's stomach suffers tortures. When you sit down to table, you want to vomit rather than eat."[7]

Inspired by Gautier, Manet was deeply impressed by the bull-fights. The last pagan spectacle of the modern world, based on a ritual as formal as the Mass, provided vicarious participation in violence, danger and death. Gautier called the *corrida* "one of the grandest sights that the imagination of man can conceive," and said that the frantic attention and dramatic intensity during the killing of the bull "is worth all the plays Shakespeare ever wrote."

In those days, well before the use of protective padding, the *picador*'s horses were frequently gored by the bulls and spilled their smelly intestines onto the bloody sand. Gautier described such a moment, and added an even more gruesome detail: "The horn had completely ripped up the horse's belly, so that his entrails came through, and almost touched the ground....The entrails are replaced in his belly, a needle and thread are passed through the skin, and the poor creature is still capable of being used again." Other cruelties — loud fireworks and fierce dogs — were used against bulls unwilling to fight and made the spectacle even more horrific. Gautier reported that "sticks, with fireworks attached...are planted in the shoulders of the *toro cobarde* (cowardly bull) and explode with a shower of sparks and detonations....When the dogs have once fastened on [the bull's ear]

they are like leeches; they might be turned inside out before they would let go."

Manet liked the *corrida*'s primitive ferocity, and in a letter of September 17 to Astruc praised "the colourful crowd, and the dramatic aspect as well, the *picador* and horse overturned, with the bull's horns ploughing into them and the horde of *chulos* [assistants] trying to draw the furious beast away." Moved by the beauty of the colorful costumes and by the paradoxical vitality in the drama of death, he also told Baudelaire: "One of the finest, most curious and most terrifying sights to be seen is a bullfight. When I get back I hope to put on canvas the brilliant, glittering effect and also the drama of the *corrida* I saw."[8] Manet's journey to Spain inspired three major works: *The Bullring in Madrid, Bullfight* and *A Matador.*

The high point of Manet's journey was his visit to the Prado, where he stood entranced before the paintings by Velázquez, the dominant influence on his work. He could not praise Velázquez enough, delighted by the strong faces of his portraits, the dramatic contrasts of bright color and rich black, the ingenious perspective. (Later, he would adapt Velázquez's mirror in *Las Meninas* to his own reflective use in *A Bar at the Folies-Bèrgere.*) He contrasted the dull colors of the Academicians to Velázquez's *The Little Cavaliers,* which he'd copied in the Louvre in 1861, and told Proust: "Now...that's good clean work. It puts you off the brown-sauce school.... Velázquez, El Greco...they're really impressive." Writing from Madrid, he told Astruc that he identified with the Spaniard's paintings and was inspired by them: "What thrilled me most in Spain and made the whole trip worthwhile were the works of Velázquez. He's the greatest artist of all; he came as no surprise, however, for I discovered in his work the fulfilment of my own ideals in painting, and the sight of those masterpieces gave me enormous hope and courage." When Manet visited Italy a decade later and was deeply impressed by the Venetian masters, he continued to use Velázquez as the

touchstone of great painting: "I like the Carpaccios, they have the naïve grace of illuminations in missals. And I rank highest of all the Titians and Tintorettos of the *Scuola di San Rocco*. But I always come back, you know, to Velázquez and Goya."[9]

IV

In May 1866 Manet's revolutionary art found a critic brave enough to defend and explain it—the young Emile Zola, childhood friend of Paul Cézanne, crusading journalist and future author of the naturalistic series of novels about the Rougon-Macquart family. After his daring articles had assaulted the conventional values of the Salon of 1866, which rejected Manet's *The Fifer* and *The Tragic Actor,* Zola was forced to resign from the republican and liberal newspaper *L'Evénement.* Zola began by championing Manet's striking originality, his radical break with academic art and his Baudelairean commitment to painting scenes from contemporary life: "What certain confreres pass off as a depiction of nature impelled him, no doubt, to question reality on his own. He apparently rejected all the knowledge and experience of previous generations; he wanted to begin at the beginning, that is, to develop art from close observation of his material."

Zola celebrated Manet's vivid technique, his clear yet detached eye and his powerful impact: "He captures his figures alive, he does not shrink before nature's rowdiness, he lets objects assert themselves, detaching each from every other. His entire being compels him to see…in simple and energetic swatches.…He is satisfied to find the right tones and the right arrangement of them. What results is a strong, solid painting." Finally, in a striking image, Zola exclaimed that Manet's penetrating vision had exposed and destroyed the pleasing but artificial art of the Salons: "You know what effect Monsieur Manet's canvases produce at the Salon. They punch holes in the wall. Spread all around them are the wares of fashionable confectioners—sugarcane

trees and pie-crust houses, gingerbread gentlemen and whipped-cream ladies."[10] In February 1867, deeply moved and grateful for Zola's spirited defense, Manet adopted his military metaphor and urged his new-found ally to exercise caution till it was time to counterattack: "I shall need your friendship and your valiant pen so much in the future that I ought to exercise the greatest discretion in making public use of them. I may be violently attacked, so it might be better to keep you or our forces in reserve until then."

Zola dedicated his novel *Madeleine Férat* (1868) to Manet, and that year Manet painted his portrait. He portrayed Zola sitting sideways, legs crossed, the bold features of his face in three-quarter view, set off against his black jacket and dark background. He holds a large white open book, and his desk is cluttered with feathered pens and ink, books and pamphlets, including his blue-covered essay on Manet whose title is clearly visible. A Chinese screen is on the left; and in the right background are three allusions to influences on or work by Manet: a Japanese print, an engraving of Velázquez and an image of *Olympia,* which Zola had called his masterpiece. But this coolly observed, somewhat stiff portrait does not suggest a formidable intellect absorbed in his artistic and literary work. Instead, with spectacles dropped on a string, Zola looks away not only from the book in his left hand, but also from the three pictures that allude to Manet's art.

Unlike Proust, whose emotional involvement in his portrait led Manet to embrace him, Zola sat in a rigid pose and became exhausted, even somnolent, while Manet, indifferent to the sitter's comfort, was fully engaged in his painting. Zola remembered "posing for hours on end. With limbs numb from remaining motionless and my eyes weary from staring at the light....Now and again, half-dozing off as I sat there, I looked at the artist standing at his easel, his features taut, his eyes bright, absorbed in his work. He had forgotten me; he no longer realized that I was there."

Ironically, though Zola felt obliged to defend Manet for politi-
cal reasons—because the establishment opposed him—he never
fully understood his art. He later admitted that "his painting has
always disconcerted me a little."[11] In June 1879 Zola attacked
Manet in a Russian newspaper and found, to his embarrassment,
that the article had been translated in a French journal. Rehearsing
the old charges, Zola said that Manet did not successfully execute
his conceptions, was easily satisfied with hasty pictures, had no
method and painted many failures. Manet would not achieve full
recognition until he formed his third great literary friendship, with
Stéphane Mallarmé, who combined Baudelaire's enthusiasm for
his work with Zola's keenness to write about it.

The scandalous publicity generated by *Luncheon on the Grass*
and *Olympia* further alienated the Academicians, who continued
to ridicule the work Manet submitted to the Salons. He was able
to live on his income but earned almost nothing from his art,
and this frustrated and worried him. By contrast, the prices of
Adolphe Bouguereau—the now-forgotten darling of the Sa-
lons—"were so high and he had so many commissions that he
was reported to have said: 'I lose five francs every time I piss.'"

In May 1867, when the work he submitted for the government-
sponsored *Exposition Universelle* (World's Fair) was rejected,
Manet decided to try another path to success, imitate Gustave
Courbet and hold his own private show. He borrowed the con-
siderable sum of 18,000 francs from his mother, built his own
pavilion just outside the grounds and mounted a one-man exhi-
bition of fifty paintings. In a public manifesto that justified the
show, Manet expressed the hope that exhibiting his work would
lessen its shocking effect, lead to public acceptance and enable
him to achieve his long-awaited recognition:

The matter of vital concern, the *sine qua non*, for the artist, is
to exhibit; for it happens, after some looking at a thing, that
one becomes familiar with what was surprising, or, if you will,
shocking. Little by little it becomes understood and accepted.

Time itself is always imperceptibly at work upon a picture, refining and softening its original harshness.

By exhibiting, an artist finds friends and supporters who encourage him in his struggle.

Eager for the public's response, Manet put out a comment book for visitors. Every night he conscientiously read their severe and often mocking reactions. Despite his strong belief in his work, he could not help being downcast. His pictures were not accepted by the public until long after his death. In *Remembrance of Things Past* (1917–27) the Duchess of Guermantes, seeing *Olympia* when it was exhibited in the Louvre, remarks with some exaggeration: "Nowadays nobody is in the least surprised by it. It looks just like an Ingres!"[12]

V

IN JANUARY 1869 one of Manet's greatest paintings, *The Execution of Maximilian* (1868), a dramatic rendering of a terrible French humiliation, was rejected by the Salon. For purely political reasons the government forbade it to be displayed, and his lithograph of the picture was also banned. Like Delacroix's *The Massacre at Chios* (1823), Manet's painting was inspired by tragic events in a distant country.

In 1859, during the struggle for the presidency of Mexico, Benito Juárez, supported by the Indian masses and by the United States, was opposed by "General Miguel Miramón, a Catholic conservative, backed by the Catholic hierarchy and the upper classes which consisted of large landowners and Spanish aristocrats." Three years later, as the Mexican civil war continued, Emperor Napoleon III sent French troops into Mexico to enforce the payment of huge foreign debts. In 1864 Napoleon installed the dreamy and idealistic Archduke Maximilian, younger brother of the Austrian Emperor Franz Joseph, as Emperor of Mexico.

Three years later, in February 1867, France reneged on its formal treaty and "Marshal [Achille-François] Bazaine and the last of the French forces left Mexico City, leaving Maximilian to face an enemy of approximately 60,000 men with his puny army of several thousand soldiers." On May 16, Querétaro, 120 miles northwest of the capital, "fell after a seventy-two-day siege and Maximilian's three-year reign ended with his surrender." Napoleon was accused of betraying Maximilian "and the French nation [was] dealt the worst blow to her prestige since Waterloo."[13] Charged with attempting to overthrow the legitimate government, Maximilian was tried by court-martial and convicted of treason. Many foreign powers urged clemency, but Juárez's government wanted to eliminate the French puppet. On June 19, 1867, on a hill overlooking the city where he'd been captured, Maximilian and two of his generals—Miguel Miramón and Tomás Mejía—were executed by firing squad.

Manet's painting was based on the wave of news reports and photographs that poured into France. According to factual accounts, the execution took place outside, at seven in the morning, near a hill and a cemetery wall; Maximilian, Miramón and Mejía were all shot at the same time; there were three separate firing squads, one for each victim; each squad had six soldiers; there was one non-commissioned sword-commander who stood in line with the soldiers; the rifles were fired when the sword commands were given; and the squads were only three paces away from the victims, who were shot point-blank. Mejía, a full-blooded Indian who looked very different from the Frenchman Miramón, was pathetically sick and had to be carried to his execution.

Eyewitnesses reported that Maximilian gave Miramón the central place of honor. According to some grim accounts, the bareheaded Maximilian did not die instantly and the coup de grace was crude: "the officer who had given the order to fire ran up and, turning over the Emperor's body with his sabre, pointed to his heart in silence. A soldier then fired a shot at such close

range that it scorched his clothes." Another source reported some sentimental details that Manet excluded from the painting: the two generals were blindfolded, an abbot and bishop were present, "Franciscan priests put three black wooden benches and crosses against the wall behind the victims, Indians carried coffins to the scene, the spectators cried abundantly."[14]

Manet's portrayal of the execution contains a personal as well as a political element. Berthe Morisot's brother-in-law, Paul Gobillard, had lost an arm while serving as an officer in the Mexican war, and Manet must have heard his account of the disastrous campaign. Manet also read a description in Gautier's *Wanderings in Spain* of the painting that inspired his work— Goya's portrayal of a French firing squad during the Napoleonic invasion of Spain—before he actually saw it in the Prado: "Goya executed, with a spoon for a brush, a painting of the *[Tres] de Mayo* (Third of May), where some French troops are shooting a number of Spaniards. It is a work of incredible vigor and fire."[15]

Manet produced four versions of *The Execution of Maximilian*— now in Boston, London, Copenhagen and in Mannheim, Germany—of which the last is by far the best. He changed many of the historical details to make the pictorial, almost cinematic drama more immediate and intense. In the final painting, the high wall is perpendicular to the victims, and seems to press against them and shut them in. There is only one firing squad instead of three, and the riflemen do not shoot at exactly the same time. There are seven soldiers and one sergeant, not twenty-one soldiers, and they are concentrated in a small group instead of being spread out in a long line. Maximilian, not Miramón, is in the middle and wears a Mexican hat to show his solidarity with the common people. The victims—together, not separate—hold hands in a gesture of fraternal support. The soldiers wear distinctively French, not Mexican, uniforms. The rifles almost touch the chests of the victims, yet the execution is bloodless.

Manet tightly structures the painting. He links the participants in this political tragedy by splashes of white: the white shirts of the victims, the white sword belts and spats of the soldiers, the white puff of gun smoke that circles above their heads and wafts toward the small crowd of observers on the other side of the wall. He also connects the pyramid of victims, soldiers and spectators to the pyramidal form of the central observer, whose elbows rest on the wall and arms support her grief-stricken head.

The events depicted show that the executioners' shots are serial, not simultaneous. The dark-skinned, clean-shaven Mejía, struck by the fatal bullets, falls backwards but has not yet collapsed on the ground. The bearded Maximilian and Miramón stand upright and bravely await their imminent death. The extremely close range, reduced from three paces to the length of the long-barreled rifles that shoot out red tongues of flame, would have splattered the blood of the victims all over their executioners. Manet clearly delineates the faces of the emperor and his generals, but leaves the riflemen featureless. The casual indifference of the sergeant, loading his rifle to finish off the victims, increases the horror of their sacrifice. For all its apparent objectivity, Manet's sympathy is clearly with the victims. The familiar uniforms of the firing squad reveal that the French, not the Mexicans, have killed Maximilian. Manet's shocking picture, highly critical of the government's betrayal and humiliation, packed the same political punch as a news photograph of a modern battlefield.

VI

MANET HAD PRACTICED fencing on the voyage to Brazil and was fond of using the imagery of duels, still an honorable European tradition in the latter half of the century. He once remarked, after he and Carolus-Duran began to paint each other's portraits but never finished: "We exchanged two shots but failed

to hit." In February 1870, hypersensitive about all his recent re-
jections, Manet suddenly lost his temper with Edmond Duranty,
a critic who had always shown respect for his work. Duranty
had simply written, in one of his reviews, "M. Manet showed a
philosopher trampling oyster shells and a watercolor of his *Christ
with Angels.*" Constantly attacked and suffering acutely from pub-
lic opprobrium, though he tried to hide his feelings, Manet was
under considerable strain. He could not bear even gentle criti-
cism from a friend. This apparently innocuous sentence sent
him into an uncharacteristic rage, and he slapped the critic in the
face at their familiar rendezvous, the Café Guerbois. Duranty
was obliged to challenge him to a duel; Manet chose swords as
weapons; and, seconded by Zola, he met the critic in the forest
of Saint-Germain. Though Duranty's provocation was slight and
the two men were friends, the seconds allowed the duel to
proceed.

According to the police report: "There was only one *engage-
ment,* but this was so violent that both épées were damaged.
Monsieur Duranty was slightly wounded above the right breast
when his opponent's épée glanced off a rib. In consequence of
this wound the seconds decided that honour was satisfied and
that there was no point in continuing the duel." Zola's friend
Paul Alexis, a habitué of the Café Guerbois, added a slightly
comic note and suggested that both parties were greatly relieved
to find their opponents uninjured: "completely ignorant of the
art of fencing, Manet and Duranty threw themselves upon each
other with such savage bravery that, when the four astonished
seconds had separated them...their swords appeared to have
been turned into a pair of corkscrews. That very evening they
had become the best friends in the world again."

After the duel was over and feeling embarrassed that he'd
gone berserk, Manet tried to dismiss the dangerous encounter as
a joke: "There was only one thing I was afraid of, that my thrusts
would pass over his head. I was so springy! I can't tell you what

trouble I went to, the day before the duel, to find a pair of really broad, roomy shoes in which I would feel quite comfortable.... After the duel, I was going to give them to Duranty but he refused them because his feet were larger than mine. We have wondered ever since how we could have been silly enough to want to run each other through."[16]

Five

DINING ON RATS
1870–1879

I

꘠ TWO DECADES after the bloody coup that made him emperor and three years after the execution of Maximilian, the vainglorious Napoleon III brought France into a new disaster. In July 1870, exaggerating a diplomatic quarrel about the succession to the Spanish throne, he declared war on Prussia. The French were fired with patriotism, but no match for the better-equipped and well-organized Prussian army. The war was doomed from the start. The novelist Gustave Flaubert expressed the frustration felt by many when he told George Sand: "I am nauseated, heart-broken at the stupidity of my fellow-countrymen. The incorrigible barbarism of the human race fills me with deep gloom. This war enthusiasm, unmotivated by any idea, makes me long to die so that I need no longer witness it." On September 1, only six weeks later, after defeats in Alsace and Metz, Napoleon III was crushed in the battle of Sedan and surrendered his army of 83,000 men. The Germans bombarded Paris, gradually starving the city as it endured the bitterest winter in living memory. The armies fought a series of battles around the city, which remained under siege.

The southern regions of France were unaffected by the war. Most families who had the means to leave Paris did so, and Suzanne, Léon and Manet's mother fled to Oloron in the Pyrenees. Manet hadn't bothered to write to Suzanne on his journey to Spain, but he kept in close touch with her now, and gave a detailed account of his activities during the siege of Paris. On Sep-

tember 10 he reported that women were forcing men to join the military: "The women are up in arms; in Montmartre they've taken on the rôle of the police and are trying to prevent the men from staying home." Even at this stage he could foresee disaster: "We poor Parisians are going to be caught up in a terrible drama—death and destruction, looting and carnage will be inevitable if Europe doesn't intervene in time." The Parisians, fiercely republican in spirit, were determined to oppose the German army and the French government. But in mid-September Manet wrote that the militia could not resist the onslaught and would suffer humiliating defeat, and described the public's mood: "Yesterday we were with Degas and [my brother] Eugène at a public meeting at the Folies-Bergère where we heard General Cluseret speak....The present provisional government is very unpopular and it looks as if the true republicans are planning its overthrow after the war."

The painters Camille Pissarro and Claude Monet, dedicated socialists who hated the Second Empire, had gone into exile in England. Manet's patriotism was stronger than his dislike and distrust of the government, and he felt obliged to defend his country. In November 1870 he volunteered as an artillery lieutenant in the National Guard, which protected Paris during the German siege, and the following month joined the general staff. The National Guard was hastily expanded from 24,000 to 90,000 and then, through compulsory registration, to 350,000. Poorly organized and trained, and paid only 1.50 francs a day, they could not possibly defeat the Prussian forces. But only a small percentage of them had the real job of relieving the regular army on the fortifications that surrounded Paris. The historian Alistair Horne described the conditions under which Manet served. For month after month the National Guard, "given no other tasks than to stand guard passively on the walls or to quell disorders in Paris," experienced "grinding boredom and a sense of futility." Their feeling of "uselessness was understandably demoralizing;

as they whiled away the time smoking, drinking, playing cards, and gossiping, the boredom became chronic."[1] Their drunkenness and lack of discipline undermined their ability to fight and led to clashes with the local civilians.

At first Manet's military duties were light, and he had time to use his portable paintbox and easel. He painted a church with a tall bell tower in *Snow Effect in Petit-Montrouge,* while looking out over the battlements. A month later he said that the army, isolated in the fortifications, was threatened by disease and starvation: "We're beginning to have enough of being boxed in here without any outside contacts....A smallpox outbreak is spreading and at the moment we're down to 75 grams of meat per person, while milk is only available to children and the sick." In mid-November the food situation became desperate. The fastidious traveler who'd refused to eat Spanish cuisine was now dining on rats, cats and dogs, with donkeys and horses as delicacies.

From November 30 to December 2, during the battle of Champigny-sur-Marne (a village southeast of Paris) when the French attempted unsuccessful sorties from the city, Manet carried dispatches under fire. He still found time to write to his family in Oloron: "We've reached the decisive moment.... There's fighting everywhere, all round Paris. The enemy caused fairly heavy losses yesterday; the militia faced their fire with courage enough, but unfortunately the troops of the line gave way.... I was on guard at the fortifications—it's very tiring and very hard. One sleeps on straw, and there's not even enough of that to go round." On December 2 he came under fire and seemed to take it in stride: "Yesterday I was at the battle that was fought between Le Bourget and Champigny. What a din! One quickly gets used to it, with shells flying over one's head from all sides." By January 6, 1871, he was confined to his bedroom with boils that erupted when he was carrying dispatches on horseback. On January 15, thirteen days before Paris surrendered, he grimly remarked that food was almost exhausted and the bombardment was merciless: "All the horses have been eaten....No

more gas, only black bread, and the cannon fire all day and all night long." After five months of boredom, malnutrition and intense anxiety, the Parisians were psychologically unprepared "to face the humiliation of an unprecedented defeat, or of the crushing peace terms that lay ahead."[2] The starving capital surrendered on January 28, 1871.

Napoleon III went into exile in England, and the victorious Prussians—waiting for the treaty to be signed and reparations to be paid—remained stationed outside the capital. In February 1871 parliamentary elections set up a provisional government, led by the elderly conservative Adolphe Thiers, which voted to move the National Assembly from Paris to Versailles. Thiers negotiated the peace treaty with the Prussians, in which the French lost Alsace-Lorraine and had to pay heavy reparations. The Parisians, furious at the sacrifice they had borne and determined to oppose the authorities in Versailles, established an independent city government called the Commune and set the scene for a civil war.

At this point Manet left Paris to join his family in southwest France. Two letters to his engraver friend, Félix Bracquemond, written in mid-March, express his republican views and his hostility to Thiers. His friend, the painter Count Albert de Balleroy,

> got me into the House—I never imagined that France could be represented by such doddering old fools, not excepting that little twit Thiers who I hope will drop dead one day in the middle of a speech and rid us of his wizened little person....
>
> The only government of honest people, calm people and intelligent people is the republic and only with that kind of government are we able to recover in the eyes of Europe from our dreadful disasters....It was a great mistake on the part of Thiers and the Assembly not to come back to Paris immediately after the German evacuation.

A civil war duly broke out and, for the second time in three months, troops attacked the capital. On May 21, as the Germans

watched and waited, the French troops loyal to Thiers entered Paris. The Germans had besieged and bombarded Paris, but they had never invaded the city. Now French soldiers murdered working-class Parisians and piled up their corpses in the streets. In the course of one bloody week they executed about 20,000 people, including many women and children. A historian concluded that "in terms of bloodshed, the 'expiation' imposed upon the Commune was to eclipse by far either the 'Terror' of the first French Revolution, or even the St. Petersburg revolution of 1917." In May 1871, after the fierce suppression of the Commune, France had been "shamefully defeated, riven by civil war, bankrupted by the German reparation demands and the costs of repairing Paris."[3]

Manet returned to Paris in June, after the killing was over, to find the streets in ruins and the houses gutted by fire. In August the strain of war overwhelmed him and he suffered a nervous breakdown. He stopped working for several months, wandered aimlessly from café to café in search of solace and was finally treated by a doctor who brought him out of his depression.

Manet felt the Versailles government was hopelessly reactionary, the Commune a savage dead end. He called the statesman Léon Gambetta—anticlerical opponent of the Second Empire, war minister and advocate of revenge against Germany—"the only capable man we have." In an excellent article on Manet's politics, Philip Nord explained that Manet, his family and almost all his friends held radical republican beliefs. He tried to democratize the Salons, and during his twenty-year career created many "politically charged subjects and themes....In the 1860s, he stood against the Empire, took the North's part in the American Civil War, and militated in support of the secularist cause. Manet execrated the military men who had led France to defeat in 1870 and, during the Commune, aligned himself with the [liberal republican] party of conciliation in opposition to Versaillais repression."

Manet created three extremely powerful works about the siege and the Commune. His lithograph *The Balloon* (1862) fore-shadowed the theme of his painting *The Rue Mosnier Decorated with Flags* (1878). In the former, the festive Parisian crowd, gathered in the street to watch the ascent of the balloon, ignores the crippled boy in the center foreground—a sad contrast to the agile lads who've climbed the poles to get a better view. In the latter, an isolated, heavy-set, one-legged man, tilted on crutches, wearing a worker's smock and beret, and undoubtedly a casualty of the war or the Commune, struggles toward the shadows of a nearly empty street, bedecked with flags that celebrate (ironically) the *Fête de la Paix.*

Manet's lithograph *Civil War* (1871–73) shows only the legs and feet—in striped trousers and polished shoes—of another civilian victim lying next to some dead soldiers in a fortified street. Theodore Reff, in his discussion of Manet's *The Barricade* (1871), which portrays a military firing squad executing civilians, points out the "intimate connection between his image of the Parisian rebels, cynically abandoned by Thiers to their fate at the hands of the vindictive army, and that of the doomed Maximilian, abandoned by the equally cynical Napoleon to his fate at the hands of the Mexican army."[4] These unsettling images reveal Manet's lifelong interest in the rituals of death: corpses of rebels and drowned sailors; bullfights and dead toreadors; executions in Mexican cemeteries and Parisian barricades; casualties of war and funeral processions.

II

MANET'S RECORD of rejections by the Salons was worse than any of his great contemporaries, but he nevertheless declined to exhibit in any of the Impressionist shows held between 1874 and his death in 1883. Eager for official recognition, he perversely preferred to assault the Salons directly rather than join the flanking movement. His refusal to take part in the first Impressionist

exhibition was also influenced by his surprising success in the
1873 Salon with *Le Bon Bock* (The Good Beer), whose jovial sub-
ject resembled the burly, bearded and bearlike painter Gustave
Courbet. This hearty, ruddy-faced, hedonistic fellow—wearing a
tasseled cap at a jaunty angle, a neckerchief and a stippled vest
over his ample belly, while puffing a long-stemmed pipe and
clutching a glass of beer—exudes repletion and contentment.
But even this crowd-pleasing picture was treated with disrespect.
When Manet complained he'd "been astonished to see in a cata-
logue a very poor reproduction of his *Bon Bock*," the editor bru-
tally told him that "the engraving after *Le Bon Bock* is very bad
because it is a good reproduction of the painting."

Though Manet remained devoted to the Salons, he admired
and praised the Impressionists; though he went his own way, he
was still considered their leader. Duret wrote that Manet gath-
ered around him "a select circle of writers, artists, connoisseurs,
and distinguished women, with a small band of disciples... [who
all] displayed every mark of the warmest friendship for him." In
the 1870s Manet exclaimed: "Just look at this Degas, this Renoir,
this Monet! Ah, my friends, what talent!" After visiting the
Exposition Universelle, he mocked the prevailing academic taste:
"Those people! How they can laugh at the work of Degas,
Monet and Pissarro, crack jokes about Berthe Morisot and Mary
Cassatt...when they produce painting like that!" In December
1883 Pissarro recalled the brilliant innovations of the Impres-
sionists, and caustically condemned the bourgeois taste that had
prevailed throughout Manet's lifetime: "Everything they have *ad-
mired for the last fifty years* is now forgotten, old-fashioned, ridicu-
lous. For years they had to be forcibly prodded from behind,
shouted at: This is Delacroix! That's Berlioz! Here is Ingres! And
the same thing has held true in literature, in architecture, in sci-
ence, in medicine, in every branch of human knowledge." The
painter Frédéric Bazille, who was killed in the Franco-Prussian
War, had explained what Manet's pioneering work meant to his

younger followers: "Manet is as important to us as Cimabue or Giotto were to the Italians of the Quattrocento, and as the Renaissance is beginning again, we must be part of it."[5]

The traumatic events of 1870–71 marked a turning point in Manet's life and a watershed between his early and late works. In the 1870s he began to adopt some Impressionist techniques and subjects: *plein air* pictures of the Seine in *Argenteuil* (1874) and *Boating* (1874); flickering light on glittering water in *Claude Monet and His Wife in His Floating Studio* (1874) and *The Grand Canal, Venice* (1875); and two full-breasted, Renoiresque nudes in *The Brunette with Bare Breasts* (1872) and the complementary *Blonde with Bare Breasts* (1878). Four major paintings—*The Railway* (1873), *Masked Ball at the Opéra* (1873–74), *Nana* (1877) and *Café-Concert* (1878)—express his dominant themes during this decade and reveal his characteristic cunning, charm and wit.

A contemporary journalist who visited Manet's studio at 4 rue de Saint-Pétersbourg, near the Gare Saint-Lazare, while he was painting *The Railway*, described the steam, sound and vibration of the trains that rumbled right near the house: "The train passes close by, sending up plumes of white smoke that swirl and eddy in the air. The ground constantly shakes under one's feet like the deck of a ship in full sail…and trains disappear [into the tunnel] with a shrill whistle as if into a gaping mouth." A modern historian noted the importance of the railroad terminal: "the Gare Saint-Lazare was the oldest, largest, and most important station serving Paris. It serviced long-distance lines to Normandy and Brittany and heavily used commuter lines to Argenteuil and other towns west of Paris." The background of the picture reveals a glimpse of Manet's studio as well as the signalman's hut and the stone pillar and steel trestle bridge of the Pont de l'Europe, under which the trains passed as they entered the station.

The Railway, like most of Manet's important works, is tightly structured and subtly suggestive. The woman (perhaps mother or nursemaid) and child, outside the iron fence that separates

them from the train tracks below, are connected by their red hair, by their coral earrings, by the blue dress of one and the huge blue bow of the other, by the black ribbons round the woman's neck and the child's hair, by the white ruffles on the woman's collar and cuffs and those on top of the girl's sleeve. The woman is seen from the front; the girl—with bare left arm extended toward the woman and red hand gripping an iron railing—is seen from the back; they complement each other and comprise a unified whole. The seated woman, holding the girl's sleeping puppy, looks up from her book to face the viewer while the standing girl remains absorbed in the spectacle of billowing smoke and racing steel. The bars of the iron fence (echoed by the parallel white lines of piping on the woman's bodice and skirt) separate them both from the rushing machine. The woman quietly holds our gaze, her fingers in her book, and ignores the passing train—its presence obscured yet invoked by its huge cloud of steam—that fascinates the modern child. Woman and child, looking in two different directions, have distinct interests, but their connection transcends the mechanical—symbolized by the train, the bridge and the bars—and links them to the transient women and children in the smoky train.

Manet constructed *Masked Ball at the Opéra* in a series of vertical parallels: the pair of white thighs visible through the railings of the balcony, the leg in a high-laced red boot dangling over the edge, its owner daringly sitting astride it; the eight gaslights on the pillars that support the balcony; the black-suited gentlemen and their wavy sea of shiny and sometimes disembodied black silk top hats—all tilted at different angles and contrasted with the point of Punchinello's garish green and red hat; the starched white shirtfronts, the white faces of the men and masked ladies in the crowd; and the seductive, bare white arms of the women (one of whom has dropped her mask on the floor) in tights and high-laced boots that echo those of the acrobat on the balcony. The art historian Linda Nochlin, ignoring the flirtatious charm

of the picture, emphasized its erotic elements: "The female trunk and leg at the top border of the painting function like traditional shop signs—a leg at the stocking seller, a watch at the clockmaker—advertising the available merchandise.…Manet reveals sexual commerce all too openly, constructing the inextricable mingling of business and pleasure in a variety of literal and figurative disguises—all this in a painting that itself plays seriously with strategies of disguise and recognition."

In *Olympia* the client's arrival was announced in the prostitute's boudoir by the gentle innuendo of his flowers and the witty image of the bristling pussycat. In *Nana,* the client has arrived in the dressing room, impatiently waiting and watching as the actress prepares her toilette. Nana stands in profile, her back turned to her gentleman, in front of a gilt couch. The two soft pillows on the couch seem to press against her belly and buttocks and foreshadow her sexual commerce later in the evening when, like Olympia, she becomes horizontal. Her back and buttocks are on the same axis, but her high waist is tightly constricted by a corset that makes her belly protrude. Her contorted shape is repeated in the serpentine neck of the spread-legged crane on her Japanese screen and by the sinuous curve of the sofa's edge. Her raised little finger and cloudy powder puff, reflecting the shape of the round mirror and the round platform on its stand, emphasize her coquettish nature. The burnt-down candles suggest the end of the affair, and Nana's expression, unlike the alert look of Olympia, is vapid and banal. The gentleman caller sits cross-legged on the red plush sofa, in formal dress, with top hat, drooping mustache and cane gripped in his fist. Seen in her underwear, Nana seems vulgar and undignified, her patron greedy and ready to pounce. Manet casts a cold eye on this cynical mating dance.

In *Café-Concert,* Manet portrays three characters in one of Degas' favorite settings. The handsome older man on the right, perhaps the most powerful masculine image in all his work, has

a high, curved-brim top hat (worn low on his forehead), florid complexion, impressive nose, huge gray mustache and goatee, wing collar and wide red cravat, and strong, crossed hands (one of them holding a cane). He looks away from his disconsolate and soon-to-be-abandoned young companion. Snub-nosed, with thick black eyebrows, dressed in a cheap hat and drab brown jacket, she stares down at the smoking cigarette between her fingers. They are seated in front of a gleaming marble counter with two golden beers. Standing behind and between them, a waitress with hand on her hip gulps down a glass of beer before rushing off to serve drinks. In the gaslit background a singer, with grotesque nose and weak chin, performs her act on stage. The three main figures, forming a pyramid shape and looking in different directions, represent three quite different social types, each caught in a private moment amidst the racket of the noisy café.

The woman and child in *The Railway;* the importunate women revealing their bare arms and legs near the densely packed crowd of black figures in the *Masked Ball at the Opéra;* the self-absorbed Nana and barely restrained gentleman caller; the man, waitress and tart in *Café-Concert,* all suggest variations on the theme of urban isolation that Manet first revealed in his bitter portrait of his parents. As Richard Wollheim perceptively observed: "In his group pictures Manet was able to convey the sense of momentary withdrawal, of abstraction, of secretiveness, along with a strong register of physical presence, by the particular way he captured the fleeting [lack of connection] between the members of the group."[6]

III

THOUGH MANET was subject to hostile criticism in the press and the Salons, his circle of friends gave him continuous moral support and revered his genius. In 1873 he formed a close and stimulating friendship with the poet Stéphane Mallarmé, who would argue his merits in print. Their deep mutual admiration

and affectionate relations were based on common traits: "culti-vated charm, distinction of mind, the gift of conversation"—as well as their great talents and failure to achieve public recogni-tion. Mallarmé's biographer added that "both came from similar upper-middle-class backgrounds, which neither entirely shook off and to which they had reacted in the same way. Both had re-belled against careers in the civil service which had been pre-selected for them without consultation by their families. Both had likewise flouted convention by marrying, in quite remark-ably similar circumstances, foreigners judged by their respective families to be of inferior social status." (Mallarmé's wife, the German Marie Gerhard, was a governess and daughter of a schoolteacher.) On the way home from teaching English in a *lycée,* the devoted Mallarmé dropped in at Manet's studio nearly every day for the next decade.

In the 1870s Mallarmé succeeded Zola as Manet's defender and champion. (Zola was his literary antithesis: Mallarmé's po-etry was abstract and opaque, while Zola's novels were grind-ingly realistic.) Noting the limitations of Zola's critical writings on Manet, Mallarmé stressed "the pain he caused Manet when, after praising him and seeming at first to have understood him, he spent the rest of his life saying that Manet was 'incomplete' as an artist. Zola blamed Manet for producing nothing but sketches, fragments, studies. But does that matter when each new piece is more powerful than the one before it?...Zola was never able to see a work of art in any terms other than the num-ber of printings."[7]

Mallarmé wrote two important, if rather abstract, essays on Manet. In "The Painting Jury for 1874 and Manet," he attacked the Salon jury for rejecting two major works and preventing the public from seeing *Swallows* and *Masked Ball at the Opéra.* His de-scription of the colors and textures in the latter was vibrant and rapturous: "one can only marvel at the exquisite nuances in the blacks: in the dress coats and dominoes, in the hats and masks, in

the velvet, the broadcloth, the satin and silks. The eye is hardly aware of the need for the bright notes injected by the fancy dress: it only distinguishes them after having been first attracted and held by the outstanding charm of the solemn and harmonious color of a group composed almost exclusively of men. There is therefore nothing disorderly or scandalous about the painting, which seems to want to step out of its frame: it is, on the contrary, the heroic attempt to capture, through means peculiar to this art, a complete vision of contemporary life."

Mallarmé's "The Impressionists and Edouard Manet" first appeared in English, with the help of the Irish poet Arthur O'Shaughnessy, in the *Art Monthly Review and Photographic Portfolio*, published in London on September 30, 1876. The essay is an appreciation, explanation and defense of Manet's art in the context of the newly formed Impressionist movement. Following Baudelaire, Mallarmé wrote that Manet's work will "educate the public eye" and render "the graces which exist in the bourgeoisie…as worthy models in art." In a striking account of Manet's impulsive technique, Mallarmé said: "Each time he begins a picture, says he, he plunges headlong into it, and feels like a man who knows that his surest plan to learn to swim safely, is, dangerous as it may seem, to throw himself into the water."[8]

Mallarmé neglected his teaching, and in July 1876 the inspector of schools gave him a bad report. Noting the poet's poor performance in the classroom, the report declared that "M. Mallarmé is not very strong in English and that despite the friendly warning he received last year, he has done absolutely nothing to acquire what is required for him to be equal to his duties." His limited knowledge of English did not prevent him from translating the poems of Poe, just as Baudelaire had translated the stories, and Manet collaborated in this project. The painter had executed three studies of Poe in the early 1860s, the last of which was posthumously reproduced as the frontispiece to Mallarmé's translation of *Les Poèmes d'Edgar Poe* (1888). In 1875 he illustrated

Mallarmé's translation of "The Raven"; the following year he drew four illustrations for his poem "L'Après-midi d'un faune" (The Afternoon of a Faun); and in 1879–81 he did two India ink drawings for the translation of Poe's "Annabel Lee." A visitor to Manet's studio in 1876 mentioned "the large fireplace and identified some oriental porcelain vases, a tankard, a spotted ceramic cat, a clock, and, in 'the place of honour' on the mantelpiece, a stuffed raven sitting on a bust of Minerva."

Mallarmé's essays were partly based on his experience in 1876 of posing for his portrait by Manet. Antonin Proust captured Mallarmé's essential features: "His eyes were large, his straight nose stood out above a thick moustache which his lips underlined with a light stroke. He had a prominent forehead beneath a shock of hair."[9] Manet's portrait of him is more informal and introspective than the one of Zola. With a ruddy complexion, a high shock of dark wavy hair and a reddish, Nietzschean mustache that droops over a weak chin, Mallarmé leans back on an upholstered chair. Tilted to the left, he wears a kind of sea captain's coat. One hand is in his pocket and the other, resting on a sheaf of manuscripts, holds a lighted cigar whose trail of smoke suggests the opacity of his poetry. Poised yet withdrawn, gentle and melancholy, Mallarmé seems dreamy and completely lost in thought.

Manet also had some contact with British writers and painters. The Impressionists' search for subjects northwest along the winding Seine, then to Normandy and the Channel coast, oriented them toward England. Manet, Degas and Cassatt all traveled there; Morisot painted the Isle of Wight on her honeymoon. Pissarro and Monet lived and worked in London for several years; and the English painters Lord Leighton, Walter Sickert, John Lavery and William Rothenstein visited the artists' studios in Paris.

A visit to Manet's studio, where his paintings were on view, was considered essential for English artists and writers. Whistler

took the young poet Algernon Swinburne there in 1863. The following year the thirty-six-year-old painter and poet Dante Gabriel Rossetti was also taken to visit Manet. Rossetti, a leading Pre-Raphaelite, whose own work was highly detailed and hard-edged, full of medieval themes, formed a negative impression of his pictures: "There is a man named Manet to whose studio I was taken by Fantin, whose pictures are for the most part mere scrawls, and who seems to be one of the lights of the School." Though Rossetti disliked Manet's apparently unfinished paintings, in 1865 he urged him to send his work to the Royal Academy. Jealous of Manet's private income and devoted following, Rossetti found him personally unappealing. He later "called Manet a conceited ass—and indeed the Frenchman was...a conspicuous 'swell' in British terms, surrounded by a clique of admirers. Arrogant self-regard was bolstered by independence, for Edouard Manet did not need to paint potboilers, or please patrons, or fear falling prices. No wonder if Rossetti was envious."[10]

The young Irish writer and camp follower, George Moore, was awed by the Impressionists, and his recollections suggest Manet's immense prestige. In about 1872 the group moved from the Café Guerbois in the rue des Batignolles, where they had met for lively discussions since 1866, to the Café de la Nouvelle-Athènes (named for the district renovated in neoclassical style by Baron Haussmann), a smaller, quieter venue in the Place Pigalle. Models, eager to be hired, gathered round the fountain in this square, and "Italian women in their picturesque national dress were by far the most numerous." Moore recalled that "it was a great event in my life when Manet spoke to me in the café of Nouvelle Athènes" and gave a vivid description of the painter: "I had admired the finely-cut face from whose prominent chin a closely-cut blonde beard came forward; and the aquiline nose, the clear grey eyes, the decisive voice, the remarkable comeliness of the well-knit figure, scrupulously but simply dressed, represented a personality curiously sympathetic."

Moore hung on every word, hero-worshipping and at the same time putting on airs. William Butler Yeats' satiric description of Moore in his *Autobiography* suggests why the Impressionsts regarded him as slightly absurd: "He had gone to Paris straight from his father's racing stables, from a house where there was no culture…acquired copious inaccurate French, sat among art students, young writers about to become famous, in some café; a man carved out of a turnip, looking out of astonished eyes." Manet also found Moore charming but ludicrous and sometimes irritating: "I remember him as a golden-haired fop, and aesthete before the days of Wilde….None of us thought anything of him as a writer, but he was very welcome wherever he went, for his manners were amusing and his French very funny. He tried to shock and astonish people."[11]

His friendship with Manet had a comic element. The pastel *Portrait of George Moore* (1879) verges on caricature and was likened to a picture of a "drowned man taken out of the water." Wearing a high white collar, green cravat and dark jacket, Moore stares out at the viewer with blurred blue eyes. His pale Irish skin contrasts with his full red lips, disheveled red hair, scraggly beard and mustache. Unlike Proust, who pleased Manet by praising his rapid technique, Moore fussed about his portrait and urged the painter to do more work on it. Manet refused the request and gave Proust a striking description of Moore's face: "Some of the [sitters] come back without being asked, wanting me to do some retouching, which I always refuse to do. Look at that portrait of the poet George Moore. As far as I was concerned, it was all finished in a single sitting, but he didn't see it that way. He came back and annoyed me by asking for a change here, something different there. I won't change a thing in his portrait. Is it my fault if Moore looks like squashed egg yolk and if his face is all lopsided?"

Moore later confessed that "Manet in the opinion of many people made me look like a figure of fun." But he put up with it,

realizing what an honor it was to be painted by Manet, and later published the pastel portrait as the frontispiece to *Modern Painting*. Moore's lively, if unreliable, accounts of the Impressionists, in four different books, helped introduce their art to an English audience. Shortly before Manet's death, Walter Sickert recalled going to visit the artist: "I carried with me two letters from Whistler, one of them to Manet. Manet was too ill to see me, but I heard him through the open door ask his brother to take me to see the studio. Of that visit I remember two things: the painting of Rochefort's escape from New Caledonia in a little boat...and the bearded head of George Moore in pastel."[12]

ABSOLUTE TORTURE
1880–1883

I

❧ ON MAY 21, 1871, as the Commune collapsed under the onslaught of the Thiers government, Berthe Morisot's mother, who'd remained in Paris with her family, "heard a terrible hubbub, a rumbling of carriages, at full speed, people running, cavalry squadrons, galloping, and cries in the midst of it all. We... learned that it was Rochefort being escorted to Versailles." The déclassé aristocrat and politician Henri de Rochefort was the subject of one of Manet's greatest works. *The Escape of Rochefort* (1880–81), like *The Execution of Maximilian,* was an imaginative depiction of a contemporary event and, like *The Battle of the Kearsarge and the Alabama,* a marine landscape.

Rochefort ended up on the Right, a fanatical anti-Semite and opponent of Captain Alfred Dreyfus, but he began his career on the extreme Left, as a vitriolic critic of Napoleon III. His alliance with the Communards made him a republican hero. Arrested for his newspaper articles attacking the Versailles government, Rochefort was sentenced on September 1, 1871, to life imprisonment at a penal colony in Nouméa, a French possession and capital of the remote South Pacific island of New Caledonia. Using his powerful connections, Rochefort managed to remain in France for two years after his arrest. But in August 1873 he was sent to the penal colony. As one of four thousand Communards deported to distant island prisons, he had to spend more than four months confined in the cargo bay of a ship.

Once on the island political prisoners were allowed to build themselves simple mud huts, live where they liked, and go fishing and swimming. But life there was hard, and prisoners convicted of criminal offenses endured far worse conditions. The penal colony became "renowned and reviled for excruciating labor and gratuitous corporal punishments....The brutal guards, the misery of their daily lives, and the horrifying spectacle of ritualized punishments all conspired to make life on Nouméa wretched in the extreme....In order to break the will of the convict, the administration employed flogging, attendance at executions, thumb screws, solitary confinement, and rations reduced to starvation levels." After Rochefort's escape, the colony cracked down on political prisoners and treated them as harshly as criminals.

On March 20, 1874, three months after reaching New Caledonia, Rochefort and five other prisoners, taking advantage of their relative freedom, escaped from the island. They contacted John Law, the captain of an Australian ship, swam out to a rock and were picked up by another convict in a stolen boat. Under cover of night they climbed aboard the *P.L.C.* and hid in the hold till they had left the harbor of Nouméa. After a fifteen-day voyage, they disembarked at Newcastle, north of Sydney, on the east coast of Australia. After traveling via the United States to Europe, and living in Switzerland, Rochefort was amnestied in July 1880 and allowed to return to France. Manet, who met him soon afterwards and heard the exciting story of his escape, said: "I saw Rochefort yesterday—they used a whaling dinghy for their boat—the colour was dark grey—six people—two oars."

In *The Battle of the Kearsarge and the Alabama* Manet gives a distant view of the ships in action, the clouds of smoke from cannon fire and the survivors, tiny specks bobbing in the rough, dark sea and clutching a spar. *The Escape of Rochefort* takes a closer view, showing the escapees rowing to freedom in a whaleboat. The bushy-haired and mustachioed Rochefort, facing the viewer,

confidently guides the tiller and steers the boat to safety. In the distance, the tall-masted Australian ship, under a heavy gray-black sky, awaits their arrival; in the foreground, the choppy sea behind the boat is streaked with jagged yellow. The turbulent sea behind them symbolizes the past, the distant calm foreshadows the promising future.[1]

Manet was not generally inclined to paint scenes of heroism. That same year he took a very different attitude in his portrait of a supposedly heroic figure, Eugène Pertuiset, a big game hunter and author of *Les Aventures d'un chasseur de lions* (1878). In the late 1860s Manet had accompanied this pompous gentleman to present a lion skin to Napoleon III, but they were kept waiting for three hours and not granted an audience. Amused by the imperial put-down, Manet told Proust: "How Pertuiset fumed! You should have seen him roll up his skin. Napoleon evidently understood that the skin would be useless to him. Had it been the skin of a doe [a pun on *biche,* a courtesan]! And so, I did not see Napoleon III and he did not see me."

In 1855 Delacroix had painted a realistic and exciting *Lion Hunt,* which Manet certainly knew and admired. But his own treatment of the same subject in *Portrait of M. Pertuiset, the Lion-Hunter* (1880) is savagely funny. Pertuiset is a stiff, wooden hunter, kneeling and holding a double-barreled gun. A thick mustache that hides his mouth and a set of drooping side-whiskers around his chubby cheeks make him look smug and self-important. He wears an incongruous black felt hat with a feather, a dark green, gold-buttoned Bavarian hunting costume and high black boots. The stuffed hide of an outsized, open-eyed, open-mouthed lion, with formidable pointed canines, is cut off by the trunk of a tree and lies behind, instead of in front of him, like a real trophy. Wandering far from its natural habitat, the lion has been dispatched in a placid French landscape. Huysmans, perceiving Manet's satire, referred to a forest west of Paris and described Pertuiset "on one knee, pointing his gun into the

hall where he no doubt espies some wild beasts, while a yellow-ish dummy lion is stretched out behind him under the trees.... The pose of this side-whiskered hunter, as if to shoot a rabbit in the Bois de Cucufa, is childish." The portrait seems to prove Vladimir Nabokov's dictum in *Pale Fire:* "The one who kills is *always* his victim's inferior."[2]

Manet was criticized in his own time, as he has been in the modern period, for his persistent and all-too-obvious technical faults: the wooden, lifeless left leg in *The Absinthe Drinker* (1858–59), the guitar that's strung the wrong way for the player in the *Guitarist* (1860), the inaccurate perspective of the oversized bull in the background of *Mademoiselle V.... in the Costume of an Espada* (1862), the lake that flows on two different levels in *Luncheon on the Grass* (1863), the spear wound on the left (rather than right) side of Christ's chest in *The Dead Christ with Angels* (1864). But these discrepancies were probably deliberate attempts to under-mine the realism of his pictures, to challenge ordinary percep-tion, to surprise and disorient the spectators, and to make them look in a new way at a new style of painting. The distorted re-flection in the mirror in *A Bar at the Folies-Bergère* (1881–82), one of his most celebrated paintings, is the most notorious example of Manet's illusionism.

The Folies-Bergère was a café, a garden promenade and a theater that featured ballets, pantomimes, acrobats and musical performances. In Manet's painting the palace of pleasure is wit-tily linked—by the dangling legs in tights and the high, green, pointed boots of the acrobat, between two globes of light in the upper-left corner—to the seductive festivities in *Masked Ball at the Opéra*. In the background of *A Bar at the Folies-Bergère* a well-dressed crowd in the balcony, under bright moons of light and a huge, glittering chandelier, gazes at the spectacle and at each other. The barmaid, as somber, imposing and monumental as Piero della Francesca's similarly shaped Madonna of the Miseri-cordia in San Sepolcro, dominates the foreground. She has long

blond bangs, a rosy complexion and a melancholy expression. She wears Manet's favorite neck ribbon (with locket) and gold bracelet, and a handsome, low-cut, lace-trimmed black velvet jacket that accentuates her full bosom, wasp waist and ample hips. The barmaid leans on a marble counter, decorated with a vase of flowers that complement those fastened to her breast, and offers her tempting wares: a delicious bowl of tangerines (Manet's greatest still life), as appealing as her own fresh face, and colorful bottles that range from Bass ale and *vin rosé* to green Chartreuse and golden-foiled champagne.

Behind her, and extending for the entire length of the four-and-a-quarter-foot painting, is the gold frame of an enormous mirror. The French philosopher Maurice Merleau-Ponty has called a mirror "the instrument of a universal magic that changes things into spectacles, spectacles into things, me into others, and others into me." We, the viewers, stand opposite the barmaid on the other side of the counter and, looking at the reflection in the mirror, see exactly what she sees. Her own reflection, however, is not directly behind her, according to the strict rules of perspective, but at a right angle to where she's standing. It seems to reveal her long hair, cheek, collar and back as she serves and chats to a male customer. A critic has noted that Manet's "preliminary study shows her placed off to the right, whereas in the finished canvas she is very much the centre of attraction."[3] Though Manet shifted her from the right to the center, he kept her reflection on the right. Seen in the mirror, she seems engaged with a customer; in full face, she's self-protectively withdrawn and remote.

Two literary critics have offered suggestive interpretations of this enigmatic painting. Roger Shattuck observed that "standing between two worlds, dejected without being tragic, the barmaid…[is] lost between reality and illusion." Enid Starkie wrote that the woman "expresses all the sadness and the weariness of a Baudelairean character as she gazes out at 'le spectacle ennuyeux de l'immortel péché'" (the tedious spectacle of immortal sin).

Unlike her customers, we are not lining up to buy a drink, look-
ing at the bottles and deciding what to have. We look directly at
her and focus our attention on her rosy, oval face. We notice her
world-weary, disillusioned expression, and see her as a sensitive
and forlorn human being. The barmaid, dispensing pleasure but
receiving none herself, knows the Folies-Bergère is well named.

In 1882 Manet was seriously ill, yet at the peak of his powers
as an artist. This great painting suggests the inexorable progress
of his fatal disease, the shadows closing in. There is music and
laughter amidst the bright lights of the dance hall and bar, yet
the barmaid's steady gaze and black dress convey deep sadness.
The fashionable gentleman reflected in the mirror represents
the possibility, for the barmaid, of escape from servitude into
another, though more luxurious, form of bondage. Yet "the
prince of darkness," Shakespeare wrote, "is a gentleman," and
the gentleman at the bar, approaching the barmaid from an un-
expected angle and appearing in an oblique reflection, is a figure
of death. The painting is Manet's farewell to the follies of love
and the pleasures of life, and the viewer shares his regret and
mourns the loss of a great talent. As John Richardson noted,
Manet's "culminant work opens up tantalizing vistas of un-
painted masterpieces."[4]

II

THE ONSET OF Manet's last illness coincided with his intimate
friendship with Méry Laurent, who appeared as the woman in the
white dress and long yellow gloves, resting her elbow on the bal-
cony (as the barmaid rests her hands on the marble counter), in
the background of A Bar at the Folies-Bergère. The tall, powerfully
built daughter of a laundress, she was born in 1849 as Anne-Rose
Louviot. She ran away, while still very young, from her husband,
a Nancy grocer, and became a nude dancer and unsuccessful ac-
tress on the Paris stage. Méry, always known by her stage name,
"renowned for her stately good looks, her statuesque and buxom
features, luxuriant blonde hair and perfect complexion, became

the mistress of a rich American, Dr. Thomas Evans," the dentist of Napoleon III. When George Moore asked Méry why she didn't leave Evans, who'd given her a secure income, she replied, with a mixture of loyalty and cynicism: "Why should I descend to a meanness when I could find contentment and perhaps happiness in being unfaithful to him?" Moore found Méry "the epitome of the witty, charming woman of fashion, an embodiment of the spirit of liberation from hypocrisy." Later on she became a model for the attractive but cruel Odette Swann in Marcel Proust's *Remembrance of Things Past*.

Manet met Méry in 1876 and was irresistibly attracted to her sensuality, coquettishness and occasional vulgarity. He had an affair with her before passing her on to Mallarmé. Méry inspired Manet, who said he'd like to paint her in a *plein air* Impressionist style: "What I've always longed to do would be to place women like you in green outdoor settings, among flowers, on beaches, where contours are eaten away in the open air, and everything melts and mingles in the bright light of day, because I can assure you I'm not just an insensitive brute"—interested only in sleeping with her. She modeled for three important late works: *Autumn* (1881), *Woman in Furs: Portrait of Méry Laurent* (1882) and the Degas-like pastel, *Woman in the Tub* (1878–79). The last work, in which Méry leans over and sponges herself as the water runs daintily down her left leg, "presents all the characteristic features of Manet's art: a very special blend of spontaneity and freshness...with rigorous composition and a taste for clear curved lines across horizontals that subdivide the background of the picture: mirror, dressing table, flowered cretonne in subtly colored folds.... The woman posing looks at the artist unafraid, confident that her nude body, though imperfect, encounters a friendly and indulgent gaze."[5] During Manet's last illness, Méry, always sympathetic and attentive, tried to distract and amuse him. She sent him flowers and sweets, and the luscious tangerines he painted in *A Bar at the Folies-Bergère*. After his death she always brought the first white lilacs of the season to his grave.

Suzanne was surely on the scene, giving what comfort she could to her husband, but nobody seems to have mentioned her presence at the deathwatch.

Manet's health had been deteriorating for a long time. In 1876, when he was forty-four, his right leg became so stiff that he couldn't bend it. By early 1878 he felt acute pain in his left foot, developed a limp and was forced to use a cane. He conscientiously endured grueling hydrotherapy treatments—intended to stimulate his dysfunctional nerves, dilate his blood vessels and restore his ability to walk—in five-hour sessions of ice-cold showers and intense massages at a medical clinic in Bellevue, on the Seine, west of Paris. In June 1880, in considerable pain, he wrote: "I'm doing penance, my dear Méry, as never before in all my life. Still, if the end result is good, there'll be no regrets. I find the water treatment here absolute torture." An artist-friend reported that in February 1883, when Manet tried to paint during one of his attacks, "he dropped his brush and staggered. 'He seemed to be fumbling like a blind man, turned, tried to move, groaned weakly....He clutched at the sofa with both hands and collapsed onto it.'"

Manet's illness was officially attributed to poor circulation in his legs. But it was really locomotor ataxia (tabes dorsalis), a degenerative disease of the spinal cord that led to a classic triad of symptoms: sudden paroxysms of lightning pain; failure of muscular coordination and paralysis in the legs; difficult urination, incontinence of the bladder and sexual impotence. The cause of this disease, which could neither be cured nor alleviated by hydrotherapy, was tertiary (late-stage) syphilis. Several of Manet's literary contemporaries—Guy de Maupassant, Jules de Goncourt and Alexandre Dumas *fils*—were afflicted with syphilis, and Manet had witnessed the horrific symptoms in his father and in Baudelaire. In a letter of February 1860, the poet had clinically described his own "mouth ulcers, painful constrictions in the throat which make it painful to eat, surprising bouts of weariness, loss of

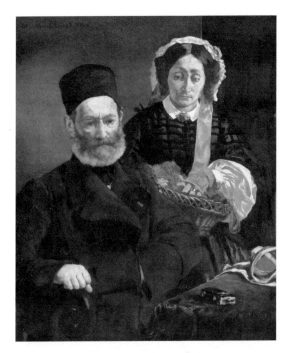

Manet, *Portrait of M. and Mme. Auguste Manet* (1860). Réunion des Musées Nationaux/Art Resource, New York

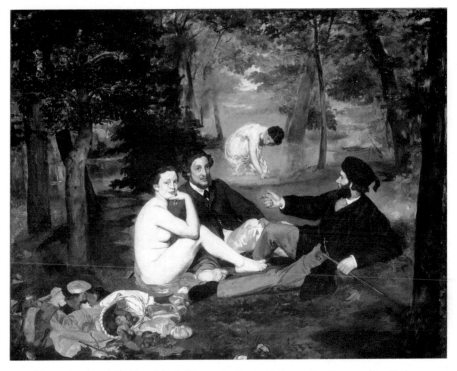

Manet, *Luncheon on the Grass* (1863). Réunion des Musées Nationaux/Art Resource, New York

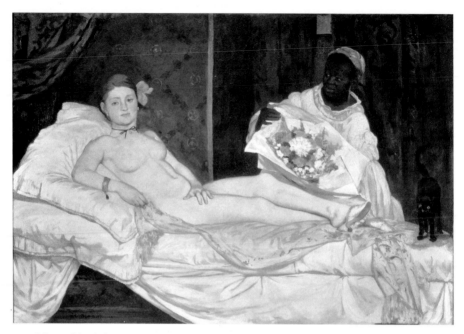

Manet, *Olympia* (1863). Réunion des Musées Nationaux/Art Resource, New York

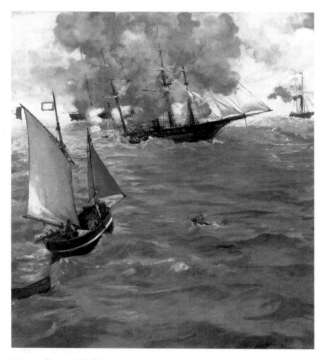

Manet, *Battle of the Kearsarge and the Alabama* (1864).
John G. Johnson Collection, Philadelphia Museum of Art

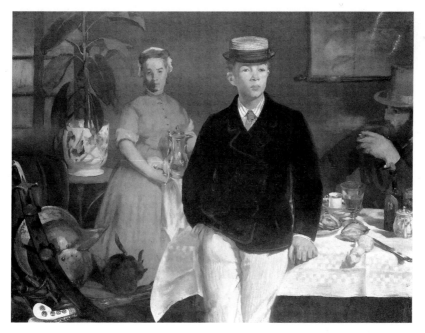

Manet, *The Luncheon* (1868). Bayerische Staatsgemäldesammlungen, Neue Pinakotek, Munich

Manet, *The Execution of Maximilian* (1868). Kunsthalle, Mannheim

Manet, *The Railway* (1873). Gift of Horace Havemeyer in memory of his mother, Louisine Havemeyer, image © 2004 Board of Trustees, National Gallery of Art, Washington, D.C.

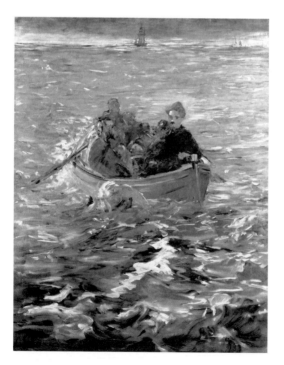

Manet, *The Escape of Rochefort* (1880–81). Kunsthaus, Zürich

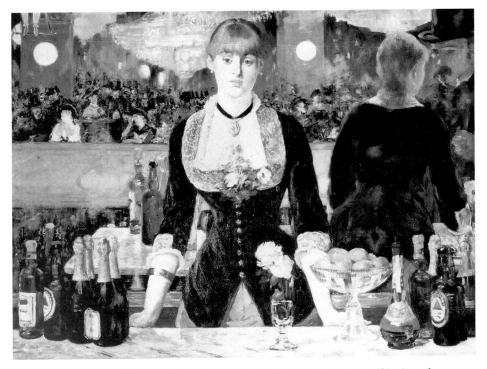

Manet, *A Bar at the Folies-Bergère* (1881–82). The Samuel Courtauld Trust, Courtauld Institute of Art Gallery, London

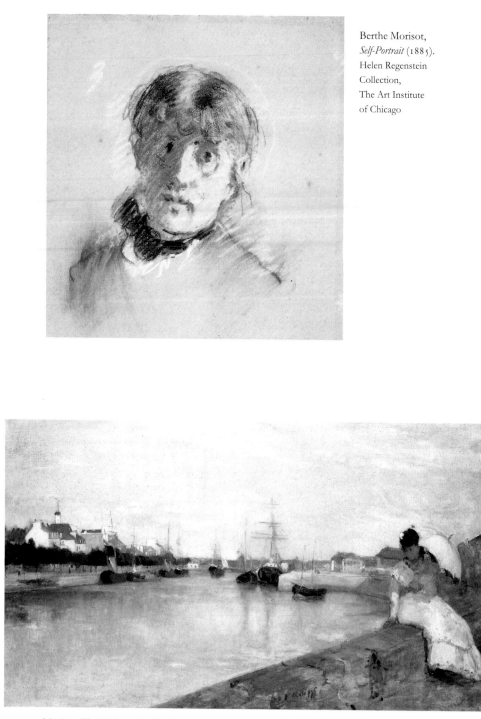

Berthe Morisot,
Self-Portrait (1885).
Helen Regenstein
Collection,
The Art Institute
of Chicago

Morisot, *The Harbor at Lorient* (1869). Ailsa Mellon Collection, image © 2004 Board of Trustees, National Gallery of Art, Washington, D.C.

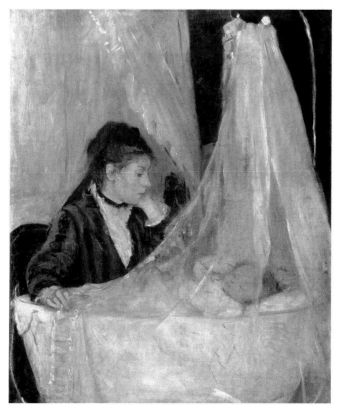

Morisot, *The Cradle* (1872). Réunion des Musées Nationaux/Art Resource, New York

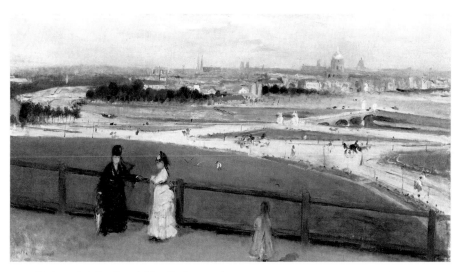

Morisot, *Paris Seen from the Trocadéro* (1872–73).
Santa Barbara Museum of Art, Gift of Mrs. Hugh N. Kirkland

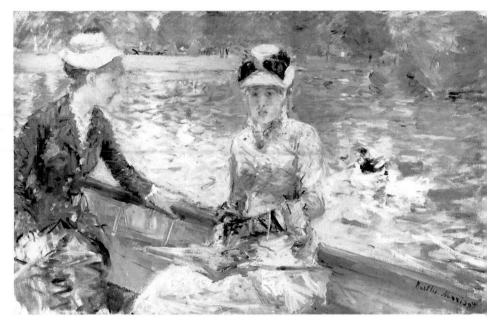

Morisot, *Summer's Day* (1879). National Gallery, London

appetite…lack of flexibility in the knees or elbows, with tumours, even in the neck joints near the head."

Manet's physical pain was exacerbated by mental anguish about the sexual origins of his disease: resentment and rage if he'd inherited it from his father; shame and disgust if he'd contracted it, possibly in Rio, from a prostitute; horror and guilt if he'd passed it on to Suzanne. As he accusingly told his mother when referring to himself at the end of his life: "One should not bring children into the world when one makes them like this!"[6]

Doctors always made Manet think of undertakers. But since no one told him what the doctors thought, he continued to make plans for the future. His doctor gave him massive doses of ergot, a drug derived from the fungus on rye plants, which contracts the blood vessels and smoothes the muscle tissue. Ergot is still used to induce contractions in childbirth and relieve migraines. But it is highly toxic when taken in large quantities, as Manet rashly did, in the hope of a cure. It acted as a temporary stimulant, but had grave side effects: "giddiness, fatigue, depression, formications [the sensation of insects crawling on the skin], muscle twitching, tonic spasms, convulsions, delirium, and loss of speech." Ergot poisoning also causes gangrene by constricting the blood vessels and impeding circulation in the legs. Ulcers formed on the bottom of Manet's toes and didn't heal because the underlying tissue had been destroyed and turned black. In mid-March 1883 he was again attacked by sharp, piercing pains in one leg. He consulted two doctors but, his mother said, they did "little to quiet my fears. The foot is swollen and fever chills have begun."

Degas grimly reported that "Manet is done for. That doctor… is said to have poisoned him with too much diseased rye seed.… He is not in the least aware of his dangerous condition and he has a gangrenous foot."[7] On April 20 *Le Figaro*, noting the grisly details, reported that Manet's left leg was in deplorable condition and a radical operation had been performed: "Gangrene had set

in to such an extent that the toe nails fell off at a touch. The patient was given chloroform and…the leg was amputated above [*sic*] the knee. Manet experienced no pain, and passed the day as well as could be expected." The newspaper concluded, rather oddly, that "there is no reason to believe that his condition was serious."

Eyewitnesses immediately created myths about the amputation. One source reported: "Such was the general emotion and confusion that the leg, severed just below the knee, was thrown into the fireplace." If the doctor had done so, the smell would have been overpowering. Claude Monet, who saw Manet at the very end, told the art dealer René Gimpel: "When I approached his bed, he said: 'Now watch out for my leg. They wanted to cut it off, but I said they mustn't and I've kept it. Watch out.' And he died without knowing that in fact it had been amputated." The photographer Félix Nadar, who also saw Manet on his deathbed, confirmed this improbable story: "He told us on the very day before his death of all his fine plans and discoveries while—a horrible memory—our eyes kept exploring, under the bulge in the blanket made by the dressings, the place left by the leg which had been amputated the day before under an anaesthetic, and whose removal our poor dear friend did not suspect to his last breath."[8] But the amputation took place ten days (not one day) before his death; and since Manet was lucid, he must have known that his leg had been cut off. On April 30, 1883, Manet, aged fifty-two, "was attacked by a violent fever, accompanied by deathly shivering" and convulsions, and died of complications following the amputation. Zola and Monet helped to carry his coffin to the grave.

III

MANET DIED WITHOUT achieving the official and popular recognition that he'd strived for all his life. In November 1881 Antonin Proust had been appointed minister of fine arts in the

short-lived government of Léon Gambetta, and the following month he awarded Manet the *Légion d'honneur*. Nevertheless, Manet lamented that the superintendent-general of the Beaux Arts under Napoleon III could "have made my fortune and now it's too late to compensate me for twenty lost years." Eight months after Manet's death Camille Pissarro—who was also a failure for most of his life—contrasted (as Baudelaire had done) Manet's flawed character and his great art: "Manet, great painter that he was, had a petty side, he was crazy to be recognized by the constituted authorities, he believed in success, he longed for honors.... He died without achieving his desire."

In January 1887 the poet and novelist Henri de Régnier took up this idea. But he felt that Manet had successfully concealed his weaknesses and impressed his admirers: "I suspect that Manet was such a charming man that he fascinated his friends to the point of inspiring in them admiration for his paintings; and now, through the large number of conversations about him here, I see that he was an indecisive painter, full of doubt and preoccupied with success." In his funeral oration, Proust emphasized Manet's magnanimity as well as his ability to inspire other painters. He praised him for having had the generosity to applaud "the successes, almost always greater than his own, carried off by those who followed him and were inspired by his example."[9]

Had Manet lived, his generosity would certainly have extended to his faithful model, Victorine Meurent, who'd returned to Paris after a mysterious trip to America and began her own modest career as a painter. In August 1883, fallen on hard times, she wrote to Manet's widow, reminded her of the artist's promise and asked for help:

You doubtless know that I posed for a large number of his paintings, notably for *Olympia,* his masterpiece. M. Manet showed much interest in me and often said that if he sold these paintings he would save a reward for me. I was young

and carefree in those days—I left for America. When I came back, M. Manet, who had sold a large number of his pictures...said he would give me something. I refused, thanking him profusely and saying that when I was no longer able to pose, I would remind him of his promise. That time has come much sooner than I expected.

Suzanne had no interest in Victorine's well-being and suspected she'd been Manet's mistress. Jealous of her importance in his life, she did not answer the letter.

Suzanne also aroused the anger of Manet's niece Julie, the daughter of Berthe Morisot and Manet's brother Eugène. Driven by greed and manipulated by a clique of unscrupulous dealers, Suzanne authenticated paintings by Manet that she knew had been retouched and even repainted after his death. Julie wanted Suzanne's permission to sue the dealers but, she recorded:

> I come away furious, there is nothing to be done, nothing to say. Aunt Suzanne wrote on the back of the picture that she recognized it as one of her husband's works after hesitating a little, realizing that it had had some retouching. "I couldn't say it wasn't by my husband," she says to me with her Dutch nonchalance, "because the women were by him." I tell her shortly that she shouldn't have signed. I get a bit carried away. I think she finds I'm meddling in what doesn't concern me. She's very calm and says that it's always like this with sketches. It's true that her own brother has repainted many of my uncle's canvases.

In 1890 Morisot, Monet and John Singer Sargent raised 20,000 francs by public subscription, bought the notorious *Olympia* from Suzanne and presented it to the French nation. It hung in the Musée de Luxembourg until 1907, when Georges Clemenceau, whose portrait Manet had painted in 1879–80 and who was then prime minister, had it quietly moved to the Louvre. It was not actually displayed for another ten years.

Manet's personality, as well as his art, cast its spell on many artists who followed him, especially on the painter Berthe Morisot, a favorite model and loving friend. An 1894 tribute from the Pointilliste artist Paul Signac synthesized Manet's finest qualities: "What a painter! He has everything, an intelligent mind, an impeccable eye, and what a hand!"[10] As a man he lives on in the art of others. Manet and Baudelaire had both appeared in Fantin-Latour's *Homage to Delacroix* (1864). Six years later Fantin-Latour painted *A Studio in the Batignolles (Homage to Manet)*—the first of several tributes and the direct inspiration for Sir William Orpen's *Hommage à Manet* (1909). Orpen included a huge copy of Manet's portrait of his only pupil, Eva Gonzalès, in the top half of the painting, above six artists who are gathered around a table.

In the twentieth century Manet's importance has continued to grow. At least three modern artists have imitated Manet, just as Manet based his paintings on the masterpieces of the past. René Magritte's *Perspective (Manet's "The Balcony")* (1950), Pablo Picasso's *Luncheon on the Grass* (1961) and Larry Rivers' *I Like Olympia in Blackface* (1970) are all adaptations of Manet's most famous works, and all were inspired by Manet's daring approach to subject and style.

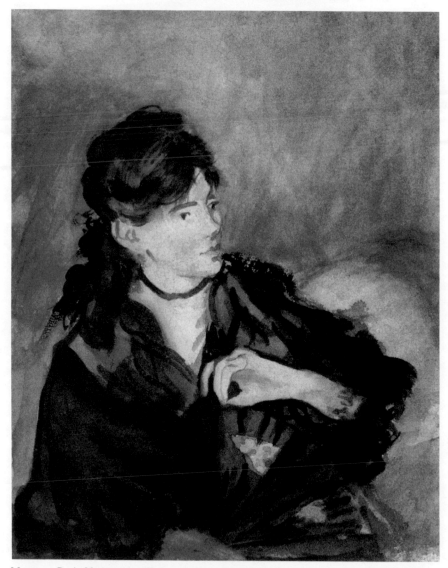

Manet, *Berthe Morisot with a Fan* (1874). *Helen Regenstein Collection, the Art Institute of Chicago*

FRIENDLY MEDUSA
1841–1867

I

❧ BERTHE MORISOT, a descendant of the eighteenth-century French painter Jean-Honoré Fragonard, was the most appealing of all the Impressionist painters. She was born on January 14, 1841, in Bourges, in central France, where her father, Edme Tiburce Morisot (who'd briefly studied architecture), was prefect, the chief administrative official of the province. From 1841 to 1848 the family lived in Limoges, and from 1849 to 1851 in Caen and Rennes, where Edme was also prefect, before finally settling in Paris in 1852. Ascending to the upper ranks of the civil and judicial service, and achieving a post similar to that of Manet's father, Edme became chief clerk of the court that dealt with commercial cases and then chief judicial advisor to the government's audit office. Berthe's mother, Marie-Cornélie, though somewhat sharp-tongued, was well read and sociable, with an amiable temperament and the gift of pleasing. The family led a comfortable and cultivated upper-middle-class life in Passy, a suburb near the Bois de Boulogne, on the western edge of Paris. Their lively Tuesday dinners included many distinguished guests: the politician Jules Ferry, the composer Giacchino Rossini, and the painters Carolus-Duran and Alfred Stevens.

Berthe had two older sisters, Yves and Edma, and a younger brother, Tiburce. Soon after the move to Paris the three sisters entered an elite private school, the Cours Adeline-Désir, which trained middle-class girls to be conventional wives. The school tried to give the students "a general culture based on Catholic

values." There were lessons in social etiquette and classes in arithmetic (for household accounts), grammar and syntax, reading and history, geography and natural science. There were also lessons in knitting, sewing and crochet; music, pastel drawing and painting. When the girls showed some talent for art, they had lessons with Geoffroy-Alphonse Chocarne, but soon gave them up. Tiburce later reported that the results of Chocarne's deadly exercises were

> reminiscent of the landscapes made out of hair which are displayed in the windows of some funeral shops. Oh! those wretched journeys back from the rue de Lille to Passy for the three little girls in short capes, long skirts, and hats with ruffles and ribbons tied under the chin, escorted by their father, who fetched home, in sullen silence, his bevy stupefied by Chocarne's instruction....After a few months...Edma and Berthe announced to their mother that they would prefer to abandon the whole idea of painting rather than spend four hours three times a week at Chocarne's.

Berthe and Edma, concentrating on art, were much happier with Joseph-Benoit Guichard, who'd been a pupil of Ingres and had taught Manet's engraver friend Félix Bracquemond. A good-natured, encouraging teacher, with a pock-scarred face, Guichard was born in Lyons and now lived in Passy. Under his tutelage the girls began to copy the Old Masters. Working in the Louvre was socially acceptable and enabled them to meet young men—like Bracquemond and Fantin-Latour, who became Berthe's diffident suitor—outside their parents' social circle.

Guichard was shocked, however, when he realized that the girls were serious about their artistic vocation and wanted to become professional artists. He warned their mother, in the strongest possible terms, about the consequences of such a choice and urged her to stop them: "Do you realize what this means? In the upper-class milieu to which you belong, this will

be revolutionary, I might almost say catastrophic. Are you sure that you will not come to curse the day when art, having gained admission to your home, now so respectable and peaceful, will become the sole arbiter of the fate of your two children?" Art was a thief and seducer who would violate their home and ruin their calm, bourgeois life. If Berthe and Edma became artists, they would mingle with bohemian, radical and disreputable friends, and forfeit their reputation and social position. They would become less feminine, compete in a man's world, and lose the chance to marry and have children. Mme. Morisot, who'd have cause for anxiety later on, rejected his advice. Her daughters had character and commitment; she believed in their talent and encouraged their artistic careers.

In the early 1860s Berthe and Edma studied with their last and most eminent teacher, Camille Corot. A pioneer *plein air* painter of tranquil landscapes, especially in the Forest of Fontainebleau, he emphasized the quality of the sketch more than the finished composition and developed a late, misty style. Morisot learned how to achieve her calm, hazy effects from Corot, who paved the way for the Impressionists. Fatherly and openhearted, generous and influential, Corot became a frequent guest of the Morisot family. Her father built a studio for Berthe in their garden, and by 1864, when she was twenty-three, she began to exhibit in the Salon.

Unlike his sisters, Berthe's brother, Tiburce, showed no inclination to work. He once announced that he'd been appointed secretary in the colonial government and was about to depart for the Sudan, but never actually left for Africa. He had a pleasing manner, led a hedonistic existence and "developed a penchant for plump, mature women and nymphomaniacs."[1]

II

MORISOT WAS NOT only well bred and intelligent, but also dramatically attractive. Elegant and aloof, she had a voluptuous

figure, black hair, dark eyes, Spanish complexion and wild yet melancholy expression. Duret called her "graceful, very distinguished, and perfectly natural. The slender, nervous body betrayed the sensitive impressionable temperament." A young painter in her social circle, Jacques-Emile Blanche, recalled "how she scared me...with her 'strange' dress, always in black or white, her dark and burning eyes, her angular, thin, pale face, the curt, abrupt, nervous words, and the way she laughed when I asked what she hid in 'her notebook.'"[2] Mallarmé called her *"l'amicale méduse"* (the friendly Medusa), for she had a powerful effect on men. Accustomed to being admired, she confessed while on holiday in St. Jean de Luz: "I am surprised at being unnoticed as I am; it is the first time in my life that I am so completely ignored."

Morisot's life and art were nourished in the privacy of her immediate family: first with her mother and sisters, then with her husband and daughter—all of whom posed for her. To acquaintances, and even close friends, she seemed at once intense and distant. The poet Paul Valéry, who married her niece, described her piercing vision: "Morisot's life was in her great eyes, whose extraordinary concentration on their function, on their continual activity, gave her that air of foreignness, of separation, which cut one off from her. By *foreign* I mean *strange:* foreign in a peculiar way—rendered alien and remote by excessive presence."[3]

Though Mme. Morisot encouraged her painting, she could also be quite critical, and her harsh remarks sometimes wounded the hypersensitive Berthe. When her mother interfered with her work and made unhelpful suggestions, Berthe became irritated and caustically remarked: "Why don't you take the brush yourself?" Sometimes her mother would undermine Berthe's fragile self-confidence. "Mother told me politely," she informed Edma, "that she has no faith in my talent, and that she thinks me incapable of ever doing anything worthwhile. I see that she thinks me raving mad." She sometimes experienced periods of artistic

sterility and, her mother reported, suffered creative agony even when she was painting: "Whenever she works she has an anxious, unhappy, almost fierce look. I cannot say how much this comes from wounded pride, but I do know that this existence of hers is like the ordeal of a convict in chains." Mme. Morisot must have sometimes thought Guichard was right.

When Jacques-Emile Blanche visited Berthe's studio, she was going through a difficult period of self-doubt and felt very negative about her own work. Blanche recorded in his diary: "She has nothing of her own to show me; she destroys everything that she makes at this time: 'oil painting is too difficult.' This morning, once again, in desperation she threw into the lake of the Bois de Boulogne a study of swans she was following in a boat; wanting to give me a small gift, she searches in vain for a watercolor. In vain."

After reading the diaries of Marie Bashkirtseff, Morisot identified with the young Russian émigré painter who'd died of tuberculosis before she could fully develop her artistic powers. Morisot also suffered from the personal and social constraints that limited her freedom and creativity. As Bashkirtseff wrote: "What I long for is the liberty to ramble alone, to come and go, to seat myself on the benches in the garden of the Tuileries, and especially of the Luxembourg, to stop at the artistic shop-windows, enter the churches, the museums, to ramble at night in the old streets, that is what I long for, and that is the liberty without which one can not become a true artist."[4]

Morisot feared that she might fail as an artist, and her limited life as a spinster inevitably made her wonder if she'd made a terrible mistake. Early in 1869, Edma, at twenty-nine, a year older than Berthe, had given up art to marry the naval officer Adolphe Pontillon (Manet's old shipmate) and moved with him to Lorient in Brittany. She wrote to Berthe soon after to express some misgivings. In March, Berthe reassured her by emphasizing her own loneliness and lack of love: "Do not revile your fate. Remember

that it is sad to be alone; despite anything that may be said or done, a woman has an immense need of affection. For her to withdraw into herself is to attempt the impossible." But she was also deeply ambivalent. Only a month later she took the opposite point of view by asserting that art was more valuable: "Men incline to believe that they fill all of one's life, but as for me, I think that no matter how much affection a woman has for her husband, it is not easy for her to break with a life of work." Though talented and apparently self-assured, Morisot was torn by the emotional conflict between art and marriage.

As Berthe approached thirty, her mother felt that marriage was vital for her future well-being. "I am a bit disappointed to see that Berthe won't settle down like everybody else," she wrote. She saw that Berthe's artistic ambition was an impediment to a prospective husband: "It is like her painting—she will get compliments [from suitors] since she seems so eager to receive them, but she will be held at arm's length when it comes to a serious commitment." She warned Berthe of the worst consequences of her decision: her parents and friends would die, she would lose her good looks and she'd be left all alone, in a dubious social position. "Everyone thinks that it is better to marry," she maintained, "even making some concessions, than to remain independent in a position that is not really one. We must consider that in a few more years she will be more alone, she will have fewer ties than now; her youth will fade, and of the friends she supposes herself to have now, only a few will remain. How I wish the dear child had all this turmoil of feeling and phantasy behind her."[5]

III

THOUGH MORISOT and her mother had doubts about her future as an artist, she had from her early twenties enjoyed a successful career. Women had been permitted to exhibit in the official Salons since 1791; and she'd had her work accepted there

almost every year between 1864 and 1873. Manet and Edgar Degas, established artists who belonged to her family's social circle, strongly disagreed about whether to exhibit in the Salons. She showed considerable independence and courage in her decision to reject Manet's forceful arguments and join the Impressionists—Degas, Pissarro, Monet, Renoir and Cézanne—when they first began to exhibit at Félix Nadar's studio in 1874.

Morisot grew fond of Pissarro and Renoir, who came from a very different background from her own. The good-natured anarchist Camille Pissarro, born in 1830 on the Danish island of St. Thomas in the West Indies, was the son of a Jewish father and a Creole mother. He came to France in 1855 and became a close friend of Manet and Cézanne. He had studied under Corot, who provided a link to Morisot. The oldest in the group and the only one to exhibit in all eight shows, his bald head and long beard, his patriarchal demeanor and desperate poverty made him seem even older. Married to a sturdy French peasant, he had seven children. Best known for landscapes with peasant figures, he lived in London in the early 1870s, and then in villages outside Paris for the rest of his life. Renoir, the son of a tailor, was born in 1841 in Limoges, where the Morisots had also lived, but moved to Paris in childhood and spent most of his life there. He began by decorating porcelain and blinds; and in Professor Charles Gleyre's studio he met Monet, who, like Morisot, became a close friend. Influenced by Fragonard, he painted spontaneous landscapes, luscious nudes and portraits of fashionable women.

Secretly hurt at being considered an amateur by the critics, Morisot was no doubt flattered by the Impressionists' invitation. But it's significant that Degas, the principal organizer, followed convention and wrote to her mother—not to Berthe herself—about exhibiting with them. Degas thought Berthe's talent and social standing would lend prestige to the show, and hoped she might be able to persuade the reluctant Manet to join the group.

When Guichard, the prophet of doom, saw Berthe's work ex-
hibited with the Impressionists, he was predictably horrified.
Like Manet, he believed success could only come from showing
one's work in the Salons. He lamented to her mother that
Berthe, by associating herself with these disreputable renegades,
was insanely destroying everything she had achieved: "When I
entered, dear Madam, and saw your daughter's works in this per-
nicious milieu, my heart sank, I said to myself, 'One does not as-
sociate with madmen except at some peril.'...If Mademoiselle
Berthe must do something violent, she should, rather than burn
everything she has done so far, pour some petrol on the new
tendencies....To negate all the efforts, all the aspirations, all the
past dreams that have filled one's life, is madness. Worse, it is al-
most a sacrilege."

Nevertheless, Morisot remained faithful to the Impressionists
and exhibited with them in all but one of the shows held be-
tween 1874 and 1886. But she also became involved with their
personal conflicts. The imperious Degas, who scorned the offi-
cial jury, insisted that none of the Impressionists could show at
the Salons, and brought in several Italian cronies whom the
other artists thought inferior. In some contentious years, when it
seemed that the exhibition might not even take place, Morisot
served as a mollifying force. As she modestly observed: "This
project is very much up in the air, Degas' perversity makes it al-
most impossible of realization; there are clashes of vanity in this
little group that make any understanding difficult. It seems to me
that I am about the only one without any pettiness of character;
this makes up for my inferiority as painter." With considerable
self-awareness, she contrasted the positive feminine qualities—
sentiment, sensitivity and perception—with typically female
weaknesses: "The truth is that our value lies in feeling, in intu-
ition, in our vision that is subtler than that of men, and we can
accomplish a great deal provided that affectation, pedantry, and
sentimentalism do not come to spoil everything."[6]

A friend recalled that Morisot worked with the same nervous intensity and penetrating glance as Manet. She "always painted standing up, walking back and forth before her canvas. She would stare at her subject for a long time (and her look was piercing), her hand ready to place her brushstrokes just where she wanted them." Her accretive method of work, using several different materials, was "to start with a light pencil sketch, to repeat or vary the theme in sanguine, to remodel the composition in pastel and, quite often, to carry forward the theme in watercolor and occasionally to carry it to a final culmination in a finished oil." The effect, as the poet Jules Laforgue noted, was often chromatically stunning: "a thousand conflicting vibrations, in rich prismatic decompositions of color."[7]

Morisot's delicate, elusive work has been overpraised by feminist critics and undervalued by most others. Her paintings, even more than those by Monet, lack historical context, dramatic tension and narrative meaning. They do not stimulate the viewer to ask what's happening in the picture or what it means. Critics therefore tend to discuss the technique, composition and color, or indulge in fanciful interpretations. Also, as the critic Elizabeth Mongan points out, Morisot's sitters, like those of Renoir, are highly stylized: "most of the young girls [she] drew and painted resemble each other, with their heart-shaped faces framed by unruly strands of hair, and their softly pouting lips."

Morisot's major works can be roughly divided into landscapes and domestic scenes. In contrast to her own inner turmoil, most of her paintings show one or two women, sometimes with a child, in a tranquil and harmonious setting. *The Harbor at Lorient* (1869), her first seascape, was painted on the Atlantic coast of Brittany. Sitting on a stone wall that runs along the harbor, Edma wears a fashionable white dress, shades herself with a white umbrella and gazes downward. Several fishing boats float on the placid water that reflects the wispy clouds and high vault of the bright blue sky. Across the harbor are a tree-lined promenade and

the houses and church tower of the town. The mood of the painting, as in most of Morisot's work, is calm and soothing.

On the Balcony (1871–72) shows a woman in profile, dressed in black and holding a white parasol. She leans on the iron railing of a high balcony, next to a pillar with a pot of red flowers, and looks down at her child. The little girl, her long red hair in a bow, wears a white pinafore over a blue dress and high black shoes that show the tops of her white socks. She faces away from the viewer and looks through the rails. Beneath her is a suburban landscape, with the Seine flowing under a bridge. In the distance, under a cloudy blue sky, appear the golden dome and twin spires of the Parisian skyline. The mother seems to be protecting the child from the threatening spread of the city.

The subjects of *Two Seated Women* (1869–75)—which may portray Berthe and Edma—look remarkably alike. They wear the same white dress with blue spots, ruffled collar and wide sleeves, and have black Manet-like ribbons around their necks. One of them is seated on a floral-patterned sofa, beneath a framed fan, decorated with the figures of Spanish dancers; the other sits on a wooden chair with a draped flowered shawl. Both women have high dark hair, pale skin, blue eyes and rosy lips. The woman on the left wears a gold bracelet and black stone ring; the one on the right holds a Japanese fan. The space between the two fans in the center of the sofa is empty and emphasizes the distance, rather than affinity, of the near-twins. As in a painting by Manet, the women—one looking down, the other to the left—are mysteriously self-absorbed and disconnected.

The Cradle (1872), Morisot's most famous painting, is based on Edma and her baby, Blanche. The beautiful mother, seated in profile, wears a characteristic black dress with a deep ruffled neckline. She reflectively rests one hand on her chin and the other on the cradle, echoing the pose of the blurry-featured infant. As she gazes down at the cradle, the baby sleeps peacefully under a high-coned, diaphanous white net, trimmed with pink

ribbon. The painting idealizes motherhood, yet also suggests maternal concern. In Tolstoy's *Anna Karenina* (1877), the auto-biographical hero Constantine Levin reacts to the birth of his first child with an uneasy mixture of pleasure and fear: "he was oppressed by a new sense of apprehension—the consciousness of another vulnerable region. And this consciousness was so painful...that it drowned the strange thrill of unreasoning joy and even pride which he had felt when the infant sneezed." We can only guess what Morisot's restrained yet suggestive mother is thinking: of the pain she suffered to give birth to the child? if it will survive to adulthood? whether it will have a happy life?

The Little Servant (In the Dining Room) (1885–86) is painted with the blurred brushstrokes of Morisot's late style. Dominating her own milieu, the servant is a surprisingly impressive and self-assured figure. She's surrounded by domestic furnishings: a cupboard with its glass doors open, a clock, a bust and oil lamp in the background, a chair and dining table with fruit bowl and wine decanter, and a lively white dog scampering at her feet. In the far background, a large window reveals a nearby house. The maidservant has pretty features, rosy cheeks and strands of hair trailing down behind her ears. She wears a jacket over a blue dress, buttoned up to her high collar, and a white apron over a long skirt that shows her feet—one pointed in front of the other—in striped stockings and black shoes. Holding a dish and preparing to serve a meal, she suggests the pleasant, secure, even cosy atmosphere of Morisot's household.

Three late self-portraits, all painted when she was forty-four, reveal how she saw herself and presented herself to the world. The pastel of her head, with only a suggestion of her shoulders and chest, is executed in swirling and oblique strokes of black and white chalk. She confronts the viewer in a haunting blur of wild hair; large, dark, shadowy eyes; and a tense, haggard expression. In the more elaborately developed painting, she's full-breasted, with parted hair falling below her eyebrows, and wears

a black scarf and floral-patterned beige dress. She holds a brush and palette, stands sideways and looks at the viewer with a more self-assured demeanor.

The third self-portrait is painted on tangerine paper, with a few blue and white strokes, for contrast, in the background. Her seven-year-old daughter Julie, standing in profile to her left, has the blurred features that made many critics complain that Morisot's work (even more that Manet's) was unfinished. Berthe, her parted hair lighter, handsome features and strong chin more sharply delineated than in the other portraits, wears a tight-fitting dress and has a solid, magisterial pose. The self-portraits with palette and with Julie show the tension between the two sides of her life and, as Huysmans wrote, the "turbulence of agitated and tense nerves."[8]

Morisot, like all the Impressionists, came in for some pretty rough treatment by the critics. The implacably hostile Albert Wolff, reviewing the first Impressionist exhibition of April 1874 in the influential *Le Figaro,* blatantly described her as insane: "There is also a woman in the group, as is the case with all famous gangs. Her name is Berthe Morisot, and she is interesting to behold. In her, feminine grace is preserved amidst the frenzy of a mind in delirium." There was worse to come. When another detractor, confusing Morisot with models of easy virtue, called her a "whore," Pissarro chivalrously defended her by punching the critic in the face.

But not all critics were blind to her considerable achievement. George Moore, who adored the Impressionists as much as Wolff hated them, perceived the subtle and refined feeling of pictures like *Chasing Butterflies* (1874): "Morisot exhibited a series of delicate fancies. Here are two young girls, the sweet atmosphere folds them as with a veil, they are all summer, their dreams are limitless, their days are fading, and their ideas follow the flight of the white butterflies through the standard roses. Take note too of the stand of fans; what delicious fancies are there—willows, balconies, gardens, and terraces."

Another sympathetic critic, writing in *Le Temps,* called Morisot the purest artist of them all, the one who adhered most closely to their innovative principles of color and light: "There is but one real Impressionist in this group and that is Berthe Morisot. Her painting has all the frankness of improvisation; it does truly give the idea of an 'impression' registered by a sincere eye and rendered again by a hand completely without trickery." The painter Odilon Redon, observing her work with a professional eye, agreed about the impressive effects of her drawing and color:

> Berthe Morisot retains the marks of an early artistic education which sets her distinctly apart, with Degas, from that group of artists whose rules and formulas have never been clearly announced. Look at these water colors produced with such liveliness, these "taches" [spots of color], extremely subtle and feminine, they rest upon indications, linear intentions, which give her charming works an accent which is truly finer, more delicately formulated than that of others.[9]

Morisot certainly lent prestige to the embattled group.

IV

MORISOT'S ALLIANCE with the Impressionists put her into close contact with Degas. Like Manet, he was a well-educated and cultivated man from her own social class. Though she found his manner off-putting, even irritating, she admired his caustic wit and astonishing talent, was fascinated by his eccentric character and frequently mentioned him in her always lively letters. In 1869, five years before she joined the Impressionists, she told Edma: "I certainly do not find his personality attractive; he has wit, but nothing more." Two years later, she'd warmed up to him a bit: "Degas is always the same, a little mad, but his wit is delightful." Much later, in 1884, she still enjoyed his company: "Degas is always the same, witty and paradoxical."

A flirtatious element that both seemed to enjoy added spice to their friendship. Using the language of seduction, in May 1869

Berthe told Edma that their sister "Yves has certainly made a conquest of Monsieur Degas. He asked her to permit him to paint a portrait of her." She then gave delightful examples of the wit—at the expense of rival painters—that enlivened his creation of the portrait: "Monsieur Degas has made a sketch of Yves, that I find indifferent; he chattered all the time he was doing it, he made fun of his friend Fantin, saying that the latter would do well to seek new strength in the arms of love, because at present painting no longer suffices him. He was in highly satirical mood; he talked to me about [the painter Puvis de Chavannes], and compared him to the condor at the Jardin des Plantes."[10]

Degas' forced gallantries, as Mary Cassatt also discovered, were oblique and allusive, self-defensive and satiric—very different from the pleasing way Manet talked to women. "He came and sat beside me," Morisot uneasily reported, "pretending that he was going to court me, but this courting was confined to a long commentary on Solomon's proverb, 'Woman is the desolation of the righteous.'" Though this misogynistic proverb sounds biblical, it is actually by one of his favorite writers, the French socialist Pierre-Joseph Proudhon. (Flaubert, quoting these harsh words, attributed them to Proudhon.)

In 1869 Degas, mocking her romantic feelings, told the recently married Edma to read Benjamin Constant's novel *Adolphe* (1816). Edma took his advice and felt the book "grows on you," just as Degas said it would, and Degas couldn't help laughing when he heard she was reading it. *Adolphe,* the story of a passionate but irksome love affair, is full of pain, self-deception and disillusionment. After his mistress dies Adolphe escapes the bondage of love, but begins to regret her loss and cannot enjoy his loveless freedom. Somerset Maugham shared Degas' taste for the book and also prescribed it as an antidote to romantic inclinations. Whenever anyone fell in love with him, he offered "the victim or beneficiary of love a copy of *Adolphe,* as you might give quinine to a friend going on a journey."[11]

Like all the Impressionists, Morisot greatly admired the "fierce" art of Degas and told Monet that Degas' late nudes were becoming more and more extraordinary. On hearing that Degas was also writing sonnets, she added her own shaft of wit by asking how his unattractive women could possibly inspire poetry: "And these women in their tubs? What will he do with them?" Morisot was desperately eager to win Degas' esteem and have him praise her work. In 1870 she felt, with some exaggeration, that Degas had "supreme contempt" for her art. A year later her mother, also on the lookout for Degas' response, recorded a slight but significant change in attitude when he happened (for once) to be in a good mood: "M. Degas dropped in for a moment yesterday. He uttered some compliments, though he looked at nothing—he just had an impulse to be amiable for a change. To believe these great men, she has become an artist!" Only much later and shortly before Morisot's death did Degas offer undiluted praise and give great pleasure by telling her that "her somewhat vaporous painting concealed the surest draftsmanship."[12] In the end, Morisot fully justified Degas' belief in her talent as an artist.

Eight

MORISOT AND MANET
1 8 6 8 – 1 8 7 4

I

❧ MORISOT'S RELATIONS with Manet were not based, as with Degas, on flirtation and wit, but on deeper feelings. In July 1868 Berthe and Edma were copying a Rubens nude in that great social arena, the Louvre, when they were introduced by Fantin-Latour to the notorious Manet, eight years older than Berthe and married to Suzanne. The Manet and Morisot families became friends, and Berthe and Edouard grew increasingly intimate. Berthe's wonderfully animated correspondence, over a period of fifteen years, traces the progress of their intellectual and emotional friendship. They moved from physical attraction and flirtation, to sexual jealousy and wounding criticism, to adoration and love.

In August 1868 Manet, adopting an ironic and patronizing tone, expressed his admiration for the sisters. He jokingly told Fantin-Latour that they could help rebellious painters by using their feminine wiles to undermine the ancient members of the Academy: "I agree with you, the young Morisot girls are charming, it's a pity they're not men; but being women, they could still do something in the cause of painting by each marrying an academician and bringing discord into the camp of those old dodderers, though that would be asking for considerable self-sacrifice." Like Berthe's teacher Guichard, he too assumed that for a woman art could be only a decorative pastime. Manet also saw, beneath the playful banter, that he and Berthe were both high-strung and vulnerable, nervous and moody, critical yet full of self-doubt and craving recognition. They each had edgy rival-

ries with other painters. When Morisot was invited to the studio of Puvis de Chavannes, a faintly ludicrous figure and creator of enormously successful neoclassical murals, Manet wickedly told her to deflate his pretensions: "Don't be constrained. Tell him all the worst things that you can think of about his painting!"

The Morisots took particular interest in Manet's *The Balcony,* which Berthe had posed for and which he exhibited in the Salon of 1869. Mme. Morisot said that Manet, overwrought while waiting for the critical response, "looks like a madman." He hoped for success, but was depressed by fear of failure. When Berthe came to the opening, she discovered Manet in a kind of manic-depressive state and tried to reassure him about the picture: "There I found Manet, with his hat on in bright sunlight, looking dazed. He begged me to go and see his painting, as he did not dare to move a step. I have never seen such an expressive face as his; he was laughing, then had a worried look, assuring everybody that his picture was very bad, and adding in the same breath that it would be a great success. I think he has a decidedly charming temperament, I like it very much."

Berthe, rather vain and used to attention, could be ruffled when her artistic mentors neglected the bourgeois proprieties. Once she was strolling with Degas in a picture gallery when he ran into some acquaintances. She told her sister she "was a little annoyed when a man whom I consider to be very intelligent deserted me to pay compliments to two silly women." She became even more annoyed when Manet, who had been escorting her around the Salon, suddenly got distracted and disappeared. She thought it improper to walk alone, and when she finally found him and reproached him for his desertion, he gave her a barbed retort instead of an apology. He said she "could count on all his devotion, but nevertheless he would never risk playing the part of a child's nurse."[1]

When Eva Gonzalès (eight years younger than Morisot) became Manet's pupil, she also became a formidable rival. Manet

painted a portrait of her at her easel, and she achieved some success in the Salons. To arouse Berthe's jealousy, Manet praised Eva's personal and artistic qualities. Mme. Morisot rubbed salt in the wound by telling Berthe that "he has forgotten about you for the time being. Mademoiselle G. has all the virtues, all the charms, she is an accomplished woman." Greatly discouraged by his criticism, Berthe complained to her sister that Eva was being admired at her expense: "Manet lectures me, and holds up that eternal Mademoiselle Gonzalès as an example; she has poise, perseverance, she is able to carry an undertaking to a successful issue, whereas I am not capable of anything." Manet felt that Morisot was too respectable and restrained, and admired Gonzalès for actively competing in the art world. His feelings for Eva were strong. While he was serving in the National Guard he told her: "my admiration and friendship for you are common knowledge.... Of all the privations the siege is inflicting on us, that of not seeing you any more is certainly one of the hardest to bear."[2]

If Manet were in a good mood, he could also be very encouraging and even, in all sincerity, rate Morisot higher than her rival. Morisot delightedly told Edma: "We spent Thursday evening at Manet's. He was bubbling over with good spirits, spinning a hundred nonsensical yarns, one funnier than another....The Manets came to see us Tuesday evening, and we all went into the studio. To my great surprise and satisfaction, I received the highest praise; it seems that what I do is decidedly better than Eva Gonzalès. Manet is too candid, and there can be no mistake about it. I am sure that he liked these things a great deal." But if his mood changed, his despair could be infectious and draw Morisot, who greatly valued his opinion, into the depths of his gloom: "[Manet] says that the success of my exhibition is assured and that I do not need to worry; the next instant he adds that I shall be rejected [by the jury]. I wish I were not concerned with all this."

Though writing to her sister in Lorient was a comfort, the loss of Edma, her companion in art for so many years, intensi-

fied her loneliness and anxiety about her own future. Praise from Manet and other painters was especially important: if he noticed her, she sprang to life; if he ignored her, she became depressed. In April 1869 she wrote: "I am remorseful [at] having written in such a worried and discouraged tone....I am recovering some slight taste for life, and reproach myself for having given in to my mania for lamentation."[3]

The art historian Linda Nochlin noted that women artists usually had artist fathers or, in the nineteenth century, "a close personal connection with a stronger, more dominant male artistic personality." This was certainly true of Morisot and Cassatt, for in both cases the older male artists, Manet and Degas, provided crucial help and advanced their careers. But the men could also be arrogant and overbearing. Manet claimed, with some exaggeration, that Morisot "would not have existed without me; she did nothing but carry my art across her fan." Morisot herself sometimes felt her individuality was fading under Manet's powerful influence: "My work is losing all its freshness. Moreover, as a composition it resembles a Manet. I realize this and am annoyed."

On one occasion, Manet carried his dominance too far. When Berthe completed *Reading* in March 1870 she asked Manet's opinion of it. Instead of telling her what had to be done, he began to retouch it, got quite carried away and tried to make her work his own. Manet

found it very good, except for the lower part of the [mother's black] dress. He took the brushes and put in a few accents that looked very well; mother was in ecstasies. That is where my misfortunes began. Once started, nothing could stop him; from the skirt he went to the bust, from the bust to the head, from the head to the background. He cracked a thousand jokes, laughed like a madman, handed me the palette, took it back; finally by five o'clock in the afternoon, we had made the

prettiest caricature that was ever seen. The carter was waiting
to take it away; he made me put it on the hand-cart, willy-nilly.
And now I am left confounded. My only hope is that I shall
be rejected. My mother thinks this episode funny, but I find it
agonizing.[4]

Manet's brushstrokes are still visible around the eye and
mouth and on the dress of Mme. Morisot, who was pleased by
his improvements. Berthe once again called him a madman and
resented the imposition of his style, however well intentioned,
on her own. Though terribly upset, she felt unable to protest and
when Manet insisted, simply handed the painting over to the
carter. She said she hoped it would be rejected, but the Salon jury
accepted it, and she later showed it in the first Impressionist ex-
hibition. By taking possession of the painting Manet seemed to
have violated her, and her anguished response revealed the
depth of her feeling for him. Mme. Morisot, concerned about
Berthe's physical reaction, told Edma: "Yesterday she looked like
a person about to faint; she grieves and worries me; her despair
and discontent were so great that they could be ascribed only to
a morbid condition; moreover she tells me every minute that she
is going to fall ill.... You know how the smallest thing here takes
on the proportions of a tragedy because of our nervous and
febrile dispositions."

Berthe's friendship with Manet deepened during the siege of
Paris, when the Morisots, rejecting his advice, decided to remain
in the capital. All three Manet brothers served in the National
Guard. To scare the Morisots into leaving, Manet gave Berthe's
mother hair-raising reports of the war. Just after the war broke
out she exclaimed: "The tales that the Manet brothers have told
us about all the horrors that we are liable to experience are al-
most enough to discourage the most stout-hearted. You know
how they always exaggerate, and at present they see everything
in the blackest possible light." The Manets had told Berthe:

"You will be in a fine way when you are wounded in the legs or disfigured." Berthe retaliated by telling Edma, rather unfairly, that Manet was a vain chocolate soldier who spent most of his time changing his uniform and admiring himself.

The privations Morisot suffered and her firsthand experience of war set her nerves on edge. In late September 1870, a few weeks after war broke out, she wrote Edma:

> I have heard so much about the perils ahead that I have had nightmares for several nights, in which I lived through all the horrors of war....
>
> The militia are quartered in the studio, hence there is no way of using it. I do not read the newspapers much any more; one a day is enough for me. The Prussian atrocities upset me, and I want to retain my composure....
>
> Would you believe that I am being accustomed to the sound of the cannon? It seems to me that I am now absolutely inured to war and capable of enduring anything.[5]

After visiting them on New Year's Day in 1871, Manet told Suzanne that Tiburce, a lieutenant in the Versailles army, had been captured and imprisoned in Mainz, and the family was very depressed. Berthe was too optimistic, in fact, about her ability to endure hardships. She had always been in delicate health and, like Manet, had a nervous breakdown in the spring of 1871.

Manet and the Morisots were on opposite sides during the Commune. The ceilings by Ingres and Delacroix in the town hall were destroyed by fire during that time, and the audit office where Berthe's father worked was also burned. On June 5, 1871, after Tiburce had been released and the Commune had been brutally suppressed, Mme. Morisot, using a favorite word to describe Manet, emphasized the danger of supporting the rebels: "Tiburce has met two Communards, at this moment when they are all being shot.... Manet and Degas! Even at this stage they

are condemning the drastic measures used to repress them. I think they are insane."

Their conflicting political views did not cause a breach, and the following month Manet pleased Mme. Morisot by taking a friendly interest in Tiburce. The habitual boulevardier also urged Berthe, who'd been visiting Edma, to hurry back to the capital. He was eager to see her: "I hope, Mademoiselle, that you will not stay a long time in Cherbourg. Everybody is returning to Paris; besides, it's impossible to live anywhere else." When Berthe returned and visited the Manets with her mother a month later, the sharp-tongued Mme. Morisot wrote critically of their hot and crowded "at home." The conditions were mitigated, however, by the spirited piano playing of Suzanne, the mournful singing of the Spaniard Lorenzo Pagans and the welcome appearance of the slow-moving, heavy-lidded Degas: "I found the Manet salon in just the same state as before; it is nauseating.... The heat was stifling, everybody was cooped up in the one drawing room, the drinks were warm. But Pagans sang, Madame Edouard played, and Monsieur Degas was there. That is not to say he flitted about; he looked very sleepy."

Berthe's relationship with Manet intensified at the end of 1871. Their nervous breakdowns seemed to reinforce their bond, and as they recovered they drew closer. Manet began to praise her work, and now said that she could persevere and would surely achieve success if she tried really hard. Berthe, who craved his admiration more than anything in the world, joyfully told Edma that he had admired her appearance and asked her to sit for more portraits: "[Manet] was very nice to me. Once more he thinks me not too unattractive, and wants to take me back as his model. Out of sheer boredom, I shall end by proposing this very thing myself."[6]

Proud of her slim yet shapely figure, Berthe was as jealous of Suzanne as she was of Eva and could be as caustic as her mother. Noticing that the hefty Suzanne had gained even more weight

during her rustication in the Pyrenees, Mme. Morisot told the receptive Berthe: "[Manet's] wife is somewhat recovered, but he must have experienced a great shock at the sight of this bucolic blooming." She also remarked that Manet, painting an idealized portrait of his wife, was "laboring to make of that monster something slender and interesting!" Toward the end of the year, Berthe took up this refrain and continued to mock the unfortunate Suzanne: "I saw our friend Manet yesterday; he left today with his fat Suzanne for Holland, and in such a bad humour that I do not know how they will get there."

Their malicious and sometimes snobbish delight extended from Suzanne to other beefy women in their family and social circle. Mme. Morisot was pleased to report that Manet, implying that he no longer found his own wife attractive, had said that "in a few years Tiburce will be ashamed of his wife — he admits that she has a pretty face, but he cannot endure her figure." Berthe, still gnawing at this obsessive theme two decades later, commented on the considerable bulk of Renoir's wife and told Mallarmé: "I shall never succeed in describing to you my astonishment at the sight of that ungainly woman."[7]

II

MANET WAS THE dominant artist, and Morisot imitated several of his compositions and themes. Manet's more crowded, complex and thematically significant *View of the Paris World's Fair* (1867) clearly influenced Morisot's more simplified and expansive *Paris Seen from the Trocadéro* (1872–73), in which the same golden dome and twin church spires can be seen in the distance. In 1875 they both painted a picture with a similar domestic theme. Manet's *Washing* had a close-up of a mother and child hanging up laundry on a clothesline in a garden, while Morisot, more interestingly, in *Laundress Hanging Out the Wash,* took a bird's-eye view of several women in an open field. In the background and under a cloudy sky, a house, a bridge and factories

encroach on the rural landscape. She paid tribute to Manet by putting his *Portrait of Isabelle Lemonnier* (1880) in the background of her *Violin Practice* (1893), and by placing his portrait *Berthe Morisot Reclining* (1873) in the background of *Julie Playing the Violin* (1894).

Manet was so pleased with *The Harbor at Lorient* (1869) that Morisot gave it to him as a present, and she could sometimes influence her master. In Morisot's *On the Balcony* (1871–72), as in Manet's *Railway* (1873), the mother faces the viewer while the child, blocked by a fence, looks away. Morisot had painted women dressed appropriately for the season in *Summer* (1878) and *Winter* (1879–80); Manet completed the suite with *Autumn* (1881) and *Spring* (1882). And she clearly influenced his technique. "Had it not been for Berthe Morisot," Georges Bataille pointed out, "in whom he discovered the double enchantment of a painter's talents and a model's beauty, he might never have tried his hand at Impressionist painting."

Between 1868 and 1874, when Morisot was in her late twenties and early thirties, Manet became obsessed with her striking beauty, magnetic presence and elegance that perfectly matched his own. He expressed his love for her, and revealed her love for him, in a series of eleven portraits, with variants in watercolor, lithograph and etching. Manet treasured these pictures, several of which are among his greatest works. He kept five of them and gave her two, and she bought a third one after his death. Though he painted Eva Gonzalès as an artist, his portraits of Morisot emphasized her personality rather than her profession. His portraits, sensitive to every nuance of mood and change of expression, are more enigmatic, emotionally charged and sensual than his nude paintings of Victorine Meurent.

Morisot's tragic appearance, restrained energy and radiant intensity suggest powerful psychological undertones, as well as the sexual tensions and inhibitions of a handsome married man and a beautiful unmarried woman. Constantly changing her identity,

Manet portrayed her differently from portrait to portrait. She could appear pensive or melancholy, stricken by illness or grief, seductive behind a veil or fan, or sensually swathed in heavy furs. But her skin was always luminously white against her black clothing. As John Richardson observed, "this intelligent and striking-looking girl appealed to him because she was an obliging model with dramatic, rather Spanish features and a habit of dressing in his favorite combination of black and white — as witness some of Manet's most hallucinating portraits." The portraits also reveal the impossibility of their love, and suggest an answer to Yeats' famous rhetorical question: "Does the imagination dwell the most / Upon a woman won or a woman lost?"

In *The Balcony* (1868–69), between two green shutters and a green railing, Morisot dramatically appears on Manet's artistic stage. The composition is triangular. A distinguished-looking gentleman (the painter Antoine Guillemet), in high wing collar and wide purple tie, looks into the distance and holds his hands up, as if startled by something he's just seen. Standing in front of him, putting fawn-colored gloves on her hands (which complement the dancing hands of the gentleman) and holding her green umbrella at the angle of a violin, is the concert violinist Fanny Claus. The huge bouquet of white flowers on her hat echoes her round face. Seated below the gentleman, wearing a white dress more elaborate than Fanny's and a green ribbon that matches the umbrella, Morisot holds a red fan that forms a V with the umbrella and, like the larger V of the women's sloping shoulders, frames the standing man. Manet's Japanese dog ("Tama") and a tall potted plant are at her feet; and in the hazy background, Léon Leenhoff, like a little Ganymede, brings them a drink in a jug. Fanny's expression is blank, even fatuous, her huge floral headpiece slightly absurd. By contrast, the bareheaded Berthe, with wild curls on her forehead and black hair flowing down her shoulders, has tense fingers, large dark eyes, sinuous lips and an anxious, troubled expression, as if she's seen

something frightening that the others haven't noticed. Manet's three figures are characteristically isolated and detached from each other. His portrait of Berthe may have been inspired by the theme of lost love in Baudelaire's "The Balcony":

> Can vows and perfume, kisses infinite,
> Be reborn from the gulf we cannot sound;
> As rise to heaven suns once again made bright
> After being plunged in deep seas and profound?
> Ah, vows and perfumes, kisses infinite![8]

Berthe Morisot with a Muff (1868–69), like his late portraits of Méry Laurent, portrays her luxuriously wrapped in dark fur, with her hands plunged into a large fur muff. Her tall, ribboned hat and flowing coat, in a strong pyramidal form, suggest her forceful character. She's seated in three-quarter view, unruly hair characteristically flowing onto her brow and white cheek, her handsome nose jutting above her sensuous, slightly parted lips. In 1870, the year after Manet completed the picture, Leopold Sacher-Masoch stressed the sexual, even perverse significance of fur in his novel, *Venus in Furs* (1870). Franz Kafka developed this idea more movingly in "The Metamorphosis" (1915), when Gregor Samsa, having been transformed into a gigantic bug, "was struck by the picture of the lady muffled in so much fur and quickly crawled up to it and pressed himself to the glass, which was a good surface to hold on to and comforted his hot belly." Manet's riveting image made Morisot notorious among the artists and aroused their curiosity about her relations with Manet. When she saw her portrait in the 1869 Salon, she remarked: "I am more strange than ugly. It seems that the epithet of *femme fatale* has been circulating among the curious."

Repose: Portrait of Berthe Morisot (1870) reveals a more pensive, dreamy aspect of her character. Like *Baudelaire's Mistress, Reclining* (1862), Manet portrays Berthe seated with her right hand extended on the edge of a sofa. The fingers of her left hand spread

gracefully between her handkerchief and the star-shaped inden-
tations of the sofa buttons. She's also holding a fan and wearing
a white dress, with one white-stockinged, black-shod foot show-
ing beneath the hem. Her long dark hair hangs down her shoul-
ders and her narrow waist is secured by a black sash. Whereas
Jeanne Duval was ravaged, grotesque and repulsive, Berthe—
resting, yet alert—is gentle, tender and engaging. Her calm
demeanor contrasts with the swirling brushstrokes of the Japa-
nese triptych above her head. Berthe later told her daughter that
"her left leg, half drawn back under the skirt, used to stiffen
painfully, but Manet would not allow her to move, lest the skirt
be disarranged."9

Modern critics have followed Duret in perceiving the sexual
tension in the portrait: "The young woman with her air of
melancholy, her deep eyes, her supple, slender body, is inno-
cently seductive." Beatrice Farwell, more recently, also noted its
sensual aspects: "the relaxed position, the air of reverie, the indi-
rect gaze relate it to the traditional representation of Oriental
and erotic fantasy." Françoise Cachin observed that Morisot's
doubts and dark reveries about her emotional and artistic life
were captured by Manet "in the face, while in the pose, the dress,
the coiffure, he captured a mingling of high expectation and
momentary dejection, of distinction and bohemian carelessness.
The overstuffed couch and the Japanese triptych above likewise
suggest Morisot's personality, poised between bourgeois com-
fort and the hazards of artistic experience."10

Berthe Morisot with a Bunch of Violets (1872) (his *Woman with a
Parrot* also holds a bunch of violets) is Manet's most intensely
Spanish, most beautiful and most powerful portrait. Wearing her
typical high-crowned black hat, its brim dipping down on her
forehead, black scarf and black dress—with her white blouse
open at the neck and pointing to the corsage of violets—she
confronts the viewer directly and close to the frame of the pic-
ture. The ribbons hanging from her hat accentuate her scattered

strands of hair. Her face is half in shadow, half in light; her brown irises are unusually large; her nose delicate and lips inviting. Her expression, one critic wrote, "shows curiosity and involvement, rapt attention to the artist portraying her, a profound complicity." Violets, reflecting this complicity, symbolize the love of truth and the truth of love.

Paul Valéry described the emotional impact of this stunning portrait:

> What struck me before all else was the *black*—the absolute black of a little mourning hat, along with its tie strings as they mingle among the locks of chestnut hair with rosy gleams of light on them; it is a black that could only be Manet's....
>
> These startling passages of intense black enclose and emphasize a face whose too-large, dark eyes have an absentminded, almost a distant expression. The painting is fluid, coming easily, obediently to the supple brush stroke; and the shadows on the face are so transparent, the lights so delicate, that it makes me think of the tender and precious molding of that head of a young woman, by Vermeer.

After Morisot's death, her daughter revealed the special significance of this valedictory portrait: "I started to copy a head of Mama by my Uncle Edouard, seen against the light, in black, with a hat and a bunch of violets on her bosom. Mama bought it at Duret's sale. It's hanging in my bedroom and I look at it from my bed. It's marvelous, executed magnificently, one wouldn't believe that he did it in one or two sittings at most. Mama told me that she had posed for this picture the day before a Thursday dinner they had at Bonne Maman's restaurant. On that day my Uncle Edouard told Mama that she ought to marry Papa."

Berthe Morisot with Hat, in Mourning (for her father) (1874) portrays her with dramatic intensity, like a tragic heroine in a play by Racine. Morisot, painted in a looser style and with broader strokes, is set against a dark swirling background and seated on

a gold-flecked chair. She wears a tall black hat and is shrouded in a loose black garment, with a black ribbon wound like a phylactery around her bare white arm and a black-gloved hand resting on her chin. Her hair is loose on her forehead, her eyes are troubled, and the expressionistic slashes of paint on her face — including an Apache-like white stripe on the bridge of her nose — reinforce her sorrow and anguish. Degas owned this stunning portrait which, as Ann Dumas pointed out, demonstrated "extraordinary empathy for his subject's grief" and is "unique in Manet's oeuvre for its unrestrained expression of strong feeling."[11]

Berthe Morisot with Fan (a watercolor of 1874) is more spontaneous and seems to catch her by surprise. Dressed once more in mournful black, holding an open black fan, with loose black flowing hair and a black ribbon around her neck, she's seen in three-quarter view, tilting slightly to the left. The *V* of her parted hair complements the *V* of her neckline; and her pale skin, upturned nose and inviting lips are defined between her black hair and black ribbon. Her refined, vibrant features are as lovely as ever; her expression is intelligent and alert. Her left arm, with elegantly expressive fingers forming a circle and touching the tip of her decorated fan, is bent backward in response to something that startles her outside the frame of the picture. Manet placed a gold ring on her finger and gave her this graceful portrait as a wedding present.

The sheer number and beauty of these portraits naturally aroused curiosity about the intimate relations of Manet and Morisot. She was certainly in love with him, and jealous of Eva Gonzalès and Suzanne. George Moore, always a close observer, stated "there can be little doubt that she would have married Manet if Manet had not been married already." One modern critic naively claimed that "as a gentleman, an 'honnête homme,' [Manet] would never tarnish her respectability by suggesting an illicit liaison." But liaisons, if discreet, had always been tolerated

in good society; and overwhelming passion, especially in artistic circles, often defied social conventions. His friend Duret pointed out that "after Edma was married [in 1869], Berthe used to work with Manet in his studio. From that moment she passed under his immediate influence."[12] Her letters show that her love for Manet was the most passionate experience of her life.

Berthe's letters to Edma and Manet's many portraits of her strongly suggest that they were lovers. Manet admired her work, relished her talk and fell in love with her. Often alone together in his studio, they had ample time for intimacy. They burned each other's letters when she married, both because they had something to hide and as a sign that their intimate relationship had come to an end. Though Manet did not paint Morisot after her marriage in 1874, their close friendship continued. He sent her an easel in the latest style as a New Year's gift and urged her to try more rapidly executed and spontaneous pastel drawings. He also encouraged her to visit Venice which, he felt, would inspire her as it had once inspired him. She remained devoted to Manet during his lifetime and did everything she could to enhance his reputation after his death. Manet's erotic portraits reveal not only the talent of the painter and beauty of the model, but also their intimate bond.

MAKING CONCESSIONS
1874–1895

I

❧ IN THE SUMMER of 1874 the Manet and Morisot families spent their holidays together at Fécamp, on the coast of Normandy. With some prodding from his brother, Eugène Manet sought Berthe's attention. "I wouldn't mind at all if you were to compliment me a bit on my painting," he remarked. Berthe's timid suitor looked very like his brother, and had the same high forehead, fair complexion, blond beard, medium height and slight build. The perceptive poet and diarist Henri de Régnier recorded that in character, too, Eugène "was not unlike his brother Edouard. He was a courteous and cultivated man, but visibly high-strung. Like his wife, he was reserved and willingly self-effacing." Like Edouard and Berthe, Eugène had a tendency to nervous introspection. He was not the ideal husband from the Morisots' point of view. Mme. Morisot, who had strict standards of behavior and had called Edouard a madman, also described Eugène as "crazy most of the time."

Berthe and Edouard, outside the privacy of the studio and under the observant eyes of their families, must have sought a way to escape their emotional impasse, preserve her reputation and maintain their mode of life. Edouard urged her to marry Eugène, they talked about it for a long time and she finally decided to follow his advice. She married him because she couldn't marry Edouard, and Edouard encouraged the vicarious marriage to bring her into the family and maintain their close connection. For Berthe, being painted by Manet and marrying his brother

were the next best things to marrying the great love of her life. At the age of thirty-three, as her mother suggested, Berthe had to "make some concessions." Eugène was kind, modest and understanding, and offered a practical solution to her persistent problem.

Neither she nor Eugène seemed to find it surprising or problematical that Edouard would hand Berthe over to his brother, just as their father had handed Suzanne over to Edouard, and both took comfort in the security of marriage. In 1872 she had written to Edma: "I am sad, sad as one can be....What I see most clearly is that my situation is impossible from every point of view." A month after her wedding in December 1874—a quiet affair since she was still in mourning for her father, who'd died of heart disease—she admitted that she was not in love with her husband, a pale imitation of the brilliant Edouard, and that her dream of marrying Edouard had been tragic and unreal. She told Tiburce: "I have found an honest and excellent man, who I think loves me sincerely. I am facing the realities of life after living for quite a long time in chimeras that did not give me much happiness."[1]

Custom forbade upper-class women from frequenting cafés, the heart of bohemian life, but marriage gave Morisot a home of her own, where she presided over an elegant salon. Her exotic dinner parties—she served Mexican rice and Moroccan chicken and dates—brought Manet, Degas and Cassatt together with the leading writers and composers of the time. Duret described the stimulating milieu: "Both she and her husband had inherited considerable wealth. They lived in a house which they had built in the Rue de Villejust [in Passy]. The rooms which they occupied included a large picture-gallery, in which Manet's works held the first place, and after them those of Berthe Morisot herself. The circle of their friends was limited but select; the principal guests were the painters Degas, Renoir, Pissarro, Claude Monet and the poet Stéphane Mallarmé...[who] literally wor-

shipped Berthe Morisot." De Régnier recorded that in "this atmosphere of discreet silence and sober elegance," with beautiful furniture and Manet's *Washing* on the wall, "Mallarmé found great pleasure."

Renoir's son Jean, who later became a famous film director, also described the brilliant company that gathered round Morisot: "In [her] day the Manet circle had been one of the most authentic centers of civilized Parisian life....Berthe Morisot acted like a special kind of magnet on people, attracting only the genuine. She had a gift for smoothing rough edges. Even Degas was more civil when with her."[2] Indeed, the Manet-Degas acquaintance developed into friendship in the benign atmosphere of Morisot's salon.

Berthe and Eugène traveled on their honeymoon to the Isle of Wight and London. Later they went to Genoa, Pisa and Florence, and to Belgium and Holland. Their delayed wedding journey to England in the spring of 1875 established a tense, neurotic pattern. The two high-strung temperaments grated on each other from the first. When Berthe asked him to model he was less than obliging, and that modest effort soon became too much for him. Easily upset, Eugène could work himself into a state about trivial matters and would make a fuss if her hair was untidy—as it always was in Manet's portraits.

From Cowes, on the Isle of Wight, she confessed to Edma, who had two children, that she'd failed to become pregnant, or had had a miscarriage, and felt both inadequate and downcast: "I am horribly depressed tonight, tired, on edge, out of sorts, having once more the proof that the joys of motherhood are not meant for me. That is a misfortune to which you would never resign yourself, and despite all my philosophy, there are days when I am inclined to complain bitterly over the injustice of fate." After a short time, they hurriedly left Cowes: "Eugène was depressed and I was in a bad temper because I was doing only poor work." When they were apart from each other, the rather superficial

tendresses of Eugène revealed that (unlike Edouard) he seemed to value her feminine chitchat and stylish clothes more than her intelligence and talent. "I feel very lonely without you," he wrote, "I miss your lovely chatter and your pretty plumage a great deal."

Eugène, like Tiburce, had his own income and was not terribly keen on work. He'd heard of a position in Grenoble as tax collector (the profession of Berthe's brother-in-law, Paul Gobillard), but by the time he'd applied for it, the job had been abolished. Yet he was a great help in encouraging Berthe's career and exerted himself to give her practical support and help hang her pictures. When showing her work in the seventh Impressionist exhibition in the spring of 1882, she gratefully told him: "I cannot get over everything you did for me in that first day; it seems to me that you are working yourself to death, and all on my account. This touches me deeply and vexes me at the same time." Her biographer has summarized Berthe's attitude toward marriage: "She had never loved him. Over the years she had become accepting, tolerant of his tantrums, his moods, his sanctimonious side; grateful for his considerable kindness, admiring of his decency and intelligence, and concerned about his frailties."[3]

In November 1878, the long-hoped-for child, Julie, was born. But Berthe, an anxious and inexperienced mother, was depressed and worried about her daughter's delicate health. Edouard (expressing false optimism about his own inexorable illness) warned Berthe that "it would be a good thing if, in the future, you did not frighten my mother too much about Bibi's [Julie's] health; it puts her in a fearful state. As for myself, I have been better these last two days. I have given up my cane, which is something." Julie, a lovely child, devoted to Berthe, called her a mixture of "artist and tender mother." She recalled that when they looked at Berthe's watercolors, her mother wrote words like "lady" and "duck" on the pictures to teach her how to read. Berthe planned to do a whole album of pictures to instruct children, but never completed the project.

Morisot painted Julie—a patient model, ideal subject and exceptionally pretty girl—from infancy into her teens. She portrayed her with her mother, father, nursemaid and dog, and when she was absorbed in her own activities: nursing, lying in bed, playing with toys, boats, dolls, flowers and cats; resting, dreaming, posing, sewing, reading, drawing, boating, and picking fruit; playing the flute, piano, violin and mandolin. In the swirling, roughly sketched *Julie with Her Nurse* (1880), a later variation of *The Cradle,* the well-dressed nursemaid, with blurred features and red ribbons around her white cap and collar, gazes down at the one-year-old baby sitting on her lap. Julie, like a well-fed idol, looks directly at the viewer. She wears a long white gown, and has wispy blond hair, blue eyes, chubby red cheeks, pursed lips and immensely fat forearms. The nursemaid is protective yet self-effacing; the baby is beginning to develop a forceful character of her own.

Eugène Manet and His Daughter at Bougival (1881) and *Eugène Manet and His Daughter in the Garden* (1883) are companion pieces that portray a leisurely summer idyll. In the former the luxuriant garden, confined by a blue gate with neighboring houses behind it, is alive with sunlit red flowers. Eugène, seated in profile on a blue bench, with hands in his pockets, gazes down at Julie, who looks years older than the infant of 1880 and rests her toy village on his knees. With a Vandyke beard and long straight nose, he is fashionably dressed in a wavy-brimmed bowler hat, blue cravat, fawn-colored jacket and blue trousers. The delicately featured Julie, facing the viewer, has bangs and long blond hair. She wears a yellow sunbonnet, tied with a ribbon under her neck, and a long, pink frock. Eugène carefully observes her as she moves around the tiny trees and houses, and a silent bond is formed as both become absorbed in her game. In 1882, shortly before Manet's death, Eugène reported that Edouard had visited the seventh Impressionist exhibition and declared that with this double portrait Berthe had now far surpassed Gonzalès: "your

pictures are among the best, and he has changed his opinion about the effect of [this] portrait."[4]

In the second picture, the garden, defined by a tree trunk and a small circular pond, is darker and filled with thick foliage. Eugène, seated and wearing a straw hat and long white artist's coat, holds a sketchbook and faces the viewer. Julie, with long golden hair and black sash tied round the waist of her white dress, sits on a low, cross-legged stool. She faces away from the viewer and floats her red wooden sailboat in the pond. In this painting, father and daughter, looking away from each other and absorbed in their own activities, are more enclosed but also more detached.

In *Julie Manet and Her Greyhound Laertes* (1893) Berthe's self-assured daughter is now fifteen. Round-faced, rosy-cheeked and full-breasted, in a long blue dress, a black shoe pointing out beneath it, she rests one hand on the pink sofa, the other on her dog's throat, and faces the viewer. Standing at her feet is the sleek, sharp-nosed Laertes (named for the father of Odysseus), whose sinuous shape and tail curving between his legs echo Julie's wasp-waisted figure and streaming chestnut hair. Berthe's maternal tenderness and adoration of Julie shine through all these paintings. Like the late work of Matisse, they are full of *le bonheur de vivre*.

Later on, as Julie was growing up, Morisot's black hair became prematurely white, but she retained the beauty, intensity and sadness that Manet had captured in his dazzling portraits. De Régnier, a sympathetic observer, noted her intriguing self-possession: "Tall and slender, extremely distinguished in mind and manner, [she was] an artist with the most delicate and nuanced talent.... Her hair had gone white, but her face had retained its enigmatic singularity and its fine regularity, its expression of taciturn melancholy and its fierce shyness....She seemed lofty and distant, with a sort of infinitely intimidating reserve...but from her coldness emanated a charm to which you could not remain indifferent." Renoir, another member of her intimate circle, was not enthusi-

astic about women painters, but he did an affectionate portrait of Morisot and called her "so feminine she would make Raphael's [i.e., Titian's] *Virgin with the Rabbit* jealous." Julie Manet recalled that when Mallarmé praised her mother's charm and talent, Renoir remarked: "Another woman with all that would have found some way to be intolerable."[5]

II

IN MARCH 1883 Berthe told her brother that Manet was very ill and that the doctor's overdose of ergot "has very nearly dispatched him into the next world." His death was a great shock to her, and she wrote of it with deep feeling. In a letter to Edma she described his final torments, remembered the years they had shared and the qualities—his brilliance, charm, responsiveness—that had inspired her love:

> These last days were very painful; poor Edouard suffered atrociously. His agony was horrible. In a word, it was death in one of the most appalling forms that I once again witnessed at very close range.
>
> If you add to these almost physical emotions my old bonds of friendship with Edouard, an entire past of youth and work suddenly ending, you will understand that I am crushed.... His richly endowed nature compelled everyone's friendship; he also had an intellectual charm, a warmth, something indefinable.... I shall never forget the days of my friendship and intimacy with him, when I sat for him and when the charm of his mind kept me alert during those long hours.

Another letter described their long, youthful friendship, his irresistible attractiveness and boundless vitality: "how painful the spectacle of that terrible agony was for me. Edouard and I were friends for many, many years, and he is associated with all the memories of my youth; moreover, he was such an attractive personality, his mind was so young and alert, that it seemed that more than others he was beyond the power of death."

Manet's mother, who'd been taken away from his deathbed and moved to another house, was mercifully unaware of his amputation. Four months after his death, Mme. Manet—exactly like her husband—had a stroke that left her paralyzed and speechless. "She stays in bed," Berthe wrote, "her face is frightening; her sons [Eugène and Gustave] maintain that she is quite rational, but she does not seem so to me."[6]

After Manet's death, Morisot made extraordinary efforts to enhance his reputation. Along with Manet's brothers, his wife and Claude Monet, she organized a posthumous exhibition of his paintings that opened in January 1884. Just before the show she praised his work, predicted a favorable reception and bitterly observed that his genius would be recognized only after his death: "I think that it will be a great success, that all this painting, so fresh, so vital, will electrify the Palais des Beaux-Arts, which is accustomed to dead art. It will be the revenge for so many rebuffs, but a revenge that the poor boy obtains only in his grave." After seeing this exhibition, she seemed to allude to her love affair with Manet and told Edma: "My life is not as amusing as you think. I do go to the Beaux-Arts, but the days of trysts are over."

Morisot also purchased several of Manet's works at an unsuccessful auction, helped Monet sell *Olympia* to the state, and bought her own portrait with black hat and violets. In her very last letter, she asked Degas to include a work by Manet if (as planned) he founded a museum for his own collection. When her brother-in-law, Commander Pontillon, refused to accept the gift of Manet's *Departure of the Folkestone Boat* (1869)—the captain in the painting violated the rules by remaining on the open bridge when the ship's controls were on the deck below—she presented it to Degas, who was extremely grateful. "You wanted to give me great pleasure," he told her, "and you have succeeded in doing so. May I also tell you that I deeply feel the many delicate meanings conveyed in your gift." Morisot saw the irony in Manet's growing posthumous reputation and observed: "It is

odd that Edouard with his reputation as an innovator, who has survived such storms of criticism, should suddenly be seen as a classicist. It just proves the imbecility of the public, for he has always been a classic painter."[7]

Morisot continued to live a quiet, productive life that focused on her work, her husband and daughter, her home and close friends, and her travels to the south of France and abroad. She exhibited with the Impressionists until their last show in 1886, participated in a successful show in Durand-Ruel's gallery in New York that year and in 1894 sold *Young Woman in a Ball Dress* (1879) to the Musée du Luxembourg.

In the winter of 1887 Morisot reported that Eugène was seriously ill and had become an invalid: "my husband is coughing badly, almost never leaves his room; just picture yourself a sick man…greatly to be pitied and no less high strung." Eugène recovered from this illness. But when he passed away five years later, in April 1892, she once again had to witness, as with Edouard, his final agony. When Edouard died, Berthe was grief-stricken and mourned for him with a deeper feeling than she ever had for her husband. When Eugène died, she was overwhelmed by guilt and tormented by remorse:

> I have descended to the depths of suffering, and it seems to me that after that one cannot help being raised up. But I have spent the last three nights weeping. Pity! Pity! Remembrance is the true imperishable life….
>
> I should like to live my life over again, to record it, to admit my weaknesses; no, this is useless; I have sinned, I have suffered, I have atoned for it. I could write only a bad novel by relating what has been related a thousand times.[8]

Berthe wept for three long nights because she had sinned by sleeping with Edouard and atoned for her sin by marrying Eugène—just as Auguste Manet had once sinned with Suzanne and Edouard had atoned for his father's sin by marrying her.

Morisot recovered from severe illnesses of her own in the winters of 1887 and 1890. But, like Edouard, she had to endure a painful death. It's highly ironic that Morisot, who'd always been anxiously concerned about Julie's health—suddenly canceling trips in Italy or taking her from Paris to a warmer climate in the south of France—died of pneumonia from an infection she caught from her daughter. On February 27, 1895, a few days before her death at the age of fifty-four, she told her great admirer Mallarmé: "I am ill, my dear friend, I do not ask you to come because it is impossible for me to speak." Julie, strangely echoing her mother's response to Edouard's death, left a poignant description of Berthe's suffering, and her own, on the last day of her mother's life:

> In leaving me my poor mother suffered so much and saw her end coming. She did not want me to go into her room and be left with such a sad memory. Her illness was short but painful, and with frightful pains in her throat she couldn't breathe. Oh, I never, never, thought anything could be so awful. On the Saturday morning she could still laugh, and received a visit from my cousin Gabriel [Pontillon]. Oh, how pretty she still was, looking as she always did, and how good she was. At three o'clock I spoke to Mama for the last time. At seven o'clock Dr. Ganne came. I went into Mama's room but it was impossible to stay there. I couldn't bear to see her unable to breathe and suffering so much. I thought she would be cured and instead watched her dying. It seemed to me that we already had enough misfortunes.

Berthe's unbearably sad farewell to Julie, written the day before she died, is one of the most poignant letters in French, as great as Mme. de Sévigné's letters to her daughter. Berthe made no attempt to assuage the pain of permanent separation from her beloved Julie with the conventional hope and consolation of an afterlife. Though there are many moving examples in litera-

ture of a parent mourning the death of a child, Berthe's letter is a rare instance of a parent mourning the child's loss of herself. Her last selfless thoughts were not of her own impending death, but of the effect of her death on her daughter:

> My little Julie, I love you as I die; I shall still love you even when I am dead; I beg you not to cry, this parting was inevitable. I hoped to live until you were married. Work and be good as you have always been; you have not caused me one sorrow in your little life. You have beauty, money; make good use of them. I think it would be good for you to live with your cousins [on the] Rue de Villejust....Do not cry; I love you more than I can tell you. Jeannie, take care of Julie.[9]

Berthe's belief that love survives death and continues after it, originated in the Old Testament Song of Solomon 8:6–7: "Set me as a seal upon thine heart...for love is as strong as death.... Many waters cannot quench love, neither can the floods drown it." In *Remembrance of Things Past* Marcel Proust developed the same idea, in an elaborate botanical metaphor:

> We say at times that something may survive of a man after his death, if the man was an artist and took a certain amount of pains with his work. It is perhaps in the same way that a sort of cutting taken from one person and grafted on to the heart of another continues to carry on its existence, even when the person from whom it had been detached has perished.

Suddenly orphaned at the age of sixteen, Julie recorded in her journal—in melancholy counterpoint—her own response to her mother's final message: "Oh, my dear Mama has left me a letter. In this precious letter she told Jeannie [Gobillard], 'take care of Julie.' Her last word was 'Julie.' Oh, how she suffered to prolong her life for me. The night of Friday to Saturday was terrible. Mama said she wanted to last until morning to see me again.... Oh, what sadness. I have never thought of being without Mama."

Berthe Morisot was buried near her house, in Passy cemetery, next to Edouard and Eugène. She left Julie not only her limitless love, but also the delicate and charming portraits of her as a child. Following her mother's wishes, Julie lived in the family house with her Gobillard cousins.

In 1887 the pugnacious Camille Pissarro, patriarch of the Impressionist movement and great friend of Morisot, had written that she continued to pursue her own steady course: "Madame Morisot is doing good work, she has neither advanced nor fallen back, she is a fine artist." After her death, he mourned the loss of his admired colleague: "You can hardly conceive how surprised we were and how moved, too, by the disappearance of this distinguished woman, who had such a splendid feminine talent and who brought honour to our Impressionist group which is vanishing — like all things. Poor Madame Morisot, the public hardly knows her!"[10]

On the first anniversary of her death, March 2, 1896, Degas, Renoir and Monet hung her works — as she had hung Manet's — for a memorial exhibition that made sure the public would know and remember her. Degas' biographer concluded that his long relationship with her "had had its tense moments, mostly because of what she had called his bad disposition, but it had never been broken; and in a farewell note to her daughter, Julie, written the day before she died, Berthe revealed that she had been thinking of him toward the end — still as 'Monsieur' Degas of the 1860s."

Morisot's art was cherished not only by Degas, Pissarro, Renoir and Monet, but also by her descendants. As the critic Nancy Mathews observed: "It is hard to imagine an artist whose reputation was left in better hands than Berthe Morisot's." Julie's journal was an intimate record of her life and character; her grandson Denis Rouart edited her correspondence and wrote about her art. Stéphane Mallarmé and Paul Valéry both wrote sensitive appreciations of her work.

Renoir had been appointed Julie's guardian, and Degas continued to take an active interest in her affairs. Just as Edouard had urged Berthe to marry Eugène, so Degas urged Julie to marry Ernest Rouart, the son of his old schoolmate and friend. Both mother and daughter took the advice of their mentors. On November 3, 1898, just before her twentieth birthday, Julie and her two cousins visited Degas' studio and were shown the Ingres portrait he'd just bought. Julie recorded that he then slyly turned the talk to marriage and offered to act as go-between:

> We talk of [Renoir's friend] Jeanne Baudot—M. Degas finds her way of saying good morning charming. "Her charms have seduced me," he says, then all at once he cries: "Suppose I marry Mamzelle Baudot!…That would be a funny marriage." M. Degas talks of nothing else but marriage. Speaking of Yvonne Lerolle and Eugène Rouart's marriage, he tells us that last winter in the Louvre he'd said to Ernest Rouart: "So, you see these young girls [Julie and her cousins]. Which one do you want me to propose to for you? I assure you, you won't be rejected. You're nice, you're well off, you don't look like a fast young man." Ernest didn't reply and now we understand why he took fright at the sight of us. M. Degas said he wants to make our marriages his business. He tells us he will take an interest in us. We felt such great pleasure in joking like this and chatting with this charming, witty man who was so affectionate. At his door he pinched our cheeks and kissed us.

The following month, advancing his cause, Degas told Julie: "I found Ernest for you…now it's up to you to carry on."[11] On May 3, 1899, Degas attended the double wedding of the cousins: Julie Manet married Ernest Rouart, Jeannie Gobillard married the poet Paul Valéry.

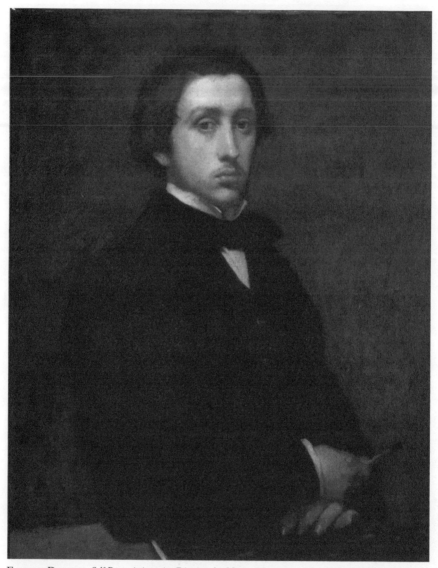

EDGAR DEGAS, *Self-Portrait* (1855). *Réunion des Musées Nationaux/Art Resource, New York*

GREAT DRAFTSMAN
1834–1865

I

❧ EDGAR DEGAS—a quintessential Parisian who lived his entire life in the same part of the city—had an exotic background. Both his grandfathers had led adventurous lives. They escaped from bloody revolutions, ventured abroad and earned their fortunes in foreign cities. His father was born in Naples, his mother in New Orleans. The family name was originally written with the noble particle, De Gas. Edgar was the first to democratize the spelling and signed his works with one word, Degas. His paternal grandfather, René-Hilaire De Gas, the son of a modest baker, was born in 1770. During the French Revolution, when food was scarce and currency unstable, he built his fortune by speculating in grain and changing money. Paul Valéry wrote of his dubious activities: "one day in 1793, while conducting business at the Corn Exchange, which at that time was at the Palais Royal, a friend came up behind him and whispered, 'Clear out!...Run for your life....The [revolutionary police] are at your house.'" He fled to Naples with part of his fortune, opened a bank and became wealthy enough to buy a vast palazzo in the city and a summer villa on the outskirts of town in Capodimonte.

Degas painted a portrait of the distinguished eighty-seven-year-old gentleman, seated on a striped beige couch, firmly gripping a gold-topped cane that rests on his crossed legs. He wears a high white collar and black cravat, white waistcoat and long black coat. His unruly white hair partly covers his balding head and muttonchop whiskers run along his jaws. His face is ruddy,

his nose is long, his lips are thin. His expression is solemn and conveys the impression of an aging but still-forceful personality.

Degas' father, Auguste, was born in 1807 and took over the family bank. Though a son-in-law called him "a perfect model of apathy and egotism," Edgar remembered him as "a very gentle, very distinguished, very kind man, witty, and above all devoted to music and painting."[1] He also did an affectionate portrait of his father at sixty-four (three years before his death), leaning forward on a chair and listening intently to Lorenzo Pagans singing Spanish songs and playing the guitar. (Mme. Morisot heard the same popular musician at Manet's "at home.") The square-faced, rugged-featured Pagans has bushy hair parted in the middle and a long drooping mustache over his half-opened lips. Auguste, with white mustache and balding head framed by the open music on the piano, has a gentle, sensitive face. Pagans' fingers play the guitar; Auguste's fingers, right next to them, are sympathetically interlaced. Completely absorbed in the melody, he stares meditatively into the distance.

Edgar's maternal grandfather, Germain Musson, had fled the Caribbean uprisings in Santo Domingo, led by the black Haitian leader Toussaint L'Ouverture, and settled among the French-Creole families in New Orleans in 1809. Edgar's mother, Célestine Musson, was born there in 1815. When Germain's wife died young in 1819, leaving five children, including the young Célestine, he moved to Paris but maintained his business in Louisiana. He invested in silver mines in Mexico, and was killed there in 1853 when his coach overturned.

Degas' parents were married in 1832 and in fourteen years had seven children, of whom five survived. Edgar, born in Paris on July 19, 1834, was the oldest, followed by Achille in 1838, Thérèse in 1840, Marguerite in 1842 and René in 1845. He was very close to his siblings, and his two brothers would cause him considerable grief. His mother died in 1847, at the age of thirty-two, "evidently worn out by childbearing, perhaps fatigued by an almost nomadic existence, quite certainly unhappy, and probably still

dreaming of [youthful] winter nights of dancing and flirting. Edgar was then thirteen years old." Though his parents were unhappily married, like the older Manets, Edgar was deeply attached to his father and devoted to the memory of his mother. The death of his mother, the extinction of her pure and selfless love, left Degas with a permanent sense of loss, and made him feel both guilty and bitter. His anger and sense of abandonment would later contribute to his suspicion of and hostility to women.

In 1845, aged eleven, Edgar entered the Lycée Louis-le-Grand, one of the best in France, and spent the next eight years there. The school's rigorous military discipline, decrepit buildings and desolate atmosphere came as a shock to boys who'd been coddled at home. In winter they suffered from "convulsive shivering, stiff joints, chapped skin, chronic chilblains and—in the crowded, overheated study rooms equipped with stoves—an unforgettable dunghill smell compounded of January mud, unwashed bodies, and stale food." The prisonlike school "even had cells for solitary confinement, which had held political prisoners during the Reign of Terror. When banished to a punishment cell, the pupil had to do 1,500–1,800 Latin lines a day."[2] Somehow, men of genius emerged from these Spartan conditions, typical of the era. Degas' distinguished predecessors included Molière, Voltaire, Victor Hugo, Delacroix and the infamous Robespierre.

The biographer of Baudelaire—who was actually expelled from the school—wrote that "the fees were high, which meant that [his] schoolfellows were for the most part the scions of the landed aristocracy and the sons of wealthy industrialists or of well-paid members of the legal profession. A number of the boarders came from the families of planters and merchants settled in the French colonies." The conservative critic Maxime du Camp, an embittered graduate, condemned the school's harsh regime and recalled that it had warped his personality: "The college is alleged to build character; I did not perceive anything of the sort, but I did see that it made me become bad-tempered, estranged, deceitful."

The students were awakened at 5:30, and the day was long. They had to remain silent during meals while a fellow pupil read passages from history books. The curriculum was narrow, with a heavy emphasis on Greek and Latin as well as history and literature, mathematics and modern languages (Edgar studied German). The teaching carefully excluded, Valéry observed, "anything to do with the body, the senses, the sky, the arts, or social life." There were forty-five students in each of the rather large classes, and thirty-eight boys slept in each dormitory. With few outings or visits home, the masters, like tutors or parental stand-ins, had great influence. Their "term reports listed each pupil's religious duties, assessed his morals, conduct, character, work, progress and position."

Degas, the best educated of all the Impressionists, derived two great benefits from Louis-le-Grand. He formed close, life-long friendships with several of his schoolmates: Paul Valpinçon, Ludovic Halévy, Henri and Alexis Rouart, and he developed a love of literature. He could masterfully quote long passages from his favorite writers of the seventeenth and eighteenth centuries: La Rochefoucauld, La Fontaine, Pascal, Racine, Saint-Simon and especially the *philosophes:* Montesquieu, Voltaire, Rousseau and Diderot—as well as his near-contemporary, Pierre-Joseph Proudhon. Degas, "with his skepticism, his sense of irony, his worldliness, and his scorn for class distinctions," remained a man of the Enlightenment.[3]

Like Manet with Couture and Morisot with Guichard and Corot, Degas studied intermittently for four years with Louis Lamothe, an incisive, dedicated draftsman who'd been a pupil of the greatly admired Ingres. Degas drew from the nude in the mornings and copied in the Louvre in the afternoons. A former student described the ineffectual Lamothe as "a poor man fated for misfortune, who was prevented by his timid nature and by his general misery from revealing his capacity as he should have." Degas soon outgrew his tuition. In a letter to the painter

Gustave Moreau he mocked Lamothe's personal weaknesses and called him "more idiotic than ever."

Degas was greatly encouraged (as Manet had been by Delacroix) by visiting the studio of Ingres, the great neoclassical draftsman. In a favorite anecdote that Degas never tired of repeating and embellishing, Ingres praised his early efforts and told him "never work from nature. Always from memory, or from the engravings of the masters.... Draw lines, young man, draw lines; whether from memory or after nature. Then you will be a good artist." This excellent advice suited his own talent and convictions. Degas and his friend were about to leave the studio when the master dramatically fainted: "Ingres bowed very deeply; and in doing so, he was seized with dizziness and fell on his face. When they lifted him, his face was covered with blood. Degas washed him and then hurried to the Rue de l'Isle to find Mme. Ingres." In other versions of the story, Degas, alert and ready when Ingres began to reel, caught him before he fell, and later proudly boasted: "I've held Ingres in my arms."[4]

Degas followed Ingres in his willingness to work obsessively on a particular painting. Ingres observed:

> It's true that I often scrape out my work and begin again... but I cannot, really, do otherwise.... I'd rather make one painting well than ten mediocrities. Then there'll be a reward for all the late nights and sacrifices.... Most of these works, which I love because of their subjects, seem to me worth the trouble to make them better, in repeating or retouching them.... Should an artist hope to leave a name to posterity, then he could never do enough to render his works more beautiful and less imperfect.

Degas also shared Ingres' belief that an artist should sacrifice social life and devote himself to work. "I'll shut myself up at home," Ingres insisted, "to lead finally a life which, anyhow, I like, retired, calm, entirely disinterested, my last moments given over

to the love of art." In his book on *Great Draughtsmen,* Jakob Rosenberg placed Degas in the great tradition of French artists who'd perfected the line and called him "the one outstanding figure of the nineteenth century, perhaps the only one who can follow Watteau [and Ingres] without giving us a feeling of decline."[5]

II

ITALY ALSO HAD a great influence on the young Degas. With close family ties and sufficient wealth to travel and study, he spent nearly three years, from 1856 to 1859, in Naples, Rome and Florence. Degas also journeyed through central Italy—to Viterbo, Orvieto, Perugia, Assisi and Arezzo—and learned color and line by copying hundreds of Old Masters in museums. He lived mainly with his family in Naples and painted several portraits of his relatives. A major port, beautifully situated on the bay and within sight of Mount Vesuvius, Naples was then the largest city in Italy. He spoke the Neapolitan dialect fluently and with an authentic accent. He loved Italian opera and the music of Domenico Cimarosa, and while painting he would entertain his models by singing Neapolitan songs. His interest in Italy later led to friendships with several popular, second-rank Italian painters who had settled in Paris: Giuseppe De Nittis, Giovanni Boldini and Federico Zandomeneghi (a comrade of Garibaldi).

In the 1850s, Italy was still a collection of small states, partly controlled by France and Austria. Degas returned to Naples from March to July 1860, just before the Risorgimento, the most significant political movement in modern Italian history. In May 1860 the popular general Guiseppe Garibaldi sailed from Genoa with a thousand red-shirted volunteers, landed at Marsala in western Sicily and liberated the island from the reactionary rule of the Bourbon king of Naples, Francis II. Garibaldi then marched up the west coast, defeated the Bourbon army and handed over southern Italy to the liberal King Victor Emmanuel II. He'd ruled the so-called Kingdom of Sardinia in Turin and became monarch of the united country in 1861. The revolution destroyed the

Bourbons, and Italy was unified for the first time since the fall of the Roman Empire. Degas' brother-in-law took part in the Italian revolution, and Garibaldi was always a hero to Degas.

In his youth Degas was very different from the madly driven artist of his later years. His *dolce far niente* life in Italy gave him so much leisure that he was in danger of never starting, let alone finishing, his work. He was very fond of quoting a passage from Rousseau's *Confessions* (1788) in which Rousseau praised the youthful need for itinerant indolence and wrote: "The idleness I love…is the idleness of a child who is incessantly on the move without ever doing anything.…I love to busy myself about trifles, to begin a hundred things and not to finish one of them…to begin on a ten-years' task and to give it up after ten minutes."

Given this tendency to idleness, Degas' father (who was supporting him) felt obliged to keep up a barrage of admonitions. He told Edgar that he would someday have to earn his living and that it would be foolish to ignore the economic realities of life: "the problem of keeping the pot boiling is so grave, so urgent, so crushing, that only madmen can scorn or ignore it." He also encouraged his son's precocious talent: "you have taken a tremendous step forward in art; your drawing is strong, the tone of your colour is right.…You can be quite certain that you'll succeed in doing great things. You have a wonderful destiny ahead of you, don't lose heart, don't get into a turmoil."[6]

To Edgar's uncle, who in 1862 had expressed concern about his apparent lack of progress, Auguste became ironic and expressed a certain impatience: "Our Raphael is still working, but has not produced anything that is really finished, and the years are passing." Two years later, though Edgar was now thirty and had made no apparent progress, Auguste — realizing (like Rousseau) that it took time for creative ideas to become transformed into art — once again expressed belief, based on reports from the family in Italy, in his son's ability: "Edgar is still working enormously hard, though he does not appear to be. What is fermenting in that head is frightening. I myself think — I am even

convinced—that he has not only talent, but genius. But will he express what he feels? That is the question."7 Edgar was lucky to have Auguste's discerning faith, encouragement and support.

Degas formed lively friendships with two French painters in Italy. James Tissot, four years younger than Degas, was well educated and had also been a pupil of Lamothe. He had "a shock of jet-black hair, a drooping Mongolian mustache, an excellent tailor, and a small private fortune." A lady friend described him as "a charming man, very handsome...nothing of artistic carelessness either in his dress or demeanour." In 1867 Degas painted Tissot in an artist's studio, fashionably dressed, with his top hat and black coat flung aside, holding a slender cane, seated in a hard chair and tilted slightly backward on his elbow. He's surrounded by art: a large Japanese-style painting hangs above him and a portrait of Frederick the Wise by Lucas Cranach just behind him. He seems world-weary, dreamy and slightly detached from his surroundings. A few years later, Tissot became involved in the Commune and had to take refuge in London. He remained in England, was influenced by Whistler and became a spectacularly successful painter of elegant society.

For a time Degas was also close to Gustave Moreau, who was eight years older, and they painted each other's portraits. Moreau began as a kind of mentor, and Degas confided in him about his youthful ideas, his cautious progress and even his doubts. Moreau specialized in painting meticulously ornate and bejeweled scenes from ancient civilizations, which would be lavishly described in Huysmans' novel *Against Nature* (1884). Degas took an altogether different artistic path. According to the poet and dandy Robert de Montesquiou, Moreau, who'd encouraged him to paint historical pictures, felt Degas had betrayed his talent by painting contemporary life:

> Moreau never forgave Manet or Degas the use, sacrilegious in his eyes, that they made of their talent. However, when pressed for an explanation, he seemed more inclined to curse

them affectionately....Regarding Degas, the difference of opinion was more plausible. More or less contemporaries, recently companions and friends, disagreements about the schools had separated them, but in both of them one felt a fidelity to their youthful memories.

Moreau, in turn, became the target of some of Degas' wittiest mots. At first he critically yet affectionately called Moreau's painting "the dilettantism of a greathearted man." Later on he became more severe about Moreau's pretentious personality and spurious work. According to André Gide, Degas called the reclusive yet worldly Moreau "a hermit who knows the train schedule" and said "the lions he paints are chained with watchchains."[8]

Degas' Italian journey not only renewed family ties, but also reinforced his Italian cultural heritage. Like Manet with Titian and Tintoretto, Velázquez and Goya, he absorbed the qualities of the Old Masters into his own art: "the spirit and line of Mantegna combined with the dash and coloring of Veronese." He believed, like the great Italian painters, in careful thought and elaborate preparation rather than immediacy and intuition, and later told George Moore: "no art was ever less spontaneous than mine...of inspiration, spontaneity, temperament—temperament is the word—I know nothing." He fulfilled his father's hopes and realized his own ambitions of uniting line and color, and joined the great tradition of fine draftsmanship that runs from van Eyck, through Mantegna, Dürer and Holbein, to Ingres. Kenneth Clark called him, quite simply, "the greatest draftsman since the Renaissance."[9]

III

AFTER HIS STUDIES and travels, Degas began his career in 1859 as an academic painter of historical themes. Inspired by Ingres, Delacroix and the Old Masters he had copied in Italy, he first chose exemplary events in human history that would reveal

his erudition and launch his career by appealing to the Salon jury. Struggling to express his idiosyncratic vision within the confines of traditional art, Degas produced four mysterious, elusive and apparently unrelated pictures: *Jephthah's Daughter, Semiramis Building Babylon, Spartan Girls Provoking Boys* and *The Misfortunes of the City of Orléans*. These uncharacteristic early paintings all focus on women—as heroines in the second and third, victims in the first and fourth.

Jephthah's Daughter (1859–60), an awkward failure, is based on a story in Judges 11:30–40. The painting portrays the warrior Jephthah, surrounded by armed soldiers on foot and horseback, about to fight the Ammonites and rashly vowing that if he is victorious in battle he will sacrifice as a burnt offering to the Lord "whatsoever cometh forth of the doors of my house to meet me." When he triumphantly returns home, his only daughter, clad in white and surrounded by her handmaidens, emerges to greet him, swoons at the dreadful news and bewails her fate. Roy McMullen writes that "the story, like that of Agamemnon and Iphigenia, mixed pathos, horror, sadism, sexual frustration, and echoes from a primitive tribal era of human sacrifice and jealous gods."[10] It also revealed the arrogance of the warrior who foolishly hopes for a cheaply bought victory but, tormented by a tragic irony, is forced to destroy his beloved child before she can fulfill her destiny as a woman.

Semiramis was a legendary Assyrian princess and demigoddess who, after inheriting her late husband's kingdom, opened roads through wild mountains and traveled throughout her vast empire, erected huge monuments and built great cities. In Degas' painting (1860–62), Semiramis and her entourage of serene, graceful women, linked by the thread of white bands around their heads, have just been transported to the royal palace by a stiff-looking horse and chariot. They stand on a terrace overlooking the Euphrates River and gaze at the lightly sketched, dreamlike city that rises, as if by Semiramis' magical

command, in the misty distance. The painting celebrates her delicate yet majestic power and subtly hints that time will inevitably destroy what she has built. As Poe wrote in "The City in the Sea":

> But light from out the lurid sea
> Streams up the turrets silently—...
> Up many and many a marvellous shrine
> Whose wreathèd friezes intertwine
> The viol, the violet, and the vine....
> While from a proud tower in the town
> Death looks gigantically down.

In *Spartan Girls Provoking Boys* (1860–62) four cheeky, aggressive, bare-breasted adolescent maidens, wearing short aprons open at the sides, challenge five naked boys to engage in a wrestling match or sexual combat. The stiff outstretched arm of one girl, thrust toward the enticing circle made by the arms of one boy, emphasizes the reversal of traditional sexual roles. The passive boys—one crouching on all fours, two others backing away—seem unable to respond to the intimidating challenge of the provocative girls. The girls may be taunting the boys for their athletic failure or trying to incite them to glorious exploits. It might also portray a war of the sexes in which, characteristically in Degas, the females and males confront each other on opposite sides of an open space. Or it could express their youthful hopes and fears of physical love. In the background a toga-clad, bearded sage lectures a group of matrons holding their babies, who will replace the deformed infants left to die on the mountain as well as the young Spartans killed in battle.

The original title of the fourth painting, *Scene of War in the Middle Ages,* was "eclipsed for decades by another, 'The Misfortunes of the City of Orléans,' used at the brief exhibition that opened at the Petit Palais on 1 May 1918; it appeared again in the catalogue for the atelier sale. No one really knows how the painting came by this title"—which, in fact, suggests the real subject

of the picture. The "misfortunes of war" had been a major theme for painters in the Napoleonic era, though the iconology derived from Poussin's *The Rape of the Sabine Women* (an episode in Roman history), which combined nude figures, action and violence on a large scale. In *The Misfortunes of the City of Orléans,* Degas' last historical work and most horrific picture, he moved from sources in the Old Testament, the ancient Middle East and classical Greece, to sexual violence in late medieval France. On the right side of the painting are three men on horseback—two with draped headdresses and belted tunics, one bareheaded and in armor. The mounted bowman who dominates the center of the painting has an angelic androgynous face, the second man looks backwards and the third has an evil countenance. All three have raped and murdered four women, painted in grisaille, whose ghastly naked corpses lie abandoned on the ground.

The androgynous horseman in yellow shoots arrows at four naked, twisted and doubled-over survivors on the left. One of them, with bowed head and flowing brown hair, is chained to a tree; a second is doubled over with grief or wounds; the other two are trying to flee toward Orléans. In the background, beneath a sky filled with smoke and menacing storm clouds, the city's roofs and towers burn behind two spiky, barren trees. As the horse tramples one of the corpses, the ugly brute abducts a ninth woman, who's doomed to be raped before she is murdered. Her bare buttocks match those of the bent-over woman on the left as well as of the powerful stallion that carries her away; her left arm, reaching toward the golden horse in the middle, gropes desperately in the air. The red tights of the brute, the red saddle-cloth of the man in armor and the fiery red hair of the bent-over woman match the flames of the city and emphasize the themes of bloodshed and conflagration. *Misfortunes,* a French version of Goya's *Disasters of War,* portrays the tragic fate of civilian victims in war. The atrocities depicted in the foreground have also taken place in the burning city. The men—dressed, mounted and

armed—are cruel and sadistic. The women—naked, vulnerable and defenseless—are helpless and pitifully erotic.

Modern critics have written that the subject of this painting is "a mystery," that it has no literary or historical source and that "no specific disaster took place in Orléans during the Middle Ages." In a far-fetched attempt to find a source, others have tried to connect it to the American Civil War—despite its medieval title, costumes and archers. But there were, in fact, no rapes, brutalities or atrocities committed on the urban population when New Orleans surrendered to Unionist troops in April 1862.[11]

The subject of the painting actually comes from an episode in French history. In October 1428, during the Hundred Years' War, the English army had broken through French defenses and besieged the city of Orléans. In 1429 Joan of Arc, a seventeen-year-old peasant girl from Lorraine, convinced the Dauphin that she had a divinely inspired mission to expel the English invaders from France and have him crowned rightful king. In May Joan broke the English blockade, freed the city, and put an end to the English abduction, rape and murder of French women. Joan's virginity, believed to be a pure source of her miraculous powers, was essential to her role as savior. Captured the following year, Joan was tried by an English religious court and burned at the stake as a heretic. Her reputation languished until the nineteenth century, when she became an increasingly important intellectual and cultural symbol, and her cult reached its peak when she was canonized in 1920.

Degas' painting also has a literary source: the fifth volume of Jules Michelet's monumental and magisterial *Histoire de France* (1844), published twenty-one years before *Misfortunes* and widely read during Degas' school days and early adult life. Michelet, who brought out a separate edition of his life of Joan in 1853, described how William Glasdale, a villainous Englishman who bitterly hated France, "had sworn that if he should enter the town he would put all to the sword, men, women, and children." He

wrote that "rapine" took place, and described how the people of
Orléans burned part of their city to prevent its occupation by the
English invaders. He also suggested the cruelties and atrocities
that fired Degas' imagination. Many wives and children, held as
enemy hostages, were placed in Orléans and exposed to mortal
risk:

> It was to Orléans that the princes confided the care of such
> wives and children of the fugitives as they desired to retain
> [as] hostages. Its citizens displayed extraordinary zeal. They
> readily allowed their faubourgs to be burned down—that is
> to say, a whole city, larger than Orléans itself, containing a
> countless number of convents and churches, which would
> have been so many posts for the English to occupy.

Michelet—stressing the national hatreds, the military siege and
battle, the sacrifice and vulnerability of the civilians—merely
hinted at the brutality. Degas, focusing on the erotically charged
atrocities committed on the women, moved the action out of the
burning city and into the foreground of the painting.

Joan, wounded by an arrow in battle, is not actually portrayed
in Degas' painting. But—as the implied deliverer of the burning
city—she fills the empty space between the archer on horseback
who points to this space and the contorted, fleeing women who
foreshadow her own martyrdom by fire. Degas' contemporary
viewers, imbued with Joan's legend, would have connected her
to the carnage of the painting. The source of *Misfortunes* in
Michelet's *History of France* reveals the unity of Degas' four his-
torical pictures. Like Degas' women, Joan, the Maid of Orléans,
was both heroine *and* victim.

Degas abandoned ancient themes, but his treatment of this
episode from French history, as Henri Loyrette noted, foreshad-
owed his future portrayal of female nudes: "the women in this
picture...strike the same immodest attitudes as the women
Degas would later depict in the act of bathing, drying them-

selves, combing their hair, or sleeping."[12] After completing *Misfortunes* in 1865, Degas suddenly began to paint entirely new subjects and in a very different style. He moved from the historical to the contemporary world, from the neoclassical line of Ingres to more lively and psychologically incisive work, and started to portray the social life in the racecourses, theaters and cabarets of the Second Empire under Napoleon III. He chose his new, modern heroines from ballet dancers, café singers and circus performers, his new victims from absinthe drinkers, laundresses and prostitutes.

Eleven

TENDER CRUELTY
1866–1870

❦ DEGAS' CONTEMPORARIES variously described him as rather small, rather tall and of medium height. One friend said he was "very slim, with an elongated head, 'a high, broad and domed forehead crowned with silky, chestnut hair, with quick, shrewd, questioning eyes deep-set under high arched eyebrows shaped like a circumflex, a slightly turned-up nose with wide nostrils, a delicate mouth half hidden under a small mustache.'" Another friend described his manner, dress and spectacles in more detail. He had

> good proportions and a distinguished air. He carried his head high without affectation, and when talking with someone while standing up he kept his hands crossed behind his back. He dressed without studied elegance but also without eccentricity or negligence. Like all the bourgeois of his time, he wore a top hat, although his was flat-brimmed and pushed back a little on his head. On most days he protected his ailing eyes against bright light with tinted glasses or a pince-nez perched on his nose, which was a bit short. His face was almost colorless and framed by dark brown side-whiskers that were closely trimmed, as was his hair.

When working, Degas usually wore a crushed felt hat and housepainter's smock. His *Self-Portrait* (1863), painted when he was nearly thirty, shows him wearing conventional clothing, with no hint that he's an artist. He has dark hair, mustache and beard,

heavy-lidded brown eyes, snub nose and full red lips. His left hand rests in his trouser pocket; his right, with vibrantly expressive fingers, holds beige gloves and gracefully lifts a top hat. His look is solemn, sceptical and prematurely world-weary.

From his twenties to his fifties and beyond, Degas was known as "the bear": "the Degas who grumbles and the Edgar who growls." Later on, the English painter Walter Sickert saw the high-spirited side of his personality and remarked that his "perpetual characteristic was a rollicking and somewhat bear-like sense of fun." But the bear often had a sore head, and with him friends felt an uneasy mixture of admiration, affection and fear. He was absorbed in his work, and it bored him to be (in both senses of the word) diverted. His dealer and private banker, Paul Durand-Ruel, exasperated by his cantankerous stubbornness, stated: "The man's only pleasure was to quarrel. One always had to agree with him and give way to him."[1]

To keep people at a distance and ensure his privacy, Degas practiced a kind of tender cruelty. He liked to tease friends and deflate them with cutting remarks, and few risked deeper wounds by daring to reply. He justified his aggression by insisting that he'd never have time to work if he wasn't rude to people, and perversely exclaimed to a favorite hostess who'd tried to defend him: "I hear you are saying everywhere that I am not bad, that people are mistaken in me! If you take that away, what will be left to me?"

Yet he could also be kind. He asked an influential friend to put in a good word for an importunate dancer at the Paris Opéra who desperately needed an increase in salary. When one of his models was dying of consumption, he asked another favor: "She wants to die in a sanatorium.... [I hear] there's a tuberculosis sanatorium founded by your Rothschild friends. Can't you get her admitted?" One authority emphasized Degas' protective acidity: "if there ever was a man difficult to know, walled up as he was in an impregnable discretion, a kind of timidity that made

him caustic and often severe when he felt menaced, that man was Degas." Degas evaded recognition, scorned fame and despised the praise of ignorant critics. He insisted: "There's a sort of shame in being known, especially by people who don't understand you. The big reputation is therefore a sort of shame."[2]

Degas, as Morisot noted, was well known for his witty remarks, which friends were pleased to repeat during his lifetime and publish after his death. He loved to puncture pretensions and vanity. When a lady with a bold décolletage asked Degas if he was staring at her, he replied, with a mixture of flattery and impertinence: "I wish I could do otherwise." He could use his wit to comfort a friend. When a colleague was hurt by the vitriolic Albert Wolff, the implacable enemy of the Impressionists, Degas dismissed the German-born critic by saying: "How could he possibly understand? He came to Paris over the tree-tops!"

He defended art, especially when he felt his essential values were under attack. He put down a dealer who rashly called paintings "articles of luxury" by retorting: "Yours may be, *ours* are of first necessity."[3] But he also believed artists needed an element of depravity to make their way in a hostile world. He said the artist Gustave Caillebotte, who showed with the Impressionists, "has the stubbornness of a hunchback, and therein lies his talent." (Watching a hunchback pass by, he also suggested the beauty of ugliness by remarking: "*Ça a son chic*" [that has its own elegance].) He once excluded an artist from their group by insisting: "He's not wicked [*méchant*] enough for us." He shocked his close friends the Halévys by predicting that their young son, Daniel, "is vicious; he will go far." He summarized his views on this subject by paradoxically comparing the artist to the cunning, ruthless and dedicated criminal: "A painting is a thing which requires as much knavery, as much malice, and as much vice as the perpetration of a crime."[4]

Degas had a great sense of humor and was keenly amused by a sign he'd once seen in an English lavatory that, he recalled,

said: "Ond *please*...hadjust yure dress biffore leaving." When particularly pleased by one of his own witty remarks, he'd put out his hand, in a charming way, to be congratulated. Degas' satiric comments were firmly grounded on a sceptical morality. Stressing his high principles, Pissarro called him "a terrible man, but frank, upright, and loyal."[5]

<div align="center">II</div>

DEGAS' ATTITUDE to women, sex and marriage is the most puzzling and elusive aspect of his character. He was very fond of women of his own class, but his sexual life and sexual anxieties have, apart from a few hints, remained a secret. Theodore Reff shrewdly observed the paradoxical quality of Degas' private notebooks, which suggest "a worldly eroticism and an ascetic inhibition...an attitude of moral probity tinged with resignation." Degas hinted that in his twenties he'd had strong romantic feelings, mixed with disappointment and guilt, for several girls. "That was once the *bal Valentino*," he told Daniel Halévy, with a feeling of nostalgia and loss, as they walked past one of his old haunts. "One evening I unmasked a young woman there. I was at the ball; I had taken her there. I was very young then, dressed as Pierrot—I was very young." He then dropped the curtain on this untold story.

In 1856, at the age of twenty-two, he took pleasure in rejection rather than fulfillment, and tantalizingly recorded: "I cannot say how much I love that girl since she turned me down....I can't refuse...to say that it is shameful...a defenseless girl." Though this terse entry is unclear, he may have taken advantage of a young model, who refused to pose for him again. Six years later Tissot, younger and more of a ladies' man, sent him a teasing letter about his lack of progress with another girl and wondered if he was pouring his sexual frustration into his art: "And Pauline? What about her? Where are you now with her? That pent-up passion is not being wasted only on *Semiramis*. I can't

believe that by the time I'm back your virginity in relation to her will still be intact. You must tell me all about it."[6]

Wounded or guilt-ridden by his early loves, Degas became wary and defensive. He could idealize women and put them on a higher plane than men. Speaking of the "heroic" suffering of his sister Thérèse Morbilli, who was nursing an invalid husband, he insisted: "Women have goodness when we are no longer worth anything." But he sometimes dropped his guard. When Julie Manet's cousin said that Mallarmé disdained women, Degas emphasized their power: "women always think that men despise them. On the contrary, we're obsessed by them. They're our only danger, women." In his art Degas could show the ugliness of nude bathers and prostitutes, but he enjoyed the company and conversation of women and tried his best to please them.

Degas' relations with his models were conflicted, and he could be both severe and affectionate. Bad models turned up late or not at all, asked for more coal to warm the room and distracted him by shifting about instead of holding their pose. One model, the twenty-five-year-old Pauline, complained in a lively interview that conditions were substandard in his chaotic studio: "There was no clean, tidy spot on which the model might deposit her clothes, and when her work was ended she was dismissed to a dark, cold and dirty corner which was all *ce vieux maniaque* [that old maniac] allowed his models for a dressing room." She recalled that he sang with "a sweet and expressive voice," and politely, if ironically, apologized for offending her "chaste ears" when he cursed in frustration with his work. But he would also scream at her: "you pose so badly that you will make me die of rage!" It was perilous for a model to venture an opinion during her rest period. One of them dared to ask: "Is that *my* nose, Monsieur Degas? My nose was never like that," and had to pay the penalty. She was put out of the room, "and her clothes thrown out after her. And she was left to dress sadly and thoughtfully on the landing at the head of the stairs."[7]

Unlike most artists, Degas always behaved correctly with his models and did not assume the right to sleep with them. One model, who had an easy time of it, said that Degas (who drew many women combing their hair) spent four whole hours combing *her* hair, to master the motion and the texture. Another, a novice whose first job was working for Degas, remembered that she had been reluctant to take off her clothes. Degas, resorting to mild violence, enjoyed her virginal debut: "I remember that I was the first to see you naked," he said. "But it didn't happen easily. You didn't want to take off your shift. Louise [his maid] had to tear it off you. You looked so chaste; it was charming." A friend recalled that Degas liked to describe his models as if they were thoroughbred horses: "Quite fresh and pretty, isn't she? A real find. With a first-rate back. Come now, show your back."

Degas had a close connection with the seamstress, waitress, circus acrobat and model Suzanne Valadon, whom he called "that she-devil of a Maria." She was the mistress of Puvis de Chavannes, Renoir and Lautrec, and mother of the painter Maurice Utrillo. Degas praised, and even collected, her work. When asked if she'd ever slept with him, she said she would gladly have done so, out of gratitude, but "he was too scared." When friends wondered if Degas slept with his maid, if not his models, and closely questioned her about this, she replied: "Monsieur? No. He is not a man. I once went to his room when he was changing his shirt and he said to me, 'Get out, you miserable creature!' "[8] But this could mean that Degas, more discriminating than most men, did not want to sleep with *her*.

Degas was neither prudish nor impotent. He once, without the least embarrassment, stripped naked and dressed in front of Valéry. Robert Herbert pointed out that "on the eve of a visit to Spain, Degas gave his traveling companion, Giovanni Boldini, a discreet address where he should buy 'a large number' of condoms, for, he wrote, 'there can be seductions, in the first place for you, but even for me, in Andalusia. And we should only

bring back good things from this trip. Enough said.'" He once told a model about his youthful indiscretions: "Like all young men, I had a dose of the clap, but I never had much of a fling." If Degas himself was hesitant, he was quite capable of urging others to have sex for their own good. The Goncourt brothers recorded that he once "turned to his maid Sabine and said: 'At your age, if a girl has never made love, if she's still a virgin, she's unbearable. I can't stand your fussing and fretting any longer. Nittis, go and bed her.' "9

Degas may have been wounded by a youthful rejection or frightened by venereal disease, but he also had a great natural reserve, love of privacy and dedication to his work. One friend felt he was too timid to risk rejection: "he was prey to an adolescent shyness, a fear of refusal, a preliminary embarrassment and shame, that kept him from moving along the amorous way. His tentative questing, with his models, would be checked, then turned to jesting." Degas' reticence, even secrecy, inevitably provoked some wild speculation. Vincent Van Gogh (who didn't exactly have a way with the ladies) put it rather crudely by claiming that Degas had sexual problems and (as Tissot had once suggested) that he displaced all his sexual energy into the discipline of art: "Why do you say that Degas can't get it up properly? Degas lives like some petty lawyer and doesn't like women, knowing very well that if he did like them and bedded them frequently, he'd go to seed and be in no position to paint any longer. The very reason why Degas's painting is virile and impersonal is that he has resigned himself to being nothing more than a petty lawyer with a horror of kicking over the traces. He observes human animals who are stronger than himself screwing and fucking away and he paints them so well for the very reason he isn't all that keen on it himself."10

Since Degas was disillusioned with women, fearful about sex and unwilling to commit himself emotionally, it's scarcely surprising that he never married. Longing to be alone yet weary of soli-

tude, he sometimes wished for the solace of marriage and regret-
ted his inability to find a wife. In a famous notebook entry of
1857—written when he was twenty-three, filled with yearning,
sadness and the knowledge that his dreams were impossible—he
asked himself: "Could I find a good little woman, simple, calm,
who understands my whims, and with whom I could spend a
modest life of work? Isn't this a nice dream?" Fifteen years later,
while living amidst his relatives in New Orleans and observing
the pleasures of family life, he expanded his futile hopes to in-
clude children, and ended with a note of regret. Speaking of his
thirst for an ordered life, he explained: "I do not even regard a
good woman as the enemy of this new method of existence.—A
few children for me of my own, is that excessive too?…It is the
right moment, just right. If not, the same order of living, but less
cheerful, less respectable and filled with regrets." As he got older,
he often felt sad about missed opportunities.

Degas' desire to marry was sometimes provoked by exasper-
ation with his housekeeper rather than by loneliness, and he
once made a hesitant and rather absurd proposal. When helping
a cousin of the Halévys into a cab, he impulsively said: "'Made-
moiselle Henriette, your father has given me permission to ask
for your hand.' So, instinctively she gave me her hand. 'But no,' I
cried, 'I want to marry you.'…It was all because of that fool of a
Zoé whom I had fired that morning. I said to [Zoé], 'You make
me regret that I am not married. How can a man live with an
idiot, a fool like you?'…When I have a wife, Zoé will have to toe
the mark." On other occasions, when the subject came up, he
gave a rather implausible excuse for not marrying. "I could never
bring myself to do it," he told the art dealer Ambroise Vollard. "I
would have been in mortal misery all my life for fear my wife
might say, 'That's a pretty little thing,' after I had finished a
picture."

But there was a serious aspect of this excuse. The Impres-
sionist painters had married common women who could tolerate

an uncertain, bohemian existence. Unlike Morisot and Cassatt, they lacked education, culture and refinement. An intensely private artist, who felt it would be shameful to be known by people with no discrimination, Degas wanted a woman who understood not only his whims (*"mes folies d'esprit"*), but also, his art. He would never take a wife who, like his models, might mistake his picture for "a pretty little thing." Nor would he succumb to the wishes of a woman of his own class, who wanted an elegant, comfortable household. "There is love and there is work," he concluded, "and we only have one heart."[11]

Like Degas, several nineteenth-century painters and writers renounced marriage and advocated a monkish dedication to their work:

> "A married man," said Courbet, "is a reactionary in art." Gentle Corot's stand was just as uncompromising: "I have only one aim in life which I wish to pursue resolutely.... This firm decision prevents any serious attachment."
>
> Delacroix vehemently criticized a young painter who wanted to get married. "And if you love her and if she's pretty, that's the worst of all...your art is dead! An artist should know no other passion than his work, and sacrifice everything to it."

Even the Impressionists who lived with their mistresses were reluctant to regularize their relationships and legitimize their children.

Flaubert, who kept his mistress at a safe distance, also felt that conventional marriage would distract him and compromise his imaginative life: "A normal love, regular, steady, permanent, would take me out of myself too much; it would disturb me; it would lead me into a life of action, into physical reality, into the common path." Like Flaubert and the writer-hero in Henry James' "The Lesson of the Master" (1888), Degas believed that marriage interfered with the artist's quest for aesthetic perfection. When the aspiring young writer in James' story asks, "Are

there no women who really understand—who can take part in a sacrifice?," the great, solitary author responds: "How can they take part? They themselves are the sacrifice."[12] Degas believed that great art and imaginative power demanded a kind of personal purity that could only be achieved in ascetic isolation: "If you want to produce art seriously and make for yourself a little corner of originality, or at least keep for yourself a thoroughly guiltless personality, you must immerse yourself in solitude." He felt that "the most beautiful things in art come from renunciation."[13]

<div align="center">III</div>

BY 1868 DEGAS had fulfilled his youthful promise and had his work accepted by the Salon jury for four years running: *The Misfortunes of the City of Orléans* in 1865, *The Steeplechase* in 1866, *The Bellelli Family* in 1867 and *Mlle. Fiocre in the Ballet "La Source"* in 1868. He began to be noticed in the press, and, more importantly, had moved from historical to his characteristically contemporary themes: the racetrack, portraits and the ballet.

His early masterpiece, *The Bellelli Family* (1858–67), portrays his aunt, Laura Degas, her husband, Baron Gennaro Bellelli (a lawyer and liberal journalist) and their two daughters (his cousins) in their domestic setting. In letters to Degas of 1859–60, Laura poured out her bitterness against the husband she loathed. She called him "immensely disagreeable and dishonest," and predicted that "living with Gennaro, whose detestable nature you know and who has no serious occupation, shall soon lead me to the grave." She mentioned his "disagreeable countenance" and said he had no work "to make him less boring to himself"—and to her.

The charming décor, which contrasts to the couple's unhappiness, is beautifully painted: the pale blue flowers on slightly darker blue wallpaper; the mantelpiece with candlestick, plates, pilastered clock and framed picture reflected in the mirror; the narrow receding passageway on the left and the hard-to-see, little

cut-off dog in the lower right-hand corner—scampering out of sight.

In the background is a gold-framed, red chalk drawing by Degas of his recently deceased grandfather (Laura's father). The pregnant Laura, in a triangular mass of mournful black clothing, stands with one arm around her daughter Giovanna, the other resting with extended fingers on a table, and stares gloomily into the distance. The red-haired Giovanna, standing next to her mother, wears a white pinafore over a black dress, primly crosses her hands at her waist and looks solemnly at the viewer with large blue eyes. The younger, dark-haired Giulia also wears a white pinafore, but her black dress is shorter and reveals one white-stockinged leg, balanced by two legs of the chair. Seated on the edge of a hard chair in the center of the picture, her hands on her waist, she looks gravely to the left with half-closed brown eyes, past her father and in the same direction as her mother. The baron, seated in profile on a dark soft chair near the fireplace, has a high balding forehead, brown mustache and beard, and gray jacket. He looks toward, but not directly at, his wife and daughters. The new baby, it seems, will do nothing to alleviate the parents' hostility. Despite the intimate setting, the Bellellis— like the man and woman, close to each other but disconnected, in Degas' *Sulking* (1869–71)—seem fatally estranged.

Though Gennaro (1812–64), ignored by his family and disliked by Degas, seems something of a nonentity, he was actually a fiery agitator and important politician. Born in Naples, he took part in the Italian revolution against the Bourbon monarchy in 1848, fled to Marseilles the following year and was condemned to death in absentia in 1853. He lived in Florence, the capital of Tuscany, from 1852–59, and was pardoned and allowed to return to Naples in 1860. He supported Garibaldi's revolutionary movement, and became an administrator and senator in the government of King Victor Emmanuel II. The palpable tension in Degas' group portrait derives from Laura's fragile health and

mental illness, and from the political and financial difficulties of Gennaro's exile in Florence. The strained atmosphere in *The Bellelli Family* (and in Manet's portrait of his parents) seems to confirm the opening sentence of Tolstoy's *Anna Karenina:* "All happy families are alike, but an unhappy family is unhappy in its own way."

Interior: The Rape (1868–69)—sad, brooding and brown-toned—is Degas' most fascinating and enigmatic painting. It also derives its power from the tense relationship of the characters. On the right of the picture a bearded young man, fully dressed in dark clothing, his face in shadow and eye glittering, leans against the door of a cozily decorated but low-ceilinged, rather claustrophobic hotel room. His legs are spread apart and hands placed casually in his pockets, and his body casts a menacing silhouette on the wall. On the left, the disconsolate woman, separated from the coldly indifferent man by a glowing table lamp, is half-dressed and bare-shouldered. Her black dress and hat are thrown on the bed; her white undergarments are exposed in the open traveling case and flung carelessly on the sloping wooden floorboards. Wearing a green earring and white shift, resting her head on her hand and extending her bare arm on her lap, she turns away from the man and weeps. In the left background, his upturned top hat rests on a table under a framed map. The neatly made, narrow bed, an eerie detail, shows no sign of their struggle. (In Degas' *Woman at Her Toilette* [1876–77], by contrast, the single bed, with turned-down cover, is soft and inviting.)

The woman's white shift on the dark chair and white underwear in the black case are balanced by her black clothes on the white bedspread. Her white garment, the lampshade and her underwear structure the work with a bright triangle, surrounded by darkness, in the center of the picture. The domestic touches suggest that the man has paid for and entered her room as well as her body. The mirror above the fireplace reflects both the man's

passion and the emotional and psychological effects of the woman's violation. The rape is suggested by the dancing fire, her red hair and his red beard, the red flowers on the wallpaper and lampshade, the red stripes in the rug, and by the gaping case with its pink lining garishly exposed by the lamp. The hot line of red leads directly to her corset, suggestively discarded on the floor between them. In a notebook entry Degas expressed fetishistic interest in "corsets...that have just been taken off and seem to retain the shape of the body."[14]

This painting could have been called *The Misfortunes of Sex in Paris,* for the bent, bare-shouldered woman, her back exposed to the rapist, has the same vulnerable pose as the violated woman on the left edge of *The Misfortunes of the City of Orléans.* We focus first on this woman; then read the picture from left to right, from the darkness of the chair, floor, dress and trousers that lead from the woman to the man. His crotch, just above the shadow cast by the symbolic traveling case, is subtly illuminated by the lamp. He seems to block her exit and trap her forever. Though responsible for the woman's pain and grief, the man does not sympathize with, and may even sadistically enjoy, the sight of her weeping. They have coupled, but are now separated—physically and psychologically—by the illuminated space between them, a gulf that can never be bridged.

The critic Camille Mauclair has vividly described the painting's anguished atmosphere and disconcerting emotions: "we find ourselves in the terribly heavy silence which followed on the brutal struggle: a silence broken by the sobbing of the semi-nude victim, bowed down by grief, whilst, with his back to the door, the man, who, now that he has satisfied his lust, is once more correct, but mournfully so, contemplates her despair, though, despite his ennui and remorse, with a glint of madness in his eyes." Gordon and Forge noted the series of contrasts that structure the painting: "Black: white; standing: crouching; dressed: undressed; straight: curved; facing in: facing out—every fea-

ture…in each of them finds its opposite in the other. This is intimacy of a terrible kind."[15] The visual clues and body language in this dramatic picture transform an act of physical aggression into a moment of unbearable psychological anguish. The painting suggests Degas' own ambivalence about sex: the cruel pleasure of brutal dominance as well as sympathy for the violated victim.

TOUCH OF UGLINESS
1870–1874

I

✥ THE OUTBREAK of the Franco-Prussian War in July 1870 scattered the Impressionists. Pissarro and Monet went to England, Alfred Sisley stayed with his family and Cézanne hid in Provence. Renoir was drafted into the cavalry and Frédéric Bazille joined the Zouaves. Degas and Manet, in their late thirties and over military age, both volunteered for service in the National Guard. They refused to accept the defeat at Sedan as the end of the war and, as patriotic Parisians, wanted to defend the capital against the German enemy.

Degas originally joined the infantry but, after discovering that he couldn't see the rifle target, was sent to the artillery. He finally became a gunner in the ring of fortifications that circled Paris. In early October he was posted to Bastion 12, near the Bois de Vincennes, under the command of his school friend, the successful engineer Henri Rouart. With all quiet on the eastern front, Degas, secure in his fort and with no taste for military duties, could draw, read and enjoy the autumn silence. His Italian biographer related that as food became scarce "during the siege, he often had to return to his father's house to satisfy his hunger with sewer rats which could be bought for five francs each."

In October 1870 Mme. Morisot told Edma that Degas had "not yet heard a [German] cannon go off. He is looking for an opportunity to hear that sound because he wants to know whether he can endure the detonation of guns." She told Berthe that "he and Manet almost came to blows arguing over the

methods of defence and the use of the National Guard, although each of them was ready to die to save the country." Deeply affected by the death of his friend the sculptor Joseph Cuvelier, Degas was furious at James Tissot's response: "Tissot met Degas and Manet as he returned from battle and told them that he had seen a mutual friend among the dead and had made a drawing of him. When he took out the sketch to show them, Degas pushed it angrily away, telling Tissot that it would have been more fitting to bring back the corpse."[1] His affection for his friend obliterated his artistic impulses.

Referring to the government buildings burnt during the Commune, the anti-Communard Mme. Morisot vengefully exclaimed: "Should M. Degas have got a bit scorched, he will have well deserved it." Though Degas was not scorched, his sight deteriorated during the siege of Paris when cold air from an open window blew down on his face as he slept. In September 1871 he first expressed the fear that he would go blind: "I have just had and still have a spot of weakness and trouble in my eyes... being unable to read or work or go out much, trembling all the time lest I should remain like that." Living under the bright semi-tropical sun of New Orleans the following year, he noted the limitations of his vision, yet still felt he could go on painting: "My eyes are so greatly in need of care that I scarcely take any risk with them.... Manet would see lovely things here, even more than I do. He would not make any more of them."[2]

<center>II</center>

DEGAS' FAMILY was scattered throughout the world, from New Orleans and Buenos Aires to Florence and Naples. In October 1872, a year and a half after the end of the war, Degas and his brother René sailed from Liverpool to New York aboard the *Scotia* to visit his family in Louisiana. His brothers Achille and René had gone into business there, and his mother's French-speaking relatives still lived in New Orleans. Like France,

America was recovering from the disastrous effects of war. The
Civil War had destroyed the cotton-based economy and brought
in predatory northern carpetbaggers. René told the Musson fam-
ily, with mock-heroic exaggeration: "Prepare yourselves to give a
fitting reception to the Gr-r-r-reat Artist. He asks that you do
not come to meet him at the station with the Bruno Band, mili-
tia, firemen, clergy, etc."

Degas could not speak English (though he was fascinated by
and kept repeating the phrase "turkey buzzard"), and on the ten-
day voyage could not penetrate the passengers' reserve. He spent
two lively days in New York and exclaimed: "What a degree of civ-
ilization! Steamers coming from Europe arrive like omnibuses at
the station. We pass carriages, even trains on the water. It's Eng-
land in her best mood." During the four-day train ride south, he
was also impressed by the magical service in the Pullman sleeping
cars: "You lie down at night in a proper bed. The carriage…is
transformed into a dormitory. You even put your shoes at the foot
of the bed and a kind negro polishes them whilst you sleep."[3]

Once in New Orleans, Degas was overwhelmed by the exotic
architecture and luxuriant fruit and flowers, by the colorful
mingling of whites and blacks, by the old-fashioned buses and
huge boats that seemed to float into the center of town: "Villas
with columns in different styles, painted white, in gardens of
magnolias, orange trees, banana trees, negroes in old clothes…
rosy white children in black arms, charabancs or omnibuses
drawn by mules, the tall funnels of the steamboats towering at
the end of the main street, that is a bit of local colour if you want
some, with a brilliant light at which my eyes complain." Antici-
pating his ambivalent portrayal of *jolie-laide* dancers, bathers and
whores, he noticed that "the women here are almost all pretty
and many have even amidst their charms that touch of ugliness
without which, no salvation."

The linear draftsman, who loved silhouettes, admired the
walking shadows of the blacks, who seemed to stand out boldly

against the bright sky, as well as the dramatic contrast between
nursemaids and babies, bustling businessmen and slow-moving
servants, beautiful women, white or dark:

> I like nothing better than the negresses of all shades, holding
> in their arms little white babies, so white, against white
> houses with columns of fluted wood and in gardens of or-
> ange trees and the ladies in muslin against the fronts of their
> little houses and the steamboats with two chimneys as tall as
> factory chimneys and the fruit vendors with their shops full
> to bursting, and the contrast between the lively hum and
> bustle of the offices with this immense black animal force.
> And the pretty women of pure blood and the pretty 25 year
> olds and the well set up negresses!

Degas painted a number of family portraits. But he was con-
strained by fidgety models who refused to take him seriously, the
need to suit their conventional taste and the "impossible" light
that hurt his sensitive eyes. *The Pedicure,* painted in New Orleans
in 1873, achieves its power from the eerie contrast between the
ostensible and the covert subject: a cosmetic procedure and a
surgical operation. The disturbing scene is all the more somber
for taking place in a cozy domestic setting and on a flowery
white sofa, over which the subject has discarded her dress. The
body of the pubescent girl, like the seat and back of the straight
chair, is wrapped and mummified like a patient or corpse in a
huge white winding-sheet that flows onto the floor. Her eyes are
closed, she looks semi-conscious, and her stiff, cadaverous leg
extends from under the sheet and rests on the chair. The pedi-
curist, dressed in black, attentively bends his white shining dome
over her. The old man, obsessed with the vulnerably exposed leg
and foot of the comatose girl, seems prepared to cut off her toe
with his glittering instrument and throw the body part into the
shallow circular tub. Their strange intimacy and the pathological
theme give the painting great tension and interest.

Degas' Louisiana masterpiece is the group portrait, *The Cotton Office in New Orleans* (1873). This family business was run by the head of the clan, his maternal uncle, Michel Musson, a cosmopolitan gentleman who'd studied law in Germany and learned the cotton trade in England. An art historian explained precisely how his office worked:

> Degas's uncle was a factor, the planter's business representative to the outside world. Under the factor system, Michel Musson or one of his partners accepted a quantity of cotton on consignment from a small farm or large plantation. He then found buyers directly or passed the cotton shipment to other commission agents in the North who would send it to overseas purchasers.... [He] could make all the arrangements for storing the cotton, having it inspected, classified, and insured, and repacking it for further shipment.[4]

In contrast to the local cane workshops in Paris, where (Degas said) "everybody is lively; everybody is working," and to the busy offices of New Orleans, the Cotton Office, with its clouds of cotton that seem to have descended from the sky to the table, is leisurely, static, even idle. The office looks like a theatrical or operatic performance as the curtain rises on an all-male cast. The windows are raised, but there's no breeze or rustling of paper. The floor is immaculate, and at least five of the fourteen figures in the painting are doing precisely nothing. Two young men near the open rear door—perhaps office assistants or messengers—stand, one with his hands behind his back, as if awaiting orders that may never come. Degas' brother Achille, the top-hatted man on the far left, with hands hanging down and legs casually crossed, lounges against the open window frame. To his left, on the other side of the window, a derby-hatted gent dreamily rests his chin on his hand. Seated in the center, with sprawling legs and a cigarette dangling from his lips, his brother René scans the local *Daily Picayune* for interesting tidbits.

Degas attributed the pervasive idleness to the climate, which "must be unbearable in the summer and is sometimes deadening during the other seasons." But there were other reasons for the indolence in the painting. The office, in fact, was run in a casual, out-of-date fashion. On February 1, 1873, while Degas was working on the picture, the business collapsed and went bankrupt. Michel Musson was deeply in debt and "his daughter [Estelle was] losing her sight." Later on, his brother would lose his mind and several of his grandchildren would die. Degas, however, seems to have prospered from the journey. After he'd returned to Paris in late March 1873, an uncle reaffirmed Auguste's faith in his son and reported: "Edgar has come back to us, enchanted by his voyage.... He is, as you say, a likable boy and one who will become a very great painter if God preserves his sight and puts a bit more lead in his head."[5]

<center>III</center>

DEGAS' INTELLECT, personality and talent made him the natural leader of the Impressionists. But his technique and content were normally quite different from those of Pissarro, Monet and Renoir. Their paintings were "sketchy, rather than finished; painterly and loosely handled rather than linear and smooth; directly, sometimes rawly retinal rather than studio-cooked; unemotional and without ideas rather than expressive and intellectual; devoid of story rather than anecdotal." Degas' attitude toward nature, the countryside and *plein air* painting was also strikingly opposed to theirs. He almost never painted or even mentioned the peasants in the countryside: they simply didn't interest him. A confirmed Parisian, he called the excursions of the urban crowd, returning from their country jaunts laden with flowers, "hygienic outings"—as if they'd been relieving themselves in a brothel instead of enjoying a pastoral landscape. He insisted that "boredom quickly overcomes me when I even look at nature," that he "felt stifled and dazed by the amount of air"

in the countryside. On warm sunny days, he retreated indoors and "felt like sleeping all day long with the shutters closed."[6] Painting, for him, was not an outdoor sport; and he half-seriously told Vollard how he planned to punish *plein air* artists: "If I were the government I would have a special brigade of gendarmes to keep an eye on artists who paint landscapes from nature. Oh, I don't mean to kill anyone; just a little dose of bird-shot now and then as a warning."

Degas sometimes painted landscapes and seascapes, but preferred to re-create them in his studio rather than paint outdoors. A brief glimpse of the countryside, by looking out the window of a speeding train, was sufficient. "I get along very well," he said, "without even going out of my own house. With a bowl of soup and three old brushes, I can make the finest landscape ever painted." He told Sickert, "when I want a cloud, I take my handkerchief, and crumple it up and turn it round till I get the right light, and there is my cloud!" *Voilà!* He liked imagining with his inner eye instead of observing directly. When asked how he'd paint a beach, he replied in a similar fashion: "That is easy: I spread my flannel coat on the floor in my studio and make the model sit on it. You see," he said, announcing his belief that an artist must transform, not capture, what he sees, "the air one breathes in a picture is different to that outside."[7]

When taking a carriage ride from the country estate of his school friend Paul Valpinçon to a stud farm in Normandy, Degas read a French translation of Fielding's novel *Tom Jones* (1749) to vivify the people, the environment and the mood. The landscape reminded him of "England precisely. Pastures, small and large, enclosed by hedgerows; damp footpaths, ponds green and umber." Two passages in the novel may have enhanced his pleasure as he bounced comfortably along in his private carriage. Commenting on the constricted space, Fielding amusingly wrote: "in stagecoaches, where passengers are properly considered as so much luggage, the ingenious coachman stows half a dozen

with perfect ease into the place of four…it being the nature of guts, when well squeezed, to give way, and to lie in a narrow compass." Fielding also compared the congenial stagecoach journey to the relationship of the novelist and his readers: "let us behave to one another like fellow-travellers in a stage-coach, who have passed several days in the company of each other; and who, notwithstanding any bickerings or little animosities which may have occurred on the road, generally make all up at last, and mount, for the last time, into their vehicle with cheerfulness and good-humour."[8]

IV

THE BRILLIANT founding members of the first Impressionist exhibition in 1874 were Degas, Morisot, Pissarro, Monet, Renoir, Sisley and Cézanne. It's significant that the first three, who had had considerable success at the Salon, joined and remained loyal to the renegade group. A friend explained Degas' motives: "[He] used to exhibit at the Salon. He stopped doing so because his work was badly hung and, in his opinion, the public did not pay enough attention to it, although the artists gave him the appreciation he deserved." The good paintings in the Salon were swamped by thousands of mediocre works.

Degas' hostility to the juries and the opinions of critics, including those who praised his work, also drove him away. He agreed with the views expressed by the French socialist Proudhon (who'd been painted by Courbet) in *Of the Principle of Art and Its Social Purpose* (1865). Proudhon dismissed both reactionary juries and critics, and asked: "Why can't we leave artists to their own business, and not trouble about them more than we do about rope-dancers? Perhaps it would be the best way to find out exactly what they are worth." Rejecting both the Salon's exclusions and its awards, the Impressionists offered, for the first time, an exhibition of innovative painting that encouraged both public and critics to form their own opinion.

Though Degas recruited the Impressionist painters, he freely criticized their work. He maintained that Monet created nothing but beautiful decorations, and at an exhibition of brightly colored paintings he dramatically exclaimed: "'Let me out of here. Those reflections in the water hurt my eyes!' His pictures were always too draughty for me! If it had been any worse I should have had to turn up my coat collar." He urged his colleagues to emphasize draftsmanship rather than color—a more fundamental difference than studio as opposed to outdoor painting—but they ignored his advice and went their own way. In March 1874, a month before the opening of the first exhibition, Degas told Tissot (then in England) that he planned to usurp the official Salon with paintings of contemporary life: "I am getting really worked up and am running the thing with energy and, I think, a certain success.... The realist movement no longer needs to fight with the others, it already *is*, it *exists*, it must show itself as *something distinct*, there must be a *salon of realists*."9

The Impressionists had social as well as artistic differences, and the less well off were more Bohemian. Though Paul Cézanne came from a prosperous family in Aix, he adopted a defiant pose, exaggerated his southern accent, and wore a battered old hat, blue worker's overalls and a coarse coat spattered with brush marks. Approaching Manet in the Café Guerbois, he'd aggressively explain: "I am not offering you my hand, M. Manet, I haven't washed for a week." Cézanne's refusal to extend his dirty hand could have been a deferential gesture to the elegant Manet or, more likely, a self-conscious mockery of his dandyism. Though Degas felt democratic solidarity with dancers and workers, he was alienated from some of his fellow artists. He asked the well-born Gustave Caillebotte, when referring to Monet and Renoir: "Do you invite those people to your house?"

Degas was deeply disappointed when their first exhibition, held in Nadar's photographic studio on the Boulevard des Capucines, had low attendance, bad reviews and poor sales. But

he remained the driving force behind the subsequent exhibitions, and forced his followers to obey his fierce will. Caillebotte complained that it was almost impossible to exhibit with Degas, who provoked animosity, or to exclude his brilliant work, which was essential for their success. By 1881 Monet, Renoir and Sisley had withdrawn to the Salon and been replaced by Degas' Italian favorites. Their more conventional techniques and subject matter diluted the boldness of the group, but made it more appealing to the public. When Caillebotte (whose wealth underwrote their exhibitions) strongly objected to the Italians, Pissarro supported Degas. He reminded his colleague that Degas had energetically recruited Mary Cassatt, Jean-Louis Forain and Caillebotte himself.

By 1885, the touchy and aggressive Gauguin, a recent member, agreed with Caillebotte about Degas' imperious behavior, and unfairly attributed it to his egoism and ambition: "Degas' conduct becomes more and more absurd.... You may well believe me, Degas has greatly harmed our movement.... You will see that Degas is going to end his days more unhappy than the others, wounded in his vanity for not being the first and only one." The following year, class differences emerged once again as the indigent painters felt ignored by the wealthy ones. Pissarro wrote Monet that the exhibition was temporarily blocked: "Degas doesn't care, he doesn't have to sell, he will always have Miss Cassatt and not a few exhibitors outside our group.... But what we need is money, [then] we could organize an exhibition ourselves."[10] By the eighth and last Impressionist exhibition in 1886, the painters had established their reputations. They were then able to move to prominent dealers like Paul Durand-Ruel, who had international connections and provided greater visibility, publicity, sales and prestige.

Though the Impressionists had quarreled with Degas, they always appreciated what he had done for the movement. They realized that they'd learned a great deal from him and recognized him as the leading painter of the day. Caillebotte told Monet that

Degas "is very trying, but we have to admit that he has great talent...talks [with] infinite wit and good sense about painting." The generous Pissarro agreed that Degas "is without a doubt the greatest artist of the period....One can see what a real master Degas is; his drawings are more beautiful than Ingres', and, damn it, he is modern!"[11]

HORSES, DANCERS, BATHERS, WHORES

I

 DEGAS' MATURE ART emphasized work rather than leisure. He was attracted to the spectacle of the races and ballet, and fascinated by the delicately built, highly trained, intensely competitive athletes and skilled professionals dressed in gorgeously colored costumes. In performance their beautiful bodies made graceful movements and formed intricate patterns. Degas watched jockeys and dancers prepare for physically demanding feats before an appreciative but critical audience. With unusual camera angles and cinematic shots of bodies in motion, he revealed the exhaustion and exploitation, the strain and injuries of extreme moments: the frantic race of the horses and climactic leap of the dancers. He was more interested in the preliminary tension before a race or ballet than in the actual event; in observing the jockeys and their mounts as well as the dancers and their gentlemen admirers.

In Degas' time, horses were an important part of everyday urban life and pulled carriages and omnibuses through the streets of Paris. Though he was not (like Mary Cassatt) a keen rider, he occasionally mounted a horse and knew the different breeds. He was not primarily interested in the winner and time of the race. Instead, as Theodore Reff observed, at the racetrack "Degas consistently chose quieter, more sober scenes on its periphery: mounted jockeys assembling before the race or lining up at the starting pole, trainers working their mounts or allowing them to graze. Here he could explore at length the horse's noble

proportions and graceful movements." But, Degas insisted, "Nothing in art must seem to be chance, not even movement." Once again, he did not actually paint from outdoor scenes. John-Lewis Brown, the French painter of horses, explained how Degas controlled and re-created his racing scenes: "Of course Degas goes to the race-courses, at Auteuil and Longchamps, but it's in his own studio, twiddling his little wooden horses about in the light, that he succeeds in reconstituting nature."[1]

Degas' racing pictures, a lifelong interest, allow us to trace his progress over a period of thirty-five years. *The Gentlemen's Race: Before the Start* (1862) is a strikingly original frieze of yellow-breeched jockeys in bright silks and caps, and horses with restive but individually distinctive postures. The scene unfolds in a deep green field, in front of a row of fashionably dressed gentlemen and ladies with parasols. In the background, under a thickly clouded sky with faint patches of blue, the chimneys of factories — encroaching on the rural landscape — erupt from brown hills and shoot out trails of smoke like streaming horses' tails. The jockeys and spectators form two contrasting social groups that stand out against the drab industrial buildings where unseen men and women are at work.

Degas used a lighter, but more subdued palette of browns and blacks in *Racehorses before the Stands* (1866–68), and rearranged the elements of the previous painting. Seven horses and jockeys, casting jagged shadows that seem to pursue them on the sandy track, are lined up from the right to the center of the painting, descending in size to indicate a sharp perspective. At the end of the line a jockey, standing up in the stirrups, tries to control a frisky black horse. This wild movement contrasts with the placid stillness of brown horse and jockey standing on the left, near the white rail on the side of the track. Beneath the peaked tower of the tan pavilion a crowd, many of them long-skirted ladies with bright umbrellas, strolls and chats while waiting for the race to start. In the background, under a pale purplish sky and behind a

cluster of trees, appear the roofs of a few houses and the ubiqui-
tous smokestacks. The mood of both jockeys and spectators is
one of quiet yet energetic anticipation.

In his *Exercising Racehorses* (1880) we read the frieze of six
horses and riders—one of them rearing backward, another
showing only its rear legs and hindquarters—from left to right
as they amble across a grassy field spotted with red wildflowers,
with reddish green hills and with a low grayish pink sky in the
background. Horses and riders, in harmony with each other, fit
easily into the gently undulating landscape. Years of observation
and painstaking drawing helped Degas advance from the almost-
wooden horse in his *Semiramis Building Babylon* (1860–62) to the
spirited animals in this picture.

The strangest and most dramatic of the racecourse paintings
is the late *Fallen Jockey* (1896–98). Under a low cloudy sky, a huge
dark brown horse, seen in profile, casting a menacing shadow
and ready to run out of the frame, gallops beneath a cloudy sky
and down a steep green hill. Its front legs are extended off the
ground, its braided mane sticks out in five sharp spikes and its
tail waves high off its rump. Beside (not behind) the horse,
which is still saddled, lies the motionless fallen jockey. He could
be injured, perhaps even dead. Flat on his back, with a beard, ex-
tended arms and feet almost touching, he resembles a crucified
Christ—sacrificed to sport.

II

THE YOUNG BALLET DANCERS of the day were recruited en-
tirely from the working class, and began their arduous training at
the Opéra at the age of seven or eight. They gave up their chance
of a formal education, and could scarcely read or write, yet at-
tended dance classes six days a week, and spent afternoons and
many evenings rehearsing their next performances. Ludovic
Halévy, whose novel about sexual intrigue in the Opéra ballet was
illustrated by Degas, vividly described the austere yet childishly

hysterical atmosphere of the rehearsal room in his novel *Les Petites Cardinal* (1875): "[In] a large square room, the floor is slightly slanted, there is an earthen stove, some benches for the mothers, and a rattan chair for the professor, and this is the extent of the décor. Handrails are fixed to the walls. Daylight streams in from above, brutal and garish. The lesson has not yet begun; there is an infernal din...fifteen little brats laughing, screaming, leaping, squealing, howling." The work was intensely competitive, physically demanding and interminable, and the girls were never allowed to stop: "it's the lesson, the class; the rehearsals, in the foyer or on the stage, of steps, of groups, and of the ensemble. It begins at nine o'clock in the morning and is over at four in the afternoon....It must go on forever and renew itself without a break. Only under this condition will the dancer keep her suppleness and lightness. A week of rest will cost her two months of work."

Unlike the girls who toiled in the dreary factories and mills near the racetracks on the outskirts of Paris, the dancers had glamorous work and a potentially promising future. At the age of ten the less-talented girls were ruthlessly rejected, and the others began their slow progress from student *rats* to the almost unattainable stratosphere of *première danseuse*. "Rigorous annual and biannual examinations were held to determine this advancement, followed by appropriate adjustments to the dancers' level of pay." In the 1880s this ranged enormously, from 700 to 30,000 francs a year.[2] (Seamstresses and lacemakers, for example, earned 600 to 900 francs, teachers 4,200.) The Opéra ballet had a hierarchy as rigid as the army. In 1875 there were 111 dancers and teachers, with the girls and women divided into four main groups, in order of accomplishment: twenty-eight *sujets*, eighteen *coryphées* (named after the leader of the chorus in ancient Greek drama), eighteen in the *deuxième quadrille* and nineteen in the *premier quadrille*.

After the girls were chosen and began to advance, they mastered the daily rituals and last-minute preparations, overseen by their mothers, which had to be completed before they could appear in class, in rehearsals and on stage. "What serious and deli-

cate matters there are to be considered," Halévy wrote, "that the ribbons of their ballet shoes are securely tied, that their tights have no creases and are firmly fixed about their hips, that the seams are straight, the bows properly tied, and the tarlatan [tutu] skirts are puffed out prettily. The inspection over, the mothers energetically rub chalk on the soles of their daughters' ballet shoes." Degas meticulously illustrated this process in his work. Huysmans brilliantly described Degas' ballerinas as "veritable goats built for jumping, real dancers with springs of steel and knees of iron... [with] a special beauty compounded of plebeian coarseness and of grace." He added that despite their steel springs, "it takes a good deal of suffering to arrive at the aerial lightness of the sylphide and the butterfly." The still-growing girls had to twist their supple bodies into acrobatic movements that deformed their feet and knees. The cruel system quickly used up and discarded many young hopefuls.

Degas saw his dancers, shopgirls, laundresses and nude bathers, the women uneasily alone in public places like cafés and racetracks, in their economic context. All of them seemed to be, or actually were, sexually available. The Opéra ballet, made up of bold adventurers as well as dedicated professionals, was a sexual arena that provided an alternative livelihood for failed dancers and princely rewards for those who accepted the protection of rich patrons. Exactly the same privileged and predatory members of the elite Jockey Club appeared both on the turf and in the wings of the opera house. The wealthy, upper-class subscribers to season tickets—including Degas himself—"were given free run of the theater, not only the stalls and boxes from which the performance was viewed, but also the wings of the stage, its maze of corridors, the dancers' dressing rooms, and the *foyer de la danse*, the green room where the *abonnés* congregated with the dancers before, during, and after the performance."[3]

Since respectable nineteenth-century women wore long dresses that completely covered the body, the dancers' flimsy costumes and bare arms and legs were especially enticing. The

excitement was heightened when all the male roles were taken by cross-dressed women. Ludovic Halévy described how the foyer of the ballet—like the Oriental harems portrayed by Ingres and Delacroix—fulfilled, and sometimes exceeded, male fantasies: "all around us coming and going were the twenty-five pretty girls of the *corps de ballet....* 'This,' M. Auber said to me, 'is the only room that I love. Pretty heads, pretty shoulders, pretty legs, as much as one could wish for. More than one could wish for.'" Most men would pay a fortune to spend a night with a young girl, transfigured by makeup, costume and the illusion of stage lighting.

The composer Hector Berlioz compared the Opéra to a "house of assignation," with fashionable predators, depraved virgins and precocious vice. The wealthy patrons treated the ballerinas as if they were confined to a game preserve, a deer park or a seraglio. One former dancer crudely exclaimed: "As soon as she enters the Opéra her destiny as a whore is sealed; there she will be a high class whore." The typical ballet mother, with the hard face of an old concierge, would invest many tedious hours, days and years in her daughter's career. The young dancer was the only hope of rescuing her family from the grinding toil and poverty of working-class life. If she didn't succeed as a ballerina—and it was much easier for her to attract a rich patron than become a *première danseuse*—her mother would recoup her investment by selling her sexual favors.

A mother kept a beady eye on her daughter—not to protect the girl's virginity, but to preserve it for the highest bidder. In Halévy's sequel, *La Famille Cardinal* (1883), Mme. Cardinal, the mother of two dancers, "interrupted her speech and rushed off at a trot toward the stage, only to return a moment later dragging her daughter Pauline by the ear. 'Ah! You little creature.' 'But *maman...*' 'I tell you that Monsieur de Gallerande just kissed you there, behind that stage flat.' 'I say he didn't.' 'I say he did....' 'Ah, monsieur,' said Madame Cardinal, 'two daughters, at the Opéra,

in the ballet, what a trial for a mother!' " No wonder mothers felt that "a gentleman is always nicer with his gloves on."

The dancers themselves made sure they were paid the top price for sexual favors. One critic, explaining their nickname, wrote: "The *rat* is a student of the school of dance, and it is perhaps because she is a child of the house, because she lives there, because she gnaws there, jabbers there, splashes there, because she corrodes and scratches the décor, frays and tears the costumes, causes a wealth of unknown injuries and commits a wealth of wrongdoings, occult and nocturnal, that she has received this name of *rat*."[4] The term chiefly referred to the ballerina's unerring ability to gnaw away at her protector's fortune.

This backstage intimacy and intrigue fascinated Degas as much as the actual performance. The ballet synthesized his interest in movement and costumes, in music and theater, in watching women performers on stage or in cafés, while bathing or in brothels. The dynamic young bodies of his Spartan girls led directly to the adolescent *rats* of the Opéra. In the 1880s, after painting ballerinas for more than a decade, he asked a Parisian banker for a small favor: "Have you the *power* to get the Opéra to give me a pass for the day of the *dance examination*?...I have done so many of these dance examinations without having seen them that I am a little ashamed of it." In a letter to the director, he said the Opéra felt like his second family: "[You] have been so charming to me, you have favoured me so exceptionally, that I feel myself a little attached to your fortunes and that I am getting to be, as they say, one of the household."

The dancers seemed equally attached to Degas. They appreciated his interest in their work and tried hard to please him. One young dancer remembered him as "a quiet, kind old man who wore blue spectacles to protect his eyes, and who used to stand at the top or bottom of the many staircases in the building, drawing the dancers as they rushed up and down. He used to ask them to stop for a moment, just as they stood, in order [to] make

quick sketches of them." One of his biographers described the process of close observation and precise execution as Degas ran, "pencil in hand, hiding under his evening cloak the sketchbook where he hurriedly records some movement he has glimpsed. Then when the lamps have been put out, he returns to his studio and there, in the sternest withdrawal, transcribes on canvas or paper the spoils gathered by his ardent eyes."[5]

The diarist and man of letters Edmond de Goncourt, admitted to Degas' studio, was amused to find the artist caught up in his work. It was strange to see him twirling around while "explaining his ballet pictures with choreographic phrases, mimicking occasionally an arabesque, and stranger still to notice how he mixed the aesthetics of dancing with the aesthetics of painting." Degas saw the harmony of the arts in the same way as the Renaissance poet Sir John Davies did in *Orchestra:*

> Dancing, the child of Music and of Love;
> Dancing itself, both love and harmony,
> Where all agree and all in order move;
> Dancing, the art that all arts do approve.

One contemporary produced a witty caricature of the two aspects of Degas: the gray-bearded, potbellied painter, his upper half dressed in a conventional jacket, waistcoat and tie, but his lower half in pink tights and ballet slippers, posing before a mirror in a rehearsal room. Degas, though always "correct" with his models, once received an unwelcome visitor on their account. His paintings of young dancers — and perhaps the complaint of an extortionate mother — had aroused official suspicions. While he "was making sketches at the Opéra, many professional ballerinas were also modeling in his studio, even the *petits rats;* to the point that one day he received the visit of a police inspector seeking an explanation for the many comings and goings of little girls to his house at rue Victor Massé."[6]

Degas painted the ballerinas not only on stage, but also behind the scenes: in the dressing room, the rehearsal room, the

foyer and the wings. He contrasted the natural postures of the resting dancers with the exquisitely mannered movements of the balletic performance. An enthusiastic critic praised his idealized portrayal of the texture of dancers' costumes, and said he was "in love with the white gauze of her skirts, with the silk of her tights, with the pink touch of her satin slippers, their soles powdered with resin." But Degas also—with truly modern originality—emphasized the realistic as well as the illusory aspects of the ballet. He exposed the secret hardships behind the elegant façade, and contrasted the beauty, glamour and apparent grace of the dancers with the sweat, exhaustion and strain—even physical damage—of ordinary girls offstage. Degas' idol, Ingres, had described the dancers as "wretches disfigured by their efforts, red, inflamed with fatigue, and so indecently strapped-up that they would be more modest if they were naked." Degas himself recorded in his notebook a grim but all too common accident that, like a casualty of war, may well have extinguished the hopes of a young aspirant: "During a *pas de trois* one of the girls falls and remains on the floor, tears, they surround her, carry her away by her arms and legs, melancholy."[7]

Degas' ballet pictures contain both abstract design and narrative content. In *The Orchestra of the Opéra* (1870), his ballet dancers, seen from the first row, make their first, tentative, fluttering appearance above the orchestra. On stage yet off-center, their feet are cut off by the edge of the stage, their heads by the edge of the picture. All white arms and legs, pink and blue tutus, they form a bright pattern, mobile and delicate, in contrast to the solid, seated, black-clad, bald and bearded musicians, dominated by the massive bassoon player in the center of the picture. In a red velvet box in the left background, a single spectator observes the dazzling performance.

The curve of the spiral staircase in *The Rehearsal* (1873) repeats the arabesque of the dancers and—with four disembodied silhouettes of legs descending and two legs on the floor—anticipates the cinematic velocity of Marcel Duchamps' famous *Nude*

Descending a Staircase (1912). The scattered slippers, fan and scarf, the rear view of the bending girl with a large pink bow around her waist and the obscene gesture, thumb to teeth, of the seated girl with spread legs and red shawl, all emphasize the casual, random aspect of the dark, multi-figured scene that extends into the mirrored room in the background.

The Dance Class (1874) is one of Degas' most intricate and delightful ballet scenes. One of the monkey-faced girls twists and turns before the ballet master, whose large vertical stick and rigid stance contrast with the dancer's arabesque. His red shirt is echoed in a dancer's red flower and a mother's red shawl. Meanwhile—in a room containing a music stand, a bass viol (flat on the floor), a half-hidden piano, a poster and a huge mirror—the other dancers are absorbed in themselves: observant, pensive and apprehensive, looking in the mirror, seated cross-legged, leaning against the wall, adjusting their costumes or chatting to their mothers on the high platform. Though apparently distracted, all nervously await their turn to perform.

There's no sign of the photographer in the subtle *Dancer Posing for a Photographer* (1875). Posed with her left foot on pointe, her right foot flat, her arms raised *en couronne* and thighs just visible beneath the tutu, the self-absorbed dancer stands before a mirror in an apparently empty room. The greenish wintry light seeps through the tall windows and gauzy curtains, and the painting is structured by the vertical frames of the glass and the horizontal floorboards. Outside are the top floors, rooftops and chimney pots of Parisian buildings. The ballerina, dancing on air as well as on wood, seems to float six stories above the ground.

In *The Dance Class* (1881) Degas' camera-eye focuses on a close-up version of the 1874 painting with the same title. Three young ballerinas, like the three Graces, extend their arms *en couronne* in front of a large mirror that reflects both the girls and the buildings seen through the opposite window. The agile girl in the middle, on pointe and with her left leg extended at a right

angle for balance, shows her white knickers and wears a bright
yellow bow around her waist. The Graces are balanced by three
other figures: two girls (one with unusually long hair and a
dangling green sash) looking down and away from the dancers,
and the bald, chinless ballet master, with bushy eyebrows, mus-
tache and a billiard-ball-shaped head, who gazes at them. Seated
in a hard, cane chair in the center foreground, and quite distinct
from the other trios, a mother in a lace-collared blue dress and
ridiculously trimmed straw hat reads a newspaper. Degas unites
these disparate and distinctive subjects in a strikingly original
composition.

Dancer in Her Dressing Room (1880) is a rather sinister ap-
pendage to the dance pictures. Her eyes cast down on her work,
a seamstress puts the finishing touches on the costume of a
pretty, elaborately dressed and coiffed ballerina. As the dancer
waits for the seamstress to finish, a crouching, leering, apelike
man (quite unlike the impatient gentleman attending Manet's
Nana) waits for the moment to pounce on her. The composition
emphasizes their intimacy: his head seems cradled in the crook
of her right arm and her right hand seems about to grasp the top
of his T-shaped cane. The painting shows the ironic contrast be-
tween her two roles: she is both dancer and mistress, paid to per-
form in the ballet and the boudoir.

Contemporary critics responded to the irresistible beauty of
Degas' dancers, but also understood the wretchedness behind
the magic. Paul Lafond emphasized the sickliness of the striving
young ballerinas who emerged from the proletarian underclass,
their origins still visible under the glamorous lights:

He shows all the real ugliness underlying the stage pageantry—
the unhealthy precociousness of these little girls, their child-
ish limbs topped by faces of little old women, too delicate,
too bold or too dreamy. Most of his dancers are minor super-
numeraries who appear in the group scenes and the back row

of the ballet, with their soiled feet and anaemic pallor....With an audacity which is both strong and attractive, he shows her emerging from a lower world, proud of appearing in the glow of the footlights, with a sly, common expression on her vulgar monkey-face.

Huysmans also stressed the physical deterioration and precarious life of the aesthetic athletes: "How true, how alive it is! The figures seem to exist in air. Light bathes the scene convincingly. The expressions on the faces, the boredom from their painfully mechanical work, the scrutinizing look of the mother whose hopes will harden when the body of her daughter wears away, and the indifference of their companions to drudgery they know, these are emphasized and recorded with the pointedness of an analyst who is always both cruel and subtle." Huysmans also took up Degas' fundamental theme, the harsh, often painful reality beneath the glamorous illusion: "The exercises accelerate, the legs are raised in cadence, the hands grip the barre running around the walls of the room, while the toe-slippers frantically thump the floor and the lips automatically smile. The illusion becomes so complete when the eye fastens upon these dancers that all of them come alive and gasp for breath."

Rainer Maria Rilke, grasping the "fluttering mood" of these pictures, wrote that the dancers "stand around, usually in groups...fastening their slippers or adjusting their cloudlike skirts, with the sadness of birds who have lost their wings just when they are about to make further progress, but have not yet learned to use their legs." Paul Gauguin, developing the theme of Halévy's *Cardinal* novels and Degas' *Dancer in Her Dressing Room,* praised the reality while emphasizing both the balletic and sexual illusions: "Nothing is real but the effects they create, the skeleton, the human structure, the movement; arabesques of all sorts. What strength, suppleness and grace!...If you are aspiring to sleep with a dancer, do not permit yourself to hope, for a single

moment, that she will swoon in your arms. That never happens;
the dancer only swoons on the stage."[8]

<div align="center">III</div>

DEGAS' LAUNDRESSES, without rich guardians or protectors,
were even more sexually vulnerable than the dancers. In the
1870s there were about 70,000 laundresses in Paris, many of
whom were the mothers of aspiring ballerinas. In contrast to the
well-dressed upper-class women, laundresses, like dancers, re-
vealed their bare arms, and had to wash and pleat the tutus of the
ballerinas. There were many stories of oriental potentates send-
ing their laundry to Paris: the laundresses did the actual work.
They also picked up the dirty linen and delivered the clean, and
could be seen trudging to and from the houses of their Parisian
clients. George Orwell, who lived in a poor district of Paris sixty
years later, described the gradations of poverty and how each
level fed on the one below. He pointed out that "amid the noise
and dirt lived the usual respectable French shopkeepers, bakers
and laundresses and the like, keeping themselves to themselves
and quietly piling up small fortunes." Degas admired these
warm, industrious, working-class families, and said that "one
finds very light rooms, scrupulously clean.... The doors are open
onto the landings; all the world is gay, all the world works; nor
have these people the servility common to the shopkeepers.... It
is a delightful society."

Valéry (adopting Huysmans' word) called Degas "a cruel
connoisseur of all the shapes and attitudes of women," and
Degas could find much to admire in an ugly woman. "Ah, yes,
that's always the point," he said. "To be a woman, and not be
pretty.... There are some women [like laundresses and whores]
who should barely be spoken to; they should only be caressed....
It's among the common people that you find grace."[9] Edmond
de Goncourt, always observant and on the scene, visited Degas
in February 1874 (just before the first Impressionist exhibition)

and found his choice of subjects both strange and surprisingly appropriate:

> Yesterday I spent the whole day in the studio of a strange painter called Degas. After a great many essays and experiments and trial shots in all directions, he has fallen in love with modern life, and out of all the subjects in modern life he has chosen washerwomen and ballet-dancers. When you come to think of it, it is not a bad choice. It is a world of pink and white, of female flesh in lawn and gauze, the most delightful of pretexts for using pale, soft tints.
>
> He showed me, in their various poses and their graceful foreshortening, washerwomen and still more washerwomen...speaking their language and explaining the technicalities of their different movements in pressing and ironing.

Like his dancers, Degas' laundresses are both appealing and pathetic; they suffer physical exhaustion and are exploited by men who pose as their patrons. In *Woman Ironing* (1876), a solitary, bare-armed laundress, standing in profile and wearing a white-spotted blue blouse, mauve apron and tiny earring, bends over and presses down on a triangular, wooden-handled flatiron. Drying shirts hang limply from a rail above her head and seem to press down upon her, and the opaque windows add to the claustrophobic atmosphere. Yet she persists with her skillful but mechanical work, occasionally sprinkling water from a bowl on the soft-covered table, and piles up the stiff, perfectly starched shirts—like the ones Fitzgerald's Jay Gatsby displays to impress Daisy Buchanan.

In *Women Ironing* (1884), roughly painted on unprimed canvas, two weary women—one tense, one relaxed—stand side by side. The heavier one, in a pink blouse, with thick, red hair coiled on top of her head, leans over, chin against her chest, and presses down the iron with the force of both hands. The other woman—in blue skirt, white open-necked blouse and orange

kerchief—shows her bare arms well above the elbows. As if captured in a photograph, she stretches her arm and releases an exhausted, animalistic, open-mouthed yawn while grasping a bottle of water to dampen the shirts and quench her thirst. Though the women are quite close to each other, they are too tired and absorbed in their work (paid by the piece) to have any meaningful connection.

In the 1880s Degas moved from dancers' bare legs and laundresses' bare arms to completely nude bathers freed from all constraints. "Two centuries ago," he remarked, "I would have painted *Susanna in Her Bath;* now I paint women in a tub." By taking naked women (as Manet did) out of their idealized biblical or classical context, he was far ahead of his time. He provoked criticism, but laughed at the hypocritical remarks: "nude models are all right at the Salon [he said], but a *woman undressing*—never!"[10]

In Degas' time, when few houses had running water, women rarely washed themselves and almost never bathed. Only prostitutes were legally required to clean themselves. One needed a servant to heat, fill and empty the low round basins imported from England. In *The Breakfast after the Bath* (1895) the maid, serving a cup of tea to the bather bending over and drying herself with a fluttering towel, recalls the handmaiden bringing a shawl to the naked goddess in Botticelli's *The Birth of Venus.* Degas said of the drowsily domestic *Woman Getting Up* (1883)— complementing his *Woman Retiring* (1883) and portraying the same subject of Morisot's charming *Getting Out of Bed* (1886)—"I painted her waking up. There was nothing to be seen but her legs feeling about through the opening of the bed-curtains for her slippers, which had been thrown on an Oriental carpet."

Degas' bathers combined candor with lubricity. Some of them look like bears coming out of their caves, others are both tempting and repulsive. When they boldly and shamelessly squat or bend over—as in *Woman Bathing in a Shallow Tub* (1885) or *After the Bath (Woman Drying Her Feet)* (1905)—they seem to be

relieving rather than cleaning themselves. He said that he rep-
resented woman as a "human animal taking care of itself," and
told Sickert: "I've perhaps considered woman too much as an
animal."[11] He occasionally portrayed a delicately built young
woman with fine features, high, pointed breasts and luxuriant
hair. In *Young Woman Combing Her Hair* (1890–92) she almost
seems to be playing the cello. But the faces, bodies and postures
of his women, bending over and exposing their huge rear ends,
were usually not attractive.

In the nineteenth century, when his bathers were considered
shocking, even the sympathetic and intelligent Huysmans called
Degas a cruel misogynist. In his two essays of 1880 on Degas,
the monkish Huysmans (who despised the flesh and wrongly as-
sumed that Degas shared his views) emphasized in vigorous
prose the perverse, bestial and degrading aspects of the bathers:

> By overthrowing the one idol constantly spared, namely,
> woman, he proceeded to vilify [her] by picturing her in the
> bath-tub and in all the intimate and humiliating poses of her
> toilet....
>
> There is, in these pastels, with their mutilated stumps, jos-
> tled throats and crippled gestures, a whole series of attitudes
> which are inherent to the woman, even the young and beau-
> tiful one, who may be adorable when erect or reclining, but
> who becomes froggish and ape-like when...she is forced to
> bend down....
>
> [Their] vulgarity of figure and coarseness of features in-
> spired, at once, continence and horror.

Modern feminist critics have used this perverse interpretation as
a stick to beat Degas. Yet Huysmans, arguing for Degas' place in
contemporary art, ranked him above all others: "In an age when
all painters wallow in the trough of crowds [at the Salon], he has
achieved, in silence and far from the crowd, works which are not
to be equaled....This artist is the greatest we today possess in

France."[12] Fifty years later, when Degas' nudes had become tamely familiar, Aldous Huxley used the same pictures to stress the artist's self-inspired modernism. Degas' work speaks to us, Huxley casually remarked, "in terms which are essentially our terms, in our idiom which has the modernity of contemporary slang, coupled with the elegance and beauty of the finest poetry....Some artists need as inspiration Ovid and the Nicene Creed, but all that Degas required was a tin tub and a woman's bubs."

Art criticism is intensely subjective, inevitably rooted in its own time. Fifty years after Huxley and a century after Huysmans, Edgar Snow's book on Vermeer persuasively rescued Degas from Huysmans' base accusations. Turning Huysmans' arguments upside down, and brilliantly linking the linear colorists Vermeer and Degas, Snow emphasized Degas' delicacy, tenderness and respect, his denial of masculine desire, his purity and his innocence. He praised

> the delicacy and hesitancy of Degas' approach, the tenderness with which he creates for his nudes their own body, their own privacy, their own space, and the protectiveness with which he insists upon measuring and respecting the distance that separates him from them....
>
> The sense of erotic fulfillment that enriches and intensifies these canvases is predicated on a denial of masculine will, desire, and, above all, sexual presence....
>
> Their seemingly inexhaustible views of female rituals of bathing, washing, drying, cleaning, toweling, and combing, accumulate to bring about a genuinely ablutionary vision: they become ritual purifications of the space in which they are conceived. Disencumbered of all excrescences of guilt, shame, and embarrassment, the flesh glows with innocence."[13]

Degas' fifty monotypes of prostitutes, secret and virtually unknown during his lifetime, were considerably more shocking

than his nude bathers. In the nineteenth century, Paris whore-houses, a leading industry, were graded as finely as oysters. There were, catering to degrees of wealth and taste (and in descending order): *maisons de rendez-vous*—decorous houses that added a *fris-son* to the encounter by emulating a bourgeois, domestic setting; *maisons à partie*—festive locales where patrons could eat, drink and gamble as well as consort with whores; *maisons de tolérance*—legal places, regulated by the police; *maisons closes*—no-frills broth-els; and *maisons de passe,* where rooms were rented by the hour.

Degas' brothel drawings—satiric, amusing and much closer than his bathers to Huysmans' description of his art—provoke both fascination and disgust. Their most striking feature is the pasty, misshapen flesh of the raddled and repulsive women, naked except for chokers, colored stockings and high-heeled shoes, who sit with their legs open. With heavy breasts, sagging bellies, fleshy hips, bulging buttocks and forced smiles on their grotesque, primitive faces, it would seem difficult, given the in-tense competition from the various *maisons,* for these old tarts to attract any clients. In one drawing, a rare Chaplinesque figure—with bowler hat, mustache and cane—seems most reluctant to accompany the whore. Another customer is reduced to a lasciv-ious monster, crouching and grimacing beneath a woman in a tub. Most of the time the bored, restless women sit around in their sordid surroundings, waiting for some action. When they do engage in sex, it's often solitary or with each other. In the ex-tracurricular *Relaxation* (1879–80), for example, one naked whore sprawls on the floor in the foreground, another lounges on the sofa and wriggles her legs in the air, while the third throws back her head, raises her skirt and unselfconsciously pleasures herself. In *The Name Day of the Madam* (1876–77)—a scene at once witty, sacrilegious and obscene—the naked, broad-hipped, frizzy-haired, potbellied whore blesses the massive madam, with hand on her head, while she and the others, sprawled before a mustard background, present offerings of large but cheap bouquets.

Degas' brothel scenes struck a responsive chord among his fellow artists. Van Gogh wrote that the "calm and modeled" nudes were a kind of perfection that, "like coitus," can momentarily "make the infinite tangible for us." Renoir, referring to *The Name Day of the Madam*, explained how Degas transcended the sordid genre: "Any treatment of such subjects is likely to be pornographic, and there is always a desperate sadness about them. It took a Degas to give to the *Fête de la Patronne* an air of joyfulness, and at the same time the greatness of an Egyptian bas-relief."[14]

BANKRUPT

1874–1879

I

❦ AT MID-CENTURY the family bank created by Degas'
grandfather, Hilaire, was firmly established, and the family in
Naples prospered and married into the Italian nobility. But when
Degas' father died in Naples in February 1874 he was deeply in
debt, and the family declined more publicly and precipitously
than Manet's. Auguste's sons and daughters assumed he would
leave a wealthy estate, but instead they faced scandalous humili-
ation and comparative poverty. An art historian wrote that "Au-
guste DeGas…had gradually diminished the assets of 150,000
gold francs at his disposal in 1833, and had sold his holdings in
the Italian branch of the bank to his brothers in Naples." In the
1860s Edgar's feckless brothers, Achille and René, had obtained
a large unsecured loan, negotiated through the Degas bank in
Paris, to set themselves up as wine importers in New Orleans.
At the same time René lost money speculating in cotton futures
and his father borrowed to protect him. "The liquidation of [Au-
guste DeGas'] bank left numerous outstanding debts, including
one very large claim of 40,000 francs he had borrowed from the
Bank of Antwerp, evidently in 1866, to cover René DeGas's con-
siderable loss."

Degas had financial setbacks of his own. In 1873 a severe
economic depression, "the Victorian equivalent of the Wall
Street Crash of 1929," had forced the dealer Paul Durand-Ruel
to withdraw his support of Degas and the Impressionists, who
were preparing to hold their first exhibition in April 1874. An

Italian painter who met Degas in Naples right after his father's funeral assumed he was wealthy. He described Degas as "an immensely perceptive and serious man; in the midst of all this, the fact that he is rich must help him immensely." But he could not keep up appearances for very long. As the oldest son and now head of the family, Degas felt obliged to save their honor by assuming responsibility for their massive debts.

The legal business of his father's estate dragged on, in its tedious way, for several years. Returning to Naples in June 1876, Degas, whose work was totally disrupted, complained of being ground down by the degrading process: "How much time one wastes on matters quite apart from one's life, on undertaking humiliating procedures, taking part in interminable discussions that one doesn't even understand, to save one's poor name from bankruptcy!" The disposal of his father's Italian palazzo and villa was not finally settled until 1909.

In January 1877

> Achille and his guarantors, Edgar Degas and Henri-Gabriel Fevre (their brother-in-law, married to Marguerite), attempted to save the family's reputation by assuming the monthly installment payment on René's debt of 40,000 francs. Describing how they were facing the threatened sale of their furniture by the bank [Henri Musson] said: "In Paris I see Edgar denying himself everything, living just as cheaply as possible. The seven Fevre children are clothed in rags. They eat only what is necessary. Honor is involved.[1]

Uncle Henri exaggerated their hardships. Though Degas made a great financial sacrifice, Roy McMullen explained that he was not in dire poverty after the failure of his father's bank. He "continued to have his bachelor's quarters, his housekeeper (still Sabine Neyt), his café conversations, his evenings at the Opéra, and his holidays in Normandy." But he had lost his independence, income, social prestige and self-confidence, and now had

to support himself as a painter. His young friend Daniel Halévy, stressing Degas' intense sensitivity, described the emotional impact of the financial disaster: "He accepted the complete responsibility for which he was in no way obligated. He paid the full amount of the debts. His way of life changed completely. He had been living in the rue Blanche, in a modest but very pleasant house. He disposed of it. He gave up everything he owned [though not his art collection] and rented a studio at the foot of an alley off the rue Pigalle....The new dwelling repelled me and I felt that our friend had been in some way degraded."

Soon after the bankruptcy Degas once again suffered public humiliation for his brothers' outrageous behavior. In August 1875 Mme. Manet told Berthe Morisot that "the gentleman who caused such excitement at the Bourse was Achille Degas. I saw the report of the incident among the sensational news items." Achille had been married in Louisiana, but had a mistress in Paris whose husband had challenged him to a duel. On August 19 the man beat him with a cane in front of the Paris Bourse. Achille, fearing danger, was carrying a revolver. He fired five wild shots, two of which slightly wounded his assailant in the face.

A few days later Morisot, a lawyer's daughter and concerned about the scandal, told her husband: "I dropped in yesterday at Achille Degas'; he is worried about the outcome of his case. He has been advised to have it tried in the court of assizes. The judges of the Correctionelle court would find him guilty."[2] Achille was sentenced to six months in prison, later commuted to one month, and a fine of fifty francs. He emigrated to Switzerland, where in 1889 he fell ill, and in 1891 had a stroke that left him half-paralyzed. He was forced to remain in bed for the last two years of his life, and lost his speech and his reason. He insisted that no one be invited to his funeral and died, just after being brought back to Paris, in 1893.

In New Orleans, meanwhile, René continued to behave badly. In 1869 he'd received an ecclesiastical dispensation to marry his

first cousin, Estelle Musson. Before the wedding she'd contracted opthalmia (inflammation of the eye) and became totally blind. In April 1878, three years after Achille's scandal, René abandoned his wife and six children, and left New Orleans with his mistress. Furious about René's cruel treatment of his wife, whose blindness aroused fears for his own vision, Edgar severed all contact with his brother for nearly a decade.

Some family members perversely blamed Edgar for refusing to be reconciled with René and delaying the long-overdue settlement of his father's estate. In June 1882 his brother-in-law Edmondo Morbilli told his wife Thérèse that "Edgar has displayed a complete lack of understanding, with the result that I despair of ever convincing him through serious arguments!...If I had taken him seriously, I would have had to ask you to break off all relations with him, even though he's your brother. Edgar is probably doing some good painting. I don't dispute that, but as to the rest, we must always think of him as a child, so as not to be angry with him."[3] The brothers were eventually reconciled, and René became one of the principal heirs to Degas' valuable estate. Degas not only suffered for his brothers' misdeeds, but also lost the sibling he cared for most. In 1889, the year of Achille's first illness, his beloved sister, Marguerite Fevre, was compelled to emigrate to Argentina, and he never saw her again. She died in Buenos Aires six years later.

II

As a bachelor Degas could organize his life around his work and establish a regular routine that suited his conventional taste. He had lunch almost every day at the Café de la Rochefoucauld. On Monday he went to the Opéra where he had a season ticket and could go backstage. He dined regularly with his old schoolmates: Alexis Rouart on Tuesdays, Henri Rouart on Fridays. He also remained in close contact with the Halévys and with his colleagues Manet, Berthe Morisot and Mary Cassatt.

His domestic existence was run—and often ruled—by a succession of housekeepers. Sabine Neyt was succeeded by the maid Clothilde, who went completely mad. Degas was forced to spend a day locked with her in a carriage, searching for a suitable insane asylum. The round-faced, bespectacled, intelligent Zoé Closier, a former teacher and lively conversationalist, looked after him for the last twenty-five years of his life. She was a terrible cook, and the fastidious Valéry recalled a typical dinner chez Degas: "there was a faultless insipidity in the all-too-innocent veal and macaroni cooked in plain water, served, very slowly, by old Zoé. After that there was a kind of Dundee marmalade, which I found intolerable." She was also inclined to be bossy. On one occasion, when the master announced that he was having guests for dinner that evening, she referred to the dreaded Dundee marmalade and sharply replied: "I am making jam today, and I don't want to be disturbed." But she kept the apartment clean, ran errands in town, rejected unwanted visitors and took care of him when he was ill.

The deeply conservative Degas was resolutely opposed to all social reform—as well as to children, dogs and flowers—and hostile to most new inventions: "the very mention of *confort moderne* put him into a rage." He would exclaim, "speed, speed, is there nothing more stupid?"[4] He called the airplane "small," the bicycle "ludicrous," the telephone "absurd." "And when the [telephone] bell rings, you get up and answer it?" he asked. "Why, yes. Certainly." "Just like a servant," he concluded. He took two old-fashioned carriage trips through the French countryside, but also liked riding in the Paris omnibus and taking long train journeys to Naples and to Spain.

Though he disliked modern technology, Degas was fascinated by photography and by innovative methods of painting. He never used photographs for his pictures, but persuaded many relatives and friends to pose at great length for this painstaking new form of art. His nudes, his self-portrait with Zoé, and (using

nine oil lamps) his famous photo of Renoir and Mallarmé, who had to remain absolutely still for half an hour, were masterpieces. A woman who'd posed for him as a little girl remembered: "'My legs were folded so that they wouldn't stick out at front, my arm pushed into a cushion, my head placed by his hands as he wished. Only in front of him was I immobile. His eyes fixed on me; my eyelids blinked, but that didn't matter.' The pose was four minutes—'and that was hard!'"

The endlessly curious Degas experimented with various media: etching, aquatint, drypoint, lithograph, monotype, pastel and sculpture. He explored "a vast range of materials and techniques, and employed certain of them—sometimes to disastrous effect—in unusual combinations, such as pastel over monotype, metallic paint on silk, and water-based media in conjunction with oil." His friend Marcellin Desboutin, who posed for *The Absinthe Drinker*, amusingly described Degas in the grip of his latest obsession. Degas was "no longer a friend, a man, an artist, he's a zinc or copper plate, blackened with printer's ink, and plate and man are flattened together by his printing press whose mechanism has swallowed him completely."[5]

III

DESPITE ECONOMIC and familial disasters, Degas continued to create major works in the 1870s. He painted theatrical illusion in the circus, the cafés and *café-concerts;* portraits, full of character, of close friends like Duranty and Martelli; and the spectacle of street life in Paris. Influenced by Japanese prints, Degas emphasized asymmetrical compositions and used abrupt foreshortenings, unusual perspectives and radical cleavage of his figures. In *Mlle. La La at the Cirque Fernando* (1879), the daring acrobat surpasses the athletic feats of the jockeys and ballerinas by dancing in mid-air and ascending like an angel. The frizzy-haired mulatto performer, known as the Black Venus, thrusts back her head and juts out her iron jaw. Dressed in a frilly white bodice and knickers,

with tights and high white boots, she maintains her swiveling balance by bending her knees and extending her arms fore and aft. Seen from below, as if soaring in flight, La La is hoisted on a pulley rope toward the high ceiling—punctuated by six square windows around two decorated columns—and keeps her teeth clenched lest she fall to her death. Degas creates a vertiginous effect by the odd angle of vision and by the leftward tilt of the vaulted ceiling, whose green is echoed in the fringe of her costume and whose structural frame seems to press against the rope and pierce her body.

In the Parisian *café-concerts,* open only in the summer, clients sat at tables under trees while ordering from the restaurant and watching the performance on stage. A critic wrote that "people flock to these vast halls where they can listen to the blare of lively music while drinking sweet, watery, brown *mazagran* [black coffee], draught beer with its light froth, or syrupy cherry-brandy." *The Song of the Dog* (1876–77) portrays the popular, red-haired cabaret-singer Thérésa acting out her witty song with a canine facial expression, hunched shoulders, bent arms and wrists (in long white gloves), pretending to be a dog that puts out its paws and begs for its supper. Under the dark night sky, background of thick trees, and bright lights from the dangling chandelier and the illuminated globes bobbing in the air, the crowd chats and drinks, strolls and snoozes below her as she pours out her song in full-throated ease.

Singer with a Glove (1878) depicts Thérésa close up and from below the stage. She wears an elaborately trimmed mauve dress and raises her black-gloved right hand in a dramatic gesture. Her head is thrown back, her eyes are in shadow, her skin chalky pale and her red-rimmed mouth wide open. Unlike the exhausted, yawning laundress, the open-mouthed singer seems to enjoy her work. A contemporary critic rather gloomily insisted that "Degas shows up with incomparable clarity the wretchedness of the women in these *café-concerts* and low music-halls, the vulgarity

of their type, the meanness of their attitude; it would be impossible to draw up a more sombre indictment of their abject lives." But he missed the obvious pleasure Degas derived from the lively atmosphere and vibrant performance. Thérésa, Degas wrote, has "the most grossly, delicately, wittily tender voice imaginable. And feeling, and taste, where could one find more? It is admirable."[6] Manet portrayed the patrons at the *café-concerts,* Degas focused on the performers.

Degas was clearly fond of the chubby Florentine art critic Diego Martelli, who was fifty when Degas painted his portrait in 1879. Perched in three-quarter view on an X-shaped stool—with hair *en brosse,* chalky forehead, thick arms crossed, protruding belly and strangely foreshortened legs—he's framed by a large, greenish blue, circular couch, strewn with his papers, skullcap and scarf. The bright red slippers on the floor in front of him add a cozy touch. Staring down contentedly, the well-fed Martelli—whose rotundity is emphasized by the round couch and the fanlike painting in the background—seems amiable, relaxed and reflective.

The novelist and art critic Edmond Duranty (despite his duel with Manet) championed the Impressionists, especially Degas, whom he called "an artist of rare intelligence, preoccupied with ideas." Degas' portrait of 1879, when his friend was forty-six, is more intense than the picture of Martelli. Degas gives Duranty a stagelike backdrop of bookshelves that extend to the very top of the frame, and piles up books and papers on his crowded desk. Balding and bearded, with a high forehead and lively blue eyes, he rests one hand on a book and the other (with two extended fingers) on his face. Huysmans, who knew and liked Duranty, described how the portrait had captured his appealing, inquisitive character: "We see M. Duranty surrounded by his prints and his books, seated at his table, with his slender, nervous fingers, his bright, mocking eye, his acute, searching expression, his wry, English humorist's air, his dry, joking little laugh—all of it

recalled to me by the painting, in which the character of this strange analyst of human nature is so splendidly portrayed."[7]

Degas had more trouble with his female sitters, who often forced themselves upon him, than he did with colleagues and friends like Martelli and Duranty, and could not resist deflating their vanity and pretensions. When a beautiful woman wanted to pose for him, he bluntly told her: "Yes, I'd like to do a portrait of you, but I'd make you put on a cap and apron like some little maidservant." When the self-important Mme. Dietz-Monnin decided she no longer had the time to pose for him and wanted to send her clothes to be worn by a model, Degas was furious and responded in his most waspish manner: "I was so surprised by your letter suggesting I reduce [the portrait] to a boa and a hat that I shall not answer you....I regret having started something in my own manner only to find myself transforming it completely into yours....I cannot go into this more fully without showing you only too clearly that I am very much hurt."[8]

The masterpiece of this period is Degas' *Place de la Concorde (Vicomte Ludovic Lepic and His Daughters)* (1876). It was thought to have been destroyed in Germany during World War II, but recently turned up in the Hermitage Museum in St. Petersburg. The talented, worldly Lepic was a "painter, engraver, sculptor, balletomane, gentleman jockey, and greyhound-fancier," who showed his work in the first two Impressionist exhibitions. In the foreground of the unusual composition, the tall, bearded, forceful and energetic Lepic strolls to the right. The vertical lines of his top hat are echoed by the columns of the streetlights; his cigar points in one direction, his furled umbrella in the other. His long-nosed greyhound and his two stylish and self-possessed little girls, standing on either side of him—one in profile, one in three-quarter view—stop for a moment and look to the left. (The older girl has the same pert, cheeky, sophisticated face of the nine-year-old Hortense Valpinçon, whom Degas had painted in 1871.) An elegant pedestrian, half cut off at the left, stops to

stare at the striking Lepics. In the background, a horse and carriage slowly start to cross the empty space at the center of the picture, which lies between the aristocratic family group and the familiar buildings of the Place de la Concorde. The vigorous but charming painting resembles a cinematic tracking shot that swings from left to right. In this work, Meyer Schapiro observed, Degas "strove to break up the notion of fixity, of definiteness of position, and to invent forms of grouping that were related to the qualities of stroke and color that could produce a heightened, uncanny effect of movement and emergence, yet correspond to a momentary attention."

Schapiro perceptively characterized Degas as "melancholy, acerbic, repressed, a self-doubting artist tormented by a goal of perfection." Though Degas, like Manet, created his works with impressive fluency, he was rarely satisfied with the end result. He said to Vollard, always eager to get his hands on Degas' art: "You know how much I hate to sell my work. Besides, I always hope eventually to do better."[9] He told the German painter Max Liebermann: "I would like to be rich enough to buy back all my pictures and destroy them by pushing my foot through the canvas." In 1874 the opera singer Jean-Baptiste Faure, a major collector of Degas' work, bought four paintings, two of which were delivered in 1876. When the other two had still not arrived eleven years later, he went to court and finally forced Degas to hand them over. His friends learned to be wary of his urge to repossess and repaint. Ernest Rouart told Valéry how his father had weakly, and fatally, surrendered to Degas' obsession: "after seeing again and again at our house a delightful pastel my father [Henri] had bought and was very fond of, Degas was seized with his habitual and imperious urge to retouch it. He would not let the matter alone, and in the end my father, from sheer weariness, let him take it away. It was never seen again."[10]

Fifteen

DEGAS AND MANET
1861–1883

❦ DEGAS AND MANET first met in the Louvre, that thriving crossroads of social life, in the latter half of 1861, when they were both in their late twenties. Degas was etching a copy of Velázquez's painting of a royal child, the *Infanta Margarita* (1653). He recalled that he "had started to work with his needle directly on the already grounded plate, without the aid of a preparatory drawing, when he was interrupted by a voice behind him saying, 'You have a lot of nerve, and with that method you'll be lucky if you come out with anything.'" This dramatic encounter in the center of the French art world brought together Manet's favorite painter, Degas' uncharacteristically bold etching, and Manet's cheeky and rather patronizing advice—offered in a disembodied voice, before they'd been formally introduced or even seen each other. It was the challenging beginning of a sharp-edged yet comradely rivalry that lasted until Manet's death.

The two young painters soon discovered they were kindred spirits. Both were Paris-born and educated, well-off, cultured and sophisticated. Manet had been to Rio, Degas would travel to New Orleans. Manet had praised the beauty of black women and apparently slept with them. Degas later said that his friend would have appreciated the beauty of the Louisiana landscape and people even more than he, with his weak eyes, was able to do. The teenaged Manet had painted rotten cheeses in Brazil; Degas would produce a major work, *The Cotton Office*, in New Orleans.

Manet's father urged him to study law or become a naval of-
ficer; Degas' father (named Auguste, like Manet's), who loved
music and had artistic inclinations, mildly recommended a legal
career and then encouraged his painting. Both families, once
prominent, suffered scandal and decline. Manet and Degas had
studied for five or six years with teachers of the old school, Cou-
ture and Lamothe. They eventually rejected their teachers' con-
ventional ideas and academic art, yet spent years assiduously
copying and assimilating the Old Masters. They were the great-
est artists of their time, but neither Manet nor Degas won the big
prize of the day, the coveted Prix de Rome; and neither opened
a school or (with the exception of Eva Gonzalès) taught pupils.

Though hostile to the French government and over military
age, both Manet and Degas did their patriotic duty by serving in
the National Guard during the Franco-Prussian War, and sym-
pathized with the fate of the massacred Communards. Despite
grave disabilities, both continued to work. In the last months of
his life, when severely ill and partly paralyzed, Manet painted
small still lifes. Degas, when nearly blind, turned to pastels and
sculpture. Manet inspired Degas to abandon his early historical
paintings and paint scenes of contemporary life. Like Manet,
Degas painted figures in the studio rather than outdoors.

The artist Jacques-Emile Blanche contrasted their habits of
working, one social, the other solitary:

Manet liked to be looked at as he bent over his easel....He
would have painted quite readily in the Place de la Concorde,
with a crowd around him, just as among his friends in his stu-
dio, although at times he was impatient and scraped and
rubbed out his work. But he would quickly get over that, and
smile at the girl posing for him or joke lightly with a journal-
ist. Degas, on the contrary, double-bolted his door, hid his
work, unfinished or in the course of completion, in closets,

intending to take it up again later, in order to change the harmony or accentuate the form. His work was always in a state of becoming. Worry gripped him, for he was at once proud and modest.

Manet was the greater innovator, Degas the more technically accomplished. A critic has described their strong artistic bonds: "the things Degas and Manet have in common go even beyond similar ideas and concepts of painting and the shared destinies of outsiders within a group of outsiders: they used the same models, shared an iconography and indulged in reciprocal quotations that is almost amusing in its consistency, suggesting that they actually delighted in crossing brushes." Both portrayed people separated, even in the most intimate domestic settings, and alienated from one another. This shared theme, which dominated their work, distinguished them from their contemporaries and makes their art seem especially modern and timeless.

Roy McMullen observed that Degas and Manet had wit and zest for life: they were "united by…their indulgence in irony, their delight in the passing Second Empire show, and their love of *flânerie*."[1] Yet the two men were temperamental opposites. Manet was charming, with a richer, warmer, more responsive personality. The unsociable, caustic Degas was guarded and hostile. Naively optimistic and resilient, Manet sought honors in the Salons. Degas was cynically indifferent to public acclaim. Manet was irresistibly attractive to the ladies, and married early. Degas' gallantries were forced, and he never got beyond thinking about marriage as a welcome relief from the strains of social life. "It is really a good thing to be married," he said, "to have good children, to be free of the need of being gallant. Ye gods, it is really time one thought about it." The single-minded Manet told George Moore: "I also tried to write, but I did not succeed; I never could do anything but paint." The more adventurous and

many-talented Degas was a sculptor, photographer and poet. Though married to a musician, Manet was bored by music, while Degas—a habitué of the Opéra—was devoted to it.

The more self-assured and independent Degas despised and distrusted all medals and honors. He hated anything controlled by the state, the Salons, the Académie des Beaux-Arts and the *Légion d'honneur*, and disdainfully insisted: "Sir, in my day one did not 'make good.'" One of his most perceptive mots (which illuminates the self-destructive impulse of many current celebrities) warned of the dangers and disasters that came with official recognition: "There is a kind of success that is indistinguishable from panic."[2] Manet, crushed by the condemnation of fatuous critics (whose praise he perversely sought), felt he needed all the protection he could get. When Degas belittled a mutual friend who had been awarded the *Légion d'honneur*, Manet replied: "You must take everything that distinguishes you from the crowd.... In this dog's life of ours, where everything is a struggle, one can't be too heavily armed." "To be sure," Degas interrupted, "I was almost forgetting what a bourgeois you are." Their arguments at the Café Guerbois provoked Degas' competitive instinct and he challenged Manet by boasting: "'I shall be at the Institute [of France] before you will, Manet!' The other burst out laughing. 'Yes, sir,' continued Degas, 'because of my drawing.'"

During one of their endless arguments about the value of honors and decorations, Degas criticized Manet for constantly seeking fame. Wounded by the scandal surrounding *Olympia,* Manet retorted that Degas lacked ambition and was satisfied to have no reputation at all. The English artist William Rothenstein reported that Degas thought Manet was "over-worldly: '*Mais tu es aussi connu que Garibaldi; que veux-tu de plus?*' [But you are as famous as Garibaldi; what more do you want?] Degas chaffed him once. Manet's answer came pat: '*Mon vieux, alors tu es au-dessus du niveau de la mer.*' [Old boy, then you are just above sea level.]" The

unregenerate Manet felt that the fame, or notoriety, of a Garibaldi was not enough. He wanted to be a celebrity, and added that "if I get into an omnibus and some one doesn't say 'Monsieur Manet, how are you, where are you going?' I am disappointed, for I know then that I am not famous."[3]

Their approach to the creative process was diametrically opposed: Manet was expressive and spontaneous, Degas cool and calculating. Mallarmé compared Manet's painting to a diver plunging headlong into a dangerous sea. His pictures were vibrant, charged with sexual feeling; Degas' work had, in Robert Hughes' fine phrase, the "unrelenting power of aesthetic deliberation." Manet exclaimed: "The only way is to paint straight off what you see. If you've caught it, all right. If not, then try again. All the rest is humbug." By contrast, Degas insisted: "No art was ever less spontaneous than mine. What I do is the result of reflection and study of the great masters; of inspiration, spontaneity, temperament…I know nothing."

Comparing himself with his rival, Degas turned Manet's statement upside down and suggested that Manet's theory was in conflict with his practice. Despite their differences, Degas maintained that they were inspired by the same traditional sources. Valéry, who knew them well, wrote: "Degas declared that the study of nature is meaningless, since the art of painting is a question of conventions, and that it was by far the best thing to learn drawing from Holbein; that Edouard himself, though he made a boast of slavishly copying nature, was in fact the most mannered painter in the world, never making a brush stroke without first thinking of the masters." Contrasting the character and art of his two colleagues, Renoir revealed that Degas' prediction about his drawing had come true and pointed out a surprising paradox: "Manet, who was so mild and gentle, was always controversial, while Degas, bitter, violent, and intractable as he was, was from the start recognized by the Institute, the public, and the revolutionaries."[4]

II

MANET AND DEGAS' most serious quarrel took place in 1869 after Degas painted a portrait of Manet and Suzanne, *M. and Mme. Edouard Manet.* When Manet saw the finished work, he was furious, and swore that Degas had distorted the features of his dear wife. He retaliated with an act of brutal vandalism, slashing out a third of the picture—obliterating the front of Suzanne's face and body as well as her hands and the piano she was playing. When Vollard asked Degas about the mutilation of his painting, he replied with surprising equanimity:

> It seems incredible, but Manet did it. He thought that the figure of Madame Manet detracted from the general effect. But I don't, and I'm going to try to paint her in again. I had a fearful shock when I saw it like that at his house. I picked it up and walked off without even saying good-bye.

In a later account by Vollard, Degas was even more conciliatory. He defended Manet, even agreed with him about the portrayal of Suzanne, and condemned his own self-destructive behavior:

> "But M. Degas, didn't Manet himself cut up the portrait you did of him and his wife?"
>
> Said Degas sharply:
>
> "What business have you, sir, to criticise Manet? Yes, it's quite true, Manet thought his wife didn't fit into the picture; as a matter of fact he was probably right. And I made a fool of myself over that affair, for, furious as I was at the time, I took down a little still life that Manet had given me, and wrote to him: 'Monsieur, I am sending you back your *Plums*'....Ah! What a lovely painting that was! It was a clever thing I did that day, and no mistake! When I made it up with Manet, I asked him to give me back 'my' *Plums,* and he had sold it!"

In Degas' first account, Manet had no reason to be angry. Degas disagreed that Suzanne "detracted from the general effect" and was shocked by Manet's violent overreaction. He was glad to get his own picture back and do more work on it, but was so enraged that he couldn't even speak. Later, when Vollard took Degas' side and criticized Manet, Degas defended him, and even suggested that Manet might have been right. Honor demanded that he give back Manet's gift of *Plums,* though he hated to part with anything in his collection and was heartbroken when he could not recover it.

This bitter quarrel erupted from personal, not artistic, differences. Manet was notoriously touchy about the fat and foreign Suzanne, who was mocked by the Morisots and others in his social circle. He suspected that Degas was parodying his own recent painting, *Mme. Manet at the Piano* (1867–68), in which he'd idealized his wife, portraying her in profile, centered in the picture, with her delicate fingers on the keyboard. In Degas' double portrait, Suzanne also sits erect and in profile at the piano. But on the left the nattily dressed Manet, with hand on his chin and one leg folded under him, sprawls on a sofa. Manet took offense, not only at Degas' depiction of Suzanne's face but also at the portrait of himself, which he thought made him look like a philistine, bored and dozing off during his wife's performance. In a fury, Manet attacked the portrait—the psychological equivalent of stabbing Degas himself.

Degas' main regret was that he gave up the precious *Plums.* He attached a new strip of canvas to the painting, and planned to resurrect Suzanne and return a superior version to Manet. But he kept putting it off and never got around to doing it, and the strip of bare canvas served to remind him of Manet's fit of temper. When Vollard expressed surprise that Degas had resumed their friendship, he admitted that he'd succumbed to Manet's charm, and said: "No one can remain at outs long with Manet."[5] Their altercation revealed the dark, uncontrollable side of

Manet's character. In 1870 he would react in a similar way to the critic Duranty, first provoking him to a duel and then (as with Degas) resuming their friendship. Paradoxically, once again, the mild and gentle Manet behaved violently while the bitter, irascible Degas accepted the insult and smoothed things over. This episode had an ironic coda. In 1894, after Léon Leenhoff had cut Manet's masterpiece *The Execution of Maximilian* to pieces to make it more salable, Degas retrieved the fragments from different locations and carefully reassembled them. This version of the painting is now in the National Gallery in London.

Their running debate — conducted in cafés, ateliers and fashionable dining rooms — focused on their competing claims to be the most innovative painter and to portray the most modern subjects. Manet, who followed Baudelaire's lead, accused Degas of closing his eyes to "real" life. George Moore, eagerly listening to the cut and thrust, reported that Manet fairly maintained that "Degas was painting *Semiramis* [1860–62] when I was painting 'Modern Paris.'" Degas, always ready with a sharp retort, savagely compared Manet to their slick, fashionable contemporary Carolus-Duran. He attacked Manet's fatal longing for honors and, in a striking simile, claimed that the supposedly spontaneous artist lacked natural creativity: "Manet is in despair because he cannot paint atrocious pictures like Duran, and be fêted and decorated; he is an artist, not by inclination, but by force. He is as a galley slave chained to the oar."

Claiming preeminence Degas told Halévy: "That Manet. As soon as I did dancers, he did them. He always imitated." It is difficult to judge — because of approximate dates and variant titles in French and English — exactly who came first, in the ebb and flow of their exchange, with specific subjects. Degas was the first to paint dancers and popular singers in the *café-concerts,* but Manet painted milliners and women bathing in a tub before he did. The high-laced boots of the acrobat dangling over the balcony in Manet's *Masked Ball at the Opéra*

(1873–74) reappear in Degas' *Mlle. La La at the Cirque Fernando* (1879).

Degas and Manet not only met in cafés and fashionable salons, but also went to the races together. In about 1869 Degas drew his friend, seen in profile and from behind, standing in an elegant pose, with one knee bent and hand in pocket, wearing a top hat and holding the knob of a cane up to his bearded chin. Standing next to him, a faintly sketched woman is watching the horses and crowd through a pair of binoculars. Three years later, in the lower right-hand corner of *The Races in the Bois de Boulogne* (1872), Manet reciprocated by painting Degas, also seen from behind, wearing a top hat and accompanied by a woman. In this painting Manet was as interested in the fashionable spectators and carriages, in the white buildings of the village in the background, as he was in the four horses (one with a startlingly upright jockey) running across the foreground with legs extended.

Their competitive friendship inspired them both. Degas, who anticipated Manet in racing pictures, was more interested in the horses than the people. But Jean Boggs pointed out that Manet's *The Dead Toreador* (1864) significantly influenced Degas' *The Steeplechase* (1866): "Degas' painting was based on Manet's entry to the Salon of two years earlier, [*The Dead Toreador*]....Degas adopted not only the subject (an athlete killed in competition) and to some extent the composition (a sharply foreshortened recumbent figure in the foreground with additional figures and animals above), but most important the ambition: to take a scene from contemporary life and enlarge it to heroic proportions."[6]

Manet's *Races at Longchamps* (1867) also trumped Degas by portraying, for the first time in the history of art, horses and jockeys galloping head-on to the viewer. Against a cloudy blue sky, green hills, spiky and swirling trees, and between two crowded, fenced-in rows of fashionable spectators (including a woman on the left with a billowing white dress and parasol), six closely packed horses gallop through a cloud of dust and across the

Photo of Degas, 1900. Bibliothèque National de France

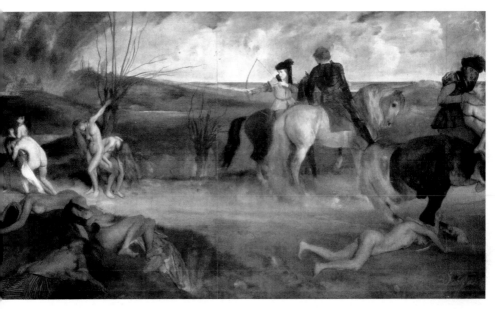

Degas, *The Misfortunes of the City of Orléans* (1863–65). Réunion des Musées Nationaux/Art Resource, New York

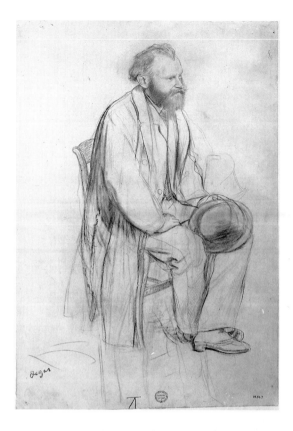

Degas, *Study for a Portrait of Edouard Manet* (1866–68) Metropolitan Museum of Art, New York

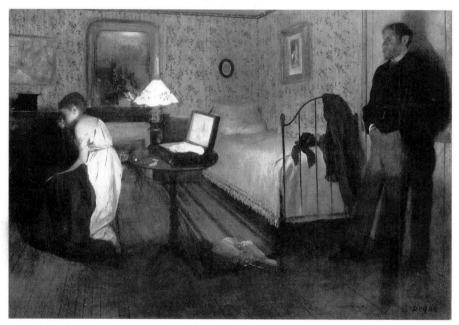

Degas, *Interior: The Rape* (1868–69). Philadelphia Museum of Art: The Henry P. McIlhenny Collection in memory of Frances P. McIlhenny

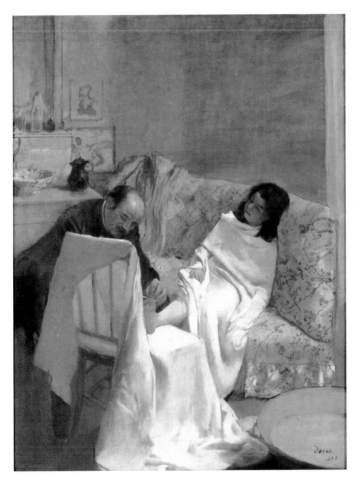

Degas, *The Pedicure* (1873). Réunion des Musées Nationaux/Art
Resource, New York

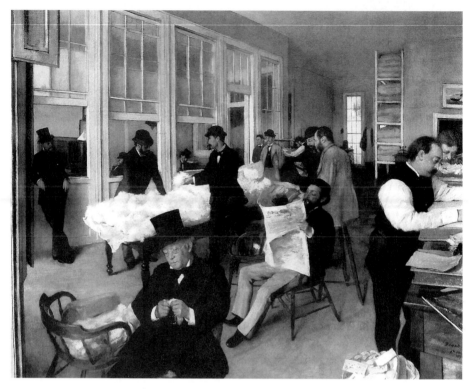

Degas, *The Cotton Office* (1873). Musée des Beaux-Arts de Pau (France)

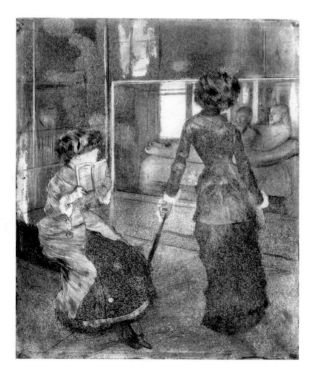

Degas, *Mary Cassatt at the
Louvre: The Etruscan Gallery*
(1879–80). Réunion des
Musées Nationaux/Art
Resource, New York

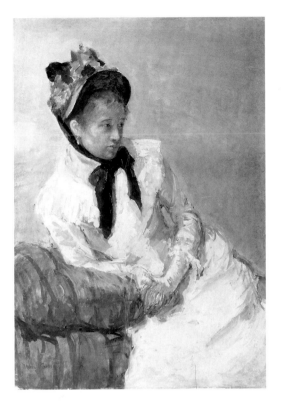

Mary Cassatt, *Portrait of the Artist* (1878). Metropolitan Museum of Art, New York

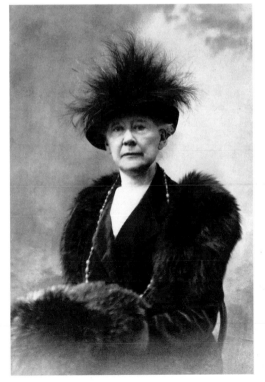

Photo of Mary Cassatt, after 1900. Frederick Arnold Sweet research materials on Mary Cassatt, Archives of American Art, Smithsonian Institution, Washington, D.C.

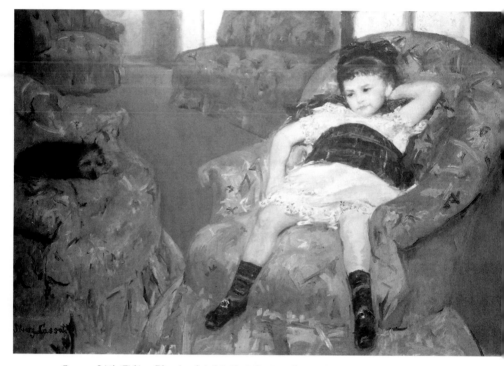

Cassatt, *Little Girl in a Blue Armchair* (1878). Collection of Mr. and Mrs. Paul Mellon, image
© 2004 Board of Trustees, National Gallery of Art, Washington, D.C.

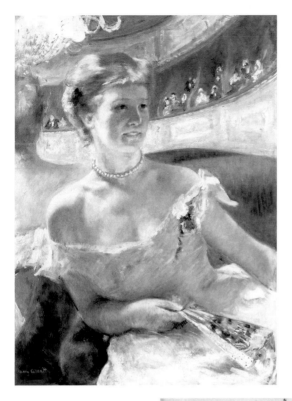

Cassatt, *Woman with a Pearl Necklace in a Loge* (1879). Philadelphia Museum of Art: Bequest of Charlotte Dorrance Wright

Cassatt, *The Letter* (1890–91). Philadelphia Museum of Art: The Louis E. Stern Collection

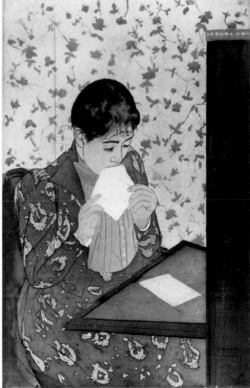

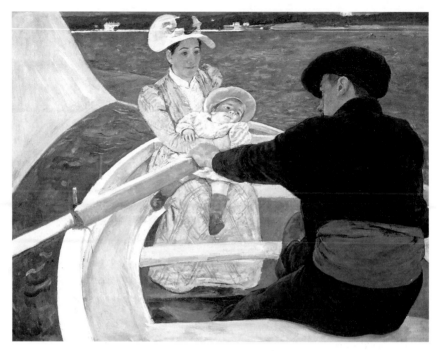

Cassatt, *The Boating Party* (1894). Chester Dale Collection, image © 2004 Board of Trustees, National Gallery of Art, Washington, D.C.

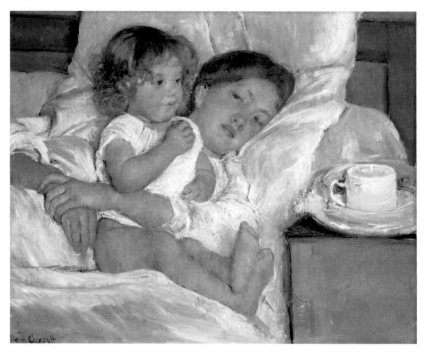

Cassatt, *Breakfast in Bed* (1897). Huntington Library and Art Collections, San Marino, California

finish line. The slightly blurred brushwork conveys an exciting proto-futuristic sense of speed and motion.

Both artists portrayed the seedy before-and-after mood of sexual relations. In Manet's *Nana* (1877) the half-cut-off gentleman, clasping his cane and crossing his knees, testily waits for his mistress to finish dressing, before undressing, for they seem to be going out before going to bed. In Degas' *Admiration* (1876–77), a comically grotesque version of Manet's picture, a kneeling, leering older man rests his chin on the edge of a tub, grasping its curved sides, to get a better look at the curvy, naked young woman who's risen out of the water like a Venus.

There's a curious connection between Degas' pastels and Manet's late painting *Chez le Père Lathuille* (1879). The young Lathuille recorded that while he was on military leave, in his father's popular restaurant near the Café Guerbois, Manet got him to pose with the model and actress Ellen Andrée. He told him: "You're a volunteer flirting with a pretty woman. Place yourselves like this and like that and chat with each other while I'm working." Manet wanted to change him into a civilian, and said: "Take off your tunic.... Put on my jacket!" The scene is set in a charming garden, where a young man, wearing a fawn-colored jacket and apparently sitting on air, has boldly invited himself to the woman's table (he has no plates or food). He has poured himself a glass of champagne and put his arm around her, resting his hand on the back of her wooden chair. The side-whiskered, white-aproned older waiter, holding a coffeepot, stops to observe them—perhaps with surprise or disapproval of the man's seductive maneuvers. The young man's black hair is parted in the middle, he sports a mustache and sideburns, and wears a large black cravat under a wide wing collar. He pushes his face uncomfortably close to the older woman, seen in *profil perdu*. She sits stiffly and shows no sign of interest; he smirks and stares right at her. Like the subjects of Degas' series of drawings, *Criminal Physiognomy,* the following year, Manet's young man has

a low forehead, prominent nose, thick lips and prognathous jaw. He bears a striking resemblance to the criminals whose "stains of vice" Degas observed when, after a notorious trial, they were convicted of murder. The garden setting and pleasant story behind the picture have blinded critics to Manet's satiric portrayal of the ugly, intrusive, apelike seducer.

Degas' *The Absinthe Drinker* (1875–76) has the same shadows, drab dress, full glass and empty bottle as Manet's *The Absinthe Drinker* (1858–59), whose subject was also a social outcast. But Degas' painting is much gloomier than Manet's. The highly toxic and addictive absinthe, a wormwood liqueur (now illegal), acted powerfully on the nerve centers, intoxicated rapidly, and could cause delirium and hallucinations. The unnaturally thin, narrow-shouldered, concave-chested, drab-looking woman has cheaply decorated shoes and a wavy hat that ludicrously crowns her roughly fringed red hair. With a full greenish glass and drained bottle in front of her, she stares ahead, eyes heavy-lidded, as if trying to forget the past and unable to face the future. Next to her, and not nearly as dejected, a bushy-haired artist, dressed in Bohemian garb and with hat pushed back on his head, looks off to the left, absorbed in his pipe and beer. The heavy shadows behind the stupefied seated figures emphasize their alienation and melancholy depravity.

Degas' setting in the Café de la Nouvelle-Athènes and inclusion of the artist figure make his woman, still clinging to the remnants of respectability, more sympathetic and his picture more complex than Manet's. The strikingly modern mood of Degas' painting suggests the atmosphere of Hemingway's "A Clean, Well-Lighted Place" (1933). In this story the illuminated café represents a kind of peace, security and refuge that contrasts with the client's isolation, loneliness and despair. The older waiter sympathizes with the traumatized client and shares his fear of the threatening darkness: "I am of those who like to stay late at the café....With all those who do not want to go to bed. With all those who need a light for the night."[7]

The woman in Manet's *The Plum* (1878)—also sitting at a marble table in a café, with cheap hat, ruffled dress and untidy red hair—is not nearly as shabby, sad and grim as Degas' pathetic absinthe addict. Manet's woman is prettier, more pensive and more attractively dressed in a pink frock. The serpentine green metal grill behind her head suggests her convoluted thoughts. Wide-eyed yet dreamy, charming and appealing, seen close up in a bright light, she rests her pale face on the back of her hand. Delaying the pleasures of the café while waiting for her companion, she holds an unlit cigarette and stares contentedly over her untouched plum soaked in brandy: a modern woman boldly on her own.

Manet's and Degas' portraits of their parents reveal their contrasting attitudes to their subjects. Manet's 1860 portrait of his paralyzed father is mercilessly harsh; Degas' portrait of his elderly father listening to Lorenzo Pagans (1871–72) is sweet and tender. Degas' guitarist, Pagans, seems more naturally absorbed in his music than Manet's more artificial, inaccurately posed *Spanish Singer,* or *Guitarrero* (1860).

Manet's portrait of Léon Leenhoff in *The Luncheon* (1868) seems modeled directly on Degas' portrait of his younger brother, *Achille De Gas in the Uniform of a Cadet* (1855). Achille was seventeen years old, Léon sixteen in these portraits. Both boys are standing up and leaning with one hand on the furniture, their bodies turned slightly to the right and right legs crossed over their left knees. Achille's cadet's sword is echoed by the elaborately decorated swords on the floor near Léon. The teenaged boys look remarkably alike—almost like brothers. Both have a flat face, widely spaced eyes, broad nose, large nostrils and full lips. By modeling Léon on Achille, Manet covertly suggested that Léon was his brother, not his son.

Manet's portrait of his old friend Antonin Proust (1880) was very different from the relaxed poses and casual settings of Degas' portrayals of Tissot, Duranty and Martelli. Manet shows Proust as a dandy, boulevardier and man of the world.

The pale-skinned, sharp-nosed Proust looks directly at the viewer, and has an elegantly parted gray mustache and beard. Standing in three-quarter view and close to the frame of the picture, he sports a silky top hat, brown double-breasted coat, flower in his button hole and cravat speared by a tie pin. He rests one gloved hand on his hip and the other on a jauntily angled cane. Poised and self-assured, he's suffused with well-being and seems a mirror image of Manet himself.

By contrast, Degas' five quickly executed drawings of Manet (1866–68) were immediate and direct. Seated on a hard chair, clasping his hands between his thighs, holding his hat or dropping it on the floor, he crosses his legs and trails his long overcoat on the ground. The energetic yet finely balanced Manet, with wild hair and receding hairline, has a determined expression, intense yet reflective, and seems ready to plunge into a new painting. In these portraits Degas caught the impulsive, spontaneous aspects of Manet that distinguished him from Degas' own more cautious and careful personality.

III

TANTALIZING GLIMPSES have survived of Manet and Degas' personal relations. In 1868 Degas missed a great opportunity to travel to England with Manet—the only one who knew how to handle his quick temper and sharp tongue. In a letter that resembled Mary Cassatt's invitation to Morisot to see Japanese prints, Manet wrote Degas that Alphonse Legros, the French-born professor at the Slade School of Art, would be a useful intermediary: "I'm planning to make a little trip to London, tempted by the low cost of the journey; do you want to come along?...I think we should explore the terrain over there since it could provide an outlet for our products....Let me know immediately because I will write and tell Legros what day we'll be arriving so that he can act as our interpreter and guide."

Degas refused the invitation; and when Manet returned he

told Fantin-Latour that the journey had been a great success: "I would have loved to have had you with me on this little trip and de Gas was really silly not to have come with me. I was enchanted by London, by the welcome I got from everyone I visited, Legros was very kind and helpful....I believe there is something to be done over there; the feel of the place, the atmosphere, I liked it all and I'm going to try to show my work there next year." He also told Fantin-Latour that Degas would have been stimulated by the trip: "tell Degas it's about time he wrote to me. I gather from Duranty he's becoming a painter of 'high life'; why not? It's too bad he didn't come to London, those well trained horses would have inspired a few pictures."

Perhaps thinking of Degas, Manet wrote Zola that the English artists were gentlemen and did not have the "ridiculous jealousy" of the French painters. At the same time, he said he missed the lively conversation at the Café Guerbois. Adopting an ironic tone, he suggested the kind of intellectual topics debated by the artists who were always searching for an audience. "I envy your being able to discuss with that famous aesthetician Degas," he told Fantin-Latour, "the question of whether or not it is advisable to put art within the reach of the lower classes, by turning out pictures for sixpence apiece."[8] Manet and Degas had plenty to say. They gossiped about the latest scandals, and talked about how to paint pictures; about the Old Masters, their travels, teachers, training and new techniques; about the Salons, galleries, dealers, critics, money—and the lack of money.

They could also be cruel about each other. The contemplative Degas had admitted that he lacked, even disdained, Manet's characteristic spontaneity. He rejected Manet's sudden assault on the canvas, and thought works of art should be "as carefully plotted as the perfect crime." But Manet, the ladies' man, turned Degas' aesthetic against him and tried to connect his artistic beliefs to the crusty bachelor's supposed lack of sex. Morisot, Manet's confidante, reported: "Manet said to me very comically

yesterday, 'He lacks spontaneity, he isn't capable of loving a woman, much less of telling her that he does or of doing anything about it.' " This revealing comment implies, by contrast, that Manet could love a woman like Morisot, express his love and sleep with her.

Most of the time, however, the two rivals were amiable and pleased with each other's achievements. In 1871, their quarrel about his slashed portrait forgotten, Manet told mutual friends that "Degas is making great progress and is bound to be successful in the very near future." Always on the lookout for ways to promote his friends' careers, Manet felt, after the old Opéra had burned down, that the new one being built by Charles Garnier provided a great opportunity for Degas. His early historical pictures made him well qualified to paint traditional subjects. "Degas should have decorated the foyer of the Opéra," Manet said. "Post-*Semiramis* Degas, that is. He would have created a series of absolute masterpieces."9

Like Manet, Degas could be both sympathetic and hostile. He told George Moore that "Manet is a true Parisian, he knows how to take a joke." In 1871 he wrote Tissot: "I have seen something new of Manet's...well finished, done lovingly....What talent that fellow has." He was, therefore, all the more distressed when Manet, the natural ally and leader of the Impressionists, obstinately refused to join the first Impressionist exhibition when they most needed him. Writing to Tissot in London in the spring of 1874, Degas condemned the vanity of the misguided Manet, who hopelessly sought recognition in the Salon: "Manet, egged on by Fantin-Latour and crazy himself, continues to refuse....Manet seems determined to keep aloof, he may well regret it....I definitely think he is more vain than intelligent."10

Degas was a passionate collector of Manet's work. He owned eight paintings and fourteen drawings, nine etchings on Japanese paper, fifty-nine separate proofs and an almost complete set of his prints. In the place of honor, opposite his bed and the first

thing he saw when he awoke in the morning, were Manet's still lives: *Ham* and *Pear.* Degas also owned several other masterpieces: *The Execution of Maximilian, Departure of the Folkestone Boat, Mme. Manet on a Blue Sofa, Berthe Morisot with Hat, in Mourning* and the Degas-like *Woman in the Tub.* But he irritated Manet—and kept him in line—by refusing to praise his pictures (Manet craved Degas' admiration as much as Morisot craved Manet's). He once visited Manet's studio, looked at the latest work, complained that his weak eyes prevented him from seeing well and said nothing. A few days later Manet ran into a friend who told him: "'I met Degas the other day as he was coming out of your studio. He was enthusiastic, bowled over by everything you showed him.' 'Oh, the pig,' Manet replied. 'He said absolutely nothing to me.'"

Whatever his reservations about Manet personally, Degas always kept in touch with his latest paintings. In 1882, when he first saw Manet's use of the mirror in *A Bar at the Folies-Bergère,* he immediately understood his technique and likened it to Velázquez's *Las Meninas.* In a shorthand letter to Henri Rouart, Degas called Manet "Stupid and fine, knows a trick or two without impression[ism], deceptive Spanish painter." After Manet's death, Degas remembered the spell of his charm. He wrote that Antonin Proust, in his 1897 memoir of Manet, "gives him an attitude that I don't like. Manet was ever so much nicer, ever so much simpler."[11]

Sixteen

WOUNDED HEART

1880–1888

I

❧ As EARLY AS 1870, when he was thirty-six, Degas had lost the sight of his right eye. For the rest of his long life he suffered from myopia, blurred vision and intolerance of bright light, and lived with the constant threat of blindness. He had impaired central vision and suffered "the torment that it was to draw, when he could only see around the spot at which he was looking, and never the spot itself." In 1873 he fatalistically exclaimed: "I shall remain in the ranks of the infirm until I pass into the ranks of the blind." Five years later a friend lamented that Degas "spends hours in a dark and desperate mood, matching the gravity of his condition."[1] By 1884, at the age of fifty, Degas had still not come to terms with his disability. He said he was "often tempted to give it up and to go to sleep for ever"—to close his eyes, accept darkness and wait for death. A decade later, doctors tried to improve his ever-failing sight by covering his right eye and allowing the left one to see through a slit in his spectacles, but strong light still hurt him. At the turn of the century, at sixty-five, he portrayed himself as a living corpse: "I am a dead man, or all but dead, for the thought that he is going blind is death to a painter....I must learn a blind man's trade now." If he lost his sight, he said bitterly, "there will be nothing left for me to do but to recane chairs."[2] By 1906 he could see only patches of colors, outlines of forms.

Though he kept working until nearly the end of his life, his infirmity filled him with anger, regret and self-pity. Looking at

his early work with Mary Cassatt, he sadly remarked: "When I did that I had my eyes!" He told his older friend, the rich dilettante Evariste de Valernes, whose career seemed static as Degas forged ahead: "I envy you your eyes which will enable you to see everything until the last day. Mine will not give me this joy; I can scarcely read the papers." Daniel Halévy described Degas' gradual withdrawal from society and the depressing effect of his illness: "His eyes are getting worse and worse and he wears special glasses which embarrass him very much; all that saddens him and I suspect he remains alone to hide from our eyes the melancholia against which he has striven so hard."[3]

As Degas' vision deteriorated he changed from oil painting to pastel, which did not require mixing of pigments, drying time or varnishing. As his drawing became freer and wilder, he built up layers of pastel, achieved painterly effects and seemed to be carving solid images into paper. Edmond de Goncourt, identifying Degas' disease (the same one that his blind cousin and sister-in-law, Estelle, had), said that his limited vision had somehow sharpened his attention and increased his ability to capture the exact movement of his subject: "An original fellow, this Degas, sickly, neurotic, and so ophthalmic that he is afraid of losing his sight; but for this very reason an eminently receptive creature and sensitive to the character of things. Among all the artists I have met so far, he is the one who has best been able, in representing modern life, to catch the spirit of that life."

Perversely, Degas' eye disease made him even more passionate about art collecting. He wished even more fiercely to possess, before it slipped away from him, what he could scarcely see. Halévy, alarmed by Degas' rash behavior at art auctions, recalled that "he kept bidding and letting himself be carried away by prices that frightened even him. What's more, he couldn't even see the pictures he bought. He would ask me: 'What is it?' and then remember." His close friend, the sculptor Albert Bartholomé, was also concerned about his grandiose plan to build a museum for his

collection and the economic consequences of his latest obsession: "After the [collecting of] walking sticks, it was photography, and now paintings, with an intensity that I am afraid worries
Durand-Ruel, and that worries me for his future. His disinterestedness is all very fine, as is his idea of a museum. But…one
must eat."[4]

Degas wanted to hold on to his own work as well as acquire
the work of others. He told Tissot that out of financial necessity
"practically everyone I have given pictures to has sold them,"
and felt his work was falling into alien hands. Though he lived
modestly and was always short of money until he paid off
the bankruptcy debts, his own work fetched increasingly high
prices. The money he made from his paintings enabled him to
indulge in his only two luxuries: traveling and collecting art. In
addition to two major El Grecos, works by Goya and numerous
Daumiers, he owned—amazingly—twenty paintings and ninety
drawings by Ingres, thirteen paintings and 190 drawings by
Delacroix. His private collection of contemporary art, which he
kept till the end of his life, included Japanese prints, two works
by Morisot, twelve by Cassatt and thirty by Manet, as well as
many other pictures by Pissarro, Sisley, Cézanne, Renoir, Gauguin and Van Gogh. Some of these were bought, some exchanged; others were gifts. He also owned a great many of his
own masterpieces, all his whorehouse monotypes and all his
sculpture. His superb collection, more suitable for a Renaissance
prince than a nineteenth-century artist, chosen with an unerring
eye and impeccable taste, would indeed have filled a substantial
museum. Instead, it was dispersed in five massive sales, after his
death, in 1918–19.

In 1912 the house that Degas had inhabited for twenty-two
years came up for sale. When the new owner decided to pull it
down, he was forced to move. Vollard sadly observed that the
artist could have bought the house and continued to live there:
"M. Degas, you would only have had to open your portfolios to

have the three hundred thousand francs they were asking for that house." Degas could not bear to part with a single work from his collection and replied: "Can an artist chuck away three hundred thousand francs like that?"[5] In the rue Victor Massé he'd had apartments on three different floors: one to live in, one for his collection and the top floor for his studio. After his final move to the boulevard de Clichy, he kept the work of others on display from the floors to the high ceilings of his apartment and hid his own work in secret rooms that no one ever saw.

II

IN MIDDLE AGE, hiding his real self and more bearlike than ever, Degas adopted his irascible public persona and became "Degas." His concave face and round-shouldered stoop, wrote the English artist William Rothenstein, "his raised eyebrows and heavily-lidded eyes, gave him an aspect of aloofness; and in spite of his baggy clothes, he looked the aristocrat that he was." Paul Gauguin, who had mixed feelings about Degas, noted the contrast between his appearance and his true self, and described the delicate sensitivity beneath the gruff exterior:

> In appearance, with his silk hat on his head, his blue spectacles over his eyes—not to forget the umbrella—he is the image of a notary, a bourgeois of the time of Louis-Philippe [King of France, 1830–1848].
>
> If there exists a man who cares little about looking like an artist, it is certainly he; he is so much of one. He detests all liveries, even this. He is as good as gold; yet, fine as he is, people think him morose....
>
> The tendernesses of intelligent hearts are not easily seen.

To the outside world Degas, who claimed that he didn't know how to be agreeable in society, was predictably disagreeable. Vollard gave a hilarious example of how Degas, at his most bearish, imperiously responded to his dinner invitation. Food,

decorations, time, pets, scent and lighting all had to meet his exacting specifications:

> "But listen: will you have a special dish without butter prepared for me? Mind you, no flowers on the table, and you must have dinner at half past seven sharp. I know you won't have your cat around and please don't allow anybody to bring a dog. And if there are to be any women I hope they won't come reeking of perfume. How horrible all those odors are when there are so many things that really smell good, like toast—or even manure! Ah," he hesitated, "and very few lights. My eyes, you know, my poor eyes!"

When all the preparations had been properly made and the dinner had punctually begun, a nervous little boy (warned, no doubt, about the fearsome guest) started to tap his plate with a knife. Degas roughly cried out: "'What's that racket!' which so frightened the lad that he immediately turned pale and vomited all over the table."[6]

Eager for Degas' witty and stimulating conversation, hosts gave in to his demands. But he could never control his sarcastic judgments, splenetic touchiness and capricious temper: it was all part of his bearish performance. Degas fastened on a victim's weakness, fought stubbornly for victory in arguments and combined ferocity with humor. It was great fun—as long as you weren't the target. Valéry, who knew him well, illuminated this aspect of his character:

> [He had] a certain prankishness, a perverse tendency to seize on whatever was ridiculous or foolish in other people's ideals....He was a great arguer, merciless in retort....Unyielding, he would quickly reach the stage of shouting, using the harshest language....[He was] a constant, brilliant, unbearable guest, spreading wit, terror, and gaiety...[with] his irony, his aesthetic acuity, and his vehemence....A monster of intelligence and self awareness...he carried out his demo-

litions with a sort of tenderness that blended very oddly with his ferocious irony...[and] a winning blend of mockery, fun, and familiarity.

The painter Odilon Redon, impressed—as Monet had been in the Café Guerbois—by Degas' brilliant talk, noted the paradoxical contrast between his fierce image and (when he was in the right mood) his lively congeniality: "The main interest in his talk is the rage he exhales against the false and the absurd. I told him how pleasantly surprised I was, in view of his reputation for being a tiger, by his communicative sociability. He said he maintained that legend of ferocity to get people to let him alone. When I left him my mind was awake and alert."[7]

Patriotic, honorable and generous, Degas had an abrasive personality. A critic summarized his principal qualities: "Degas' disdain for [critics and] politicians, his preoccupation with the moral essence of the popular soul, his sympathy for the simple folk of the Paris *faubourgs* and country hamlets...all these sentiments, illogically combined with a firm and obstinate attachment to those liberal values somehow embodied in the polite conversation and good manners of upper-class society, constituted the main elements in his character."

In mid-August 1884, while staying with the Valpinçons in Normandy a month after his fiftieth birthday, Degas, overcome by deep depression, wrote two soul-searching letters. Exaggerating his decline and loss of creative inspiration, he suggested that a crucial defect of character—a cold heart—had cut him off from the current of life:

Where are the times when I thought myself strong. When I was full of logic, full of plans. I am sliding rapidly down the slope and rolling, I know not where, wrapped in many bad pastels, as if they were packing paper....

If you were single, 50 years of age (for the last month) you would know similar moments when a door shuts inside one and not only on one's friends. One suppresses everything

around one and once all alone one finally kills oneself, out of disgust. I have made too many plans, here I am blocked, impotent. And then I have lost the thread of things.[8]

Fear of the personal and aesthetic consequences of his undeveloped heart, which had kept him from marriage and led to accusations that his art was cruel, became a recurrent theme in Degas' correspondence from the 1870s to the 1890s. He compared his heart to a delicate musical instrument that had to be, but was not, "rubbed up and used a lot so that it keeps bright and well." In letters to Bartholomé that expressed an almost Kafkaesque need for misery, he admitted his lack of feeling, described his heart as a shrunken organ that had just enough substance to keep him going and said his work had devoured his life. His heart, he claimed, was not only wrapped in pastels but also sewn like dancers' slippers into a satin bag: "At bottom, I have not got much heart. And what I once had has not been increased by the sorrows of my family and others; I have been left only with what could not be removed, comparatively little....Thus acts a man who wishes to end his days and die all alone without any happiness whatever....Even this heart of mine has something artificial. The dancers have sewn it into a bag of pink satin, pink satin slightly faded, like their dancing shoes."

Degas loved his friends, yet withdrew from intimate contact. Referring to the bust he was doing of Hortense Valpinçon, the daughter of close friends, he wrote that he was trying to reciprocate the affection he'd received from them: "As one grows old, one tries to give back to people the good they have done to you, and to love them in turn." In his most poignant, self-lacerating letter, he apologized to his older friend, de Valernes, whose portrait he'd painted in 1865, for his defects of character: "I was or seemed to be hard with everyone through a sort of passion for brutality, which came from my uncertainty and my bad humour. I felt myself so badly made, so badly equipped, so weak, whereas it seemed to me, that my calculations on art were so right. I

brooded against the whole world and against myself. I ask your pardon sincerely if, beneath the pretext of this damned art, I have wounded your very intelligent and fine mind, perhaps even your heart."[9] In late middle age Degas acknowledged that his dedication to art had cost him dearly and had severely restricted his emotional life. Though his friends continued to respect and admire him, he'd used his genius as an excuse for being unpleasant. His acute sensitivity now magnified these failings.

Degas showed the benign, paternalistic side of his character with favorite children, impoverished colleagues and promising younger artists. He was especially fond of Morisot's teenaged daughter, Julie, and she was devoted to Degas. "I don't know why people say he's nasty," she recorded, "he seems so nice, he kisses you in such a fatherly way." When he discovered that an English photographer was destitute in Dieppe, he told Ludovic Halévy: "Watch over Barnes whilst protecting him so that he may quite simply be happy."

He encouraged his former model, Suzanne Valadon, also struggling against poverty, with generous praise. "From time to time," he told her, "I look at your red chalk drawing in my dining room, which is still hanging there. And I always say: 'That she-devil of a Maria, what talent she has.'" Both Lautrec (who worshipped Degas) and Gauguin (a reluctant follower) treasured the master's rare praise. Lautrec proudly told his mother that "Degas has encouraged me by saying that my work this summer wasn't too bad." He also quoted Degas alluding to Genesis and saying: "Well, Lautrec, I can see that you are one of us."[10] Degas pleased Gauguin at his artistic debut by saying, "Like a good papa...'You have your foot in the stirrup.'" Once the quibbling among the Impressionists was over, Gauguin saw the exemplary side of Degas' character:

Man and painter, he is an example. Degas is one of those rare masters who, having only to stoop to take them, has disdained fortune, palms, honours, without bitterness, without jealousy....

In his talent and his behaviour, Degas offers a rare ex-
ample of what the artist ought to be, he who has had among
his colleagues and admirers all those now in power...and
who has never accepted anything for himself. One has never
heard of or seen on his part, any dirty trick, indelicacy, or un-
worthy action of any kind. Art and dignity.

At the age of eighty Degas, keeping up with the latest art, ad-
miringly said that what the young Cubists were attempting
seemed even "more difficult than painting."[11]

<div align="center">III</div>

LATE IN LIFE, Degas developed another artistic interest. In
February 1889 Stéphane Mallarmé told Morisot, who'd intro-
duced him to Degas, that the painter had quite unexpectedly
thrown himself into poetry with the same passion he devoted to
his art: "His own poetry is taking up his attention, for—and this
will be the notable event of the winter—he is on his fourth son-
net. In reality, he is no longer of this world; one is perturbed be-
fore his obsession with a new art in which he is really quite
proficient." Degas wrote twenty carefully crafted sonnets, limit-
ing himself to this difficult and demanding form. Most of them
dealt with the same subjects as his paintings: horses and race-
tracks, ballet dancers and the Opéra. Though he painted with
ease, he suffered creative torment when he wrote poetry. After
he'd complained about the agonies of writing, Mallarmé—who
admired his sonnets but may have resented the amateur's incur-
sion into his own field—gave him a paradoxical, Degas-like put-
down. "'What a business!' [Degas] lamented. 'My whole day
gone on a blasted sonnet, without getting an inch further....And
all the same, it isn't ideas I'm short of...I'm full of them...I've
got too many.'... 'But, Degas,' rejoined Mallarmé, with his gentle
profundity, 'you can't make a poem with ideas.... *You make it with
words.*'" Bowing with uncharacteristic modesty, Degas acknowl-

edged Mallarmé's superiority and admitted: "you humiliate me with pleasure."[12]

Degas preferred Mallarmé's conversation to his poetry which, he admitted, he could not comprehend. During one of the poet's public readings he fidgeted with palpable boredom. Teasing Mallarmé about his notorious obscurity, Degas asked him: "Is it true that in one of your sonnets, one of your critics sees a twilight, another sees a dawn, and still another sees the absolute?" Despite the painter's obvious lack of enthusiasm, the poet sent Degas, who was supposedly illustrating Mallarmé's poems, an encouraging if opaque quatrain, which was translated as: "Muse, who choose him, if you can pacify the anger of my confrère Degas, give him this speech to read."[13]

Degas' sonnet "Pure-Bred" captured in words his love of horses and the quintessential qualities he'd portrayed in wax and clay: "the natural disposition and true character of the animal," as he told François Thiébault-Sisson in 1897, the accentuation of "bone and muscle and the compact firmness of flesh...which is solid and which does not lie." The sonnet describes a spirited and superior thoroughbred, exercising at dawn and taking his energy from the warmth of the rising sun. Carefully trained and well-prepared for the race, the innocent colt is taken over by a gambler and exploited for profit rather than allowed the pure joy of running: "*Tout nerveusement nu dans sa robe de soie*":

> You can hear him coming, his pace checked by the bit,
> His breath strong and sound. Ever since dawn
> The groom has been putting him through his paces
> And the brave colt, galloping, cuts through the dew.
>
> Blood-strength, like the burgeoning day drawn up from
> The East, gives our novice runner,
> Precocious, impervious to ceaseless work,
> The right to command crossbreeds.

Nonchalant and diffident, with slow-seeming step,
He returns home for oats. He is ready.
Now, all at once, the gambler grabs him.

And for the various games where he's used for gain
He's forced onto the field for his debut as a thief,
All nervously naked in his dress of silk.

In the first of his four sonnets on ballerinas Degas (alluding to the nineteenth-century German composer Karl Maria von Weber) subtly imitates in verse the leaps and falls, the death and rebirth of the dancer, as well as the melancholy music of the woodwinds and strings. Degas mentions his own weak eyes as he attempts, from his box at the opera, to track her swift movements in the glaring lights. Then, suddenly, the magic spell is broken. The dancer fatally miscalculates her leap and falls like a frog into the pond of Aphrodite:

She dances, dying. As around the reed
Of a flute where the sad wind of Weber plays,
The ribbon of her steps, twists and knots,
Her body sinks and falls in the movement of a bird.

The violins sing. Fresh from the blue of the water
Silvana comes, and carefully ruffles and preens;
The happiness of rebirth and love on her cheeks,
In her eyes, on her breasts, on her whole new being.

And her satin feet, like needles embroider
Patterns of pleasure. The springing girl
Wears out my poor eyes, straining to follow her.

With a trifle, as always, the beautiful mystery ends.
She bends back her legs too far in a leap,
It's the leap of a frog in the Cytherean pond.[14]

The racehorse is constrained and exploited; the dancer falls and ruins the magic.

The next sonnet imagines a goddess of the dance, with "speaking hands" and "passionate feet," rousing a sleepy young dancer and forcing her to "leap and soar." On the distant stage, in makeup and costumes, commonplace but heroically trained, girls are transformed into alluring priestesses who serve the cult of the dance. In contrast to the dark view of the earlier sonnet, the ballerinas in this poem retain their magic and sustain the theatrical illusion:

> As if an indolent nature in those days,
> Confident of beauty, would rest—would sleep
> Too heavily; if not for a certain grace
> Rousing her with a happy, panting voice.
>
> And then, keeping an irresistible time
> With the movement of her speaking hands,
> And the interweaving of passionate feet
> Forcing her to leap before her with delight.
>
> Begin, you darlings, with the futile help
> Of Beauty—leap despite your common face,
> Leap, soar! You priestesses of grace,
>
> For in you the Dance is embodied now,
> Heroic and remote. From you we learn,
> Queens are made of distance and dyed flesh.

The fourth sonnet also repeats key words ("all" and "see"), uses classical references and develops the theme of illusion on stage. The mysterious dance is silent, the bodies both moving and still: quiet and held in one place. Once again, the artist's eye strains to catch the fleeting movements of the painted harlequin. The young ballerina—pursued by the predatory patrons of the Opéra as Atalanta, the virgin huntress, was pursued by men who wished to marry her—remains sealed in the mystery of her fascinating art. The aging Degas, trying to recall their step, is tormented by aesthetic as well as sensual desire for these graceful girls:

All that the fine word *pantomime* implies
And all that the *ballet's* agile, lying tongue
Says to those who grasp the mystery
Of bodies moving, eloquent and still;

Who see — who *must* see in the fleeting girl
— Incessant, painted, harlequin, severe —
Vanish all trace of their transitory soul,
Flashing faster than the finest strophe;

— All, even the crayon's careful grace:
A dancer has All, though weary as Atalanta:
Serene the tradition, sealed to the profane.

Beneath fake boughs, your infinite art observes:
Uncertain of a step, I think of you,
And you come — you come, tormenting an old faun.

"Little Dancer," focusing on a specific model, provides the verbal complement to Degas' own major sculpture *The Little Dancer, Aged Fourteen*. He calls Marie van Goethem, bred in the gutters of Montmartre, a scamp. Dancing on the wooden lawns of the stage, she's compared to Marie Taglioni, the great Parisian ballerina of the 1830s, as well as to the pastoral nymphs and graces of Greek mythology. She has a cheeky expression, the nose of Cyrano's Roxane, China-porcelain blue eyes and the graceful chiaroscuro flight of Shakespeare's Ariel in *The Tempest*. With a thin arm she balances her pose both onstage in the gleaming opera house and in his own sculpted masterpiece, which grounds the nymph in contemporary reality:

Dance, winged scamp, dance on the wooden lawns,
Love only that — let dancing be your life.
Your skinny arm assumes the attitude
And balances your flight against your weight.

Taglioni, come, Princess of Arcady!
Nymphs, Graces, come you souls of yore,

Ennoble and endow, smiling at my choice,
With form the boldfaced little neophyte.

Montmartre may give the breeding and the mind,
Roxelane the nose, and China the eyes—
But vigilant Ariel offers this recruit

The dancing feet of daylight and of dark.
Then for my pleasure let her know her worth
And keep, in the golden hall, the gutter's breed.[15]

Degas' sonnets—often quoted but never explained—express the themes of reality and illusion, permanence and transience. They acknowledge his own weaknesses and longings, and show how he observed, understood and sympathized with the vulnerable horses and dancers. Obsessed and inspired by the magic of ballet, he captured the dancers in words and immortalized them in art.

IV

THE IMPRESSIONISTS were better known in England than in any other foreign country. Degas' fame reached across the Channel and attracted a number of eminent English writers and artists. The poet and painter Dante Gabriel Rossetti, usually hostile to French art, praised Degas' originality. In the *Academy* of April 29, 1876, he wrote that the ballet pictures, which sometimes portrayed the dancers in awkward poses, showed "surprisingly clever pieces of effect, of odd turns of arrangement, and often of character, too pertinaciously divested of grace." Sidney Colvin—art critic and, later on, keeper of prints and drawings at the British Museum—wrote a more insightful account in the *Pall Mall Gazette* of November 28, 1872. Admiring Degas' extraordinary insight about commonplace events, he praised a dance rehearsal and *At the Races in the Countryside* (1869): "It is impossible to exaggerate the subtlety of exact perception, and the felicitous touch in expressing it, which reveal themselves in his

little picture of ballet-girls training beneath the eye of the ballet-master, and his other picture of a bourgeois family in an open carriage at the races—the father on the box, with the mother watching her baby in the arms of its wet-nurse. Without the slightest pretension, these are both of them real masterpieces."[16]

The foppish Whistler and the obsequious George Moore, who'd visited Manet, pushed their way past Sabine and Zoé and turned up at Degas' studio. Degas found in Whistler's studied artificiality an irresistible object of scorn. When discussing the eloquent Whistler with Frank Harris—the energetic journalist and editor, later notorious for his sexually explicit memoirs—Degas had let loose a satiric shaft: "He should paint with his tongue," Degas said, "then he might be recognized as a genius." Whistler was frightened of Degas, who once told him: "you behave as though you have no talent." "When Whistler, chin high, monocle in his eye, frock-coated, top-hatted, and carrying a tall cane, walked triumphantly into a restaurant where Degas was sitting," the painter deflated him by remarking: "Whistler, you have forgotten your muff."

Knowing his missiles would find their way back to the target, Degas had to apologize for Moore's publication of some of his cruel comments about Whistler. Graciously accepting the apology, Whistler exclaimed: "That's what comes, my dear Degas, of letting those vile studio-crawling journalists into our homes!" Degas, who guarded his privacy, shared Whistler's hatred of predatory reporters: "Those people trap you in your bed, strip off your shirt, corner you in the street, and when you complain, they say: 'You belong to the public.'"[17]

Moore may have been a "studio-crawler," but he left a valuable record of Degas' opinions in six essays, published between 1886 and 1918. Degas told Moore that art must retain its mystery and that critics did no good by trying to explain its meaning. Art criticism, he felt, failed to educate readers and simply made artists more egoistic: "I think that literature has only done harm

to art. You puff out the artist with vanity, you inculcate the taste for notoriety, and that is all; you do not advance public taste by one jot." Degas also explained his attitude toward his nude bathers with two striking phrases—"human animal," "looked through a key-hole"—that have strongly influenced the way modern critics have interpreted his work. "She is the human animal occupied with herself," he told Moore. Up to now "the nude has always been represented in poses which presuppose an audience, but these women of mine are honest, simple folk, unconcerned by any other interests than those involved in their physical condition. Here is another; she is washing her feet. It is as if you looked through a key-hole."

The quick-witted, silver-tongued Oscar Wilde, visiting Degas' studio with Whistler in 1894, met his match in Degas, who quickly pierced his façade. He remarked that Wilde, straining to make a dramatic impression, "seemed to be playing Lord Byron in a suburban theatre." When Wilde praised his work and said, "you know how well known you are in England," Degas, alluding to Wilde's notorious homosexuality, replied: "Fortunately, less so than you." When the poet and editor William Ernest Henley asked him about Degas, Wilde, unable to appreciate Degas' achievement, responded in a series of cynical statements: "he loves to be thought young, so I don't think he would tell his age. He disbelieves in art-education, so I don't think he will name a Master. He despises what he cannot get, so I am sure he will not give any information about prizes or honours. Why say anything about his person? His pastels are himself."[18] By then, the sixty-year-old Degas was himself a Master, and genuinely despised all honors. Absorbed in the reality of everyday life, he did not share Wilde's views on "art for art's sake."

SOLITARY PROSPERO
1889–1917

I

❧ IN SEPTEMBER 1889 Degas finally went to Spain. Like Manet, he was most concerned with the cuisine, the bullfights and the pictures, but he did not paint Spanish subjects. He traveled with the flashy, egoistic and highly successful Italian painter Giovanni Boldini, and the two forceful personalities clashed along the way. Degas expected to be roasted on the plains of Castille, but planned to take refuge in the cool museums. He arrived in Madrid early in the morning, toured the Prado from nine to noon and was ecstatic about the art of Velázquez. In the fierce heat he returned to the Hotel de Paris for lunch. Though warned in France about the food, he ate admirably in Spain. Later that afternoon the energetic traveler went to (but did not describe) a bullfight.

Reading *The Arabian Nights* and remembering that Delacroix had visited Morocco, Degas crossed the Straits of Gibraltar to Tangier and joined an exotic procession. "Can you imagine me on a mule," he asked the sculptor Bartholomé, "taking part in a cavalcade that was led by a guide in a violet silk robe on the sand of the sea, in the dust and along the paths of the surrounding countryside?" When he returned to Paris, Degas expressed his annoyance with the slick, irritating Boldini. "What a great talent you have," Degas told him, "but what a funny idea of humanity; when you paint a man you make him ridiculous; and when you paint a woman you make her dishonored."

The following September, recalling perhaps the carriage ride in Normandy when he read *Tom Jones,* Degas and Bartholomé left Paris for the home of their artist friend Pierre Georges Jeanniot in Burgundy. They traveled for a week, pulled by a white horse in a quaint tilbury (a light, two-wheeled carriage without a top), with Bartholomé holding the reins. Amused by the antics of the willful horse, Degas wrote that after devouring a great quantity of oats, "He slowed down to a walk too often. He acted exhausted in a town he did not wish to leave." Then, reflecting on his own somber character, he added: "One needs to have been sad and serious for a long time to enjoy oneself so much.... Our coachman [Bartholomé] is carrying the horse in his arms." According to one story, they painted the troublesome horse with black stripes and transformed him into a zebra. The deception amazed the local peasants, but was exposed during a rainstorm when the paint began to run. After completing 375 miles in fifteen days and eating some formidable meals along the way, they met the painter Forain in a restaurant outside Paris. Dissatisfied with the still unripe cheese, Forain told the waiter: "One does not give Brie like that to Parisians!"

The slow-paced journey inspired Degas to paint some rare landscapes. Describing Degas' technique, Jeanniot noted how his chromatic landscapes gradually emerged and came into being—like the magically expanding flowers in Proust's novel—from the once-blank surface. Degas created "a valley, a sky, white houses, fruit trees with black branches, with birches and oaks, ruts filled with water from the recent downpour, orange colored clouds flying in an agitated sky, above the red and green earth."[1]

II

AS DEGAS' SIGHT deteriorated and he took up pastels, he also began to concentrate on sculpture, working in wax and clay as early as the mid-1870s, and treating his favorite subjects in a new

medium. Degas observed horses at breeding farms and race-tracks, but (unlike the English artist George Stubbs, who also portrayed horses) he did not paint them from life. The journalist François Thiébault-Sisson met Degas in 1897 and wrote an account of his methods. Degas told him an improbable anecdote, taken from an unnamed biographer, about how the novelist Charles Dickens broke through his imaginative roadblocks by making models to represent his fictional characters:

> Whenever he lost his way in the complicated weave of his characters and did not know what lot should befall them, he got himself out of the knot...by building figures to whom he assigned the names of the characters. When he had them on the table in front of him, he endowed them with the personalities which were...suitable to each, he had them talk to each other...and the situation instantly cleared up, the newly alert novelist resumed his task and brought it resolutely to successful conclusion.

Degas did not find this story in a biography of Dickens, but in a chapter on Dickens in Hippolyte Taine's *History of English Literature* (1863):

> There is a painter in [Dickens], and an English painter....An imagination so lucid and energetic cannot but animate inanimate objects without an effort....Blank nature is peopled, inert matter moves....Imaginary objects are designed with outlines as precise and details as numerous as real objects, and the dream is equal to the reality.

Degas identified with the "painter" in Dickens, but forgot the actual details of Taine's description and assumed that Dickens' method matched his own. In his studio he showed Vollard his little wooden horses. "When I come back from the races," he said, "I use these as models. I could not get along without them. You can't turn live horses around to get the proper effects of

light."[2] Degas had been using small models. He now made stick figures and built them up with wax and clay, using his fingers to show the muscles and movement he could no longer depict with a brush. His horses—rearing on hind legs, galloping with raised forelegs and tail, or lunging ahead with wraithlike jockeys—have fine detail, crisp surfaces and a lively movement. Recalling the majestic steed of Verrocchio's *Colleoni* in Venice, they spring forward with a sudden release of tension and energy. Degas' work seems to leap off the pedestal, and makes the sculpture of Rodin and Maillol seem inert.

Degas created stampedes of horses, with heads straining forward or twisted to one side; vibrant corps de ballet that seem ready to leap up and fly away; a bounty of bathers with long swirls of hair (one of them seen from above and lying on her back in a shallow circular tub) attentively washing themselves. One statue (like Manet's *Nymph Surprised*) portrays a *Woman Taken Unawares* (1892) who is modestly covering her private parts. But most of Degas' women are supremely unselfconscious, like cats licking themselves clean.

In his pioneering study, John Rewald described how Degas would move his hand along the body of the model or dancer in order to transform the sensation of her figure into a work of art: "even though he was seated very close to the model, he could only dimly distinguish her shape, and had to get up at every instant to feel with his hand the curve of the hip or the position of a muscle which his thumb would model in clay." Sculpture allowed him to continue to explore the shapes and movements of the body he loved, but could no longer clearly see. The *Dancer Fastening the String of Her Tights* (1885–90), twisting backwards with her right arm on her lower back, has the same *contrapposto* pose as the headless, one-armed torso of the *Bather Rubbing Her Back with a Sponge* (1900). Degas portrays his dancers, more solid and substantial than the anorexic skeletons of today, dressing, adjusting, stretching, bending, bowing, rehearsing, resting, scratching, chatting and

napping. Their attitudes suggest that they were often terribly bored, and hated to have every pose and gesture controlled by the dancing master. The dancer was trained to conceal her effort; Degas revealed—with a sense of intimacy and immediacy, a vivid equilibrium of forms—the mechanics of strenuous action.

The most famous piece of sculpture by Degas and the only one exhibited in his lifetime—at the sixth Impressionist exhibition in 1881—is *The Little Dancer, Aged Fourteen* (the previous year, as an *amuse bouche,* he'd shown its empty glass case). The original three-foot statue had real hair and ribbon, linen bodice, diaphanous muslin tutu and pink satin ballet slippers, and the golden amber of the wax captured the warm tints of the human complexion. The bronze *Little Dancer*—with back-tilted head and splayed feet—has a monkish fringe of hair, closed eyes, sloping forehead, muzzlelike mouth and protruding jaw, long braid tied with a yellow ribbon, unusually thick neck (to support her heavy head), pinned-back shoulders, flat chest, raised hip, slightly distended belly (like a Germanic Eve), buttoned off-the-shoulder bodice, tiny waist, ragged gauzy skirt, spindly legs, thin arms and hands clasped behind her back. *Jolie-laide,* pathetic, frail, vulnerable yet magically attractive, she resembles the dressed-up, doll-like icons that populate the dusky corners of Spanish cathedrals.

The model was the Belgian adolescent Marie van Goethem, whose mother was a laundress and oldest sister a prostitute and thief. Marie's Aztec features—what Degas called the chic of ugliness—make her look like an Amazonian shrunken head. In 1881 *The Little Dancer,* as Ann Dumas noted, "seemed to invoke all at once the macabre associations of an Egyptian mummy, a religious relic, and a kitsch verismo waxwork"—an African fetish or voodoo image. One critic was shocked by "the fierce inelegance of the pupil who will grow up into a woman for whom diplomats will commit follies," and Marie, in fact, was already acquiring a reputation for loose morals. Once more Huys-

mans, the most brilliant and penetrating art critic of Degas' time, ignored these banal reactions and recognized his revolutionary achievement. He called the statue of *The Little Dancer* "the only really modern attempt that I know in sculpture....All the ideas about sculpture, about cold, lifeless whiteness, about those memorable formulas copied again and again for centuries, are demolished....M. Degas has knocked over the traditions of sculpture, just as he has for a long time been shaking up the conventions of painting."[3]

Degas' technique was recklessly and deliberately self-destructive. As filling for his wax and clay statues, he used matches, paper, cork, sticks, rags, rope, wood, sponges, cloth, plugs and even the broken handles of paintbrushes. These objects worked their way to the surface and made holes in the sculpture. "I must be a fool to have put corks in this figure," Degas exclaimed in a moment of exasperation. "Imbecile that I am, with my mania for wanting to make economies of two coppers! There is my [work] entirely destroyed! Oh, why did I thrust myself into sculpture at my age?"

Vollard was horrified when an early version of *The Little Dancer* suddenly crumbled to pieces, and urged Degas to make his work permanent. But the artist rejected this idea:

> "Have it cast!" he cried. "Bronze is all right for those who work for eternity. My pleasure consists in beginning over and over again. Like this....Look!" He took an almost finished *Danseuse* from his modelling stand and rolled her into a ball of clay....
>
> "All you think of, Vollard, is what it was worth. But I wouldn't take a bucket of gold for the pleasure I had in destroying it and beginning over again."[4]

In his endless quest for perfection and lack of interest in the finished work—the very heart of his aesthetics—Degas resembled Leonardo da Vinci. As Giorgio Vasari wrote in his life

of Leonardo: "His knowledge of art, indeed, prevented him from finishing many things which he had begun, for he felt that his hand would be unable to realise the perfect creations of his imagination, as his mind formed such difficult, subtle and marvellous conceptions that his hands, skilful as they were, could never have expressed them."

After Degas' death in 1917, about 150 wax sculptures (known only to his most intimate friends) were found in his studio. They had to be hidden in the cellar of his bronze founder, Adrien Hébrard, to protect them from the German bombardment of Paris in World War I. Some had almost crumbled to dust, others had his thumbprints still visible. Only seventy-three of them were intact or could be repaired. These were cast in rough-surfaced bronze, limited to twenty-two copies of each work and first exhibited in 1921. The casting, Thiébault observed, gave freshness and keenness to "the fissured wax shapes, weakened and dusty, with the armature breaking through the surface" and twisting out of the extended limbs.[5]

Degas was influenced by both Greek and Renaissance sculpture. *The Young Daughter of Niobe, with Hands Behind Her Back* (440 B.C., Terme Museum, Rome), for example, influenced his *Dancer at Rest, Hands Behind Her Back* (1880). He sometimes captured the delicacy, grace and power of Donatello and Cellini. Degas himself clearly influenced the sculpture of Gauguin, Matisse and Picasso. But his truest artistic legacy is found in the magnificent drawings of horses and riders and the statues of dancers by Henri Gaudier-Brzeska, a young artist killed (while Degas was still alive) in the Great War.

III

NATIONAL POLITICS also darkened Degas' life in the 1890s and alienated him from his closest friends. Two of his fundamental beliefs, patriotism and honor, had inspired his enlistment during the Franco-Prussian War and his assumption of the fam-

ily's debts when their bank collapsed. These noble principles, along with his nationalistic sympathy for the army, led him astray during the Dreyfus affair, an episode that tore French society apart. In 1894 the army accused Alfred Dreyfus, a Jewish captain in the intelligence section, of selling secret documents to the Germans. On flimsy, forged evidence, a court-martial convicted him of treason and sentenced him to life imprisonment, with solitary confinement, in the penal colony on Devil's Island, off the coast of South America.

In January 1898 a reexamination of the evidence incriminated a French major, Walsin Esterhazy, but a military court acquitted him. That month Emile Zola's fiery pamphlet, *J'accuse,* proclaimed Dreyfus' innocence and riveted public attention on the affair. Zola, tried and convicted of libel, fled to England. Monarchists, Catholics, conservatives, nationalists and anti-Semites tried to defend the army's authority and honor. The fanatical novelist and politician Maurice Barrès claimed that "the reckless Dreyfusards were sapping military morale. 'Even if their client were to be proved innocent,' Barrès wrote, 'they would remain criminals.'" Socialists, liberals and intellectuals demanded justice and a reversal of Dreyfus' conviction. In September 1899 Dreyfus, white-haired and broken by his four-year ordeal in prison, was brought back to France for another trial. He was again found guilty, but his sentence was reduced to ten years. In 1906, twelve years after his first trial, he was finally exonerated and decorated with the *Légion d'honneur.* Dreyfus resumed his military career and fought gallantly in World War I.

Degas had a number of Jewish friends and patrons. He'd painted portraits of Ludovic Halévy, Rabbi Astruc, Mme. Charles Hayem, Alphonse Hirsch and Henri Michel-Lévy. He came close to caricature in his portrayal of the hook-nosed financier Ernest May in *Portraits at the Stock Exchange* (1878–79). But he became a fanatical opponent of Dreyfus and got furious with anyone who disagreed with him. When Edouard Drumont began to publish

his violently anti-Semitic, anti-Dreyfus newspaper *La Libre Parole* (Free Speech), Degas had Zoé read the articles aloud to him every morning. According to Valéry: "With the advent of the Dreyfus affair, he was quite beside himself. He would bite his nails. He would listen for the slightest hint of what he suspected, would burst out, would make a clean break at once: 'Adieu, monsieur…' and turn his back on the enemy forever. Very old and intimate friends were *cut* in this fashion, without hesitation or appeal."

"One does not speak of [Dreyfus]," Degas exclaimed, "so as not to cry with rage." Like the equally anti-Semitic and anti-Dreyfusard Renoir, who wrote that "to remain with the Jew Pissarro is [to join] the revolution," Degas also broke with his kindly old comrade. Referring to the legend of a cursed figure, he called Pissarro "the poor old wandering jew." He then asked: "What did he think since the revolting *affaire?* What did he think of the embarrassment one felt, in spite of oneself, in his company?…What went on inside that old Israelitic head of his? Did he think only of going back to the times when we were more or less unaware of his terrible race?"[6]

Degas lashed out at anyone he suspected of sympathizing with Dreyfus. When he abruptly told a poor model: "I don't want you any more!" and she pointed out that "you always said I posed so well, Monsieur Degas," he irrationally replied: "Yes, but you are a Protestant, and the Protestants and Jews are hand in glove in the Dreyfus affair." Isaac de Camondo, a Jewish banker and collector of his work, sent his mistress to invite Degas to dinner. When he refused she declared: "'But I'm not Jewish.' 'That's true,' answered Degas, in the hearing of twenty persons, 'but you're a whore!'"

Stubbornly nationalistic and blinded by fanaticism, Degas preferred to break with his oldest friends rather than face the truth. Infuriated by Daniel Halévy's attacks on established authority, he severed relations with the family. "'This is the last of

our delightful chats,' lamented Daniel in 1897. 'The bond is bro-
ken—our friendship perishes.'" In a sad letter of December
1897, written in coldly formal diction but suffused with the rem-
nants of his old affection, Degas told Ludovic's wife that he now
found their company unbearable and could no longer continue
to see them:

> It is going to be necessary, my dear Louise, to give me leave
> not to appear this evening and I might as well tell you right
> away that I am asking it of you for some time to come. You
> couldn't imagine that I would have the courage to be gay all
> the time, to make small talk. I can no longer laugh. In your
> goodness you thought that these young people and I could
> mix with each other. But I am a burden to them, and they are
> even more unbearable to me. Leave me in my corner, where
> I will be happy. There are very good moments to remember.
> If I let our affection, which goes back to your childhood, suf-
> fer greater strain, it will be broken.[7]

Degas' withdrawal from Jewish (and even Protestant) friends
intensified his isolation. The word "alone" recurred in the letters
of the aging *celibataire*, along with the idea that his wounded heart
had shriveled up and left him in solitude. Referring to Julie
Manet's husband, whose proposal he had encouraged, he said: "I
am alone. I see how happy [Henri] Rouart's son is. It is a good
thing to marry.—Ah, *la solitude*." Longing for a wife but knowing
he was unfit for the commitment to conjugal life, he considered
marriage desirable but impossible. Nevertheless, he urged Vol-
lard to marry and assuage his solitude: "You do not realize how
terrible it is to be alone as you grow old." With no children to
care for him and carry on his name, he had "nothing to think of
but—death."

Sometimes, as a note of self-pity crept in, Degas felt that he'd
made the wrong choice and was doomed to misery. He referred
to himself as "a man who wishes to end his days and die all alone

without any happiness whatever." To Mme. De Nittis he opened
his lacerated heart and lamented his loneliness: "Living alone,
without a family, is really too hard. I never would have suspected
it would cause me so much suffering. Here I am now, getting old,
in poor health.... I've really made a mess of my life on this earth."[8]

IV

THOUGH PENNILESS at the time of the bankruptcy and in-
clined to think of himself as poor, Degas—like all the Impres-
sionists who survived into the twentieth century—eventually
achieved financial success. At the auction of Henri Rouart's col-
lection in December 1912, Degas' *Dancers Practicing at the Bar*
(1876–77) was bought, at Mary Cassatt's urging, by her friend
Louisine Havemeyer for about $95,000. It was the highest price
ever paid for a work by a living artist, but provoked a bitter reac-
tion from Degas. Angry that collectors and dealers were profi-
teering by reselling a work that he'd originally sold for only $100,
he compared himself to "the horse that wins the *Grand Prix* and
is given a bag of oats." Ironically, in the same year he was forced
out of his apartment and had to stop working, even on pastels
and sculpture, because of his near blindness.

A friend wrote George Moore that in his last years the gray-
bearded Degas "lived alone and almost blind, seeing nobody,
without any kind of occupation." Daniel Halévy, who resumed
relations with Degas after a break of ten years, was shocked "to
see him dressed like a tramp, grown so thin, another man en-
tirely." He described Degas as "a dirty, disheveled, sordid Pros-
pero in his studio filled with bizarre sculpture, shriveled wax
figures crumbling into dust, and unfinished, unwrapped can-
vases leaning against the wall in sad disorder."[9]

Thinking perhaps of Manet's amputation, Degas boasted that
he still had his legs. Though no longer tempted by long journeys,
he loved to take tram rides out to the suburbs. Shortly before his
death, the shrunken, dim-sighted old man could be seen groping

his way through the crowded streets of the city. One photo showed him buttoning his fly as he left a pissoir. Vollard wrote that "he spent his days wandering about. In the course of his perambulations he always came back, nostalgically, to his former home [on the rue Victor Massé]. With his bowler hat, turned greenish, on his head, wrapped in a faded ulster, his eyes failing him more and more, he was obliged, when he wanted to cross the street, to ask a policeman for his arm."

Manet had portrayed city crowds in *Music in the Tuileries* and *Masked Ball at the Opéra*; Degas had done so in his pictures of the stock exchange, racetrack and *café-concerts*. Like Manet he remained, till the end of his life, a Parisian stroller, hiding his identity and disappearing into the streaming crowd. As Baudelaire wrote: "For the perfect *flâneur*, for the passionate spectator, it is an immense joy to set up house in the heart of the multitude, amid the ebb and flow of movement, in the midst of the fugitive and the infinite. To be away from home and yet feel oneself everywhere at home; to see the world, to be at the centre of the world, and yet to remain hidden from the world."[10] Massed together with others but with no sense of community, Degas in old age symbolized the tragic side of modern urban life: the isolation of the artist and alienation of the man in the crowd. Forever wandering the streets, the aged painter—lonely, isolated and distressed—joined his inner chaos to that of the atomized mass.

Overwhelmed by solitude and fearing the approach of death, Degas became increasingly bitter and withdrawn, though his old wit could still flash out. When a visitor, hearing that a mutual friend had died, lamented that it might soon be his turn, Degas replied: "in that case, I won't bother to take the crepe off my hat." He was cared for at the end by the devoted Zoé and his niece, Jeanne Fevre, who moved from Nice to Paris to help look after him. In November 1915 his brother René, who'd become reconciled with Edgar, described his deteriorating health, restless urge to walk and withdrawal into himself:

Unhappily, I cannot tell you anything encouraging. Considering his age, his physical state is certainly not bad; he eats well, does not suffer from any infirmity except his deafness, which is increasing and makes conversation very difficult....When he goes out, he can hardly walk farther than place Pigalle; he spends an hour in a café and returns painfully....He is admirably looked after by the incomparable Zoé. His friends rarely come to see him because he hardly recognizes them and does not talk with them. Sad, sad end! Still, he is going gradually without suffering, without being beset by anxieties, indeed surrounded by devoted care.

Two years later and two weeks before his death, an old friend, the sculptor Paul Paulin, reported that Degas, looking like a biblical patriarch, was withdrawn but still impressive:

He does not go out. He dreams, he eats, he sleeps. When he was told that I was there, it seemed that he remembered me and said, "show him in." I found him seated in an armchair, draped in a generous bathrobe, with that air of the dreamer we have always known. Does he think of something? We cannot tell. But his pink face seems narrower; it is now framed by long thinning hair and a great beard, both of a pure white, giving him great presence.

Degas died from cerebral congestion, at the age of eighty-three, on September 27, 1917. Remembering the advice he'd received from Ingres in his youth, he told his disciple Forain that his funeral oration should be limited to one brief sentence: "He greatly loved drawing." Mary Cassatt described the wartime funeral on October 2: "Degas is no more. We buried him on Saturday, [with] a beautiful sunshine, a little crowd of friends and admirers, all very quiet and peaceful in the midst of this dreadful upheaval of which he was barely conscious. You can well understand what a satisfaction it was to me to know that he had been

well cared for and even tenderly nursed by his niece in his last days."[11]

Bernard Berenson, the most influential art historian of the twentieth century, placed Degas among the greatest painters of all time: "Outside Velázquez, and perhaps, when at their best, Rembrandt and Degas, we shall seek in vain for tactile values so stimulating and so convincing as those of [Leonardo's] *Mona Lisa*; outside Degas, we shall not find such supreme mastery over the art of movement as in [Leonardo's] unfinished *Epiphany* [*Adoration of the Magi*, 1482] in the Uffizi." The English artist and writer Max Beerbohm, alluding to Berenson's tactile values, fancifully but poignantly described the aged Degas, a survivor of the nineteenth century, looking down from his studio window at the twentieth:

> Of all the great men whom I have merely seen the one who impressed me most was Degas. Some forty years ago I was passing, with a friend, through the Place Pigalle; and he, pointing up his stick to a very tall building, pointing up to an open window...said, "There's Degas." And there, in the distance, were the head and shoulders of a grey-bearded man in a red béret, leaning across the sill. There Degas was, and behind him, in there, was his studio; and behind him, there in his old age, was his lifework; and with unaging eyes he was, I felt sure, taking notes of "values" and what not of the populous scene down below, regretting perhaps...the absence of any ballet-dancers, or jockeys, or laundry-girls, or women sponging themselves in hip-baths; but deeply, but passionately observing. There he was, is, and always will be for me, framed.[12]

MARY CASSATT

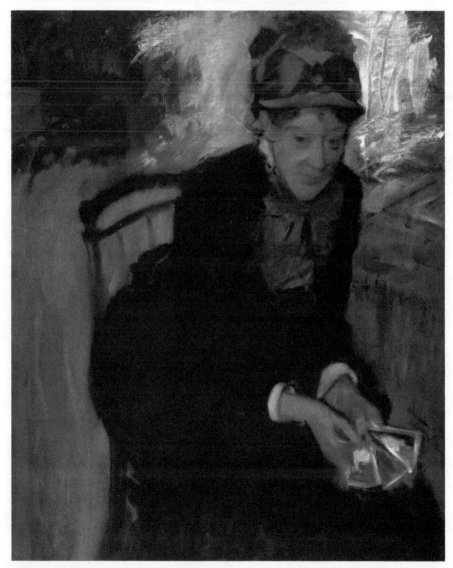

DEGAS, *Mary Cassatt* (1884). *National Portrait Gallery, Smithsonian Institution, Washington, D.C.*

AMERICAN ARISTOCRAT
1844–1879

I

❧ MARY STEVENSON CASSATT, the only American among the Impressionists, spent most of her life in France. Descended from French Huguenots named Cossart who came to New York in the seventeenth century, she was born near Pittsburgh on May 22, 1844, the fifth of five children of a prosperous banker, Robert Cassatt. Mary's close friend Louisine Havemeyer described her father as a "very courteous, tall, white-haired man with a military bearing." Her mother, Katherine, a refined and cultured woman, "had the most alert mind.... She was a fine linguist, an admirable housekeeper, remarkably well read, was interested in everything, and spoke with more conviction and possibly more charm than Miss Cassatt."

The family moved to Philadelphia when Mary was five, and she was taught at home by a governess. From the age of seven to eleven she lived in Europe with her family, who sought medical treatment in Paris for her brother Robert's bone disease. Her brother Aleck studied engineering in Darmstadt, Germany, where they lived in 1855. After Robert died that year at the age of thirteen, the Cassatts returned to America. Educated from an early age in French and German, and later fluent in Italian and Spanish, Mary was familiar with European languages and literature. As a child she was high-spirited, athletic and aggressive. Aleck later wrote that she was "always a great favorite of mine. I suppose because our taste was a good deal alike. Whenever it was a question of a walk or a ride or a gallop on horseback, it

didn't matter when or what the weather, Mary was always ready, so when I was at home we were together a great deal. We used to have plenty of fights, for she had a pretty quick temper."

Like the other Impressionists, Mary had to overcome parental opposition to her artistic career. Manet was supposed to be a naval officer, Degas a lawyer, Morisot a wife and mother. Mary, a homely child, recalled her shameful inability to please her stern father: "a girl's first duty is to be handsome and parents feel it when she isn't. I am sure my Father did, it wasn't my fault though." Mary remembered for many years that her angry father, using the melodramatic language usually reserved for a fallen woman or a dishonorable marriage, "had told her he would almost rather see her dead than have her go to Europe by herself to become an artist."[1] The families of the French painters respected art; Robert Cassatt had little time for it.

Like the other painters, whose reluctant but affluent fathers could support them for many years, Mary had an unusually long training in art. Manet had spent six years as a pupil of Couture; Morisot six years with two early teachers and with Corot; Degas had spent four years, interrupted by several years in Italy, with Lamothe. At the age of sixteen Mary enrolled in the Pennsylvania Academy of the Fine Arts in Philadelphia. Women were excluded from drawing nude models but, oddly enough, were allowed to attend anatomy classes at the Pennsylvania Medical University. Instruction at the Academy was casual, and teachers turned up now and then to comment on the students' work as they copied paintings. Thomas Eakins (also born in 1844), perhaps the greatest American painter of the nineteenth century, was one of her fellow students.

Limited by the restrictions at the Pennsylvania Academy and by the lack of first-rate works of art in American museums, Mary persuaded her father to let her study abroad. In 1865, when the Civil War had ended and she was twenty-one, she settled in Paris with her mother and Eliza Haldeman, a friend from the Acad-

emy. The Ecole des Beaux-Arts did not admit women, but Cassatt found several attractive alternatives. She attended classes for women only with Charles Chaplin—a fashionable painter of young ladies who'd also taught Manet's pupil, Eva Gonzalès—and worked from models. She took private lessons from the famous Jean-Léon Gérôme, a traditional academic painter specializing in classical and oriental subjects. A professor at the Ecole, Gérôme would also teach Raffaëlli, Edouard Vuillard and Henri Rousseau. Finally, in 1868–69, she moved to Villiers-le-Bel, just north of Paris, to study with Manet's old teacher, Thomas Couture. None of these artists had a lasting influence on Cassatt, who reacted against their academic teaching.

At this stage she probably gained most from copying Old Masters at the Louvre. Eliza Haldeman wrote home in 1868, describing the social atmosphere at the museum: "There is a quantity of our old Artist acquaintances over here just now and I am afraid the Louvre will become a second [Pennsylvania] Academy for talking and amusing ourselves.... As gentlemen cannot come to see us at the Hotel, we are obliged to receive them at the Louvre." One notable art acquaintance was Julian Alden Weir, who, after studying with Gérôme, was strongly influenced by the Impressionists and became active in American art circles in Paris. (His father, Robert, Poe's drawing teacher at West Point, inspired "the ghoul-haunted woodland of Weir," in Poe's poem "Ulalume.")

Cassatt had wealth, culture and intelligence, but her formidable array of off-putting qualities—plain features, haughty demeanor, abrasive personality, fierce independence and dedication to her work—would have discouraged the most ardent suitors. One day in the summer of 1868, Cassatt, Eliza Haldeman and her brother Carsten paused to admire an exquisite lace wedding veil, at the fabulous price of $1,000, in the window of a Paris shop. Cassatt impulsively told Carsten she'd marry him if he would give it to her as a wedding present. Nervous and embarrassed, no

doubt, by her fairy-tale-like challenge, he immediately agreed. Then, appalled at what he had done, he turned the incident into a joke, and claimed for weeks afterwards that they were engaged. A little later Eliza assured their anxious mother that Carsten had not yet bought the veil and was about to escape to Italy.

Though everyone conspired to treat this odd event in a light-hearted way, Cassatt lost face. She had proposed marriage and demanded an exorbitant bride-price, revealed her interest in Carsten and had her offer rejected. She was subjected to Eliza's mild satire and mocked by her supposed fiancé. A French critic called her "that masculine American." People thought her aggressively unfeminine because she was willing and able to compete in the male art world. She seems to have given up expectation of marriage and never had a real proposal until late in life, when she was too old to change her ways.

Cassatt interrupted her studies and returned to America just before the Franco-Prussian War broke out in July 1870. While the French artists suffered deprivations during the siege of Paris, she found plenty to complain about at home. After five years in Europe, she was shocked at first by the philistine indifference to art in America. She lamented: "I cannot tell you what I suffer for the want of seeing a good picture, no amount of bodily suffering occasioned by the want of comforts would seem to be too great a price for the pleasure of living in a country where one could have some art advantages." Coming home made her realize how much she had changed. No matter how American she felt, her heart was in Paris.

Her father had finally accepted her vocation as an artist, but he was a hardheaded businessman and pressured her to support herself. He felt she should either sell her current work (despite an indifferent market) or turn out conventional, salable stuff, which she of course refused to do. Though willing to pose, her father was not a good model. She wrote that "I am working by fits & starts at father's portrait but it advances slowly as he drops

asleep while sitting." Feeling she would "go crazy" if her father persisted in his unreasonable attitude about money, she reached a crisis and became terribly discouraged. In July 1871 she announced that she'd given up painting while forced to live in America. Eager to achieve her independence, she took symbolic revenge on her father and wrote: "I too am ravenous for money & am determined to try & make some, not by painting though. I have fully made up my mind that it is impossible for me unless I choose to set to work & manufacture pictures with the aid of photographs. I have given up my studio & torn up my father's portrait, & have not touched a brush for six weeks nor ever will again until I see some prospect of getting back to Europe."[2] She had hoped to sell two of her paintings, well received when she exhibited them in a jewelry store in Chicago, and have new works commissioned. But in October 1871 a fire in the store destroyed them.

After the war Cassatt went back to Europe and pursued her studies in Italy and Spain. She received a $300 commission from the Catholic bishop of Pittsburgh to copy two paintings by Correggio that would decorate his cathedral. In 1872 she lived for six months in Parma—famous for its cheese and hams—with Emily Sartain, whom she'd known at the Pennsylvania Academy. (Emily's father, John, the Philadelphia engraver and publisher of *Sartain's Magazine,* had given shelter to the deranged, hallucinating Poe, at the end of his life.) In Parma she copied the Correggios and studied engraving with Carlo Raimondi, a professor at the local academy of art.

After Parma, Cassatt spent another six months on her own in Seville, where she boarded with a family and rented a studio in a ducal palace. Twenty-five years later Somerset Maugham (also in his twenties) went to live there and loved it. He recalled that "it seemed a land of freedom. There I became at last conscious of my youth." Cassatt worked hard in Seville, but (unlike Maugham) found life there rather dull. In January 1873, adopting

a condescending tone, she wrote Emily that "my little [language] teacher will serve as a walking dictionary, more convenient than looking up all the words I don't know. I confess the 'Andalusian salt' doesn't seem to me so 'salty,' I don't see their great wit." Since women were secluded and it was improper to speak to men, Cassatt felt rather lonely, but she learned a great deal from living and working there by herself. Later on, she told Louisine Havemeyer that "[Berthe] Morisot was right when she said a young student should go to some provincial town where there are a few good pictures and avoid the distractions and snares of the studios of Paris....I went to Seville when I was a young girl. It was horrid and I was alone, but I braved it out for a year."[3] Her early Spanish paintings of 1873—like the swaggering *Torero and Young Girl* and the simpering *On the Balcony*— were painted before she developed her characteristic style. Like Degas' historical paintings, they have little in common with her mature work.

<div align="center">II</div>

CASSATT RETURNED to Paris in the spring of 1873, aged twenty-nine. A tall (five feet, six inches), wiry, angular and athletic young woman, elegantly dressed in black, she had brown hair, grey eyes and a ruddy complexion. Her mouth and chin were large, and her face was dominated by a prominent square, pudgy nose. Quick-tempered since childhood, she was also, wrote Emily Sartain, "a tremendous talker and very touchy and selfish." Her natural prickliness was intensified by the need to defend herself from her father's demands and from unwanted approaches by strange men while living and traveling alone in Europe. A biographer called Cassatt, who was used to getting her own way, "querulous and vindictive...difficult, unreasonable, and violently opinionated." Her lonely stay in Seville had made her tougher and more mature.

Lois Buchanan, a niece of president James Buchanan, mar-

ried Cassatt's beloved brother Aleck in 1868 and became her life-long rival for his affection. In a letter of August 1880, Lois told her sister how much she disliked her: "I cannot abide Mary and never will.... There is something to me utterly obnoxious about that girl. I have never yet heard her criticize any human being in any but the most disagreeable way. She is too self important and I can't put up with it." Cassatt fired the parting shot after Lois' death by suggesting that Lois had victimized Aleck, and by describing her as "an unhappy woman & made those around her unhappy."[4]

Ambitious and single-minded, Cassatt was greatly discouraged when the Salon rejected her early paintings in 1867. *The Mandolin Player* was accepted the following year, but she was again rejected in 1869. After her return to Europe she had a picture accepted by the Salon every year between 1870 and 1875, and attracted the attention of both critics and artists. Ironically, as her work became stronger, she was rejected again in 1877 and 1878. She became increasingly angry, and as hostile as Degas to the irresponsible selection of the jury. In her opinionated way she dismissed the value of juries, and later declared: "I have not served on a jury, never will serve on any jury, nor be the means of repressing the work of another painter."

Cassatt's first sight of Degas' work in a shop window had a powerful impact and radically changed her life. When they met in 1877 and he invited her to join the Impressionists, she was ecstatic. "I accepted with joy," she recalled. "I hated conventional art." Her association with the avant-garde gave her a new sense of freedom, a release from constraint, and she began to exhibit with them from their fourth show in 1879. Her bitterness about her recent rejections by the Salon made her particularly responsive to joining a group of like-minded, innovative and immensely talented artists.

A contemporary critic described how Degas energetically organized the exhibitions by funding, renting and decorating the

premises, and transforming a conventional apartment into an art gallery:

> The little group of Independents bravely continues its pere-grinations through the unoccupied *entresols* [mezzanine land-ings above the ground floor] of Paris. Usually M. Degas leads the caravan. About February, he goes out to look, consulting the noticeboards and interrogating the concierges.—"Do you have a free apartment in the house?"—"Yes, sir."—"Would the proprietor consent to let it for a month?" If the proprietor agrees, M. Degas gives a sign to his companions. The interior decorator is informed immediately. As many works are collected as a drawing-room, a dining-room, two bedrooms, a bathroom and a kitchen could contain. A turn-stile is installed in the ante-room and the day for the opening is fixed.[5]

Cassatt could be generous and self-effacing. She used her ag-gressive drive, personal wealth and powerful American connec-tions to do everything she could to advance the careers of fellow artists. She refused to have her own image reproduced in any publication and, like Morisot, did not insist on having her name on the posters. The dealer Vollard recalled:

> It was with a sort of frenzy that generous Mary Cassatt laboured for the success of her comrades: Monet, Pissarro, Cézanne, Sisley and the rest. But what indifference where her own painting was concerned! What an aversion from "push-ing" her work in public. One day at an exhibition, they were fighting for and against the Impressionists. "But," said some-one, speaking to Mary Cassatt without knowing who she was, "you are forgetting a foreign painter that Degas ranks very high."
>
> "Who is that?" she asked in astonishment.
>
> "Mary Cassatt."

Without false modesty, quite naturally, she exclaimed, "Oh, nonsense!"

She soon formed close friendships with Renoir, Pissarro, Manet, Morisot and especially Degas, and was immensely stimulated by their conversations about art and shrewd advice about how to establish her career. One summer, when Cassatt and Renoir were painting in Normandy and staying at the same village inn, they would meet in the evening to

> discuss various technical problems together over a pitcher of cider. Once she said to him: "There is one thing against your success: your technique is too simple. The public doesn't like that."
>
> "Don't worry," he said, "Complicated theories can always be thought up *afterwards*."

Despite her loyalty to the group, she was (like Degas) willing to cast a cold eye on their defects. She spoke of "Renoir creating his 'fat red women,' and Monet painting the reflections in water that [she] dubbed 'glorified wallpaper.' "[6]

Cassatt carefully studied the work of her contemporaries, and absorbed their ideas about subjects and techniques. In Renoir's *The Loge* (1874), for example, a beautiful pale-skinned woman, with large blue eyes and bright red lips, faces the spectator from her box at the Opéra. She wears flowers in her hair and on her low-cut dress, and strings of pearls around her neck, and holds a fan in white-gloved hands. Behind her, a dark-skinned, bearded companion, in evening dress, ignores her while searching with binoculars for attractive faces in the audience. Like Renoir, Cassatt portrayed the spectators rather than the onstage performers at the Opéra. In her much brighter *Woman with a Pearl Necklace in a Loge* (1879), exhibited in her first Impressionist show, her red-haired older sister, Lydia, also faces the spectator and, leaning on her right arm, looks to the left. She, too, with an even bolder

décolletage, has flowers in her hair and on her white-trimmed pink dress, pearls around her neck and white fan in her white-gloved hand. A large mirror behind her reflects the audience in two tiers of private boxes. The chandelier casts a glinting light on her feathery, reddish blond hair—heightened by her soft velvet chair, pink gown, smiling lips and rosy complexion. Both richly colored women, representing the height of the beau monde, are attentive yet self-absorbed, and enhance the spectacle of the opera they are about to watch. Cassatt learned from Renoir how to look at the Opéra from a male point of view, yet gave the scene a female interpretation. The critic Maxime du Camp described how the startling, half-naked women in the loges appeased the ravenous appetites of the men in the audience. Their revealing dresses provided "a rare glimpse, in these censorious times, of 'arms, legs and shoulders.' Placing such 'décolletés' before the public, he declared, was like 'a fairy tale, where fresh meat was thrown to an ogre to satisfy his hunger.'"[7]

III

IN THE COURSE of her long apprenticeship in Europe, Cassatt developed slowly. She did not produce a major painting until the late 1870s, when she was over thirty; and once she found her mature style, she didn't change it. She mostly painted domestic interiors, with no clear sense of place; and male subjects, apart from members of her family, were rare. (*The Boating Party* was a brilliant exception.) She confined herself to the drawing room and nursery, the garden and the river, and usually ignored the urban landscape. She portrayed a world far more circumscribed than the one in which she actually lived. Her two great themes were the rituals of the rich: taking tea, going to the opera and riding in a carriage, dressed in large hats and elaborate gowns; and mothers and children, physically close and psychologically absorbed in each other. Morisot had a purer Impressionist technique. By comparison, a modern critic noted, "the rigorous

draftsmanship, structured compositions, and sober palette of [Cassatt's] genre scenes...seemed closer to the harder-edged style of English artists than to the brushy surfaces, shimmering hues, and loosely defined forms of French artists." Her range of subjects was narrow and she tended, for both personal and economic reasons, to repeat herself.

Cassatt's best paintings, within her self-imposed confines, were subtle and poignant. The delicate, fragile beauty of paintings like *Woman with a Pearl Necklace in a Loge* and *Tea* (1879–80) evoke the elegance and refinement of the French and American society portrayed in the novels of Henry James and Edith Wharton. The atmosphere of Cassatt's studio on the rue de Laval resembled a scene from one of her own paintings. A visitor recalled that "statues and articles of *vertu* filled the corners, the whole being lighted by a great antique hanging lamp. We sipped our *chocolat* from superior china...upon an embroidered cloth."[8]

In *Tea* Cassatt's ceremony seems as formal as the Japanese. The upper-class drawing room is richly furnished with striped wallpaper and a chintz sofa. A bell rope for summoning servants, which fades into the stripes, divides the gleaming silver tea service (light reflecting off the precious metal). It rests on a red-lacquered table, separates the women (as in Degas' *Bellelli Family*) from the gilt mirror and marble fireplace, and gives weight to the event. The hostess, without a hat, is seated in profile with her chin resting reflectively on her hand. The visitor, in street dress and long yellow gloves, faces the viewer and, with extended little finger, sips daintily from the blue-rimmed cup that covers most of her face. The hostess does not join her guest, and her cup remains strangely empty on the tray. The atmosphere is proper and fashionable, silent and stiff, and the striped wallpaper both separates them and cages them in. Though the two women are sitting next to each other, almost touching, there's no intimacy and warmth in this apparently tedious social ritual. Cassatt both participated in the tea ceremony and also remained satirically aloof from it.

In *Lady at the Tea Table* (1883–85) a formidable, self-possessed, aristocratic older woman is set against the gleam and polish of gold-rimmed blue and white porcelain. Her head is centered and framed by a picture (within a larger frame) on the back wall. She wears a dark blue dress and a diaphanous lace scarf that's wrapped around her head and flows down her chest. Her brown hair severely parted in the middle, she has a high, smooth forehead, stern expression and cold blue eyes. Though she's about to pour tea into four china cups, her companions (perhaps frightened away) are not shown. There's a satiric element in her curved, clawlike fingers (emerging from lace cuffs and decorated with impressive sapphire rings) and in the ring finger, holding the handle of the teapot, that seems to extend into a spiky, witchlike nail. Not surprisingly, the subject, Cassatt's cousin Mrs. Robert Riddle, disliked the all-too-revealing portrait.

By contrast, the portrait of her seventy-three-year-old mother, *Mrs. R. S. Cassatt* (1889), an invalid with heart disease, is gentle and sympathetic. She's also seated and looking to the left, with her head framed by a picture — and there's a vaguely sketched vase of red and yellow flowers behind her. Her solid black dress widens from her lace-wrapped neck and cameo brooch, and flows down to the bottom of the picture, contrasting with her long white cashmere shawl. Sitting on a gold-framed, red velvet chair, she rests her chin on one hand while the other clutches a handkerchief (suggesting tears). Staring sadly into space, she seems to contemplate the approach of death.

Cassatt sensitively portrayed attractive adolescent girls on the verge of womanhood. In contrast to the vibrant self-assurance of Lydia in *Woman...in a Loge,* the polite and proper, twinlike girls in *Two Young Ladies in a Loge* (1882)—which also has a chandelier and a double tier of boxes reflected in the background— sit unnaturally erect and rigid under the glare of the lights and the roving binoculars of the spectators. One girl crosses her white-gloved arms, covering her mouth with an enormous floral

fan. Her pouting companion, with downcast eyes and maidenly breast, wears a black Manet-like choker and low-cut white dress, and holds a large bouquet. One woman carries the smell of flowers, the other wafts it into the air with her fan. Unlike Lydia, they're too nervously constrained and apprehensive to enjoy being part of the spectacle.

In *Young Girl at a Window* (1883) another adolescent is seated in a wicker chair on a black-railed balcony. Behind her are a swirl of thick green foliage, a large, red-roofed structure with many chimney pots and the distant buildings of Montmartre. The girl wears a handsome ruffled white frock and gauzy white bonnet tied below her chin with a ribbon. Her face is ruddy and pert, and she holds on her lap one of Cassatt's favorite Belgian griffon dogs, which gazes curiously through the rails. The dog's drooping left-front brown paw is slyly echoed in the curved fingers of the girl's brown-gloved left hand. Unlike the stiff upper-class girls in the loge, this poised, rosy-cheeked young lady, also dressed up for the occasion, is more at ease with her setting, her dog and herself.

Cassatt's picture of her brother and nephew, *Portrait of Alexander J. Cassatt and His Son Robert Kelso Cassatt* (1884–85), shows the same warmth and affection as the portrait of her mother. (Aleck later became president of the Pennsylvania Railroad and one of the most powerful men in America.) The boy, dressed in black suit, tie and boots, and stiff white Eton collar, perches on the arm of a soft, yellow-and-red chair, whose colors and pattern are echoed in the drapes in the background. One hand rests on his knee, the other is wrapped affectionately around his father's shoulder. The father's black jacket is offset by the white newspaper he's holding with both hands and resting on his crossed legs. Though Aleck has a ruddy complexion and drooping brown mustache, father and son, whose cheeks and heads are touching as they gaze off to the right, look remarkably alike. The alignment of the eyes, two touching heads and two black torsos

merging into one suggest their physical bond and psychological connection.

IV

IN THE 1860S Cassatt abandoned her Romanticism and stopped painting the costume pictures of peasants, carnivals and bullfighters inspired by her stays in Italy and Spain. She then adopted Manet's credo—"*Il faut être de son temps*" (one must be of one's time)—and devoted herself to an acute and realistic portrayal of fashionable scenes and everyday life. Manet's *plein air Boating* (1874), which she persuaded the Havemeyers to buy, clearly influenced her *Boating Party* (1894). In Manet's picture, a muscular man, dressed casually in white shirt and trousers, with a green-banded straw hat and drooping mustache, holds the tiller. He's outlined, near the sail that's secured by a rope to a cleat, against the greenish blue water of the river in the top half of the painting. On the left and in profile, a woman wearing a high white hat and veil and striped mauve dress leans back on the gunwales.

In Cassatt's picture of mother and child at sea the figures in the sailboat have shifted. The rower, clad entirely in dark blue, with a large beret and wide cummerbund, has his back to the viewer and his hands on the oars that propel the boat. Both the sailor and woman—seated upright, holding a reclining baby and facing him in the bow of the boat—are silhouetted against the brighter blue of the river, which reaches to a few houses on the distant shore. The vivid yellow of the boat's interior planks and oars are echoed in the flowers on the woman's curved hat. The informally posed figures in Manet's boat, guided by the wind, seem more placid and relaxed. Cassatt's sailor, rowing hard in the rougher water, with back bent and one foot braced against the thwart that cuts across the bottom of the woman's dress, is more vigorous and athletic. The woman, concerned perhaps about the safety of the pink-dressed, stiff-legged baby at the center of the

picture, whose face is half-shadowed by a hat, looks at (rather than away from) the sailor, and seems preoccupied, even anxious about their destination. In *The Boating Party*, one of her most successful paintings, Cassatt broke out of her usual calm domestic scene and created an intriguing tension between the figures in the boat.

Cassatt had both social and artistic relations with Manet and Morisot. Her Paris apartment was near Manet's, they had mutual friends and occasionally met during his later years. Louisine Havemeyer recalled her visit to Cassatt at Marly-le-Roi, on the Seine outside Paris, in the summer of 1882, when both Cassatt and Morisot lived close to the dying Manet. Morisot, his intimate friend, had to protect him from visitors. Cassatt's "villa joined Manet's home and his fatal malady made him very ill at that time. After luncheon we walked over to his villa to ask after him. Mme. Morisot met us at the gate and at Miss Cassatt's enquiry sadly shook her head, saying that he was very ill and that she feared the worst. Mme. Morisot walked back with us and I recall that she was a charming and intelligent woman, and that she and Miss Cassatt were very friendly and talked of art matters." After Manet's death, when the Impressionists raised money to buy *Olympia* from his widow and present it to the Musée de Luxembourg, Cassatt refused to contribute. She greatly admired the painting and wanted it to go to America.

Cassatt's friendship with Morisot was more intimate and competitive. They came from a similar upper-class background, and did not have to sell their pictures to support themselves. They never defied the social conventions of their class and time, and would never, like George Sand, have worn trousers or smoked a pipe. But their personalities were very different. Morisot was feminine, sensuous and charming; Cassatt was homely, austere and caustic. Morisot spoke softly and quietly; Cassatt's voice was loud and harsh. Morisot expressed her personal feelings, Cassatt repressed hers. Morisot was emotional, troubled and filled with

doubts; Cassatt was determined, confident and single-minded about exhibiting and selling her work. Morisot was helped by her husband; Cassatt had to help herself. Confronted by the choice between art and marriage, Morisot married *and* continued to paint, though she was distracted by social life and devoted to her daughter. Mallarmé wrote that "all her creative work burned within a maternal flame." Cassatt never married. Though Morisot was sympathetic and discreet, Cassatt brusque and frank, with a keen intellect and sharp tongue, they became friends after exhibiting together.

The Manets and Morisots socialized with each other at dinners and parties, and often invited Degas. Cassatt saw Degas at meetings, exhibitions, museums, sales and studios. She sometimes met Morisot in Paris or when they lived near each other in summer houses. But she didn't seem to mix in their social circles and, as an American, was more isolated than the three French painters. After her youthful friendships and travels with her girlfriends from art school, her social life was mainly confined to her sister and parents, and to her brother's family during their frequent trips to Europe. Later on she lived with her devoted maid and companion, Mathilde.

Morisot's biographer was too negative when she wrote that Berthe "certainly respected the American's intelligence and artistry, and recognized her dedication. They corresponded in friendly terms and exchanged visits; they had mutual friends and mutual interests.... [But] beneath their veneer of polite civility, little love was lost between them."[9] Morisot, three years older, formally addressed Cassatt as "Chère Madame," while Cassatt wrote to her more personally as "Chère Berthe." But there was a reaching out, a mutual respect, a definite warmth and intimacy in the friendship of the two women, who remained somewhat apart from the rougher café-comradeship of the men.

In the fall of 1879, after studying works of art in northern Italy, Cassatt told Morisot that contemporary painters had

learned everything they knew from the Old Masters: "I saw many things to admire, beautiful frescoes, really, I don't see that the moderns have discovered anything...anything more about color or drawing." She then became more personal and expressed admiration for Morisot's work, looked forward to her return to the group after giving birth to Julie and sent her warmest greetings: "I am so happy that you have done so much work, you will reclaim your place at the exposition with *éclat* [brilliance]....I am very envious of your talent, I assure you....I would have gone to see you before my departure but my father is never very decisive....Bring back many pretty things, and much health and courage. I am eager to see what you have done....Many kisses to Miss Julie and a thousand best wishes to her mother from their Affectionate friend."

Morisot responded to Cassatt's encouragement and warmth, and they became friendlier in the 1880s. After meeting Cassatt at an art exhibition in 1882, Morisot told Eugène that "she seems to wish to be more intimate with us. She asks to do portraits of Bibi [Julie] and of you." Though Cassatt was no doubt sincere, for Julie was an attractive child, and she was always on the lookout for male models, she never painted Berthe's family. The following year Berthe urged her brother Tiburce, still in search of a job, to talk to Cassatt, who had asked about him and might be helpful.

In April 1890 Morisot, in turn, offered to help Cassatt find a summer house. Absorbed in printmaking, Cassatt urged Morisot—in an enthusiastically imperious tone—to come with her to look at Japanese prints: "Thank you very much for your letter and for your offer to look for a retreat for us for this summer, but we have Septeuil. At any rate we will be neighbors....I am not able to go and have lunch at Mézy, but if you would like, you could come and dine here with us and afterwards we could go to see the Japanese prints at the Beaux-Arts. Seriously, *you must not* miss that. You who want to make color prints couldn't dream of

anything more beautiful....You *must* see the Japanese—*come as soon as you can.*" Relations between the friendly rivals cooled a bit in Morisot's final years. She felt that Cassatt, jealous of her successful first solo exhibition, would never congratulate her—though Cassatt did express her admiration in a letter to Pissarro. When Morisot died unexpectedly in 1895, Cassatt mentioned the loss of her old friend in one rather cold and offhand sentence: "We lost Mme. Manet (Berthe Morisot) this winter, carried off in five days by grippe."[10]

Critics often compared the two female Impressionists, who had similar subjects and techniques. George Moore pointed out that Cassatt's "art was derived from Degas and Madame Morisot's was derived from Manet's." During the sixth Impressionist exhibition of 1881—which did not include Renoir, Monet and Sisley—one critic claimed the two women were the only interesting artists: "Morisot and Cassatt were the obvious standardbearers for the new style...and for the first time in recorded history women artists were singled out as the undisputed leaders of avant-garde painting." Morisot was considered far more feminine, informal and Impressionistic, with her vaporous figures and nervous energy: "Her sitters (like herself) seemed softer and more tender than the rather stiff, seemingly Puritanical characters portrayed by Cassatt." Gauguin, who thought Cassatt was the greater artist, concluded: "Miss Cassatt has as much charm, but she has more power."[11]

Morisot's *Summer's Day* (1879) and Cassatt's *Summertime* (1894) both portray two female figures, floating gently in a riverboat next to swimming swans or ducks. In Morisot's picture, two women—one facing the viewer, the other in profile—lean on the gunwale, with the birds, rippling water and the green bank of the shore behind them. Cassatt paints the features of the mother and daughter (whose bare arm and back are warmed by the sun) close-up and in more detail. They're watching the ducks, which are next to them, and, with just the bow of the boat showing, are surrounded on three sides by the brightly colored water. Cas-

satt's figures, absorbed in the ducks, the water and perhaps their own reflections, seem more vivid and dramatic. Morisot's mothers and daughters are usually next to each other; Cassatt's are always touching, even entwined.

Morisot's *The Cherry Tree* and Cassatt's *Young Women Picking Fruit* (both 1891–92) are also comparable. In both, one female picks fruit while the other watches and assists. Morisot is more wavy and painterly, Cassatt more hard-edged and linear. Morisot's fruit picker (her daughter, Julie), standing backwards on a V-shaped ladder with both bare arms stretched out, is covered by a swirling canopy of trees and a bright blue sky. Standing on the ground below her, a child (her niece Jeanne), face hidden by a white hat, and with long, strawberry blond hair flowing down her front and back, holds up a small basket to catch the ruby-red cherries.

In Cassatt, the adult figures are silhouetted against a green field, a background of bright flowers and trees, and a distant, cloudy blue sky. The fruit picker—a plain country girl with red hair, ruddy complexion and what appears to be a cauliflower ear—is wearing a plain white dress and pulling down a pear. Seated just below her, gazing up and holding a plucked pear, an older woman wears a blue-feathered hat and a sharply defined floral-printed blue dress with lace collar and cuffs. Seen in profile, she also has a florid complexion, rests her chin in her hand and watches while passively helping her companion. Cassatt's close-up once again makes her plain but solid women more lively and engaged with each other. When Degas saw this painting he said, in an ambiguous compliment: "No woman has a right to draw like that."[12] In both Morisot and Cassatt fruit picking, a leisurely rural pursuit with no symbolic overtones, is not associated with Eve and temptation, sin and death.

Manet, Degas, Morisot and Cassatt all portrayed, in their different ways, the theme of reading, an occupation that conveniently occupied the sitter. In Manet's *Reading* (1868) Suzanne, grandly seated on a sofa—with her arms extended, and wearing

an elegant white dress, with jet necklace and black belt—dominates the painting. Léon, in a dark brown suit and standing behind her against a dark background, stares down at his book. She seems oblivious to Léon, who seems to be reading silently to himself. In *Reading (Reading "L'Illustré")* (1879), painted with swift brushstrokes and in a more Impressionistic style, Manet emphasizes the woman's attractive face and fashionable black clothing, and the colorful garden that appears in the background. In Degas' *The Dance Class* (1881) the dowdy mother of one of the dancers, slouching in a wooden chair in the foreground, glances at a newspaper to pass the time and ignores the five ballerinas. By making the master's bald head echo the white crown of the reader's straw hat, Degas wittily links the two grotesque figures.

For Morisot and Cassatt reading is the primary rather than incidental activity, and they emphasize absorption rather than detachment. In Morisot's *Mme. Morisot and Her Daughter* (1869–70), set in a richly furnished living room, the daughter gazes at the mother reading her green bound book, whose gilded pages echo the daughter's bracelet and the frame of the painting behind her. In Morisot's *Reading* (1873) a well-dressed woman, sitting alone in a green field as a horse cart passes in the distance, has abandoned her umbrella and fan to concentrate entirely on her book. Cassatt frequently includes reading in her domestic scenes. In the Jamesian *Portrait of a Lady* (1878) her mother, staring seriously through her pince-nez, is alone with her reflection in a mirror and completely immersed in *Le Figaro*. In *Family Group: Mrs. Cassatt Reading to Her Grandchildren* (1880), the ruddy-faced grandmother, reading fairy tales from a bright red book, is surrounded by a triangle of intensely alert children, fascinated by her every word. Manet's and Degas' readers are isolated and estranged, Morisot's and Cassatt's absorbed and engaged.

CASSATT AND DEGAS
1877–1917

I

❧ AFTER HER RETURN to Paris in 1873 Cassatt studied Degas' paintings in exhibitions, galleries and shop windows and was eager to absorb whatever she could from them. She recognized an artistic affinity, and later wrote that she had always regarded herself as a disciple: "I had already recognized who were my true masters. I admired Manet, Courbet, and Degas. I began to live.... The first sight of Degas' pictures was the turning point in my artistic life." In a perceptive comparison, she maintained that his *Dance Class* (1874) was "more beautiful than any Vermeer I ever saw." Cassatt told a friend that most painters shared her admiration and that she was "so glad you saw the Degas in [the singer] Faure's collection; you can now understand why the French artists put him so high, so far above all the rest."[1] In Degas, neither teacher nor husband, but colleague and friend, she found a man who could guide her creative life. It's rare for a successful artist to acknowledge such an influence and maintain a lifelong esteem. Though their strong personalities clashed and they were sometimes estranged, she acknowledged that "however dreadful he was, he always lived up to his ideals."

They met in 1877 and, though Degas was ten years older, soon became friends. They saw each other socially and had dinners, visited museums and galleries, shopped together for her clothes and hats, and worked together in their studios. He bought her a dog and admired her "horsewoman's passion," portrayed her several times and suggested the maternal theme that

became dominant in her art. She helped sell his paintings to wealthy American collectors who later donated them to major museums. He admired her good breeding and good taste, her dedication to work and her lack of interest in fashionable society. Above all, he praised her draftsmanship and ranked her above the more decorative Morisot who, he said, "made pictures the way one would make hats." He was attracted to, rather than put off by, Cassatt's frank opinions and forceful personality. Roy McMullen, noting their striking similarities, observed that Cassatt "was socially, artistically, and temperamentally almost his exact feminine counterpart.... Her integrity and her intelligence were evident, and there was a certain charm even in her sharp tongue and her ability to withstand, more than most women did, his caustic humor."[2]

Degas had an American mother and had visited the United States, and these connections to Cassatt's country deepened his sympathy for and understanding of her character. Degas' voyeurism compensated for his lack of intimacy with women; Cassatt's maternal pictures sublimated her desire for marriage and children. The bachelor and spinster had close relationships with their longtime servants, and in old age both hardened into rigid and opinionated, dogmatic and intolerant sages. They had a tragic bond in their eye troubles, and felt compassion for each other's disability. Cassatt went to exhibitions and looked at pictures, though she had trouble seeing them. Degas, at art auctions, had to be told what he'd just bought. Both were forced to abandon work at the end of their long lives, and wound up, in their eighties, nearly blind and desperately alone.

There were significant differences. Degas painted horses, Cassatt rode them. He hated automobiles, she loved them and was a pioneer of motoring. He was a pessimist, she was optimistic. His art grew more satiric, hers more sentimental. He praised the work of younger contemporaries like Suzanne Valadon, Gauguin and Lautrec; she was adamantly opposed to all

modern movements. Despite her conservative background, Cassatt was much more politically liberal. As an American, she disliked monarchies and supported the Commune, called liberty "the first good" and said "give me decent Republics." She was one of the very few people brave enough to oppose Degas' "nationalist jeremiads." Though pro-Dreyfus, she managed, despite brief ruptures, to retain his friendship. Cassatt sometimes ignored Degas' anti-feminist remarks and was sometimes outraged by them. When Louisine Havemeyer exhibited his paintings in New York in 1915 to raise money for the cause of women's suffrage, she was amused by the irony. His bearlike temper caused several seismic upheavals in their friendship, but (like Manet) she mixed acerbity with tact to keep him under control.

The American artist George Biddle, who knew Cassatt late in life, said "she had a veneration for Degas. What he felt was actually her law and standard." Degas clearly influenced her ideas as well as her art. Though she had a home in the country outside Paris, she was, like him, a studio rather than a *plein air* painter and shared his distrust of rural life. Contrasting the scenery with the peasants, she insisted: "the country is too beautiful, it grows wearisome. Unhappily, the people bear no resemblance to the country." She also preferred, like the reticent Degas, to keep her private life hidden from the public. Refusing a request from the Musée du Luxembourg to exhibit a portrait bust of herself, she maintained: "What one would like to leave behind one is superior art, & a hidden personality."[3] Both artists disdained juries and prizes. Like Degas, Cassatt had her own personal standards and thought little of public recognition. Late in life she reflected on "how elated I would have been if in my youth I had been told I would have the place in the world of Art I have acquired, and now at the end of life how little it seems, what difference does it all make?" Though never a formal pupil of Degas, Cassatt was (like Morisot with Manet) indebted to his teaching and particularly inspired by his use of color. The sudden change in subject

and style from her early Spanish paintings to her mature work was even more radical than Degas'.

A comparison of Degas' *At the Races in the Countryside* (1869) and Cassatt's *Driving* (1881) clearly shows the influence of the master. Degas connects his four main figures—the gray-suited, top-hatted father (looking backward from the driver's seat), mother, nursemaid and infant (seated in the carriage and protected from the sun by a pale yellow parasol)—in a tender domestic scene. The carriage rests in a flat green field with another driver and carriage, five standing horses and riders, two horses (their jockeys wearing bright racing colors) racing in front of them, and a few low houses in the distance. The expansive cloudy blue sky sets off the profile of the proud, attentive father who, like the black dog, focuses on the nursing baby, resting on a large white blanket. (In 1890 Cassatt did a sensitive drypoint on this subject, *Nursing.*)

Cassatt's *Driving,* with the figures close-up, portrays a similar open, two-seated carriage, with whip, lamp and high wheels, yet fails to suggest any human interaction. The three figures on the right (two of them in profile)—woman driver, little girl (Degas' niece) and coachman facing backward—form a pyramid and are strangely rigid. Separated by the carriage lamp, balanced by the hindquarters and docked tail of the cutoff horse on the left and connected by the taut rein, they seem to be in a photographer's studio, posing with props against a backdrop of woods. The woman's conflicting roles of lady of fashion and expert driver seem to have turned her to stone. The blond child merely rests her hand on the carriage arm instead of grasping it. Though Cassatt was an experienced driver, there's no sense of dynamic movement.

All Cassatt's near-perfect, ruddy cheeked, round-bellied children seemed to belong to the same family. Closely connected to his mother, a Cassatt child is what Degas called "the infant Jesus with his English nurse." Degas' children are more individualistic,

like the sulky and introspective Bellelli girls, the sickly and with-
drawn child getting a pedicure, the self-assured Hortense
Valpinçon. They break out of the house and into the world, like
the athletic, cheeky young Spartans, the poised and charming
ballerinas, the primitive fourteen-year-old dancer, Lepic's two
sophisticated daughters in the Place de la Concorde and the
dreamy girl getting her hair combed on the beach.

With characteristic generosity, Degas freely expressed admi-
ration for his disciple's art. When he first saw Cassatt's paintings
in the Salon, he also felt an instinctive affinity and said: "It's true.
Here is someone who feels as I do." In 1880 he announced that
her colored drypoints were charming and her work had pro-
gressed. He told Henri Rouart: "What she did in the country
looks very well in the studio light. It is much stronger and nobler
than what she had last year." Examining the graceful arc of the
model's back in her colored drypoint *The Bath* (1890–91), he of-
fered the same double-edged compliment he gave on other oc-
casions, when he maintained: "I am not willing to admit that a
woman can draw that well."[4] To Lepic, a fellow artist and con-
noisseur, Degas revealed that he had studied her work very care-
fully. Cassatt, he said, "whom you know for a good painter, [is]
at this moment engrossed in the study of the reflection and
shadow of chairs or dresses, for which she has the greatest affec-
tion and understanding." He concluded by calling her, with rare
praise, "this distinguished person whose friendship I honour."

Some of Degas' more suspect hyperboles, instead of coming
directly from the Master, were quoted by Cassatt herself. When
Young Women Picking Fruit (1891–92) was bought by the Carnegie
Institute in Pittsburgh, she repeated his comment about *The Bath*
and applied it to the painting: "He was chary of praises but spoke
of the drawing of the woman's arm picking the fruit & made a fa-
miliar gesture indicating the line & said no woman has a right to
draw like that." Alluding to their quarrel during the Dreyfus affair
and rather absurdly praising herself, she told Louisine: "When

[Degas] saw my *Boy before the Mirror* [1905] he said to Durand-Ruel: 'Where is she? I must see her at once. It is the greatest picture of the century.'" Despite her vain but somewhat justified exaggerations, there's no doubt that Degas' praise was sincere. He told Vollard: "She has infinite talent."[5]

Degas could be cantankerous but was really tenderhearted. He'd wanted the photographer Barnes to receive financial help so he could "quite simply be happy." He showed his deep affection for Cassatt by taking a fond interest in her pets. In 1879 he asked Lepic, who bred dogs, if he could "find me a small griffon, thoroughbred or not (dog or bitch)....The person who desires this dog is Mlle. Cassatt....It is a young dog that she needs, so that he may love her." Lepic duly supplied the dog, which was named Batty, and Cassatt painted her in *Young Girl at a Window* (1883). These nervous, temperamental dogs provided a notable contrast to the always quiet and well-behaved children in her pictures. George Biddle found them annoying and reported, with some irritation, that "my ring at the door was answered by the barking and scampering of the ill-natured and overfed griffons....Their churlish yappings would finally subside to an asthmatic wheeze."

In January 1889 Cassatt told Mallarmé that Degas "dreams only of poetry at the moment." She had a beloved pet parrot, and in 1890 she did a drypoint, *The Parrot,* of her maid holding him. Recalling, perhaps, Manet's elegant painting, *Woman with a Parrot* (1866), Degas dedicated a sonnet, "Parrots," "To Mademoiselle Cassatt, On her dearest Coco." The poem plays with the parrot's uncanny ability to mimic human speech, and the bond between pet and owner. The octave invokes a famous parrot from literature, the sestet describes Coco and his owner. The shipwrecked Robinson Crusoe, reading the Bible on his desert island, is startled to hear the ship's parrot calling his name, as if pitying his loneliness. Cassatt, by contrast, controls and "pities" her precious bird. Degas advises her to clip his tongue as well as

his wings, to prevent him from flying away and revealing her loving confidences to other people:

> When, far away, that manlike voice cried out,
> At the slow start of a long tropic day
> Spent reading from his faded Testament
> What must that listless Robinson have felt?
>
> The voice he heard—no longer strange to him—
> Did he then laugh? That is, he doesn't say
> It made him, poor man, cry, when it arrived,
> Shrieking his name, upon his desert isle.
>
> But as for yours, 'tis you who pity him,
> Not he you. Yet beware: this tiny saint—
> Coco—takes in and gives away, in flight,
>
> That which your heart said to the confidant.
> His wing once clipped, snip off a bit of tongue
> As well. Leaving him silent…and green.[6]

This accomplished piece of occasional verse shows Degas at his most tender and playful.

II

IN 1879, the year Cassatt first exhibited with the Impressionists, Degas—along with Pissarro and Bracquemond—invited her to contribute to his new journal, *Le Jour et la Nuit* (Day and Night), which planned to publish original prints that would experiment with the effects of light and shadow. In the spring Cassatt began to work in Degas' studio, using his tools and etching press, and the two became close—though not too close. They were used to working in isolation, and it was a pleasure, for a change, to collaborate. After several intense months Degas claimed (as he'd previously done with other projects) that he "wasn't ready," and the journal suddenly collapsed. Cassatt

learned a great deal from working with the technically skilled master but, as her mother's letter to her brother Aleck suggested, was both disappointed and angry about the wasted effort: "Degas who is the leader undertook to get up a journal of etchings and got them all to work for it so that Mary had no time for painting and as usual with Degas when the time arrived to appear, he wasn't ready—so that *Le Jour et la nuit…* which might have been a great success has not yet appeared.—Degas never is ready for anything.—This time he has thrown away an excellent chance for all of them."

Degas' desire to collaborate with Cassatt and mania for retouching once inspired him to take up her paintbrush and "improve" her work. Referring to *Little Girl in a Blue Armchair* (1878), one of her best pictures, she wrote Vollard that Degas liked the portrait and had actually painted on it: "I had done the child in the armchair, and he found that to be good and advised me on the background, *he even worked on the background.*" Unlike Morisot after Manet had worked on her picture, the more self-confident Cassatt was pleased, rather than distressed, by Degas' positive contribution. Like God creating the world in Genesis, he "saw that it was good."

Cassatt's picture was influenced by Manet's *Mme. Manet on a Blue Couch* (1874) and by Degas' *Place de la Concorde* (*Vicomte Ludovic Lepic and His Daughters*) (1876). In Manet and Cassatt the main figures are off center. She turns his three rich blue couches into four soft blue chairs. His woman reclines on a couch; her girl, with legs dangling, slumps in an overlarge chair. He places three couches in a row against a flat brown background; her sinuously curving chairs extend back into a strangely empty and haunting room. The frosty light, painted by Degas, streams in from the curtained French windows. In both pictures the main figure is on the right, a dog is on the left and there's a large empty space in the center.

Cassatt's bare-armed, bare-legged child, girdled by a tartan shawl that's echoed by her socks and by the ribbon in her hair, rests one hand behind her head and gazes downward. She has the same self-satisfied expression as the dozing brown and black Belgian griffon, contentedly stretched out on the nearby chair. Left all alone, with only the dog for company, the languid little girl seems completely content with her thoughts. The psychological tension in the painting arises from the contrast between the girl's childish pose and her Magritte-like air of adult solitude. When this great painting was refused by the Paris Exposition of 1878, Cassatt recalled: "I was furious, all the more so since he had worked on it. At that time this appeared new and the jury consisted of three people of which one was a pharmacist!"[7] This rejection helped propel her into the Impressionist exhibition the following year.

Despite Cassatt and Degas' edgy relationship, they exchanged pictures after the 1879 and 1886 exhibitions, and he owned three of her works: *Young Woman in a Loge Holding a Wide-Open Fan* (1879), *Girl Arranging Her Hair* (1886), which he prominently displayed in his apartment, and *Little Girl with Brown Hair, Looking to the Left* (1913). Passionate about Degas' art, she urged her brother, the Havemeyers and other rich collectors to buy his paintings. But her delicate role as go-between provoked more quarrels. In 1881 Degas decided to do more work on *The Steeplechase* (1866) and, as Cassatt told Louisine, she got caught in the crossfire. Degas "wanted to retouch it and drew black lines over the horse's head and wanted to change the movement....I wanted the picture for my brother Aleck and Degas declared that it was my fault that he spoiled it! I begged him so to give it as it was, it was very finished, but he was determined to change it." Cassatt tried to help and was blamed for it, and though blameless felt guilty.

Another conflict erupted that year (perhaps about the same picture), when Cassatt's brother had to pay an exorbitant price

for a Degas painting. Cassatt incurred the wrath of her mother, who felt obliged to apologize to Aleck:

> As she had to pay for Degas' picture a thousand francs more than she expected to pay, she was disposed to save all she could. She was furious at Degas and not a little provoked at Durand-Ruel—at Degas because he knew perfectly well that the picture was for her & might just as well as have sold it to her as not, and at Durand because he took so large a commission, she being an artist....She was very wrong however to consent to the arrangement which gives you so much trouble [with customs' tax] & I hope it will be a lesson to her....I am mortified at the trouble we gave you.

Once again, the obliging Cassatt got involved in a dispute with her own family as well as with Degas and his dealer.

Determined—whatever the complications—to earn money for Degas and build up the collections of Impressionist art in America, in 1893 Cassatt arranged for the Havemeyers to buy Degas' *The Collector of Prints* (1866) for $1,000. Degas, as usual, wanted to keep the picture and retouch it. After two years he declared that the value of his work had increased and demanded $3,000. Havemeyer was not only deprived of the picture during this time, but had to pay the 300 percent increase. Cassatt was outraged and, for a long time, severed relations with Degas.

In 1892 Cassatt, tempted by a lucrative $3,000 fee, made a serious mistake. She accepted a commission to join other women artists and paint a mural for the Woman's Building—designed to exhibit the products of female skill and handicraft—in the World's Columbian Exposition in Chicago. She explained that "I took for the subject of the central & largest composition young women plucking the fruits of knowledge or science & that enabled me to place my figures out of doors & allowed brilliancy of color. I have tried to make the general effect as bright, as gay, as amusing as possible. The effect is one of rejoicing, a great na-

tional fête." In order to paint the top of the fourteen-by-fifty-eight-foot mural, *Modern Woman,* without using a ladder, she had a sixty-foot-long, six-foot-deep trench dug on her country estate and lowered the canvas into it. Knowing that Cassatt's talents (like his own) were not suited to massive paintings, Degas was strongly against her doing the Chicago mural. Cassatt was determined to oppose him and maintain her independence, but dared not risk his devastating remarks before she had completed it. Admitting her vulnerability, she told Louisine:

> The bare idea of such a thing put Degas in a rage and he did not spare every criticism he could think of. I got my spirit up and said I would not give up the idea for any thing. Now, one has only to mention Chicago to set him off....I have been half a dozen times on the point of asking Degas to come and see my work but if he happens to be in the mood he would demolish me so completely that I could never pick myself up in time to finish for the exhibition. Still, he is the only man I know whose judgment would be a help to me.[8]

Pressed for time by the deadline, Cassatt misjudged the requirements of a mural. When the massive work was hoisted aloft and seen from far below, wrote Nancy Mathews, "the theme that had seemed so logical became indecipherable to the average viewer, and the style that had seemed so sunny and realistic became a jarring pattern of bright colors that was out of synch with the rest of the building." Cassatt remained in Europe and escaped the humiliating public rejection of her work, which was stored away and later disappeared.

The more Cassatt relied on Degas' judgment, the more she was crushed and paralyzed by his criticism. "Oh, my dear, he is dreadful!" she told Louisine. "He dissolves your will power....He dissolves one so that you feel after being with him: 'Oh, why try, since nothing can be done about it.'" Like Manet with Morisot, Degas seemed to enjoy exercising his power and dominating

Cassatt, who needed all her considerable strength to resist his critical remarks and attempts to interfere with her work. After seeing him at Durand-Ruel's funeral in 1892, she wrote: "To tell the truth I needed all my sang-froid & Degas takes pleasure in throwing me off the track; for years I have never shown him anything without its being finished."9

III

LOUISINE HAVEMEYER once asked Cassatt "if she often posed for Degas. 'Oh, no,' she answered carelessly, 'only once in while when he finds the movement difficult, and the model cannot seem to get his idea.'" In fact, she posed for three of his major portraits. *At the Milliner's,* a pastel of 1882, commemorates Degas' frequent visits to hat shops with her. As the characteristically cutoff shopgirl leans in from the left to offer another enticing choice, the seated Cassatt rests her elbow on the counter and gazes into a mirror to adjust the bonnet she's trying on. Though her features are rather indistinct, she looks charming under the curving brim of the hat. In *The House of Mirth* (1905) Edith Wharton reveals the harsh difference between shop workers and clients at this time. When the impoverished heroine, Lily Bart, makes a futile attempt to work at a milliner's in New York, she's surprised to discover the undisguised antagonism the working women feel for the clients: "She had never before suspected the mixture of insatiable curiosity and contemptuous freedom with which she and her kind were discussed in this underworld of toilers who lived on their vanity and self-indulgence." Degas' picture gives the upstairs view of fashionable shopping, the pleasant intimacy between the milliner and her client.

In *The New Painting* (1876) the critic Edmond Duranty urged artists to express the character of the subject by stance rather than by facial expression and wrote: "Through someone's back, we want temperament, age, social conditions to be revealed.... The pose will let us know that this person is going to a business

meeting, while that one is returning from a lovers' tryst."[10] In *At the Louvre,* a pastel of 1879 that shows Cassatt as connoisseur rather than consumer, Degas did precisely this. He showed Mary and her sister Lydia in the museum, examining the heavily framed paintings that are crammed together in several tiers. Standing and seen from behind, Mary looks directly at the pictures; Lydia sees them through a guidebook. Seated with her back to the pictures, she holds the book at eye level and gazes backward to confirm what she's just read. The wasp-waisted Mary, in a massive, stylish hat that hides her hair and neck, has her right shoulder slightly raised and head cocked contemplatively to the left. She stands erect, gently supported by a thin umbrella, held at an elegant angle. Her body—as in a ballet—reveals her character: intelligent and sensitive, finely bred and wonderfully self-assured. Walter Sickert gave *At the Louvre* a strangely misogynistic interpretation. He thought it was meant "to give the idea of that bored and respectfully crushed and impressed absence of all sensation that women experience in front of paintings." But it actually gives quite the opposite impression. Cassatt, though not portrayed as a painter and holding an umbrella instead of a brush, conveys the clear impression of a consummate professional who studies art as part of the creative process.

The etching *Mary Cassatt at the Louvre: The Etruscan Gallery* (1879–80) reverses her stance and shifts her umbrella from right hand to left. It shows her gazing intently at the huge (four-by-six-and-a-half-foot), painted terra-cotta figures of an Etruscan tomb from Cerveteri, c. 500 B.C. The long-haired, enigmatically smiling husband and wife, lying on top of a sarcophagus and enclosed in a glass case, face the viewer. The descriptive catalogue of the Louvre explained:

> The dead couple, leaning on cushions, lie on the lid, while the base of the sarcophagus represents the couch which it was then customary to use at banquets.... The woman is dressed

in a tunic and cloak, her hair falls in tight plaits on either side of her face. Her bearded husband places his arm protectively around her shoulders. It is a scene from family life, but it distils a strange atmosphere which lends these simple figures an air of everlasting tranquility.

D. H. Lawrence, also emphasizing the joyous nature of Etruscan funerary sculpture, observed that the Etruscans possessed a delicacy, sensitivity and spontaneity, and saw death as a pleasant continuation of life, with wine, flutes and dance: "the carved figure of the dead rears up as if alive, from the lid of the tomb, resting upon one elbow, and gazing out proudly, sternly....The underworld of the Etruscans becomes more real than the above day of the afternoon. One begins to live with the painted dancers and feasters and mourners and to look eagerly for them." The Etruscan couple represent the erotic pleasure and marital bliss that Cassatt, gazing at them through the protective glass, can observe but not experience.

Cassatt's self-portrait of 1878 (aged thirty-four) is idealized; Degas' *Mary Cassatt* (1884) is realistic. She portrays herself dressed in dangling earrings, a gorgeous ruffled white gown and white gloves, hat trimmed with red flowers and tied with a black ribbon around her neck. Silhouetted against a mustard-yellow background, she leans on a soft, red-striped chair and looks pensively off to the right. The features of her half-shadowed face are well defined and attractive. Degas portrays her six years later and looking much older, wearing a black dress and brown beribboned hat, sitting on a hard chair, leaning forward with elbows on her knees, holding three cards and looking down. A roughly painted splash of yellow and white, with the bare canvas showing through, provides the background to her head. Her unflattering, hunched-forward position (which wrongly suggests she has a large behind) resembles the attentive pose of Degas' father in *Lorenzo Pagans and Auguste De Gas* (1871–72) as well as the vul-

gar pose of the dancer's low-class mother, who leans forward and sticks an umbrella out in front of her, in *Waiting* (1882).

Ashamed and revolted by this portrait, Cassatt developed a pathological hatred of it. In letters to Durand-Ruel of 1912–1913, she insisted: "I do not want to leave it with my family as being [a picture] of me. It has some qualities as art, but it is so painful and represents me as such a repugnant person, that I would not want it known that I posed for it."[11] To avoid the painting being recognized as her portrait, she wanted it sold to a foreigner, without her name on it. (It is now in the National Portrait Gallery, in Washington, D.C.). What accounted for Cassatt's repulsion? Ironically, she was more attractive in the Louvre, with her face hidden, than in this portrait, where it was revealed. Degas deliberately offended her sense of propriety by the shocking informality of the undignified pose, and by the cards that suggested a gypsy fortune-teller or a croupier in a casino.

IV

THE PERSONAL relations of Cassatt and Degas—like the paternity of Léon Leenhoff and the liaison of Manet and Morisot—is one of the crucial mysteries of this Impressionist Quartet. Manet's passionate portraits expressed his love for Morisot; Degas' cool portraits, by contrast, revealed his constraints with Cassatt. He admired her breeding, culture, intellect, wit and conversation, her talent and dedication to her art. She was certainly very different from the "good little woman, simple, calm," whom he'd once dreamed of marrying. She understood his "whims," believed passionately in his art and would never have called one of his pictures "a pretty little thing." But he was too timid and reserved to express his true feelings; and her reluctance to portray adult males, outside her family, suggests an estrangement from men and fear of intimacy. She was far too individualistic, too much of a feminist and bluestocking to suit him. Both knew that if they married their strong personalities

would clash, as she struggled to retain her independence. Degas hated modern inventions yet was sympathetic to modern art; Cassatt liked the latest cars and conveniences and hated the avant-garde. She would have had to resist his cutting remarks and attempts to dominate her, his reactionary political views and cantankerous dealings with her wealthy friends.

John Rewald reported that "once, when she advised [George Biddle] to visit Degas, the latter said something about her art which deeply embarrassed her, and for several years she stopped seeing him." As a spiky, strong-willed American, she could not easily conform to the French bourgeois notion of a submissive wife. Despite mild romantic yearnings, they both knew that their irascible characters were not cut out for domestic bliss. Neither of them was viewed as a serious contender. When Degas asked for the hand of Halévy's cousin, she thought he was joking. When Cassatt offered to marry Carsten Haldeman if he bought her the wedding veil, he turned the whole episode into a joke.

Both of them were torn between art and love. As Yeats wrote in "The Choice": "The intellect of man is forced to choose / Perfection of the life, or of the work." Degas had the instincts of a hermit, and thought that "to be a serious artist today...one must be immersed in solitude." Cassatt agreed with him and, as one of her friends wrote, "had convinced herself at an early age that with all the flourishing prejudices against woman as a creative artist nothing could be accomplished in the difficult art of painting without a devotion capable of primary sacrifices." They both liked the idea of marriage, as a protection from loneliness, better than marriage itself. In the end their passion for work was greater than their desire for love or fear of a solitary old age. Both found in art a more than satisfactory compensation. As Mary's mother told Aleck: "a woman who is not married is lucky if she has a decided love for work of any kind & the more absorbing it is the better."[12]

As she got older, as her family and friends began to die, and as she became increasingly blind, Cassatt—like Degas—

lamented her loneliness and wished she had married. After Lydia's death in 1882, Mary's sister-in-law, Lois, found her "very lonesome": "She feels now that perhaps she would have been better off to have married when she thinks of being left alone in the world." In 1913, just before she was forced to stop painting, she confronted her own mortality, without the comfort of religion, and sadly wrote: "in these long sleepless nights and idle lazy days, full of pain, I thought so much of what might be beyond, living so much alone, and having so many gone before."

George Biddle recalled that "at the end of her great and finally successful career," she realized that she'd missed the most important thing and said: "After all, woman's vocation in life is to bear children." The connoisseur and art agent Augusto Jaccaci thought her increasingly bitter temper was partly caused by sexual frustration, that work dominated her life and that the choice of painting had led her to embody the Jamesian theme of the artist's unlived life:

> She's become a viper. She was always very sharp-tongued. What she needed was a husband, or a lover. She sacrificed her chance of having children, sacrificed it to her art. When she was young and showed her adorable paintings of motherhood, no compliment irritated her more than "One can feel that you're a woman!" She wished to be an artist exclusively. The other day I asked her: "If you could start life over again, would you marry?" She replied: "There's only one thing in life for a woman: it's to be a mother."[13]

The historian Paul Johnson summarized this view: "She was a very feminine woman with reservoirs of love to pour out and subject to strong emotions, so the loss [of marriage and children] was bitter....She sublimated in her work the womanly tenderness she was denied in life."

If marriage was impossible, could Cassatt and Degas have been lovers? Pierre Cabanne, offering no evidence, asserted that "the similarity of their taste, identical intellectual dispositions

and identical predilection for drawing were to transform their friendly relationship into a love affair, the duration and intensity of which we know nothing." Since (like Manet and Morisot) they destroyed each other's letters, perhaps to hide their emotional revelations, no hint of a romantic affair survives. Both would have been horrified by scandal. Jean Bouret believed they had a great intellectual affinity, but she "was too much of a woman for a man intimidated by femininity.... She does not seem to have been particularly vibrant in the sphere of love, or to have been able to capture his attention and transform it into passion."[14] Whenever he was attracted to a woman, Degas became facetious and ironic, adopting his protective motto: "Woman is the desolation of the righteous."

Cassatt may have resented Degas' lack of sexual interest in her. But after her parents and sister moved to Paris and set up a pleasant family home, her desire to marry diminished. Her biographer, discussing their work on *Le Jour et la Nuit* in 1879, concluded that she was disillusioned by the project's collapse, and became quite guarded with him afterwards:

> Her romantic imagination was always very rich, and Degas elicited from her feelings of respect, even awe, that no other man had. He dominated her thoughts and actions during that winter of making prints and they both rose to new heights from that association....
>
> Although she continued to treasure his friendship, Cassatt learned to take what she could of his inspiration, advice, or art when it was offered, knowing full well that it could be withdrawn or altered without warning. She loved him as a friend and as a brilliant artist for the rest of his life, but she never allowed herself to be betrayed again.

Degas threw some light on the sexual question. By paradoxically stating, "I would have married her, but I could never have made love to her," he emphasized their intellectual affinity and

admitted that he did not find her attractive. Her biographer wrote that Degas was too shy to express his feelings, and his way of life was too eccentric to suit her taste: "She and Degas were the best of friends, and if Degas was in love with her, and he well may have been, she could not reconcile herself to such a relationship, as his bohemian way of living was offensive to her stiffly conventional manner of life.... Any deviation from good manners or the slightest failure to meet her standards aroused her indignation."[15] She was not entirely conventional, however, and (like Degas with his models) was capable, when infuriated, of the broadest profanity. When they first met, Degas' dress and behavior were quite gentlemanly, and she was delighted to socialize with him. As he got older, however, his shabby, unkempt, miserly way of life strongly contrasted with her self-indulgent, luxurious style. It would have been quite impossible for the frugal Degas to live in such an opulent manner.

Though Cassatt in old age was a forbidding presence, George Biddle still thought she might once have had an affair with Degas. He exclaimed: "How often, had I the courage, would I have asked the prim old lady point blank, 'Was he ever your lover?'" In later years one bold relative actually dared to ask the question. Her reply was predictably indignant as well as surprisingly snobbish: "'What, with that common little man; what a repulsive idea!' Apparently the idea itself did not bother her as much as the fact of his 'commonness.'"

Degas was as well born as Cassatt, and his Neapolitan aunts had aristocratic connections (Rosa married an Italian *duca,* Laura a *barone,* Stefanina a *marchese*). As she became familiar with Degas and lost her youthful awe of the Master, it was his behavior, tramp's dress and extreme frugality, not his background, that she found common. She was deeply offended by his cutting remarks (which quickly got back to her); by his portrait of her, which she found repulsive; and by his shabby, even dishonest dealings with patrons like Aleck and the Havemeyers. In the end, as Biddle

remarked, she must have felt about Degas "as any Philadelphia spinster might feel about the French bourgeois whom she frequently saw in business relations."[16]

Degas had an occasional sexual outlet in brothels. The prudish Cassatt—with no sexual contact—may well have found sex itself repulsive. She found compensation in her pets and in the maternal themes of her paintings. Though there was a romantic element in their friendship, their feelings were not strong enough for an affair. Unlike Manet and Morisot, a meeting of the minds was sufficient for Cassatt and Degas. Neither could submit to the imperious domination of the other, and both knew that conjugal, and especially sexual, life was impossible.

Cassatt kept in touch with Degas till the end of his life and witnessed his sad decline. In September 1913 she said he was "immensely changed mentally but in excellent physical health." Two months later she called him "a mere wreck." Mentioning his disreputable appearance and unwillingness to sell anything in his valuable collection, she told Louisine: "Mercy! what a state he is in! He scarcely knows you, he neglects his clothes, he takes no interest in anything, it is dreadful. With millions of francs still in his studio, they can do him no good; he is consumed with old age." She added that when he meets an acquaintance on the street, he looks up sadly and repeats: "*Il faut mourir*" (I'd be better off dead).

Upset by Degas' deterioration and feeling that Zoé (also getting on in years) could no longer take care of him, Cassatt went south to visit his niece, Jeanne Fevre, a trained nurse. She told her about his enormously valuable collection and persuaded her to come to Paris and look after him. Soon after his death in September 1917 Cassatt wrote George Biddle: "Degas died at midnight not knowing his state. His death is a deliverance, but I am sad [since] he was my oldest friend here and the last great artist of the 19th century. I see no one to replace him."[17] Morisot's

letter on the death of Manet was inevitably more personal and emotional, emphasizing his charm and her crushing, untimely loss. Cool and elegiac, Cassatt also mourned Degas as a friend, but even more as an artist whose passing signaled the end of an era.

Twenty

PEPPERY LADY
1 8 8 0 – 1 9 2 6

I

❧ IN THE EARLY 1880s, after the death of Lydia, her sister and frequent model, and as her nephews and nieces grew up, Cassatt was drawn to children. She portrayed their ever-changing activities: sleeping, dozing, waking, nursing, eating, sitting, bathing and playing. Well-dressed, half-dressed or nude, they are always quiet and well behaved. A sense of security pervades Cassatt's work. No social convulsions threaten the status of her subjects, no epidemics threaten the lives of her children. The dealer René Gimpel perceived that her children were invariably attractive and clean, and quoted one of Degas' barbed comments: "Mary Cassatt was always independent enough to refuse to do a portrait of any child who wasn't pretty. Infant hygiene and Mary Cassatt are one and the same. Her children are always fresh from the bath; they've been raised in the English way, in the fresh air." Like Degas with his dancers, Cassatt was forced to repeat the same theme in the same style to satisfy buyers' demands for pictures of mothers and children. Maternity was the spinster's great theme. Her images of motherhood expressed her desire for children, but she preferred to paint them rather than to bear them.

Cassatt continued to create major works of mothers and children until the turn of the century. *Ellen Mary Cassatt in a White Coat* (1896) portrays her favorite niece (then two years old) as a blue-eyed, ruddy-faced, chipmunk-cheeked, imperious and terribly serious child, grasping with her small hands the arms of an oversized, gold-upholstered chair. She's royally buried in a

yellow-white, fur-trimmed, matching bonnet, dress and cape, beneath which her little feet stick stiffly out. Comfortably cocooned in her flowing costume, she seems as regal as a Spanish infanta, or a Russian princess ready to ride in an open troika across the snowy steppes.

Breakfast in Bed (1897) is the most intimate and suggestive of all her mother-and-child paintings. Next to a cup of tea on a bedside table, and framed by an emerald green headboard, a drowsy, dark-haired, soft-lipped mother lies under the covers, her head denting two white pillows. Her arms enfold her curly-haired baby, nightshirt rucked up to her waist. She's sitting, with crossed legs and arms resting on her mother's arm, on top of the blanket that covers the mother's body. There's a fine contrast between the mother's somnolent expression and relaxed arms, and the baby's alert features and expressive gestures. The mother, gazing sideways at the lively infant, might be pregnant or an invalid, lying in the bed in which the baby may well have been born. In Cassatt's art, mothers and children are intimately connected in a sensual, even erotic way. The infant has emerged from this woman's womb; the picture shows their close physical bond. Fathers seem to play no part in the family and are always absent.

The Caress (1902), more painterly than linear, shows a mother seated on a green velvet chair—with high rolled hair, a long Mannerist face, high-collared sheer blouse under a green gown fastened with a brooch—holding her baby's foot with her right hand and the baby's extended hand with her left. The naked child, standing on her mother's lap, leans backward, with distended belly, on her chest and shoulder. An older sister, with blond hair and yellow dress, stands on the mother's right, clasping the wrist and kissing the cheek of the baby between them. The heads of the mother and sister are aligned with the baby's and touch her cheeks. This painting, Cassatt's clearest use of Christian iconography, imitates Italian Renaissance paintings of the seated Madonna, the Christ child standing up on her lap and

the young John the Baptist standing on her right. This quattro-cento tradition goes back to Fra Angelico's *Linaiuoli Madonna* and *Madonna with Saints and Angels,* to Fra Lippo Lippi's *Barbadori Altarpiece* and to Domenico Veneziano's *St. Lucy Altarpiece.* Cas-satt felt obliged to refuse a prize for this painting from her old school, the Pennsylvania Academy of Fine Arts, and explained her motives to the director: "Of course it is very gratifying to know that a picture of mine was selected for a special honor and I hope the fact of my not accepting the award will not be mis-understood....I, however...must stick to my principles, our principles, which were, no jury, no medals, no awards."

Huysmans once again hit the mark in his critical understand-ing of Cassatt's art. In 1879 he found her works "more interest-ing, more fastidious, more distinguished" than those in the Salon. The following year he compared her to Morisot, and sensed the constraints of character that inhibited her expression and defined her particular talents: "In spite of her personality which is still not completely free, Miss Cassatt has nevertheless a curiosity, a special attraction, for a flutter of feminine nerves passes through her painting which is more poised, more calm, more able than that of Mme. Morisot, a pupil of Manet." Re-viewing the Impressionist show of 1881, he praised her paint-ings, which he thought combined the best qualities of both English and French artists: "Her works at the exhibition consist of portraits of children, also interiors, and they are a miracle, as Mlle. Cassatt has managed to escape from that sentimentality which so often affects English painters....There is an affection-ate understanding of quiet domesticity, a heightened sense of in-timacy....These works accentuate [a] note of tenderness, and exude a delicate fragrance of Parisian elegance."[1]

II

IN THE 1880s Cassatt also began to experiment with drypoint (engraving on copper) and aquatint, as Degas had tried pastels

and sculpture. She was more influenced than any of the other Impressionists by the Japanese art she'd so enthusiastically praised in her letter to Morisot. Gerald Needham explained that "the opening up of Japan [in 1854] revealed an almost unknown and decidedly exotic civilization which was both quaint and refined." The *ukiyo-e,* popular genre woodblock prints of Hokusai and Hiroshige, "depicted the pleasures of Edo [Tokyo] (the theaters, street scenes, and wrestlers, the café life of the brothels, and the many excursionist scenes of surrounding beauty spots)." The dominant characteristics of Japanese prints were strong outlines, emphasis on silhouettes, delicate colors, contrasting decorative patterns, direct frontality, asymmetrical compositions, flat, two-dimensional space, bold foreshortenings, dramatically angled perspectives and figures cut off at the edge of the picture frames. Cassatt described her painstaking technique as "very simple": "I drew an outline in dry point and transferred this to two other plates, making in all, three plates, never more, for each proof. Then I put an aquatint wherever the color was to be printed; the color was painted on the plate as it was to appear in the proof."[2] Her careful study of Japanese prints reinforced the linear quality of her art and enhanced the studied tranquility of her subjects.

Cassatt's three finest drypoints of 1890–91 reveal all the Japanese characteristics, and the female subjects look faintly Japanese in features and skin color. In *The Letter,* one of her most popular and frequently reproduced works, a lady with graying hair and dark eyebrows sits at a brown escritoire, looking down at a sheet of writing paper on the blue projecting desk. She has finished writing a letter and, slightly bending her head and thinking of her correspondent, licks the envelope before sealing it. The colors are sharply divided and her body is clearly outlined against the background. The leafy green-on-white design of the wallpaper animates the picture and seems to dance behind the similar yellow-on-blue design of her dress.

In *Study,* one of Cassatt's rare adult nudes, a similar woman sits on a soft red-and-white striped chair. Looking into and framed by the mirror of an armoire, she raises her arms and adjusts her hair. Her long white skirt touches the floor, and her heavy breasts (slightly lifted by her arms) are seen both directly and reflected in the mirror. The leafy decoration on the wallpaper is also reflected in the mirror and repeated in the slightly darker leaves of the carpet. As in *The Letter,* the whirling patterns provide a dynamic contrast to the woman's contemplative self-absorption.

In *The Bath*—strongly influenced by the composition of Degas' pastel *The Washbasin* (1884–86)—a half-draped woman, standing on a carpet decorated with swirling leaves, bends before a mirror and performs her toilette. Her curved back is beautifully exposed and her hands, next to two bottles of perfume, are prayerfully dipped into a basin of blue water. Her green, pink and white striped dress contrasts with the patterns on the carpet and on the water jug; and the blue water is subtly reprised in the wallpaper and the background of the carpet. Though the woman's face and breasts are more hidden than in *Study,* we remain (as with Degas' bathers) privileged witnesses of her private ablutions. In *Goodbye to Berlin* (1939), Christopher Isherwood, thinking of Japanese prints and, perhaps, of Cassatt, wrote of the camera recording "the woman in the kimono washing her hair. Some day, all this will have to be developed, carefully printed, fixed." Pissarro, who worked closely with Cassatt on colored etchings and admired the perfection of her art, wrote that her tones were "even, subtle, delicate, without stains on the seams: adorable blues, fresh rose....The result is admirable, as beautiful as Japanese work."[3]

In her paintings Cassatt undercut the pleasure principle, distanced herself from the people of her class and even satirized the hollowness of their lives. Taking tea, driving carriages and other social rituals comprised their entire existence; Cassatt's real life

was as the artist who portrayed them. She rather modestly told René Gimpel that "my pictures are for the home, they're pleasant and easy to take, and don't have anything for the public or for artists." But in a letter to Louisine Havemeyer she assumed that a picture should tell a story and (like Morisot) described the agonizing creative process, the exhausting physical and mental labor that went into every major work:

> I doubt if you know the effort it is to paint. The concentration it requires to compose your picture, the difficulty of posing the models, of choosing the color scheme, of expressing the sentiment and telling your story! The trying and trying again and again and oh, the failures, when you have to begin all over again! The long months spent in effort upon effort, making sketch after sketch. Oh, my dear! No one but those who have painted a picture know what it costs in time and strength!

Late in life, when she was nearly blind, she listed the casualties of art (Renoir had severe arthritis and Monet's vision was fading) and again told Louisine: "nothing takes it out of one like painting. I have only to look around me to see that, to see Degas a mere wreck, and Renoir and Monet too."[4]

III

THOUGH CASSATT had no husband or children, she was responsible for her elderly parents and the invalid Lydia, and their health problems stole precious time from her work. As she wrote to her close friend Camille Pissarro: "I am at my wits' end with my Mother not well & my sister incapable of helping anyone." Lydia, Mary's favorite sibling, suffered from the incurable Bright's disease, which affects the kidneys, and during the final months of her life "was treated with doses of arsenic, morphine, and the blood of animals drunk fresh at the abattoir." After this ghastly treatment, Lydia died, at the age of forty-five, in November

1882. Cassatt's father died in November 1891; and in the spring of 1895 she told a friend: "the woman you knew as my Mother is no more…only a poor creature is left!"[5] In another cruel autumn, Katherine Cassatt died in October 1895. In 1882, the year of Lydia's death, Cassatt alleviated her burdens by taking on an Alsatian-German housekeeper, Mathilde Valet, who also spoke French and English. Like Degas' Zoé, she was superior to the usual domestic servant, and remained a devoted lady's maid, companion and manager of the household until Cassatt's death forty-four years later.

Family deaths drew Cassatt into the spiritualist movement that came into fashion in France at the turn of the century. She became fascinated by various aspects of the occult—hypnotism, Theosophy and oriental mysticism—and was absorbed by the pseudo-religion that attempted to communicate through mediums with the spirits of the dead and make sense of this world through insights from the other world. She took part in a séance and believed she actually saw their table rise several feet above the ground. Her spiritualism allowed her to believe that her departed family had not only entered a better world, but were also present among the living. Mary had tried to convert Louisine to her beliefs after her friend had suffered the unexpected death of her husband, her mother and her twin grandchildren, all within one agonizing month.

To add to her family problems, in her mid-forties Cassatt had two serious accidents. In a sympathetic letter of June 1889 Degas, who admired her daring, described the riding accident and the problems that were bound to follow: "Poor Mlle. Cassatt had a fall from her horse, broke the tibia of her right leg and dislocated her left shoulder.…She is, for a long time to come, first of all immobilized for many long summer weeks and then deprived of her active life and perhaps also of her horsewoman's passion. The horse must have put its foot in a hole made by the rain on soft earth." She was fortunate to escape major injuries in

June 1890 when a Parisian driver maliciously provoked the second accident. She described the encounter in a furious letter: "I was thrown from my carriage on the stones...& as I alighted on my forehead, I have had the blackest eye I suppose anyone was ever disfigured with. The carriage was kicked to pieces, the coachman pitched out & even the dogs wounded; & all because a man driving a van thought he would amuse himself cracking his whip at my cob's head, finding it frightened her. He leaned out of his wagon & continued his amusement until he drove her nearly mad with fright & then he drove off smiling!" Much tougher than she looked, Cassatt recovered and remained as feisty as ever.

Cassatt stayed in close touch with the Impressionists after their last exhibition in 1886, and conflicts among this lively but touchy group continued to erupt. In the spring of 1891 the French Society of Painters and Printmakers, exhibiting in the main room of Durand-Ruel's gallery, perversely decided to exclude foreign artists. Cassatt and Pissarro held their own rival show in two of the adjoining rooms. Amused by their little triumph, Pissarro told his son: "We open Saturday, the same day as the patriots, who, between the two of us, are going to be furious when they discover right next to their exhibition a show of rare and exquisite works." To celebrate the event the French painters had a dinner and invited the foreigners. Like George Moore, Cassatt spoke rather queer French, and as the drink flowed and old resentments about her considerable wealth surfaced, she was mercilessly teased. Unaccustomed to verbal abuse, especially when a guest at dinner, she became terribly upset and left almost in tears.

She also got angry about the sharp business practices of Durand-Ruel, who both exhibited her paintings and sold Impressionist works to her American friends. In April 1891 Pissarro reported that Cassatt was threatening to leave the dealer: "She is incensed at Durand...[and] very desirous of upsetting

Durand. She has a lot of influence and Durand, who suspects that she is irritated with him, is trying to calm her down with promises and offers which he does not make good."[6] This crisis blew over, but another erupted in 1905 when Durand excluded her from an Impressionist exhibition in his London gallery.

Despite her quarrels, Cassatt was an avid collector of Impressionist paintings, and owned works by Degas, Pissarro, Cézanne and Monet as well as one hundred Japanese prints. At the turn of the century she took several trips to Italy and Spain with Henry and Louisine Havemeyer to search for and acquire important Old Masters. Cassatt was shrewd about the Impressionists, but she advised her friends, who relied completely on her judgment, to buy many dubiously authenticated Italian and Spanish works, and even several fakes. In the 1860s, however, America had no public collections of great art and Cassatt helped create them. In 1903 she wrote that the Havemeyers, who made major bequests to the Metropolitan Museum in New York, "are doing a great work for the country in spending so much *time* & money in bringing together such works of art. All the great public collections were formed by private individuals." Her friend Forbes Watson justly concluded that "if Miss Cassatt had never painted she would nevertheless have won a permanent place in the history of art through the number of masterpieces that she was directly instrumental in bringing into American collections."

Strangely enough, this late examination of the Old Masters had an oppressive rather than stimulating effect on her own work. Unlike Degas and most other artists, she complained, after studying many paintings in Rome by the seventeenth-century Bolognese artist Domenichino: "It upsets me terribly to see all this art....It will be months before I can settle down to work again."[7] Instead of learning from the Old Masters, as she had done during her youthful stays in Parma and Seville, she now felt unequal to their overwhelming achievement.

Cassatt bought houses as well as paintings. In the spring of 1894 her own personal fortune, the inheritance from her family

and the sale of her increasingly valuable work enabled her to buy a grand country estate. Château de Beaufresne, in the village of Mesnil-Theribus, was in the Oise Valley, near the cathedral town of Beauvais, about fifty miles northwest of Paris. The large, three-story, seventeenth-century manor had forty-five acres of land, elegant gardens and a large pond. Cassatt was determined in old age to be as comfortable as possible, and her modern innovations astonished the traditional villagers. "I have done more plumbing, another bath room," she said. "I hope I am now nearly up to the American standard. I need not say that I am so far beyond my French neighbours, that they think I am demented." By 1911 she had accumulated a fortune of $200,000, which allowed her to collect art, buy expensive clothes and antique jewelry, and run her Paris apartment and country château. Beaufresne had, in addition to Mathilde, a maid, cook, coachman, three gardeners and eight farmers.

In February 1911 Cassatt went to North Africa. After traveling through Vienna, Budapest, Sofia, Constantinople and Cairo, she took a cruise up the Nile with her younger brother, Gardner, and his family. Her biographer wrote that "she was alternately bored by the deserted temples at Luxor, Karnak, and Aswan... and crushed by the strength of their design and scale." Overwhelmed by the huge monuments, as she'd been by the Domenichinos in Rome, she felt they had extinguished her own comparatively slight creative power and constricted subjects, and told Louisine: "I wonder though if ever I can paint again.... Fancy going back to babies & women."

The pleasure trip was suddenly interrupted when Gardner fell seriously ill with hives, dysentery and Nile fever. He managed to drag himself back to Paris, but died there in April. Mary had been suffering from diabetes, rheumatism, neuralgia and weight loss, which reduced her thin body to less than one hundred pounds. Gardner's death, which filled her with grief and guilt, precipitated a major crisis. She became severely depressed, had a nervous breakdown and was unable to work for the next two

years. In May 1913, as she began to recover, she told Louisine that she had been half mad, but now felt able to resume her career: "I may have still something to do in this World. I never thought I would have. I felt as if I were half way over the border. I am so much better I think I may be still stronger, strong enough to paint once more."[8]

Cassatt did have, astonishingly enough, one more romantic opportunity late in life. James Stillman (born in Texas in 1850 and six years her junior) was, like her brother Aleck, a business tycoon. He first prospered as a cotton trader, was president of the National City Bank of New York from 1891 to 1909 and thereafter chairman of the board. He was a close associate of the Rockefellers and Standard Oil, and his bank served the great industries that flourished at the turn of the century. He owned a flat in Paris, but did not move there permanently until 1909. He collected Cassatt's work and, like the Havemeyers, asked her advice when buying art. René Gimpel reported that Cassatt "bullied Stillman, and that's how she made a collector of him. In front of a Velázquez she told him: 'Buy this canvas, it's shameful to be rich like you. Such a purchase will redeem you.'"

His biographer described Cassatt, from Stillman's viewpoint, as "a loveable, whimsical person, violent in likes and dislikes, vehement and crochety, quick-tempered and soon over it...full of all sorts of fiery causes and beliefs." Like Degas, Stillman saw that dogs were the way to her heart. He calmed and courted her with "pet-dog collars and feeding-bowls from Tiffany's." Cassatt, for her part, graciously accepted the gifts, but kept Stillman at a safe distance. When he made overtures, she unbent so far as to say, as if saying farewell: "I often think of you with very affectionate regards and hope you will find that happiness that you wish for." A few days later she conceded that he had touched her and "brought something into my life I had not had before."

Undaunted, in 1911 Stillman proposed to her and was rejected. Her biographer oddly remarked: "As with Degas, she

found him very affectionate but not very reliable." But Degas was not at all affectionate and the successful capitalist, who made a firm offer, must have been much more reliable than the self-absorbed artist. Cassatt told Louisine: "I won't allow him to have me on his mind" as a prospective bride. She played the invalid and added: "he must be glad to be rid of this sick old woman. I think I would be in his place." As it turned out, he died in 1918 and she survived until 1926.

In the winter of 1912 she rented the Villa Angeletto—in flower-filled Grasse, a center of the French perfume industry—fifteen miles above Cannes, in the Maritime Alps. For the next twelve years she spent an annual six months at the "cozy candy box of a house, with three floors, glassed-in studio, and a garden with a view over the curving hills down to the Mediterranean."9

<div align="center">IV</div>

THREE STRIKING photographs record Cassatt's descent into old age. At fifty-six, in about 1900, she was very much the grande dame, with firm mouth and fine jawline, dressed entirely in black: flame-feathered hat, stylish dress, fur-trimmed jacket, deep muff and long, jeweled necklace. In 1914, at the age of seventy, her hair was white, face lined, cheeks hollow. In a dignified pose, she wore a high-necked ruffled blouse and her favorite necklace. By 1925, the year before her death, she looked very old and thin at eighty-one. Though still sitting erect, she had no pretensions to elegance. A rug covered her legs, and she wore a homely white bandana tied around her head, very thick spectacles and several rings on her clawlike fingers.

In old age, one of the last survivors of the Impressionists, she hardened into an icon, became incapable of conversation, and made visitors uneasy with her rigid and reactionary pronouncements. In 1905 an American art student, who came to pay homage, found her "a fiery and peppery lady, a very vivid, determined personality, positive in her opinions. I was scared to death of

her." An American collector, meeting her at a dinner at Vollard's in 1909, felt she dominated the talk in a prim and tedious way: "The Cassatt, a tiresome cackling old maid with loud opinions, very Bostonese — most boresome." Her friend Forbes Watson noted, more sympathetically, the effect of approaching blindness on her character and her shocking speech. She "had none of the sweet reasonableness of the unseeing....An embittered old woman, blind and lonely, unreasonable and vituperative, [she] was still a burning force and a dominant personality, capable of a violent burst of profanity."

George Biddle left the fullest account of her endgame. Placing her origins more exactly, he stressed her asexuality, intensity and reaction against modern art:

> Socially she remained the prim Philadelphia spinster of her generation....She would never forgive [her family] for not going to see her exhibitions in New York....Her moral code was as inflexible as her ways of living....[She was] mentally detached, of fanatical intensity, and an uncompromising fighter....
>
> Miss Cassatt's mind was neither balanced nor analytic.... [She] was almost unaware of anything that happened in the world of art after 1900....Certain names and tendencies goaded her to fury.[10]

Biddle concluded: "I should hate to leave the impression that Miss Cassatt was a violently prejudiced, quarrelsome old spinster"—but that is exactly the impression he left.

Cassatt lived in France for fifty-five years and (partly because traveling by sea made her dreadfully sick) made only three trips back to America: in 1875, 1898 and 1908. She retained her American citizenship, but during her half-century as an expatriate, the once vital connection to her country had been broken and ended in bitterness and resentment. She felt that America was still philistine and provincial, that American tourists in France

were vulgar and (especially after the fiasco of the Chicago mural) that America—and even her own family—had not given her sufficient recognition.

It was an era of widespread corporate corruption and, like Degas during his family's bankruptcy, she felt personally threatened by financial scandal. In 1906 the trust-busting president, Teddy Roosevelt, her *bête noire,* attacked the railroads and investigated Aleck's "personal holdings in coal and the allegation of kickbacks and favoritism in the railroad's dealing with the coal industry." Aleck defended himself and survived the scandal, but died that year at the age of sixty-seven. The following year, after "the discovery of fraudulent weighing of raw sugar on which duty was to be paid...accusations of illegal manipulation of stock and other anti-trust issues would resurface against [Henry] Havemeyer," who also fought off the attacks and died in 1907. Cassatt hated America's crass commercialism, especially when disguised as sentimentality. When a Mother's Day holiday was proposed in Congress in 1913, the feisty old girl "thought the idea was absurd, and that the congressman's mother should box her son's 'conceited ears.'"

Cassatt's narrow social life centered around her family and a few American visitors. She deliberately avoided expatriate artists, even those with similar backgrounds and tastes, like the painters Whistler and Sargent, the novelists Henry James and Edith Wharton. She disliked her more prosperous rivals, who were greater painters, and absurdly called "Whistler a talented mountebank and Sargent a buffoon." She was "disgusted" by Sargent's slick style and financial success, had "little regard for Henry James...and loathed Edith Wharton, whom she thought no good as a writer and whose husband [whom Wharton divorced in 1913] she regarded as a parvenu. She felt they were all catering too much to 'Society.'" Unfortunately the Society she disdained tended to reciprocate and did not offer her any lucrative commissions. Her scorn for James may well have been provoked by

his unenthusiastic review of an Impressionist exhibition. In 1876 he obtusely wrote that "none of its members show signs of possessing first-rate talent, and indeed the 'Impressionist' doctrines strike me as incompatible, in an artist's mind, with the existence of first-rate talent."[11]

The cultured and talented Edith Wharton (1862–1937) had a great deal in common with Cassatt and should have been her natural ally. Both women came from old conservative families who were indifferent, even hostile, to art. In childhood the plain-looking girls had traveled and lived with their families in several Continental countries, and had been well educated by governesses in European languages and literature. They dressed with the sober magnificence suitable to women of birth and wealth. They inherited a considerable amount of money and maintained splendid homes with magnificent gardens, both outside Paris and on the French Riviera. Both doted on dogs and were motoring enthusiasts with a passion for turn-of-the-century cars. Both actively helped Belgian refugees during World War I. They each had a forbidding, imperious character and a haughty, defensive demeanor. Descriptions of Wharton apply equally and exactly to Cassatt. Iris Origo called the novelist "elegant, formidable, as hard and dry as porcelain." Kenneth Clark described Wharton as a "formidable person, extremely intelligent, immensely well read in four languages, witty, self-disciplined."

Cassatt and Wharton had psychological as well as biographical similarities. Both suffered protracted nervous breakdowns and were drawn to emotionally arid and unresponsive men. Wharton's biographer wrote that her lover, Morton Fullerton, was (like Degas) "curiously unsubstantial on the human side; he seems to have had almost no impulse to engage another person to the full depths of the other's being." Though both, in person, conveyed the impression of strict propriety, neither was as strait-laced as she seemed. Cassatt indulged in outbursts of furious profanity. Wharton wrote a vivid piece of pornography, "Be-

atrice Palmato," which described the incestuous relations of a father and daughter. The great difference between them—though both women were childless—was that Wharton married and had a lover.

 Why then did Cassatt dislike Wharton and rather oddly compare her penetrating masterpiece *The House of Mirth* (1905) to the novels of their celebrated but mediocre French contemporary, Paul Bourget? A friend of James and Wharton, Bourget also described the life of the leisured class, but he had a very different moralistic attitude, colored by reactionary Catholic and royalist sympathies. Writing to Louisine in 1906, Cassatt condemned Wharton's novel in an ex cathedra pronouncement: "literally, I could not read it, such an imitation of Bourget, a writer I cannot endure.... Those people aren't Americans, the heroine just such a one as Bourget makes or rather the situations are. She tries James for the Character.... No Art! At home or here either."[12] Both Cassatt and Wharton portrayed, sometimes quite sharply, the same social class. But she disliked Wharton's authoritative description of American high society, especially the satiric portraits of business tycoons, who resembled her brother Aleck and her friend Henry Havemeyer. She felt that such criticism amounted to an attack on herself.

 Though pro-Dreyfus Cassatt could also be anti-Semitic, which helps explain her hostility to another American expatriate writer, Gertrude Stein. In a letter of 1911 (not published by Louisine or by Cassatt's biographers), she adopted a maliciously condescending tone and was outraged that Columbia University, despite its notoriously anti-Semitic president, had begun to admit some Jews. She also alluded to the rumor that the eminent scientist Marie Curie had had an affair with a professor of physics at the Collège de France: "Did you know that Columbia College has become a college for Jews?... Nicholas Murray Butler [said] these young Jews have absolutely *no* sense of right and wrong. Now my dear, Madame Curie is a Polish Jewess! So I have been

assured and it is only too evident that she has no sense of right and wrong. That comes from centuries of oppression."

Cassatt and Stein had some notable similarities. Stein was also born in Allegheny City, Pennsylvania, "spent part of her childhood in Europe, and was strongly influenced by the intellectual spiritualism of [Henry's brother and her teacher] William James." Stein's biographer wrote that in 1908, when Cassatt was taken to Stein's Paris apartment by an American friend to see her great collection of modern art, she reacted to the bohemian ambiance like a disdainful dowager: "Circling about the room with regal stiffness, inspecting the people, inspecting the pictures, she promptly returned to her friend and said sharply, 'I have never in my life seen so many dreadful paintings in one place; I have never seen so many dreadful people gathered together and I want to be taken home at once.'"

Five years later, underestimating Stein's wealth and forgetting that she herself was a shrewd businesswoman and had bought Impressionist paintings when prices were very low, Cassatt told her niece that Stein "is one of a family of California Jews who came to Paris poor and unknown; but they are not Jews for nothing. They—two of the brothers [Leo and Michael]—started a studio, bought Matisse's pictures cheap and began to pose as amateurs of the only real art." In a rare expression of risqué humor she described their weird, Isadora Duncan–style outfits: "[Michael] Stein received in sandals and his wife in one garment fastened by a broach, which if it gave way might disclose the costume of Eve. Of course the curiosity was aroused and the anxiety as to whether it *would* give way."[13] Cassatt disliked the cultured, gregarious Steins because they were Jews, bohemians and champions of the objectionable paintings of Picasso and Matisse. She also felt that Gertrude, a notorious lesbian, gave Americans in Paris a bad name.

Cassatt was friendly (at first) with Violet Paget (1856–1935), who wrote under the name of Vernon Lee. The English novelist

and learned writer on art had spent most of her life in Italy, and was a friend of Whistler and Sargent, of Henry James and Aldous Huxley. Like Cassatt, she was tall and thin and had defective vision; like Gertrude Stein, she was a lesbian. Leon Edel wrote that Lee, "angular, with slightly protruding teeth and peering near-sightedly through her glasses, seemed the traditional man-like bluestocking." James thought she had a sharp, penetrating intelligence and called her a "tiger-cat!"

After staying in Cassatt's house in 1895 and being sketched by her, Lee nailed her to the wall in a spiky sentence. Though equally voluble herself, Lee remarked that she talked too much and revealed the limitations of her background: "Miss Cassatt is very nice, simple, an odd mixture of a self-recognising artist, with passionate appreciation [of] literature, and the almost childish garrulous American provincial." Eleven years later Cassatt, who may have discovered that Lee was a lesbian and wanted to dissociate herself from her sometime guest, told Louisine: "Someone has just sent me Mrs. Wharton's book on Italian Gardens [*Italian Villas and Their Gardens,* 1904] dedicated to Vernon Lee; the latter once staid with me, she will never again."[14]

As a young painter Cassatt had boldly joined Degas and the cutting-edge Impressionists, but by the turn of the century, resisted anything that was new. As her own work declined, she was supplanted by young artists who created the most radical change, from realism to abstraction, in the history of Western art. She, in turn, considered contemporary women painters—the Americans Cecilia Beaux and Romaine Brooks, and the French Marie Laurencin—unworthy. She couldn't understand Cézanne's growing reputation and influence; condemned Monet's late work; disliked what she called Matisse's commonplace vision and weak execution; had no understanding of the Fauves or Cubists; and strongly objected to the squalid, low-life subjects of Toulouse-Lautrec. She was, as a friend observed, "really still a little bit a 19th-century American lady." After rejecting most contemporary

writers and artists, Cassatt was left with young visitors whom she either bored or terrified.

The recovery from her nervous breakdown coincided with the outbreak of World War I in August 1914, the onset of serious eye problems and the end of her career as a painter. Her housekeeper, Matilde, a German citizen, was forced to spend the war in Italy in order to avoid internment. Cassatt, whose horses and car had been requisitioned by the French army, felt imprisoned in the countryside. Nevertheless she did her bit for the war effort by helping Belgian refugees who'd fled to Dinard, in Brittany.

The effect of Cassatt's cataracts and her increasing blindness were eerily similar to Degas' inexorable loss of vision. She had her first of many cataract operations in September 1915 and always remained uncertain about whether they would restore her failing vision. Two years later, isolated by the encroaching darkness, she exclaimed: "I shall be very lonely, and as my sight gets dimmer every day, the operated eye will not help my sight much even tho' the secondary cataract is absorbed altogether, which is very doubtful." In March 1918 René Gimpel, visiting her in Grasse, found her almost blind. Like Degas, running his sculptor's hands along the body of his model, she also stroked the potential subjects she could no longer see: "She who so loved the sun and drew from it so much beauty is scarcely touched by its rays.... She lives in this enchanting villa perched on the mountains like a nest among branches.... She takes my children's heads between her hands and, her face close to theirs, looks at them intently, saying: 'How I should have loved to paint them.'"

By the fall of 1919 she'd endured five cataract operations— each one beginning with hope and turning to bitter disappointment. She could scarcely read large print, and the following year began to wear thick spectacles to improve what little vision remained. In 1925 she could see only light with her left eye and was just able to read the clock with her right one. George Biddle, who saw her that last year, recalled her tragic state: "There she

lay, quite blind, on the green painted bed....She was terribly emaciated....At times her memory failed her."[15]

Cassatt's near blindness caused a fierce quarrel with her closest friend at the very end of her life. In October 1923 Mathilde Valet found stored away in the house twenty-five copperplates, which apparently had never been published. Unable to examine the plates herself, Cassatt consulted two colleagues who confirmed that the plates were unprinted. She then sent them to Louisine, in New York, who showed them to William Ivins, the curator of prints at the Metropolitan Museum of Art. Ivins saw that they'd been printed many years before, and sold to museums. Louisine agreed with the expert, blamed Mathilde and Cassatt's advisers in France and said, "The prints could not be falsely advertised as new work." Cassatt, who felt her integrity was being attacked and believed that loyalty should have prevailed over truth, was furious with Louisine.

Still fuming in January 1924 Cassatt told Durand: "It seems that Mr. Ivins has no desire to exhibit my dry points, according to him inferior, the plates worn. Mrs. Havemeyer didn't say a thing [to defend me]. She accepts Mr. Ivins' opinion!...Strange way to treat a friend." Pouring out her vitriol to the innocent Ivins, she irrationally stuck to her guns and wrote: "It is not pleasant to be accused of wanting to overcharge & cheat—even though poor Mathilde is to bear the burden....It is the first time in my life that I have been accused of wanting to overcharge. All the same, the plates had never been printed before." Finally she self-righteously blamed the innocent Louisine and ruthlessly severed their long friendship. Mrs. Havemeyer, she said, "is completely beneath contempt in this matter....[She] assures me that what they all want is to protect my reputation! To prove that I am not a fraud! I will not forgive that. I told her that I could take care of my own reputation and that she should take care of hers. Poor woman, there wasn't a word, a gesture, nothing that one might have expected. But since she has been a [suffrage] politician, journalist, orator, she is nothing anymore."

Cassatt, who tried to write her own letters until the year before her death, remained physically and mentally alert into her eighties, but as she grew older she became increasingly isolated. Near blindness not only prevented her from painting or reading, but also made her suspicious and imperious. Cut off from other people and withdrawn into herself, she lived with her memories. Tended by the faithful Mathilde, she died of diabetes on June 14, 1926.

In their youth Manet, Morisot, Degas and Cassatt all chose a life dedicated to art, but had various ways of defining success. Though Manet was not financially successful in his lifetime, he earned the admiration and respect of his peers. Sure of his genius, he also wanted to be famous and have the esteem of the critics. Degas wanted the joy of creating again and again, the freedom to rework a painting until he reached perfection. To him critical opinions were worthless and wealth served only to satisfy his collecting mania. Morisot and Cassatt had the courage to choose a man's career, but needed to sell their work to validate that choice. Much of their creative energy went into dealing with the conflict between work and family life.

The vital bonds and mutual support of these four artists inspired and sustained their artistic development. Unlike Ingres and Delacroix, who were lifelong enemies, Manet and Degas, though stirred by the tide of extreme emotions, encouraged each other instead of competing for leadership and prestige. Manet told Degas, with obvious sincerity: "We have all, in our minds, awarded you the medal of honor, along with many other things even more flattering." After Manet's death Degas realized: "He was greater than we thought."[16] The contemporary French public saw the work of these modern masters as vulgar and absurd. We now value their Impressionist art and see it as serene and beautiful. But it was inspired by emotional and intellectual struggle, and by the intense friendships of Manet and Degas, two older men of genius, and their young disciples, Morisot and Cassatt.

Notes

INTRODUCTION

1. Monet, in Françoise Cachin and Charles Moffett, *Manet, 1832–1883* (New York: Metropolitan Museum of Art, 1983), p. 31; Robert Herbert, *Impressionism: Art, Leisure, and Parisian Society* (New Haven, 1988), p. 48.

EDOUARD MANET

One: Indefinable Finesse

1. Zola, in Georges Bataille, *Manet,* trans. Austryn Wainhouse and James Emmons (New York, 1955), p. 22; Silvestre, in *The Impressionists at First Hand,* ed. Bernard Denvir (London, 1987), pp. 71–72; Proust, in John Richardson, *Manet* (London, 1982), p. 8; Zola, in Theodore Reff, *Manet and Modern Paris* (Chicago, 1982), p. 13.

2. Theodore Duret, *Manet and the French Impressionists,* trans. J. E. Crawford Flitch (London, 1912), p. 16; René Gimpel, *Diary of an Art Dealer,* trans. John Rosenberg (New York, 1966), p. 221; Alexis, in Otto Friedrich, *Olympia: Paris in the Age of Manet* (New York, 1992), p. 23; Pierre Schneider, *The World of Manet, 1832–1883* (New York, 1967), p. 142.

3. Schneider, *World of Manet,* p. 14; *Portrait of Manet by Himself and His Contemporaries,* ed. Pierre Courthion and Pierre Cailler, trans. Michael Ross (1953; New York, 1960), p. 37; Schneider, *World of Manet,* p. 14; *Portrait of Manet,* p. 37.

4. Richardson, *Manet,* p. 6; Claude Pichois, *Baudelaire,* trans. Graham Robb (London, 1989), p. 1; Nancy Locke, *Manet and the Family Romance* (Princeton, 2001), p. 45; Schneider, *World of Manet,* p.13.

5. *Manet by Himself,* ed. Juliet Wilson-Bareau (London, 1991), pp. 18–19, 25.

 A photograph of the sixteen-year-old Edouard, dressed in his naval uniform and with a surprisingly ugly face, is reproduced in Ronald Pickvance, *Manet* (Marligny, Switzerland: Fondation Pierre Gianadda, 1996), p. 13.

6. See E. Bradford Burns, *A History of Brazil,* 3rd ed. (New York, 1993), pp. 146; 143; *Manet by Himself,* pp. 24; 20; Ambroise Vollard, *Recollections of a Picture Dealer,* trans. Violet Macdonald (1936; New York, 1978), pp. 150–151.

7. *Portrait of Manet,* p. 39; *Manet: A Retrospective,* ed. T. A. Gronberg (New York, 1988), p. 47; *Portrait of Manet,* p. 3.

8. Couture, in Beth Brombert, *Edouard Manet: Rebel in a Frock Coat* (Boston, 1996), p. 47; Albert Boime, "Thomas Couture and the Evolution of Painting in Nineteenth Century France," *Art Bulletin,* 51 (March 1969), 48; Peter Gay, *Art and Act: On Causes in History—Manet, Gropius, Mondrian* (New York, 1976), pp. 76–77.

9. Couture, in Jacques Lethève, *Daily Life of French Artists in the Nineteenth Century,* trans. Hilary Paddon (London, 1972), p. 64; *Manet: Retrospective,* p. 60; Antonin Proust, *Edouard Manet: Souvenirs* (Paris, 1913), p. 24.

10. *Portrait of Manet,* p. 40. The corpses Manet saw in Montmartre resembled the grisly photographs of executed Communards, squashed into their narrow coffins, in 1871 (see Reff, *Manet and Modern Paris,* p. 225).

Two: Family Secrets

1. Léon Lagrange, in Anne Coffin Hanson, *Manet and the Modern Tradition* (New Haven, 1979), p. 76; Richard Wollheim, *Painting as an Art* (Princeton, 1987), pp. 176, 155.

2. Charles Baudelaire, *Selected Letters,* trans. and ed. Rosemary Lloyd (Chicago, 1986), p. 197; De Nittis, in Brombert, *Edouard Manet,* p. 97; *Portrait of Manet,* p. 49n; Jeffrey Meyers, *Joseph Conrad: A Biography* (New York, 1991), p. 144.

3. Roger De Lage, "Mon bien-aimé Edouard," *Emmanuel Chabrier* (Paris, 1999), p. 141; *Manet by Himself,* p. 63; Vollard, *Recollections,* p. 154; *Manet by Himself,* p. 13.

4. Susan Locke, in *Manet's "Le Déjeuner sur l'herbe,"* ed. Paul Hayes Tucker (Cambridge, England, 1998), p. 135; "Letters of Edouard Manet to His Wife during the Siege of Paris, 1870–71," ed. and trans. Mina Curtiss, *Apollo,* 113 (June 1981), 379; Eugénie Manet, in Brombert, *Edouard Manet,* pp. 261, 83.

5. Tabarant, in Brombert, *Edouard Manet,* p. 211; Schneider, *World of Manet,* p. 67.

Three: Habitual Offender

1. Juliet Wilson-Bareau, *Manet, Monet and the Gare Saint-Lazare* (New York, 1998), p. 19; Alan Krell, *Manet and the Painters of Contemporary Life* (London, 1996), p. 148; T. J. Clark, *The Painting of Modern Life* (Princeton, 1984), p. 38.

2. Carol Osborne, in *Impressionism in Perspective,* ed. Barbara White (Englewood Cliffs, N. J., 1978), p. 132; Lethève, *Daily Life of French Artists,* p. 139.

3. Duret, *Manet and the French Impressionists,* p. 68; Gay, *Art and Act,* p. 52; Stéphane Mallarmé, in Richardson, *Manet,* p. 10; Model and Manet, in Schneider, *World of Manet,* p. 63.

4. Manet, in Wilson-Bareau, *Manet, Monet and the Gare Saint-Lazare,* p. 182; *Manet by Himself,* p. 169.

5. Critic, in Bataille, *Manet,* p. 72; M. Proth, in Brombert, *Edouard Manet,* p. 353.

6. *Portrait of Manet,* p. 54; Tabarant, in Pierre Courthion, *Manet* (New York, 1961), p. 72; Duret, in George Mauner, with Henri Loyrette,

Manet: The Still Life Paintings (New York, 2000), p. 159; du Camp, in Kathleen Adler, *Manet* (Oxford, 1986), p. 48.

7. Richardson, *Manet*, p. 42; Cachin, *Manet*, pp. 165–166; Anita Brookner, *The Genius of the Future* (London, 1971), p. 99.

8. *The Career of the Alabama, 1862–1864* (1864; New York: Abbott, 1908), p. 26; Duret, *Manet and the French Impressionists*, p. 74; Cassatt, in Louise Havemeyer, *Sixteen to Sixty: Memoirs of a Collector* (1930; New York: Ursus, 1993), p. 223.

9. Frederick Edge, *An Englishman's View of the Battle Between the Alabama and the Kearsarge* (1864; New York: Abbott, 1908), p. 5; William Fowler, *Under Two Flags: The American Navy in the Civil War* (New York, 1990), pp. 292–293; Philip Nord, "Manet and Radical Politics," *Journal of Interdisciplinary History*, 19 (Winter 1969), 455.

10. Cachin, *Manet*, p. 219; Madlyn Millner Kahr, *Dutch Painting in the Seventeenth Century* (New York, 1978), p. 233.

 See also Willem van de Velde, *Strong Breeze* (1658, London: National Gallery), and Jacob van Ruisdael, *Rough Sea* (1660, Boston: Museum of Fine Arts), in Wolfgang Stechow, *Dutch Landscape Painting in the Seventeenth Century* (New York, 1980); and Willem van de Velde, *Ships Near the Coast* (1658, London: National Gallery), and Hendrick Vroom, *Fight with an English Battleship* (1644, Amsterdam: Netherlands Historical Maritime Museum), in Laurens Bols, *Die Holländische Marinemalerei Des 17. Jahrhunderts* (Braunschweig: Klinkhard und Bierman, 1973).

Four: Electric Body

1. *Manet by Himself*, p. 23; Edgar Degas, *Letters*, ed. Marcel Guerin, trans. Marguerite Kay (Oxford: Cassirer, 1947), p. 21; Krell, *Manet*, p. 60; Valéry, in Cachin, *Manet*, pp. 174–175; Kenneth Clark, *The Nude* (1956; New York: Anchor, 1959), pp. 224–225.

2. Charles Baudelaire, "The Cat," *Baudelaire*, ed. Francis Scarfe (London: Penguin, 1961), pp. 50–51; Baudelaire, in Jeffrey Meyers,

Edgar Allan Poe: His Life and Legacy (New York, 1992), p. 268; Charles Baudelaire, "Jewels," *Flowers of Evil*, ed. Jackson Mathews (New York, 1958), p. 23; Theodore Reff, *Manet: Olympia* (New York, 1977), p. 89.

3. Pichois, *Baudelaire*, pp. 233, 81, 190; Proust, *Edouard Manet*, p. 39.
 In "In Praise of Make-Up," *Flowers of Evil and Other Works*, ed. Wallace Fowlie (New York: Bantam, 1964), p. 205, Baudelaire justified his bizarre habit: "The black lines give depth and strangeness to the expression, and to the eyes they give a more specific appearance of a window opening unto the infinite; rouge, which colors the high cheekbone, increases even more the light of the eyeball and adds to the beautiful face...the mysterious passion of the priestess."

4 Baudelaire, "The Rope," *Flowers of Evil*, ed. Fowlie, pp. 143, 145; Pichois, *Baudelaire*, p. 102; Joanna Richardson, *Baudelaire* (New York, 1994), p. 75; Baudelaire, *Selected Letters*, p. 49; Pichois, *Baudelaire*, p. 285 (Louis Veuillot was a Catholic writer and polemicist); Cachin, *Manet*, p. 97.

5. Charles Baudelaire, "Peintres et Aqua-Fortistes," *Oeuvres Complètes*, ed. Jacques Crepet (Paris, 1925), 2:112–113; *Manet by Himself*, p. 33; Baudelaire, in George Heard Hamilton, *Manet and His Critics* (1954; New York, 1969), p. 36; Berthe Morisot, *Correspondence*, ed. Denis Rouart, trans. Betty Hubbard (1957; Mt. Kisco, N.Y.: Moyer Bell, 1986), p. 31; Baudelaire, *Selected Letters*, p. 203.

6. Denvir, *Impressionists at First Hand*, pp. 124; 72; *Manet by Himself*, p. 304; Proust, *Edouard Manet*, p. 122; Renoir, in Cachin, *Manet*, p. 17.

7. Théophile Gautier, *Wanderings in Spain* (1845; London, 1853), p. 115; Jeffrey Meyers, *Somerset Maugham: A Life* (New York, 2004), p. 45; Duret, *Manet and the Impressionists*, p. 41; *Manet by Himself*, p. 36.

8. Gautier, *Wanderings in Spain*, pp. 59, 69, 66–67, 71–72; *Manet by Himself*, pp. 37, 36.

9. *Manet by Himself*, pp. 27, 36; Vollard, *Recollections*, p. 153.

10. Emile Zola, "Edouard Manet," *Mes Haines* (My Aversions), (Paris, 1907), pp. 293, 295–296.

11. *Manet by Himself,* p. 42; Zola, in Courthion, *Manet,* p. 96; Zola, in Reff, *Manet: Olympia,* p. 25.

12. Lethève, *Daily Life of French Artists,* p. 153; Manet, in Elizabeth Holt, ed., *From the Classicists to the Impressionists* (New York: Anchor, 1963), p. 369; Marcel Proust, *Remembrance of Things Past,* trans. C. K. Scott Moncrieff (1913–27; New York, 1934), 1:1089.

13. Meredith Strang, "Napoleon III: The Fatal Foreign Policy," *Edouard Manet and "The Execution of Maximilian,"* ed. Kermit Champa (Providence, R.I., 1981), pp. 90, 96, 98.

14. H. Montgomery Hyde, *Mexican Empire: The History of Maximilian and Carlota of Mexico* (London, 1946), p. 292; Champa, *Manet and "The Execution of Maximilian,"* p. 12.

 For an early account by a German painter of how Manet used contemporary photos, see Max Liebermann, "Ein Beitrag zur Arbeitsweise Manets" ("A Contribution to Manet's Method of Work"), *Kunst und Kunstler,* 8 (1910), 483–488.

 Hemingway's account of the November 1922 execution of Greek royalist ministers, one of whom (like Mejía) was gravely ill, also conveys sympathy for the victims while objectively narrating their death. See Ernest Hemingway, *Short Stories* (1925; New York, 1938), p. 127: "They shot the six cabinet ministers at half-past six in the morning against the wall.…One of the ministers was sick with typhoid. The soldiers carried him downstairs.…They tried to hold him up against the wall.…The other five stood very quietly against the wall. Finally the officer told the soldiers it was no good trying to make him stand up. When they fired the first volley he was sitting down in the water."

15 Gautier, *Wanderings in Spain,* p. 97.

16. Schneider, *World of Manet,* p. 135; *Portrait of Manet,* p. 66n; John Rewald, *The History of Impressionism* (New York, 1946), p. 170; *Manet by Himself,* p. 51.

Five: Dining on Rats

1. Gustave Flaubert, *Letters,* ed. and trans. Francis Steegmuller (1953; New York: Vintage, 1967), p. 226; *Manet by Himself,* pp. 55, 57; Alistair Horne, *The Fall of Paris: The Siege and the Commune, 1870–1871,* 2nd ed. (London: Penguin, 1981), pp. 277, 127.

2. *Manet by Himself,* pp. 59, 57, 62, 64; Horne, *Fall of Paris,* p. 305.

3. *Manet by Himself,* p. 160; "Les Lettres de Manet à Bracquemond," ed. Jean-Paul Bouillon, *Gazette des Beaux-Arts,* 101 (avril 1983), 151; Horne, *Fall of Paris,* pp. 453, 499.

4. Philip Nord, *Impressionists and Politics: Art and Democracy in the Nineteenth Century* (London, 2000), p. 43; Nord, "Manet and Radical Politics," pp. 453, 468, 471; Reff, *Manet and Modern Paris,* p. 204.

5. Lethève, *Daily Life of French Artists,* p. 163; Duret, *Manet and the French Impressionists,* p. 85; *Manet by Himself,* pp. 303, 183; Camille Pissarro, *Letters to His Son Lucien,* ed. John Rewald, trans. Lionel Abel (1943; Boston, 2002), p. 50; Bazille, in Jean Renoir, *Renoir: My Father,* trans. Randolph and Dorothy Weaver (Boston, 1962), p. 106.

6. Wilson-Bareau, *Manet, Monet and the Gare Saint-Lazare,* p. 131; Albert Boime, *Art and the French Commune: Imagining Paris After War and Revolution* (Princeton, 1995), p. 87; Linda Nochlin, "Manet's *Masked Ball at the Opéra,*" *The Politics of Vision: Essays on Nineteenth-Century Art and Society* (New York, 1989), pp. 86–87, 76; Wollheim, *Painting as an Art,* pp. 156–157.

7. Henri de Régnier, in Cachin, *Manet,* p. 378; Gordon Millan, *The Life of Stéphane Mallarmé* (New York, 1994), p. 198; Mallarmé, in Wilson-Bareau, *Manet, Monet and the Gare Saint-Lazare,* p. 23.

8. Mallarmé, in Hamilton, *Manet and His Critics,* p. 183; Mallarmé, in Charles Moffett, ed., *The New Painting: Impressionism, 1874–1886* (San Francisco: Fine Arts Museum, 1986), pp. 30, 29.

 Mallarmé's account anticipates, in a striking way, Stein's famous advice to Jim in Joseph Conrad's *Lord Jim* (1900; New York:

Modern Library, 1931), p. 214: "The way is to the destructive element submit yourself, and with the exertions of your hands and feet in the water make the deep, deep sea keep you up."

9. Millan, *Life of Mallarmé,* p. 215; Junius, in Krell, *Manet,* p. 174; Proust, in Gronberg, *Manet: Retrospective,* p. 162.

10. Dante Gabriel Rossetti, *Letters,* ed. Oswald Doughty and John Robert Wahl (Oxford, 1965–67), 2: 527; Jan Marsh, *Dante Gabriel Rossetti: Painter and Poet* (London, 1999), p. 287.

 The Swedish playwright August Strindberg, writing to Paul Gauguin about his visit to Durand-Ruel's gallery in Paris in 1876, was more enthusiastic than Rossetti and "saw some marvelous canvases, most of them signed Monet and Manet." Paul Gauguin, *Intimate Journals,* trans. Van Wyck Brooks (1921; New York, 1936), p. 45.

11. Lethève, *Daily Life of French Artists,* p. 76; George Moore, *Modern Painting* (New York, 1894), pp. 30–31; W. B. Yeats, *Autobiography* (1936; New York: Anchor, 1958), pp. 270–271; Manet in Douglas Cooper, "George Moore and Modern Art," *Horizon,* 11 (February 1945), 120.

12. *Manet by Himself,* p. 184; Joseph Hone, *The Life of George Moore* (London, 1936), p. 306; Walter Sickert, *A Free House! or the Artist as Craftsman,* ed. Osbert Sitwell (London, 1947), p. 44.

Six: Absolute Torture

1. Morisot, *Correspondence,* p. 70; Alice Bullard, *Exile to Paradise: Savagery and Civilization in Paris and the South Pacific, 1790–1900* (Stanford, 2000), pp. 122, 124–125; Alan Bowness, "Manet and Mallarmé," *Philadelphia Museum Bulletin,* 62 (April 1967), 217.

 For an account of the penal colony and the escape, see Henri de Rochefort, *The Adventures of My Life,* trans. E. W. Smith (London 1896), 2: 80–117.

 Jan Porcellis' *Estuary Ships in a Strong Wind* (Rotterdam: Boymans Museum), with the detail of a manned whaleboat and a

prominent figure — facing the spectator — at the tiller, is a clear model for Manet's painting.

2. Proust, in Brombert, *Edouard Manet*, p. 433; Huysmans, in Cachin, *Manet*, p. 473; Vladimir Nabokov, *Pale Fire* (1962; New York: Vintage, 1989), p. 234.

3. Merleau-Ponty, in Irina Antonova, *Old Masters, Impressionists, and Moderns: French Masterworks from the State Pushkin Museum, Moscow* (New Haven, 2002), p. 194; Krell, *Manet*, p. 198.

4. Roger Shattuck, "Stages on Art's Way," *New Republic*, 216 (February 3, 1997), p. 49; Enid Starkie, *Baudelaire* (New York, 1958), p. 422; Richardson, *Manet*, p. 21.

 In *Money* (London: Penguin, 1986, p. 305) Martin Amis gives a lively if inaccurate description of *Bar*: "On this rainy afternoon Édouard Manet was our man. The first thing he did was take me back to Paris. You know that one of the girl serving in the stripclub or trapeze bar, her gentle put-upon look, the unopened half-bottles of champagne, the oranges in the thick glass bowl, and, behind her in the distance, the rank of mad tophats."

5. Millan, *Life of Mallarmé*, p. 236; Adrian Frazier, *George Moore, 1852–1933* (New Haven, 2000), p. 58; *Manet by Himself*, p. 179; Cachin, *Manet*, p. 434.

6. *Manet by Himself*, p. 247; Ernest-Pierre Prins, in Friedrich, *Olympia*, p. 292; Pichois, *Baudelaire*, p. 99; Manet, in Brombert, *Edouard Manet*, p. 451.

 For the symptoms of tabes dorsalis, see Kenneth Tyler and Joseph Martin, *Infectious Diseases of the Central Nervous System* (Philadelphia: F. A. Davis, 1993), pp. 243–245.

7. For the symptoms of ergot poisoning, see J. M. Massey and E. W. Massey, "Ergot, the 'Jerks,' and Revivals," *Clinical Neuropharmacology*, 7 (1984), 99–105; Mme. Manet, in Brombert, *Edouard Manet*, pp. 451–452; Degas, *Letters*, p. 73.

8. *Le Figaro*, in *Portrait of Manet*, p. 102; Schneider, *World of Manet*,

p. 175; Monet, in Gimpel, *Diary of an Art Dealer,* p. 314; Nigel Gosling, *Nadar* (London, 1976), p. 188; *Portrait of Manet,* p. 103.

9. Manet, in Krell, *Manet,* p. 197; Pissarro, *Letters,* p. 50; Régnier, in Millan, *Life of Mallarmé,* p. 245; Proust, in Belinda Thompson, *Impressionism: Origins, Practice, Reception* (London, 2000), p. 246.

10. Victorine, in Friedrich, *Olympia,* p. 302; Julie Manet, *Journal, 1893–1899: Sa jeunesse parmi les peintres impressionistes et les hommes des lettres* (Paris, 1979), p. 216; Signac, in Cachin, *Manet,* p. 20.

BERTHE MORISOT

Seven: Friendly Medusa

1. Margaret Shennan, *Berthe Morisot: The First Lady of Impressionism* (Stroud, England: Sutton, 1996), pp. 30–31; Tiburce, in Anne Higonnet, *Berthe Morisot* (Berkeley, 1995), p. 12; Morisot, *Correspondence,* p. 19; Shennan, *Berthe Morisot,* p. 126.

2. Duret, in Elizabeth Mongan, *Berthe Morisot: Drawings, Pastels, Watercolors, Paintings* (New York, 1960), p. 38; Blanche, in Higonnet, *Berthe Morisot,* p. 89.

3. Morisot, *Correspondence,* p. 85; Paul Valéry, *Degas Manet Morisot,* trans. David Paul (New York, 1960), p. 126.

4. Morisot, *Correspondence,* pp. 27, 82, 84; Blanche, in Charles Stuckey and William Scott, *Berthe Morisot: Impressionist* (New York: Hudson Hills, 1987), p. 57; Marie Bashkirtseff, *Journal,* trans. A. D. Hall (Chicago, 1913), 1: 416.

5. Morisot, *Correspondence,* pp. 33, 34, 83, 75–76.

6. Guichard, in Shennan, *Berthe Morisot,* pp. 151–152; Morisot, *Correspondence,* pp. 143, 177.

7. Friend, in Juliet Wilson-Bareau and David Degener, *Manet and the Sea* (New Haven, 2003), p. 230; Mongan, *Berthe Morisot,* p. 15; Laforgue, in Clark, *Painting of Modern Life,* p. 16.

8. Mongan, *Berthe Morisot,* p. 50; Leo Tolstoy, *Anna Karenina,* trans.

Rosemary Edmonds (1877; London: Penguin, 1954), pp. 751–752; Huysmans, in T. J. Edelstein, ed., *Perspectives on Morisot* (New York: Hudson Hills, 1990), p. 63.

9. Wolff, in Morisot, *Correspondence,* p. 111; George Moore, *Confessions of a Young Man* (1886; New York: Capricorn, 1959), p. 47; Paul Mantz, in Morisot, *Correspondence,* p. 225; Redon, in Holt, *Classicists to Impressionists,* p. 498.

10. Morisot, *Correspondence,* pp. 40, 62, 135, 38, 40.

11. Morisot, *Correspondence,* p. 32; See Flaubert, *Selected Letters,* p. 199; Jeffrey Meyers, *Somerset Maugham,* p. 112.

12. Morisot, in Daniel Halévy, *My Friend Degas,* ed. and trans. Mina Curtiss (Middletown, Conn., 1964), p. 77; Morisot, *Correspondence,* pp. 84, 194.

Eight: Morisot and Manet

1. *Manet by Himself,* p. 49; Morisot, *Correspondence,* pp. 33, 35–36.

2. Morisot, *Correspondence,* pp. 43, 44; *Manet by Himself,* p. 60.

3. Morisot, *Correspondence,* pp. 45, 46, 35.

4. Linda Nochlin, "Why Are There No Great Women Artists?," *Women, Art, Power and Other Essays* (New York, 1988), p. 168; Moore, in Nancy Mathews, ed., *Mary Cassatt: A Retrospective* (New York, 1996), pp. 105–106; Stuckey, *Berthe Morisot,* p. 188; Morisot, *Correspondence,* p. 48.

5. Morisot, *Correspondence,* pp. 49, 55–56, 54–55.

6. Morisot, *Correspondence,* pp. 73, 74, 81, 82.

7. Morisot, *Correspondence,* p. 82; Mme. Morisot, in Brombert, *Edouard Manet,* p. 259; Morisot, *Correspondence,* pp. 89, 84, 185.

8. Bataille, *Manet,* p. 109; Richardson, *Manet,* p. 17; Baudelaire, *Flowers of Evil,* ed. Matthews, p. 41.

9. Franz Kafka, "The Metamorphosis," *Selected Short Stories,* trans. Willa and Edwin Muir (New York: Modern Library, 1952),

pp. 59–60; Morisot, *Correspondence,* p. 36; Morisot, in Cachin, *Manet,* p. 315.

10. Duret, *Manet and the French Impressionists,* p. 74; Farwell, in Edelstein, ed., *Perspectives on Berthe Morisot,* p. 55; Cachin, *Manet,* p. 317.

11. Cachin, *Manet,* p. 336; Valéry, *Degas, Manet, Morisot,* pp. 112–113; Julie Manet, *Journal,* pp. 74–75; Ann Dumas, *The Private Collection of Edgar Degas* (New York: Metropolitan Museum of Art, 1997), p. 45.

12. Moore, in Friedrich, *Olympia,* p. 85; Shennan, *Berthe Morisot,* p. 137; Duret, *Manet and the French Impressionists,* p. 184.

Nine: Making Concessions

1. Morisot, *Correspondence,* p. 93; Henri de Régnier, in Higonnet, *Berthe Morisot,* p. 115; Morisot, *Correspondence,* pp. 76, 90, 96.

2. Duret, *Manet and the French Impressionists,* pp. 186–187; Régnier, in Morisot, *Correspondence,* p. 229; Jean Renoir, *Renoir: My Father,* p. 301.

3. Morisot, *Correspondence,* pp. 104, 105, 109, 122; Shennan, *Berthe Morisot,* p. 270.

4. Morisot, *Correspondence,* p. 118; Julie Manet, *Journal,* p. 71; Morisot, *Correspondence,* p. 124.

5. Régnier, in Higonnet, *Berthe Morisot,* p. 188; Jean Renoir, *Renoir: My Father,* p. 253; Julie Manet, *Journal,* p. 122.

6. Morisot, *Correspondence,* pp. 131, 132, 133.

7. Morisot, *Correspondence,* pp. 135, 138; Morisot, in Wilson-Bareau, *Manet and the Sea,* p. 231.

8. Morisot, in Higonnet, *Berthe Morisot,* p. 181; Morisot, *Correspondence,* p. 189.

9. Morisot, *Correspondence,* p. 210; Julie Manet, *Journal,* p. 52; Morisot, *Correspondence,* p. 212.

10. Proust, *Remembrance of Things Past,* 2: 750; Julie Manet, *Journal,* p. 53; Pissarro, *Letters,* pp. 110, 262.

11. Roy McMullen, *Degas: His Life, Times, and Work* (London, 1985), p. 428; Nancy Mathews, "Documenting Berthe Morisot," *Woman's Art Journal,* 10 (Spring-Summer 1989), 46; Julie Manet, *Journal,* pp. 202, 208.

EDGAR DEGAS

Ten: Great Draftsman

1. Valéry, *Degas, Manet, Morisot,* pp. 26–27; McMullen, *Degas,* p. 20; Halévy, *My Friend Degas,* p. 34.

2. McMullen, *Degas,* pp. 20, 23; Alex de Jonge, *Baudelaire: Prince of Clouds* (New York, 1976), p. 21.

3. F. W. J. Hemmings, *Baudelaire the Damned* (New York, 1982), p. 24; de Jonge, *Baudelaire,* p. 21; Valéry, *Degas Manet Morisot,* p. 22; Pichois, *Baudelaire,* p. 40; Joseph Czestochowski and Anne Pinget, eds., *Degas Sculptures: Catalogue Raisonné of the Bronzes* (Memphis: International Arts, 2002), p. 109.

4. McMullen, *Degas,* p. 34; Edgar Degas, "More Unpublished Letters of Degas," ed. Theodore Reff, *Art Bulletin,* 51 (September 1969), 285; Halévy, *My Friend Degas,* p. 50; Valéry, *Degas Manet Morisot,* pp. 35, 34; Jeanne Fevre, *Mon Oncle Degas,* ed. P. Borel (Genève, 1949), p. 70.

5. Marjorie Cohn, in Patricia Condon, ed., *The Pursuit of Perfection: The Art of J.-A.-D. Ingres* (Louisville, Ky.: Speed Art Museum, 1983), pp. 11, 24–25; Jakob Rosenberg, "Degas," *Great Draughtsmen from Pisanello to Picasso* (New York, 1974), p. 143.

6. Jean-Jacques Rousseau, *Confessions,* trans. J. M. Cohen (1781; Baltimore: Penguin, 1978), pp. 591–592; Auguste De Gas, in Jean Sutherland Boggs, ed., *Degas* (New York: Metropolitan Museum of Art, 1988), p. 43; Auguste De Gas, in Ian Dunlop, *Degas* (New York, 1979), p. 39.

7. Auguste De Gas, in Boggs, *Degas,* pp. 54, 55; McMullen, *Degas,* p. 74.

8. Montesquiou, in Pierre-Louis Mathieu, *Gustave Moreau,* trans. Tamara Blondel (New York, 1995), p. 67. See Jeffrey Meyers, "Gustave Moreau and *Against Nature,*" In *Painting and the Novel* (Manchester, 1975), pp. 84–95; Edgar Degas, "Notebook 22," p. 5, *Notebooks,* ed. Theodore Reff (Oxford, 1976); André Gide, *Journals,* trans. Justin O'Brien (New York, 1947–51), 1: 106.

9. R. H. Ives Gammell, *The Shop Talk of Edgar Degas* (Boston, 1961), p. 28; George Moore, "Degas," *Impressions and Opinions* (London, 1913), p. 229; Clark, *The Nude,* p. 292.

10. Henri Loyrette, in Boggs, *Degas,* p. 105; McMullen, *Degas,* p. 85.

11. Robert Gordon and Andrew Forge, *Degas* (New York, 1988), p. 43; Denys Sutton, *Edgar Degas: Life and Work* (New York, 1986), p. 55.

 See also Hélène Adhemar, "Edgar Degas et 'La Scène de guerre au moyen âge,'" *Gazette des Beaux-Arts,* 70 (novembre 1967), 295–298; Loyrette, in Boggs, *Degas,* p. 45; Christopher Benfey, *Degas in New Orleans* (Berkeley, 1997), p. 61.

 For the courteous and chivalric treatment by the Union troops, see Charles Dufour, *The Night the War Was Lost* (Garden City, N.Y., 1960), and Chester Hearn, *The Capture of New Orleans, 1862* (Baton Rouge, 1995).

12. For Joan's reputation and cult, see Marina Warner, *Joan of Arc: The Image of Female Heroism* (London, 1981). Jules Michelet, *History of France,* trans. G. H. Smith (New York, 1847), 2: 127; Loyrette, in Boggs, *Degas,* p. 107.

Eleven: Tender Cruelty

1. Paul Lafond, in Rewald, *History of Impressionism,* p. 170; Georges Rivière, in McMullen, *Degas,* p. 299; Joseph-Gabriel Tournay, in Boggs, *Degas,* p. 50; Walter Sickert, "Degas," *Burlington Magazine,* 31 (November 1917), p. 184; Durand-Ruel, in Jean Bouret, *Degas,* trans. Daphne Woodward (London, 1965), p. 239.

2. Degas, *Letters,* p. 6; Degas, "More Unpublished Letters," p. 288;

Paul-André Lemoisne, in Charles Bernheimer, *Figures of Ill Repute: Representing Prostitution in Nineteenth-Century France* (Cambridge, Mass., 1989), p. 304; Degas, "Notebook 30," p. 20.

3. Halévy, *My Friend Degas,* p. 48; Bouret, *Degas,* p. 94; Degas, in *Cassatt and Her Circle: Selected Letters,* ed. Nancy Mathews (New York, 1984), p. 293.

4. Degas, in Morisot, *Correspondence,* p. 188; Sickert, "Degas," p. 186; Degas in Nancy Mathews, *Mary Cassatt* (New York, 1987), p. 66; Halévy, *My Friend Degas,* p. 27; Gammell, *Shop-Talk of Degas,* p. 18.

5. Sickert, "Degas," p. 185; Pissarro, in McMullen, *Degas,* p. 332.

6. Reff, *Notebooks,* p. 31; Halévy, *My Friend Degas,* p. 110; Degas, "Notebook 6," p. 21; Tissot, in Boggs, *Degas,* p. 54.

7. Degas, *Letters,* p. 186; Julie Manet, *Journal,* p. 124; Royal Cortissoz, "Degas as He Was Seen by His Model," *New York Tribune,* October 19, 1919, IV: 9; Ambroise Vollard, *Degas: An Intimate Portrait,* trans. Randolph Weaver (1937; New York: Dover, 1986), p. 30.

8. Model, in Friedrich, *Olympia,* p. 183; Georges Jeanniot, in McMullen, *Degas,* p. 267; Valadon, in Sutton, *Edgar Degas,* p. 294; Halévy, *My Friend Degas,* p. 121.

9. Robert Herbert, "Degas and Women," *New York Review of Books,* 43 (April 18, 1996); Model, in McMullen, *Degas,* p. 462; Edmond and Jules Goncourt, *Pages from the Goncourt Journal,* trans., ed. and intro. Robert Baldick (1962; Oxford, 1978), p. 264.

10. Dunlop, *Degas,* p. 141; Vincent Van Gogh, *Letters,* trans. Arnold Pomerans, ed. Ronald de Leeuw (London: Penguin, 1997), pp. 388–389.

11. Degas, "Notebook 11," pp. 94–95; Degas, *Letters,* p. 26; Halévy, *My Friend Degas,* p. 96; Vollard, *Degas,* p. 64; Bouret, *Degas,* p. 66.

12. Lethève, *Daily Life of French Artists,* p. 185; Flaubert, in Friedrich, *Olympia,* p. 93; Henry James, "The Lesson of the Master," *Stories of*

Artists and Writers, ed. F. O. Matthiessen (New York, [1965]), p. 138.

13. Degas, "Notebook 6," p. 83; Daniel Catton Rich, *Degas* (New York, 1985), p. 52.

14. Laura Bellelli, in Boggs, *Degas,* pp. 81–82; *Dizionario Biografico Degli Italiani* (Roma: Enciclopedia Italiana, 1965), 7: 628–629; Degas, "Notebook 30," p. 208.

15. Mauclair, in Quentin Bell, *Degas: "Le Viol"* (Newcastle-upon-Tyne, 1965), p. [4]; Gordon and Forge, *Degas,* p. 118.

 Interior: The Rape influenced Van Gogh's *Vincent's Bedroom at Arles* (1889). Though there are no people in Van Gogh's picture, the composition is essentially the same: the door, bed with curved footboard, and picture on the wall, on the right; a window instead of a mirror and table instead of a dresser in the center background; a chair on the lower left; and especially the sharply angled and incised floorboards. Degas' picture also influenced Alex Colville's *Dressing Room* (2002). See Tom Smart, *Alex Colville: Return* (Vancouver, 2003), p. 129.

Twelve: Touch of Ugliness

1. Riccardo Raimundi, *Degas e la sua famiglia in Napoli, 1793–1917* (Napoli, 1958), p. 253; Morisot, *Correspondence,* p. 56; Michael Wentworth, *James Tissot* (Oxford, 1984), p. 80.

2. Morisot, *Correspondence,* p. 73; Degas, *Letters,* pp. 12, 25.

3. René Degas, in Boggs, *Degas,* p. 59; Degas, *Letters,* pp. 17, 13–14.

4. Degas, *Letters,* pp. 18, 27, 21; Christina Vella, in Gail Feigenbaum, ed., *Degas and New Orleans: A French Impressionist in America* (New Orleans: Museum of Art, 1999), p. 41.

5. Halévy, *My Friend Degas,* p. 53; Degas, *Letters,* p. 26; Vella, in Feigenbaum, *Degas and New Orleans,* p. 44; Eugène Musson, in Boggs, *Degas,* p. 212.

6. McMullen, *Degas,* p. 244; Degas, "Notebook 11," p. 65; Degas, *Letters,* p. 84; Bouret, *Degas,* p. 173.

7. Vollard, *Degas,* p. 56; Sickert, *Free House,* p. 192; Degas, *Letters,* p. 226.

8. Degas, "Notebook 18," p. 161; Henry Fielding, *The History of Tom Jones,* ed. R. P. C. Mutter (1749; London: Penguin, 1966), pp. 543; 813. Degas would have read *Histoire de Tom Jones, ou l'enfant trouvé,* trans. par M. de la Place (Amsterdam, 1778).

9. Jean-Jacques Henner, in Boggs, *Degas,* p. 80; Pierre-Joseph Proudhon, in Holt, *Classicists to Impressionists,* p. 436; Vollard, *Degas,* p. 46; Degas, *Letters,* p. 39.

10. Cézanne, in Adler, *Manet,* p. 98; Caillebotte, in Rewald, *History of Impressionism,* p. 348; Gauguin, in Boggs, *Degas,* p. 381; Pissarro, in Frederick Sweet, *Miss Mary Cassatt: Impressionist from Pennsylvania* (Norman, Okla., 1966), p. 100.

11. Caillebotte, in Sutton, *Degas,* p. 107; Pissarro, *Letters,* pp. 31, 319-320.

Thirteen: Horses, Dancers, Bathers, Whores

1. Reff, *Manet and Modern Paris,* p. 144; Degas, *Letters,* p. 117; Vollard, *Recollections,* p. 29.

2. Ludovic Halévy, in Czestochowski, *Degas Sculptures,* p. 104; George Shackelford, *Degas: The Dancers* (Washington, D.C.: National Gallery, 1984), p. 52; Jill DeVonyar and Richard Kendall, *Degas and the Dance* (New York, 2002), p. 120.

3. Ludovic Halévy and Huysmans, in Herbert, *Impressionism,* pp. 115, 129; Huysmans, in Gordon, *Degas,* p. 207; Shackelford, *Degas: The Dancers,* p. 14.

4. Ludovic Halévy, in Eunice Lipton, *Looking into Degas: Uneasy Images of Women and Modern Life* (Berkeley, 1986), pp. 82, 79; Ludovic Halévy, in Shackelford, *Degas: The Dancers,* p. 31; Halévy, *My Friend Degas,* p. 109; Gustave Coquiot, in Richard Brettell and Suzanne

McCullagh, *Degas in the Art Institute of Chicago* (New York, 1984), p. 147.

5. Degas, *Letters,* pp. 66, 111; Suzanne Mante, in Lillian Browse, *Degas Dancers* (London, 1949), p. 60; Bouret, *Degas,* p. 75.

6. Edmond de Goncourt, in Julius Meier-Graefe, *Degas,* trans. J. Holroyd Reece (1923; New York: Dover, 1988), p. 67; Sir John Davies, *Orchestra,* in *Poetry of the English Renaissance,* ed. William Hebel and Hoyt Hudson (1929; New York: Appleton-Century-Crofts, 1957), p. 350. For the caricature, see De Vonyer, *Degas and the Dance,* p. 15; Czestochowski, *Degas Sculptures,* p. 103.

7. Jules Claretie, in Gordon, *Degas,* p. 183; Ingres, in DeVonyer, *Degas and the Dance,* p. 90; Bouret, *Degas,* p. 126.

8. Paul Lafond, in Bouret, *Degas,* pp. 84, 86; Huysmans, in Alfred Werner, *Degas Pastels* (1969; New York, 1977), p. 34; Huysmans, in Gordon, *Degas,* p. 161; Rilke, in Lillian Schacherl, *Edgar Degas: Dancers and Nudes* (New York, 1997), p. 30; Gauguin, *Intimate Journals,* p. 133.

9. George Orwell, *Down and Out in Paris and London* (1933; New York: Berkeley, 1959), pp. 5–6; Degas, *Letters,* p. 242; Valéry, *Degas Manet Morisot,* p. 23; Halévy, *My Friend Degas,* pp. 52, 32, 48.

10. Goncourts, *Journal,* p. 206; Degas, in Fevre, *Mon Oncle Degas,* p. 52; Vollard, *Degas,* p. 48.

11. Degas, in Vollard, *Recollections,* p. 179; Moore, *Impressions and Opinions,* p. 232; Sickert, "Degas," p. 185.

12. J.-K. Huysmans, "Degas," in *Downstream,* trans. Samuel Putnam (New York, 1975), pp. 276–278, 281.

13. Aldous Huxley, *Complete Essays. Volume III, 1930–1935,* ed. Robert Baker and James Sexton (Chicago, 2001), p. 87, and Huxley, in Sutton, *Edgar Degas,* p. 13; Edgar Snow, *A Study of Vermeer* (Berkeley, Calif., 1979), pp. 26, 30, 32.

14. Van Gogh, in McMullen, *Degas,* p. 397; Renoir, in Vollard, *Recollections,* p. 258.

Fourteen: Bankrupt

1. Marilyn Brown, *Degas and the Business of Art: A Cotton Office in New Orleans* (University Park, Penna., 1994), pp. 59, 13; Marco De Gregorio, in Boggs, *Degas,* p. 213; Degas, in Brown, *Degas and the Business of Art,* pp. 83, 60.

2. McMullen, *Degas,* p. 260; Halévy, *My Friend Degas,* pp. 22–23; Berthe Morisot, *Correspondence,* pp. 106, 110.

3. Edmondo Morbilli, in Boggs, *Degas,* p. 376.

4. Valéry, *Degas Manet Morisot,* p. 21; Vollard, *Recollections,* pp. 31, 91; Degas, in Malcolm Daniel, *Edgar Degas, Photographer* (New York, 1998), p. 65.

5. Degas, in Jean Renoir, *Renoir, My Father,* p. 264; Daniel, *Edgar Degas, Photographer,* p. 47; Jennifer Gross, ed., *Edgar Degas: Defining the Modernist Edge* (New Haven, 2003), p. 21; Marcellin Desboutin, in Sutton, *Edgar Degas,* p. 124.

6. André Fermigier, *Toulouse-Lautrec,* trans. Paul Stevenson (New York, 1969), p. 80; Paul Lafond, in Bouret, *Degas,* p. 96; Degas, in Melissa McQuillan, *Impressionist Portraits* (London, 1986), p. 142.

7. Duranty and Huysmans, in Boggs, *Degas,* pp. 309, 310.

8. Rich, *Degas,* p. 14; Degas, *Letters,* pp. 60–61.

9. McMullen, *Degas,* p. 246; Meyer Schapiro, *Impressionism: Reflections and Perceptions* (New York, 1997), pp. 78, 136; Vollard, *Degas,* p. 62.

10. Degas, *Letters,* p. 265; Valéry, *Degas Manet Morisot,* p. 92.

Fifteen: Degas and Manet

1. McMullen, *Degas,* p. 98; Jacques-Emile Blanche, *Manet* (Paris, 1924), pp. 55–56; Felix Baumann and Marianne Karabelnik, *Degas: Portraits* (London, 1995), p. 261; McMullen, *Degas,* p. 156.

2. Degas, *Letters,* p.19; Moore, *Modern Painting,* p. 33; Daniel, *Degas, Photographer,* p. 71; Halévy, *My Friend Degas,* p. 119.

3. Cachin, *Manet,* p. 17; Pierre Cabanne, *Degas,* trans. Michel Lee Landa (New York, 1958), p. 34; William Rothenstein, *Men and Memories* (New York, 1931), p. 103; McMullen, *Degas,* p. 290.

4. Robert Hughes, *Nothing If Not Critical* (New York: Penguin, 1992), p. 93; Manet, in Dunlop, *Degas,* p. 54; Degas, in Moore, *Impressions and Opinions,* p. 229; Valéry, *Degas Manet Morisot,* p. 83; Renoir, in Gimpel, *Diary of an Art Dealer,* p.16.

5. Vollard, *Degas,* pp. 72–73; Vollard, *Recollections,* p. 56; Vollard, *Degas,* p. 73. Manet's early *Plums* has been lost. A later version (1880) is in the Houston Museum of Fine Arts.

6. Moore, *Confessions of a Young Man,* p. 110; Halévy, *My Friend Degas,* p. 92; Boggs, in *Degas,* p. 561.

7. *Manet by Himself,* p. 246; See Boggs, *Degas,* p. 209, for his criminal types. Hemingway, "A Clean, Well-Lighted Place," *Stories,* p. 382.

8. *Manet by Himself,* pp. 47, 49.

9. Degas, in Robert Brettel, *Impression: Painting Quickly in France, 1860–1890* (New Haven, Conn., 2000), p. 203; Manet, in Morisot, *Correspondence,* p. 40; *Manet by Himself,* pp. 162, 185.

10. Degas, in Moore, *Impressions and Opinions,* p. 226; Degas, *Letters,* pp. 11, 38–39.

11. Halévy, *My Friend Degas,* p. 121; Degas, *Letters,* p. 65; Halevy, *My Friend Degas,* p. 90.

Sixteen: Wounded Heart

1. Walter Sickert, in Degas, *Letters,* pp. 259, 34; Diego Martelli, in Baumann, *Degas: Portraits,* p. 48.

2. Degas, *Letters,* p. 96; Thiebault, in Czestochowski, *Degas Sculptures,* p. 277; Vollard, *Degas,* p. 89; Cabanne, *Degas,* p. 6.

3. Degas, in Havemeyer, *Sixteen to Sixty,* p. 265; Degas, *Letters,* p. 172; Halévy, in Degas, *Letters,* p. 253.

For an excellent discussion of Degas' eyesight, see Richard Kendall, "Degas and the Contingency of Vision," *Burlington Magazine,* 130 (March 1988), 180–197.

Degas' eye problems were similar to those of James Joyce. Joyce had poor eyesight since childhood, but after 1917 he became what he called an "international eyesore." He suffered acutely from iritis, glaucoma and cataracts, and endured eleven costly and painful operations.

4. Goncourts, *Journal,* p. 206; Halévy, *My Friend Degas,* p. 69; Albert Bartholomé, in Boggs, *Degas,* p. 491.

5. Halévy, *My Friend Degas,* p. 95; Degas, in Vollard, *Recollections,* p. 271. See Dumas, *Private Collection of Degas.*

6. Rothenstein, *Men and Memories,* p. 103; Gauguin, *Intimate Journals,* pp. 131, 133; Vollard, *Degas,* pp. 22, 35.

7. Valéry, *Degas Manet Morisot,* pp. 88, 7, 10–12, 19; Odilon Redon, in McMullen, *Degas,* p. 390.

8. Alain Silvera, *Daniel Halévy and His Times: A Gentleman-Commoner in the Third Republic* (Ithaca, N.Y., 1966), p. 38; Degas, *Letters,* pp. 80–81.

9. Degas, *Letters,* pp. 36, 99, 116; Degas, in Boggs, *Degas,* p. 380; Degas, *Letters,* pp. 171–172.

10. Julie Manet, *Journal,* p. 71; Degas, *Letters,* pp. 106, 218; Henri de Toulouse-Lautrec, *Unpublished Correspondence,* ed. Lucien Goldschmidt and Herbert Schimmel, trans. Edward Garside (London, 1969), p. 133; Degas, in Gerstle Mack, *Toulouse-Lautrec* (1938; New York, 1989), p. 308.

11. Gauguin, *Intimate Journals,* pp. 132, 134; and Gauguin, in Bouret, *Degas,* p. 224; McMullen, *Degas,* p. 460.

12. Morisot, *Correspondence,* p. 165; Valéry, *Degas Manet Morisot,* p. 62; Degas, *Letters,* p. 88.

13. Wallace Fowlie, "Mallarmé and the Painters of His Age," *Southern Review,* 2 (1966), 546:

 Muse qui le distinguas
 Si tu savais calmer l'ire
 De mon confrère Degas,
 Tends lui ce discours à lire.

14. Thiébault, in Czestochowski, *Degas Sculptures,* pp. 277–278; Degas, in Linda Nochlin, ed., *Impressionism and Post-Impressionism, 1874–1904: Sources and Documents* (Englewood Cliffs, N.J., 1966), p. 68; Rich, *Degas,* p. 106.

15. Gordon, *Degas,* pp. 192, 201, 204.

16. Rossetti, in Dunlop, *Degas,* p. 97; E. V. Lucas, *The Colvins and Their Friends* (New York, 1928), pp. 20–21.

17. Degas, in Philippa Pullar, *Frank Harris: A Biography* (New York, 1976), p. 142; Rothenstein, *Men and Memories,* p. 101–102; Whistler, in Boggs, *Degas,* p. 486; Halévy, *My Friend Degas,* p. 59.

18. Moore, *Impressions and Opinions,* pp. 221, 232; Sickert, *Free House,* p. 44; Degas, in Richard Ellmann, *Oscar Wilde* (New York, 1988), p. 430; Oscar Wilde, *Complete Letters,* ed. Merlin Holland and Rupert Hart-Davis (New York, 2000), p. 585.

Seventeen: Solitary Prospero

1. Degas, *Letters,* p. 140; Degas, in Gabriella Belli, ed., *Boldini, De Nittis, Zandomeneghi: Mondanità e costume nella Parigi fin de siècle* (Milano, 2001), p. 41; Degas, *Letters,* pp. 155, 159, 167; Jeanniot, in Sutton, *Edgar Degas,* p. 295.

2. Thiébault, in *Degas Sculptures,* p. 277; Hippolyte Taine, "The Novel—Dickens," *History of English Literature,* trans. H. Van Laun (1863; New York, 1873), volume 4, book 5, chapter 1, pp. 118–119; Vollard, *Degas,* p. 56.

3. Rewald, in *Degas Sculptures,* p. 278; Dumas, in *Degas Sculptures,* p. 42; Paul Mantz, in Bouret, *Degas,* p. 150; Huysmans, in Millard, *Sculpture of Degas,* p. 28, and in Shackelford, *Degas: The Dancers,* pp. 66–67.

4. Degas, in *Degas Sculptures,* p. 80; Vollard, *Recollections,* p. 251; Vollard, *Degas,* p. 89.

5 Giorgio Vasari, *The Lives of Painters, Sculptors and Architects,* trans. A. B. Hinds, ed. William Gaunt, revised edition (London: Everyman, 1963), 2: 157–158; Thiébault, in *Degas Sculptures,* p. 278.

6. Maurice Barrès, in McMullen, *Degas,* p. 437; Valéry, *Degas Manet Morisot,* p. 52; Degas, *Letters,* p. 211; Renoir, in Lionello Venturi, *Les Archives de l'impressionisme* (Paris, 1939), 1: 122; Degas, *Letters,* p. 217.

7. Vollard, *Degas,* p. 21; Degas, in Gimpel, *Diary of an Art Dealer,* p. 89; Silvera, *Daniel Halévy and His Times,* p. 92; Boggs, *Degas,* p. 493.

8. Halévy, *My Friend Degas,* p. 102; Vollard, *Degas,* pp. 63, 64; Degas, *Letters,* p. 99; Boggs, *Degas,* p. 216.

9. Rich, *Degas,* p. 30; Paul Lafond, in *Degas Sculptures,* p. 279; Halévy, *My Friend Degas,* pp. 103, 115.

10. Vollard, *Recollections,* p. 271; Charles Baudelaire, *The Painter of Modern Life,* ed. and trans., Jonathan Mayne (New York, 1965), p. 9.

11. Degas, in Julie Manet, *Journal,* p. 74; René Degas and Paul Paulin, in Boggs, *Degas,* pp. 497–498; Cassatt, *Letters,* p. 328.

12. Bernard Berenson, *Italian Painters of the Renaissance* (Oxford, 1930), p. 58; S. N. Behrman, *Portrait of Max* (New York, 1960), p. 133.

MARY CASSATT

Eighteen: American Aristocrat

1. Havemeyer, *Sixteen to Sixty,* p. 272; Aleck Cassatt, in Nancy Mathews, *Mary Cassatt: A Life* (1994; New Haven, Conn., 1998), p. 24; E. John Bullard, *Mary Cassatt: Oils and Pastels* (New York, 1972), p. 12; Robert Cassatt, in Mathews, *Cassatt: Life,* p. 26.

2. Eliza Haldeman, in Mathews, *Cassatt: Life,* p. 53; Cassatt, *Letters,* pp. 74–75.

3. Somerset Maugham, *Andalusia: Sketches and Impressions* (1905; New York, 1924), p. 58; Cassatt, *Letters,* pp. 114–115; Mathews, *Cassatt: Retrospective,* p. 232.

4. Emily Sartain, in Mathews, *Cassatt: Life,* p. 99; Sweet, *Miss Mary Cassatt,* pp. 195, 199, 56; Mathews, *Cassatt: Life,* p. 315.

5. Cassatt, *Letters,* p. 297; Mathews, *Mary Cassatt* (1987), p. 37; Gustave Goetschy, in Mathews, *Cassatt: Life,* p. 134.

6. Vollard, *Recollections,* p. 181; Jean Renoir, *Renoir: My Father,* p. 254; Cassatt, *Letters,* p. 270.

7. Maxime du Camp, in DeVonyer, *Degas and the Dance,* p. 95.

8. Judith Barter, *Mary Cassatt: Modern Woman* (New York, 1998), p. 62; Cassatt, *Letters,* p. 131.

9. Havemeyer, *Sixteen to Sixty,* p. 217; Stéphane Mallarmé, "Berthe Morisot," *Divagations* (1897; Paris, 1961), pp. 114–115; Shennan, *Berthe Morisot,* pp. 240, xviii.

10. Cassatt, *Letters,* p. 149; Morisot, *Correspondence,* p. 127; Cassatt, *Letters,* pp. 214, 262.

11. Moore, in Mathews, *Cassatt: Retrospective,* p. 105; Stuckey, *Berthe Morisot,* p. 88; Phoebe Pool, *Impressionism* (New York, 1967), p. 150; Gauguin, in Bullard, *Mary Cassatt,* p. 15.

12. Degas, in Barter, *Mary Cassatt: Modern Woman,* p. 132.

Nineteen: Cassatt and Degas

1. Cassatt, in Adelyn Breeskin, *Mary Cassatt: A Catalogue Raisonné of the Oils, Pastels, Watercolors, and Drawings* (Washington, D.C., 1970), p. 91, and Cassatt, *Letters,* p. 321; Cassatt, in DeVonyer, *Degas and the Dance,* p. 119; Cassatt, *Letters,* p. 240.

2. Cassatt, in Havemeyer, *Sixteen to Sixty,* p. 245; Degas, in Sweet, *Miss Mary Cassatt,* p. 33; McMullen, *Degas,* pp. 291, 293.

3. Nord, *Impressionists and Politics,* pp. 48, 99; Biddle, in *Cassatt: Retro-spective,* p. 339; Cassatt, *Letters,* p. 252; Cassatt, in *Cassatt: Modern Woman,* p. 347.

4. Cassatt, in Mathews, *Cassatt: Life,* p. 313; Degas, in Cassatt, *Letters,* p. 126n; Degas, *Letters,* p. 63; McMullen, *Degas,* p. 267.

5. Degas, *Letters,* p. 144; Cassatt, *Letters,* p. 335; Degas, in Havemeyer, *Sixteen to Sixty,* p. 244; Vollard, *Degas,* p. 48.

6. Degas, *Letters,* pp. 144–145; Biddle, in *Cassatt: Retrospective,* p. 338; Degas, in *Cassatt: Modern Woman,* p. 131.

7. Katherine Cassatt, in Cassatt, *Letters,* p. 151; *Cassatt: Retrospective,* p. 101; Bullard, *Mary Cassatt,* p. 24.

8. Cassatt, in Boggs, *Degas,* p. 561; Cassatt, *Letters,* pp. 162, 238; Cassatt, in Havemeyer, *Sixteen to Sixty,* p. 288, and in Breeskin, *Cassatt: Catalogue Raisonné,* p. 10.

9. Mathews, *Cassatt: Life,* p. 211; Cassatt, in Havemeyer, *Sixteen to Sixty,* p. 243, and in Breeskin, *Cassatt: Catalogue Raisonné,* p. 10; Cassatt, *Letters,* p. 240.

10. Cassatt, in Havemeyer, *Sixteen to Sixty,* p. 258; Edith Wharton, *The House of Life,* ed. Jeffrey Meyers (New York: Barnes and Noble Classics, 2003), p. 312; Duranty, in Baumann, *Degas: Portraits,* p. 112.

11. Sickert, *Free House,* p. 150; Maximilian Gauthier, *The Louvre: Sculpture, Ceramics, Objets d'Art,* trans. Kenneth Leake (London, 1962), p. 99; D. H. Lawrence, *Etruscan Places* (1932), in *D. H. Lawrence and Italy* (New York, 1972), pp. 29, 40; Cassatt, in Boggs, *Degas,* p. 442.

12. Rewald, *History of Impressionism,* p. 377; Cabanne, *Degas,* p. 7; Forbes Watson, *Mary Cassatt* (New York, 1932), p. 14; Katherine Cassatt, in Mathews, *Cassatt: Life,* p. 200.

13. Lois Cassatt, in *Cassatt: Modern Woman,* p. 76; Cassatt, *Letters,* p. 309; George Biddle, in *Cassatt: Retrospective,* p. 341; Jaccaci, in Gimpel, *Diary of an Art Dealer,* pp. 130–131.

14. Paul Johnson, "Is It Getting Cold in That Bath, Madame Bonnard?,"

Spectator, 280 (March 14, 1998), 26; Cabanne, *Degas,* p. 77; Bouret, *Degas,* pp. 250, 112.

15. Mathews, *Cassatt: Life,* p. 149; Degas, in Nancy Hale, *Mary Cassatt: A Biography of the Great American Painter* (Garden City, N.Y., 1975), pp. 85–86; Sweet, *Miss Mary Cassatt,* pp. 182, 146.

16. George Biddle, in *Cassatt: Retrospective,* p. 340; Sweet, *Miss Mary Cassatt,* p. 182; Biddle, in *Cassatt: Retrospective,* p. 340.

17. Cassatt, in Boggs, *Degas,* p. 497; Cassatt, in Havemeyer, *Sixteen to Sixty,* p. 249; Cassatt, *Letters,* p. 328.

Twenty: Peppery Lady

1. Gimpel, *Diary of an Art Dealer,* p. 9; Mathews, *Mary Cassatt,* (1987), p. 123; Huysmans, in Sweet, *Miss Mary Cassatt,* pp. 43, 51; Huysmans, in Denvir, *Impressionists at First Hand,* p. 131.

2. Gerald Needham, "Japonisme: Japanese Influence on French Painting," in White, *Impressionism in Perspective,* pp. 125, 129; Cassatt, *Letters,* p. 221.

3. Christopher Isherwood, *Goodbye to Berlin* (1939), in *The Berlin Stories* (New York, 1954), p. 1; Pissarro, in Ralph Shikes and Paula Harper, *Pissarro: His Life and Work* (New York, 1980), pp. 256, 258.

4. Cassatt, in Gimpel, *Diary of an Art Dealer,* p. 11; Cassatt, in Havemeyer, *Sixteen to Sixty,* p. 283; Cassatt, *Letters,* p. 313.

5. Cassatt, *Letters,* p. 157; Mathews, *Cassatt: Life,* p. 162; Cassatt, *Letters,* p. 262.

6. Degas, *Letters,* p. 125; Cassatt, *Letters,* p. 215; Pissarro, *Letters to His Son,* pp. 158, 164–165.

7. Cassatt, *Letters,* p. 286; Watson, *Mary Cassatt,* p. 9; Cassatt, in Havemeyer, *From Sixteen to Sixty,* p. 97.

8. Cassatt, *Letters,* p. 274; Mathews, *Cassatt: Life,* p. 289; *Cassatt: Modern Woman,* pp. 348, 349.

9. Cassatt, in Gimpel, *Diary of an Art Dealer,* p. 145; Anna Burr, *The*

Portrait of a Banker: James Stillman, 1850–1918 (New York, 1927), p. 296; Bullard, *Mary Cassatt*, p. 19; Mathews, *Cassatt: Life*, pp. 295, 296, 298.

10. Alan Philbrick, in Sweet, *Miss Mary Cassatt*, p. 170; Charles Loeser, in *Cassatt: Modern Woman*, p. 347; Watson, *Mary Cassatt*, pp. 8, 7; Biddle, in *Cassatt: Retrospective*, pp. 338, 340, 341.

11. Mathews, *Cassatt: Life*, pp. 279, 308; Cassatt, in Gimpel, *Diary of an Art Dealer*, p. 11; Sweet, *Miss Mary Cassatt*, p. 196; Henry James, "The Impressionists," in *The Painter's Eye*, ed. and intro. John Sweeney (London, 1956), pp. 114–115.

12. Iris Origo, Kenneth Clark and R.W. B. Lewis, in Wharton, *The House of Mirth*, pp. xiv, xvi; Mathews, *Cassatt: Life*, p. 273.

13. Cassatt, in Millicent Dillon, *After Egypt: Isadora Duncan and Mary Cassatt* (New York, 1990), p. 39; Cassatt, *Letters*, p. 311, n2; James Mellow, *Charmed Circle: Gertrude Stein & Company* (New York: Avon, 1975), pp. 25–26; Cassatt, *Letters*, p. 310.

14. Leon Edel, *Henry James: The Middle Years, 1882–1895* (Philadelphia, 1962), pp. 115, 333; Vernon Lee, in Sweet, *Miss Mary Cassatt*, p. 144; Mathews, *Cassatt: Life*, p. 273.

15. Dikran Kelekian, in Breeskin, *Cassatt: Catalogue Raisonné*, p. 19; Cassatt, *Letters*, p. 329; Gimpel, *Diary of an Art Dealer*, p. 9; Biddle, in *Cassatt: Retrospective*, p. 320.

16. Cassatt, *Letters*, pp. 336, 337, 339; Manet, in McMullen, *Degas*, p. 290; Cachin, *Manet*, p. 13.

Ayrton, Michael. "The Grand Academic" [Degas]. In *The Rudiments of Paradise*. London: Secker & Warburg, 1971. Pp. 182–194.

Barter, Judith, ed. *Mary Cassatt: Modern Woman*. Chicago: Art Institute, 1998.

Biddle, George. "Some Memories of Mary Cassatt," *The Arts*, 10 (August 1926), 107–111.

Boggs, Jean Sutherland, ed. *Degas*. New York: Metropolitan Museum of Art, 1988.

Bouret, Jean. *Degas*. Trans. Daphne Woodward. London: Thames & Hudson, 1965.

Brombert, Beth. *Edouard Manet: Rebel in a Frock Coat*. Boston: Little, Brown, 1996.

Broude, Norma. "Degas' 'Misogyny,'" *Art Bulletin*, 59 (March 1977), 95–107.

Bullard, E. John. *Mary Cassatt: Oils and Pastels*. New York: Watson-Guptill, 1972.

Cabanne, Pierre. *Edgar Degas*. Trans. Michel Lee Landa. New York: Universe, 1958.

Cachin, Françoise, ed. *Manet, 1832–1883*. New York: Metropolitan Museum of Art, 1983.

Cassatt, Mary. *Cassatt and Her Circle: Selected Letters*. Ed. Nancy Mathews. New York: Abbeville, 1984.

Champa, Kermit, ed. *Edouard Manet and "The Execution of Maximilian."* Providence, R.I.: List Art Center, 1981.

Clark, Kenneth. "Degas." In *The Romantic Rebellion*. London: John Murray, 1973. Pp. 308–329.

Collins, Bradford, ed. *Twelve Views of Manet's "Bar."* Princeton: Princeton University Press, 1996.

Cortissoz, Royal. "Degas as He Was Seen by His Model," *New York Tribune,* October 19, 1919, IV.9.

Courthion, Pierre, and Pierre Cailler, eds. *Portrait of Manet by Himself and His Contemporaries.* Trans. Michael Ross. New York: Roy, 1960.

Czestochowski, Joseph, ed. *Degas Sculptures.* Memphis: International Arts, 2002.

Daix, Pierre. *La Vie de peintre d'Edouard Manet.* Paris: Fayard, 1983.

Darragon, Eric. *Manet.* Paris: Citadelles, 1991.

Degas, Edgar. *Letters.* Ed. Marcel Guerin. Trans. Marguerite Kay. Oxford: Cassirer, 1947.

———. "More Unpublished Letters of Degas," ed. Theodore Reff, *Art Bulletin,* 51 (September 1969), 281–286.

———. *Notebooks.* Ed. Theodore Reff. 2 vols. Oxford: Clarendon Press, 1976.

———. "Some Unpublished Letters of Degas," ed. Theodore Reff, *Art Bulletin,* 50 (March 1968), 87–94.

Delafond, Marianne, and Caroline Genet-Bondeville. *Berthe Morisot ou l'audace raisonnée.* Lausanne: Bibliothèque des Arts, 1997.

Denvir, Bernard. *The Impressionists at First Hand.* London: Thames & Hudson, 1991.

DeVonyar, Jill, and Richard Kendall. *Degas and the Dance.* New York: Abrams, 2002.

Dumas, Anne, ed. *The Private Collection of Edgar Degas.* New York: Metropolitan Museum of Art, 1997.

Dunlop, Ian. *Degas.* New York: Galley Press, 1979.

Edelstein, T. J., ed. *Perspectives on Morisot.* New York: Hudson Hills, 1990.

Feigenbaum, Gail, ed. *Degas and New Orleans.* New Orleans: Museum of Art, 1999.

Fowlie, Wallace. "Mallarmé and the Painters of His Age," *Southern Review,* 2 (1966), 542–558.

Friedrich, Otto. *Olympia: Paris in the Age of Manet.* New York: HarperCollins, 1992.

Gauguin, Paul. *Intimate Journals*. Trans. Van Wyck Brooks. New York: Liveright, 1936.

Gautier, Théophile. *Wanderings in Spain*. London: Ingram, Cooke, 1853.

Gay, Peter. *Art and Act: On Causes in History—Manet, Gropius, Mondrian*. New York: Harper & Row, 1976. Pp. 33–110.

Geist, Sidney. "Degas' *Interieur* in an Unaccustomed Perspective," *Artnews*, 75 (October 1976), 80–82.

Getlein, Frank. *Mary Cassatt: Paintings and Prints*. New York: Abbeville, 1980.

Gimpel, René. *Diary of an Art Dealer*. Trans. John Rosenberg. New York: Farrar, Straus & Giroux, 1966.

Goncourt, Edmond, and Jules Goncourt. *Passages from the Goncourt Journal*. Ed., trans. and intro. Robert Baldick. Oxford: Oxford University Press, 1978.

Gordon, Robert, and Andrew Forge. *Degas*. New York: Abrams, 1988.

Gronberg, T. A, ed. *Manet: A Retrospective*. New York: Park Lane, 1988.

Halévy, Daniel. *My Friend Degas*. Trans. and ed. Mina Curtiss. Middletown, Conn: Wesleyan University Press, 1964.

Hanson, Anne Coffin. *Manet and the Modern Tradition*. New Haven: Yale University Press, 1977.

Havemeyer, Louisine. *Sixteen to Sixty: Memoirs of a Collector*. New York: Ursus, 1993.

Herbert, Robert. *Impressionism: Art, Leisure, and Parisian Society*. New Haven: Yale University Press, 1988.

Higonnet, Anne. *Berthe Morisot*. Berkeley: University of California Press, 1990.

Horne, Alistair. *The Fall of Paris: The Siege and the Commune, 1870–1871*. 2nd ed. London: Penguin, 1981.

Hughes, Robert. "Edgar Degas" and "Edouard Manet." In *Nothing If Not Critical*. New York: Penguin, 1992. Pp. 92–97, 135–138.

Huysmans, Joris-Karl. *L'Art Moderne*. Paris: Charpentier, 1883.

———. *Certains*. Paris: Tresse & Stock, 1889.

———. "Degas." In *Downstream*. New York: Fertig, 1975. Pp. 276–281.

Kendall, Richard. "Degas and the Contingency of Vision," *Burlington Magazine*, 130 (March 1988), 180–197.

Krell, Alan. *Manet and the Painters of Contemporary Life*. London: Thames & Hudson, 1996.

Lethève, Jacques. *Daily Life of French Artists in the Nineteenth Century*. Trans. Hilary Paddon. London: Allen & Unwin, 1972.

Locke, Nancy. *Manet and the Family Romance*. Princeton: Princeton University Press, 2001.

Loyrette, Henri. *Degas*. Paris: Fayard, 1991.

McMullen, Roy. *Degas: His Life, Times, and Work*. London: Secker & Warburg, 1985.

Manet, Edouard. "Letters of Edouard Manet to His Wife during the Siege of Paris, 1870–1871," ed. and trans. Mina Curtiss, *Apollo*, 113 (June 1981), 378–389.

Manet, Julie. *Journal, 1893–1899. Sa jeunesse parmi les peintres impressionistes et les hommes de letters*. Paris: Klincksieck, 1979.

Mathews, Nancy. *Mary Cassatt*. New York: Abrams, 1987.

———. *Mary Cassatt: A Life*. New Haven: Yale University Press, 1994.

———, ed. *Mary Cassatt: A Retrospective*. New York: Levin, 1996.

Meier-Graefe, Julius. *Degas*. Trans. J. Holroyd Reece. New York: Dover, 1988.

Meyers, Jeffrey. "Degas' *The Misfortunes of the City of Orléans in the Middle Ages*: A Mystery Solved," *Source: Notes in the History of Art*, 21 (Summer 2002), 11–16.

———. "Degas Sculptures," *New Criterion*, 22 (December 2003), 43–46.

———. "Old Masters, Impressionists and Moderns: French Masterworks from the Pushkin Museum, Moscow," *Apollo*, 159 (October 2003), 51–52.

Mongan, Elizabeth. *Berthe Morisot: Drawings, Pastels, Watercolors, Paintings*. New York: Shorewood, 1960.

Moore, George. *Confessions of a Young Man*. New York: Capricorn, 1959.

———. *Impressions and Opinions*. London: Laurie, 1913.

Morisot, Berthe. *Correspondence.* Ed. Denis Rouart. Trans. Betty Hubbard. 1957; Mt. Kisco, New York: Moyer Bell, 1987.

Nicolson, Benedict. "Degas as a Human Being," *Burlington Magazine,* 105 (June 1963), 239–241.

Nochlin, Linda. *The Politics of Vision: Essays on Nineteenth-Century Art and Society.* New York: Harper & Row, 1989.

Nord, Philip. "Manet and Radical Politics," *Journal of Interdisciplinary History,* 19 (Winter 1989), 447–480.

Patry, Sylvie, ed. *Berthe Morisot, 1841–1895.* Paris: Réunion des musées nationaux, 2002.

Perl, Jed. "Art and Urbanity: The Manet Retrospective," *New Criterion,* 2 (November 1983), 43–54.

Pissarro, Camille. *Letters to His Son Lucien.* Ed. John Rewald. Trans. Lionel Abel. Boston: Museum of Fine Arts, 2002.

Proust, Antonin. *Edouard Manet: Souvenirs.* Paris: Laurens, 1913.

Raimondi, Riccardo. *Degas e la sua famiglia in Napoli, 1793–1917.* Napoli: SAV, 1958.

Reff, Theodore. *Degas: The Artist's Mind.* Cambridge, Mass.: Harvard University Press, 1987.

———. *Manet and Modern Paris.* Chicago: University of Chicago Press, 1982.

———. *Manet: "Olympia."* London: Allen Lane, 1976.

Renoir, Jean. *Renoir: My Father.* Trans. Randolph and Dorothy Weaver. Boston: Little, Brown, 1962.

Rewald, John. *The History of Impressionism.* New York: Museum of Modern Art, 1946.

Richardson, John. *Manet.* Oxford: Phaidon, 1982.

Schapiro, Meyer. *Impressionism: Reflections and Perceptions.* New York: Braziller, 1997.

Schneider, Pierre. *The World of Manet, 1832–1883.* New York: Time-Life Books, 1967.

Shattuck, Roger. "Stages on Art's Way," *New Republic,* 216 (February 3, 1997), 43–44, 46–49.

Shennan, Margaret. *Berthe Morisot: First Lady of Impressionism*. Stroud, England: Sutton, 1996.

Sickert, Walter. *A Free House! or The Artist as Craftsman*. Ed. Osbert Sitwell. London: Macmillan, 1947.

Snow, Edgar. *A Study of Vermeer.* Berkeley: University of California Press, 1979. Pp. 25–36, 147–150.

Stuckey, Charles, and William Scott. *Berthe Morisot—Impressionist*. New York: Hudson Hills, 1987.

Sutton, Denys. *Edgar Degas: Life and Work*. New York: Rizzoli, 1986.

Sweet, Frederick. *Miss Mary Cassatt: Impressionist from Pennsylvania*. Norman: University of Oklahoma Press, 1966.

Thomson, Richard. *Degas: The Nudes*. London: Thames & Hudson, 1988.

Tucker, Paul Hayes. *Manet's "Le Déjeuner sur l'herbe."* Cambridge, England: Cambridge University Press, 1998.

Valéry, Paul. *Degas Manet Morisot.* Trans. David Paul. New York: Pantheon, 1960.

Vollard, Ambroise. *Degas: An Intimate Portrait.* Trans. Randolph Weaver. New York: Dover, 1986.

———. *Recollections of a Picture Dealer.* Trans. Violet MacDonald. New York: Dover, 1978.

Watson, Forbes. *Mary Cassatt*. New York: Whitney Museum, 1932.

Wilson-Bareau, Juliet. *Manet by Himself*. London: Macdonald, 1991.

———. *Manet: "The Execution of Maximilian": Painting, Politics and Censorship*. London: National Gallery, 1992.

———. *Manet, Monet and the Gare Saint-Lazare*. New Haven: Yale University Press, 1998.

Wilson-Bareau, Juliet, and David Degener. *Manet and the Sea*. New Haven: Yale University Press, 2003.

Wollheim, Richard. *Painting as an Art*. Princeton: Princeton University Press, 1987.